*China, Transnational Visuality,
Global Postmodernity*

China, Transnational Visuality, Global Postmodernity

Sheldon H. Lu

STANFORD UNIVERSITY PRESS
STANFORD, CALIFORNIA 2001

Stanford University Press
Stanford, California
© 2001 by the Board of Trustees of the
Leland Stanford Junior University

Printed in the United States of America
On acid-free, archival-quality paper

Library of Congress Cataloging-in-Publication Data
Lu, Hsiao-peng.
 China, transational visuality, global postmodernity / Sheldon H. Lu.
 p. cm.
 Includes bibliographical references and index.
 ISBN 0-8047-3896-3 (alk. paper)—ISBN 0-8047-4204-9 (pbk. : alk. paper)
 1. Postmodernism—China. 2. China—Civilization—1976–
 3. Popular culture—China. I. Title.
 DS779.23 .L82 2001
 951.05'9—dc21 2001034146

Original Printing 2001

Last figure below indicates year of this printing:
00 09 08 07 06 05 04 03 02 01

Typeset by BookMatters in 11/14 Adobe Garamond

To my students

Contents

List of Illustrations ... ix
Acknowledgments ... xi
List of Abbreviations ... xv

Introduction: Postmodernity, Visuality, and China in the Late Twentieth Century ... 1

PART I. | THEORY, CRITICISM, INTELLECTUAL HISTORY

1. Intellectuals in Transition: The Academy, the Public Sphere, and Postmodern Politics ... 31
2. Universality/Difference: The Discourses of Chinese Modernity, Postmodernity, and Postcoloniality ... 48
3. Theory and Criticism: Economic Globalization, Cultural Nationalism, Intellectual Identity ... 71

PART II. | CINEMA

4. *Ermo*: Televisuality, Capital, and the Global Village
 COAUTHORED WITH ANNE T. CIECKO ... 89
5. Diaspora, Citizenship, Nationality: Hong Kong and 1997 ... 104
6. The Heroic Trio: Anita Mui, Maggie Cheung, Michelle Yeoh—Self-Reflexivity and the Globalization of the Hong Kong Action Heroine
 COAUTHORED WITH ANNE T. CIECKO ... 122

PART III. | AVANT-GARDE ART

7. Postmodernism and Cultural Identity in Chinese Art ... 141
8. The Uses of China in Avant-Garde Art: Beyond Orientalism ... 173

PART IV.	POPULAR CULTURE, TELEVISION DRAMA, LITERATURE	
9.	Popular Culture: Toward a Historical and Dialectical Method	195
10.	Soap Opera: The Transnational Politics of Visuality, Sexuality, and Masculinity	213
11.	Literature: Intellectuals in the Ruined Metropolis at the Fin de Siècle	239
	Postscript: 1999	261
	Notes	269
	Index	305

Illustrations

1. Ermo and Xiazi (Blindman) eat at the "International Restaurant" in *Ermo*. 95
2. Ermo in *Ermo*. 97
3. Maggie Cheung as Li Qiao in *Comrades, Almost a Love Story*. 109
4. Leslie Cheung and Tony Leung in *Happy Together*. 113
5. Schizophrenic Hong (Maggie Cheung) at the end of *Farewell China*. 119
6. *Irma Vep*. 129
7. Michelle Yeoh in the James Bond film *Tomorrow Never Dies*. 135
8. Wang Jinsong. *Taking a Picture in Front of Tiananmen Square* (*Tiananmen qian liugeying*). Oil on canvas. 1992. 148
9. Fang Lijun. *Series II, No. 6* (*Di er zu, di liu fu*). Oil on canvas. 1991–92. 150
10. Wang Guangyi. *Great Criticism: Nikon* (*Da pipan: Nikang*). Oil on canvas. 1992. 151
11. Yu Youhan. *The Waving Mao* (*Zhaoshou de Mao Zedong*). Acrylic on canvas. 1990. 152
12. Feng Mengbo. *The Video Endgame Series: Taking Tiger Mountain by Strategy* (*Youxi zhongjie: Zhiqu weihushan*). Oil on canvas. 1992. 153
13. Zhang Xiaogang. *Bloodline: The Big Family, No. 2* (*Xueyuan xilie: da jiating, erhao*). Oil on canvas. 1995. 154

14. Xu Bing. *A Book from the Sky* (a.k.a. *A Mirror to Analyze the World, Tianshu/Xi shi jian*). Installation/mixed media. 1987–91. 156

15. Yin Xiuzhen. *Sowing and Planting* (*Zhong Zhi*). Installation. 1995. 162

16, 17. Yin Xiuzhen. *Ruined Capital* (*Feidu*). Installation. 1996. 163

18. Zhang Peili. *Divided Space* (*Xiangdui de kongjian*). Installation. 1995. 164

19. Qiu Zhijie. *Copying the "Orchid Pavilion Preface" a Thousand Times* (*Shuxie yiqianbian Lantingxu*). Installation/performance. 1992–95. 165

20. Zhu Jinshi. *Water of Lake Houhai* (*Houhai hushui*). Installation. 1995. 167

21. Zhu Jinshi. *Square Formation/Impermanence* (*Fangzhen/wuchang*). Installation. 1996. 169

22. Xu Bing. *A Case Study of Transference* (a.k.a. *Cultural Animals, Wenhua dongwu*). Installation/performance. 1994. 170

23. Xu Bing. *Square Words: New English Calligraphy for Beginners*. Mixed Media. 1996. 171

24. Qin Yufen. *Lotus in Wind* (*Feng he*). Installation. 1994. 176

25. Ju Ming. *Tai Chi Single Whip*. Sculpture. 1985. 177

26. Chen Zhen. *Daily Incantations* (*Zhou*). Installation. Wood, metal, chamber pots, electrical appliances, television, radios, and electrical cable. 1996. 181

27. Wang Ziwei. *Mao and Mickey*. Acrylic on canvas. 1994. 184

28. Cai Guo-Qiang. *Project for Extraterrestrials No. 9: Fetus Movement II*. Installation. 1992. 187

29. Cai Guo-Qiang. *Dragon: Explosion on Issey Miyake Clothing*. Installation/performance. 1998. 188

30. Gu Dexin. *10-30-1999*. Installation. 1999. 191

31, 32. Tiancheng gazes at the sleeping beauty Olia in *Russian Girls in Harbin*. 228

Acknowledgments

Slightly different versions of various chapters in this book have been printed in the following publications:

Chapter 2, "Universality/Difference: The Discourses of Chinese Modernity, Postmodernity, and Postcoloniality," first appeared in *Journal of Asian Pacific Communication* 9.1 and 2 (1999): 97–111.

Chapter 4, "*Ermo*: Capital, Televisuality, and the Global Village," coauthored with Anne T. Ciecko, first appeared in *Jump Cut* 42 (1998): 77–83.

Chapter 5, "Diaspora, Citizenship, Nationality: Hong Kong and 1997," first appeared under the title "Filming Diaspora and Identity: Hong Kong and 1997," in *The Cinema of Hong Kong: History, Arts, Identity*, eds. Poshek Fu and David Desser (New York: Cambridge University Press, 2000), pp. 273–88.

Chapter 6, "The Heroic Trio: Anita Mui, Maggie Cheung, Michelle Yeoh—Self-Reflexivity and the Globalization of the Hong Kong Action Heroine," coauthored with Anne T. Ciecko, first appeared in *Post Script* 19.1 (fall 1999): 70–86.

Chapter 9, "Popular Culture: Toward a Historical and Dialectical Method," first appeared as part of the essay "Postmodernity, Popular Culture, and the Intellectual: A Report on Post-Tiananmen China," *boundary 2* 23.2 (summer 1996): 139–69.

Chapter 10, "Soap Opera: The Transnational Politics of Visuality, Sexuality, Masculinity," first appeared in *Cinema Journal* 40.1 (fall 2000): 25–47.

Fragments and portions of the material contained in "Introduction"; Chapter 1, "Intellectuals in Transition"; Chapter 3, "Theory and Criticism"; Chapter 7, "Postmodernism and Cultural Identity in Chinese Art"; and Chapter 8, "The Uses of China in Art: Beyond Orientalism," first appeared in the following essays:

"Postmodernity, Popular Culture, and the Intellectual: A Report on Post-Tiananmen China," *boundary 2* 23.2 (summer 1996): 139–69.

"Global POSTmodernIZATION: The Intellectual, the Artist, and China's Condition," *boundary 2* 24.3 (fall 1997): 65–97.

"Art, Culture, and Cultural Criticism in Post-New China," *New Literary History* 28.1 (winter 1997): 111–33.

I thank *Jump Cut, Post Script,* University of Texas Press/*Cinema Journal,* Duke University Press/*boundary 2,* The Johns Hopkins University Press/*New Literary History,* Cambridge University Press, and Elsevier Science Inc./*JAPC* for allowing me to reprint and use previously published materials.

It has been an enriching, stimulating experience of rediscovery for me to write a book about China in the 1990s. I left Beijing for the United States at the dawn of the so-called "New Era" (ca. 1977–89), and was only able to make regular visits to China in the 1990s. During my student years in the United States, I missed the entire New Era, the decade of the 1980s, and indulged in the study of refined classical literature from China's past. As the forces of modernization and globalization are gathering more momentum day by day, the face of Beijing and China as a whole has undergone tremendous changes, sometimes beyond recognition. In the process of rapid urban destruction and reconstruction, history, memory, and the past have been buried under heaps of ruins and overshadowed by gleaming skyscrapers and sprawling highways. It has been quite an effort to refamiliarize myself with the Beijing I knew spatially, emotionally, personally, and intellectually as a teenager. It is baffling, challenging, and yet ultimately gratifying to make sense of the confusions and contradictions of contemporary China, to map out and fill in the blank spaces in my own mind as I try to make a connection between socialist China in the 1970s, the pre-New Era, and China in the 1990s, the post-New, postsocialist, postmodern era.

ACKNOWLEDGMENTS

Over the span of half a decade, early versions of the materials scattered throughout this book have been presented on numerous occasions at various sites in North America, China, Hong Kong, Taiwan, and Europe. I owe thanks to those events' organizers, who are too many to enumerate here individually, for providing me with forums to test out my ideas.

Many colleagues and friends helped me think through the diverse issues and subjects discussed in the individual chapters. They were the audiences and commentators at my oral presentations at various locales of the globe, or readers and editors at different stages of the writing. For their assistance, critique, and inspiration, I thank Ackbar Abbas, Stanley Abe, Julia Andrews, Jonathan Arac, Paul Bové, Anne T. Ciecko, Ralph Cohen, David Desser, Arif Dirlik, Gerald Duchovnay, Lucy Fischer, Steve Fore, Poshek Fu, Chuck Kleinhans, Marcia Landy, Jenny Lau, Lee Tain-dow, Julia Lesage, Kathy Linduff, Perry Link, Gina Marchetti, Frank Tomasulo, Q. S. Tong, Richard Trappl, Wang Fengzhen, Wang Ning, Tony Williams, Wu Hung, Yingjin Zhang, and Zhang Yiwu. I am particularly grateful to Arif Dirlik for reading the entire manuscript and offering important suggestions for revision. I am indebted to Anne T. Ciecko for her support during the writing of the book, and for her loving generosity in unselfishly allowing me to use the two essays we coauthored in my own book.

It has been a great pleasure and honor to be acquainted with many of the most outstanding Chinese artists inside and outside China, who have made it possible for me to gain insight into the ever-evolving subject of Chinese avant-garde art. I have benefitted from interactions with the late Chen Zhen, Cai Guo Qiang, Gu Dexin, Hong Hao, Qin Yufen, Wang Jianwei, Wang Jinsong, Wang Luyan, Wang Youshen, Xu Bing, Yin Xiuzhen, Zhang Huan, Zhang Lei, Zhang Peili, and Zhu Jinshi, among others. I discuss some of their work in the book, and I look forward to seeing more of their exciting, provocative art. My appreciation also goes to curators and art historians for their assistance and friendship: Chang Tsong-zung and his staff at the Hanart T Z Gallery in Hong Kong; Madeleine Grynstejn, curator of the Carnegie International 1999/2000 and her staff at the Carnegie Museum in Pittsburgh; Barbara Luderowski, Michael Olijnyk, and their staff at the Mattress Factory in Pittsburgh; Huang Du in Beijing; and Lin Xiaoping in New York City.

I thank Eugene Eoyang, Shuen-fu Lin, Michelle Yeh, John Lent, Victor

Mair, and Wang Yichuan for their help in matters beyond the pages of the book. I appreciate the support of many colleagues at the University of Pittsburgh, especially Lucy Fischer, Kathy Linduff, Keiko McDonald, Tom Rimer, and Cecile Sun. My thanks are also due the Asian Studies Program, the University Center for International Studies, the China Council, and the Department of East Asian Languages and Literatures at the University of Pittsburgh for providing financial assistance for my annual research trips to China all these years. Without these "field trips," I would have known very little about the changing reality of the contemporary Greater China area beyond what I could read on paper.

Last, but not least, I very much appreciate the efficient handling of my manuscript in the hands of my editors at Stanford University Press: Helen Tartar, Amy Jamgochian, Matt Stevens, and Leigh Johnsen. I am fortunate to have a chance to work again with Stanford University Press, which published my first book on a very different subject—classical Chinese literature and comparative poetics—more than half a decade ago.

Sheldon H. Lu
Beijing, March 2001

Abbreviations

CBD	Central Business District
CCP	Chinese Communist Party
CCTV	China Central TV
GATT	General Agreement on Tariffs and Trade
ICA	International Confucian Association
IMF	International Monetary Fund
PRC	People's Republic of China
SAR	Special Administrative Region
SEZ	Special Economic Zone
SOE	State-owned enterprise
TNC	Transnational corporations
VCD	Video cassette disc
WTO	World Trade Organization

*China, Transnational Visuality,
Global Postmodernity*

Introduction: Postmodernity, Visuality, and China in the Late Twentieth Century

This book is a study of Chinese postmodern culture in a global context at the fin de siècle—the last decade of the twentieth century and the end of the second Christian millennium. Moreover, much of the study focuses on aspects of Chinese visual culture in the 1990s as they relate to transnational forces across the world. From Tiananmen Square at the heart of the city of Beijing—China's political center—to the colorful billboards and advertisements of Western products in the streets not far from the square, or in any American department store or shopping mall filled with a multitude of low-end products with the label "Made in China," the global position of China in political and economic terms can be visibly measured. Yet the cultural dimension is much more nebulous and intangible and remains to be understood and theorized adequately.

The present interdisciplinary project is divided into four parts. The chapters in Part I offer a brief outline of Chinese intellectual history in the 1990s and review important theoretical and critical debates such as Asian moder-

nity, alternative modernity, Chinese socialism, Confucian capitalism, post-ism (*houxue*), humanism, liberalism, nationalism, the New Left, and national studies (*guoxue*). I examine the changing function of intellectuals and the academy in a transitional period, new configurations of the public sphere, the impact of economic globalization on cultural activities, and the politics of postmodernism in Chinese style. Parts II–IV are intended to provide a comprehensive inventory of the constitutive aesthetic characteristics of emergent Chinese postmodernism. The individual chapters analyze crucial manifestations of Chinese culture in film, television, literature, and avant-garde art. Special attention is given to the discussion of transnational visuality at the end of the twentieth century.

Politics and Economics

The 1990s not only brought the twentieth century to a close, but also prefigured developments in the next century. The twenty-first century begins in the aftermath of momentous events of the last decade of the previous century. It may be said that to a great extent the "new world order" established since 1990 can be traced to and was partially caused by the decisive social and political events in China in 1989. The demonstrations and protests in Tiananmen Square in the spring of 1989 had far-reaching implications for the rest of the world. Although the democracy movement failed in China, the events were made known to all the world instantaneously by the media—mostly by the power of television. Chinese students, intellectuals, workers, and Beijing citizens directly inspired massive demonstrations and widespread uprisings that ultimately brought down regimes in the Soviet Union and the socialist bloc countries of Eastern Europe. The cold war, which had dominated global geopolitics for almost half a century since the end of World War II, ended overnight.

The new economic and political configurations in the post–cold war era have been described by various cultural critics as characterized by transnationalism, global capitalism, finance capitalism, and post-Fordism.[1] Some people, Francis Fukuyama for one, have also declared the final triumph of capitalism and "the end of history."[2] Although most of the world has changed, China stubbornly remains a socialist/communist state in name.

Even though political reforms are minimal, however, the Chinese economy is actually moving decidedly and irreversibly in the direction of a market economy.

At the Fourteenth Congress of the Chinese Communist Party in 1992, the government officially adopted the policy of "socialist market economy," a euphemism for capitalist market economy, with the backing of China's former paramount leader, Deng Xiaoping. Five years later, at the Fifteenth Party Congress of 1997, a new generation of leaders headed by Jiang Zemin implemented additional economic and institutional reforms. Bankrupt and inefficient state enterprises were allowed to be sold to private individuals. Ordinary workers could become shareholders of their factories and companies. "Public shareholding," a new term used to avoid the notion of "private ownership" in a nominally socialist state, further legitimized capitalist economic practices in China. In the spring of 1998, the People's Congress swore in China's new premier, Zhu Rongji, known as China's "economic czar." In order to ease the burden of the state and put an end to inefficient and money-losing enterprises, the state began to carry out a massive layoff plan, the scale of which has been unknown in modern history. Tens of millions of workers, state employees, and bureaucrats, who had been securely protected by the country's socialist welfare system, lost jobs and income.

In late 1999, China and the United States concluded their decade-long negotiations regarding China's admission into the World Trade Organization (WTO). Under the terms of the agreement, China will completely open its markets to foreign businesses in the next several years in all fields, including the sensitive areas of finance and telecommunications. This development signals the total integration of the Chinese economy into the capitalist world system. China's "merging with the international track" (*yu guoji jiegui*) will have far-reaching repercussions for its residual socialist institutions and practices. Although WTO membership may expedite the structural transformation of the Chinese economy toward more competition and efficiency, however, segments of the working force and some industries will plunge into deeper crises.

The accelerated economic reforms in China, initiated in the late 1970s and fueled by transnational capital in the 1990s, have transformed the country into a significant participant in the global economy. "China now produces half the world's toys, two-thirds of its shoes, most of the world's bicy-

cles, lamps, power tools and sweaters. . . . China is also the largest recipient of foreign investment after the United States. More than $35 billion in direct investment poured into China in 1995, a record."[3]

China's reliance on the world economy, as well as its independence, were both tested in the Asian financial crisis that began in 1997 after stock markets in East and Southeast Asia crashed one after another. Countries such as Thailand, Indonesia, South Korea, Malaysia, and Japan experienced varying degrees of economic recession and currency devaluation afterward. The long-held mythologies of the "Asian economic miracle," "Confucian capitalism," and "the East Asian development model" evaporated into thin air. Yet China struggled to hold onto its goal of economic growth at a high annual rate despite the turmoil. It also pledged not to devalue the Chinese yuan, in order to maintain domestic stability and save the Hong Kong dollar. Now that China has committed itself to open the country's markets to the world eventually, it remains to be seen how the country will develop under the volatile system of finance capitalism whose unpredictable moves and laws of operation have destabilized much of the regional and global economy.

Culture and Postmodernism, or China in the Global Cultural Imaginary

The purpose of this study then is to map the terrain of culture in China amidst the disjunctions between socialist politics and capitalist economics. Such disjunctions are most clearly manifested in the contested realm of culture. The emergence and unfolding of postmodernism in Chinese style clears a space that mediates, reflects, and constitutes the various dilemmas and contradictions of Chinese reality at the end of the twentieth and the beginning of the twenty-first centuries. Hence, my project has a twofold aim: both to investigate the condition of "global postmodernity," by which I mean the latest stage of postmodernity and postmodernism, across the world beyond its original Euro-American confines, and at the same time to study how post-1989 China has become a chief generator of such transnational postmodernity and has thus revised the Western model.

Prevalent theories of postmodernism were formulated in the early and mid-1980s on the basis of the historical and cultural experiences of Europe

and North America. These theories did not take into account the social, economic, and cultural formations of non-Western countries and what has been called the "Third World." The second stage of the postmodernism debate occurred in the late 1980s and early 1990s, when discussions of the phenomenon focused on Latin America, Africa, and Asia.[4] The entry of China into discussions about international postmodernism constitutes the "third wave," so to speak, and is strategically significant for research because it intensifies certain old problematics and raises new questions.

Efforts to place socialist China in the global cultural imaginary have been complex and intriguing. For a long time the West has harbored two opposite attitudes toward China. One position is the humanist, liberal tradition, which assumes a critical, negative attitude toward Chinese totalitarianism. The critics are interested in discovering literary and artistic products from China that run counter to the existing regime and express a yearning for humanity and freedom. The second position is held by leftist intellectuals in whose minds Chinese socialism occupies a special, cherished place. In this tradition, Chinese Marxism, or Maoism, is seen as a healthy antidote to the orthodoxy of Soviet-style Marxism, or "Hegelian Marxism" in Louis Althusser's terminology. Furthermore, the Chinese revolution is regarded as an alternative to the sterility of capitalist modernity. Although the humanist, liberal attitude toward China is more widely accepted by the general populace, the Marxist, leftist tradition has had far more influence in academic, theoretical circles. In critical studies of politics, economy, and culture, Western Marxist theorists have often demonstrated a sustained effort to learn from the Chinese experience.

The impact of revolutionary and socialist China upon the rest of the world cannot be underestimated. "The overwhelming fact of the Chinese Revolution, seizing state power in 1949 and remaining a key defining polarity until after the end of the Cultural Revolution, exercised enormous influence on anti-colonial struggles throughout this period, from the end of the Second World War up to the mid-1970s."[5] Mao's theory of the Three Worlds has also had global currency in offering a blueprint for revolutionary, anticolonial, and anti-imperialist struggles around the world. "The true prestige of the Three Worlds Theory came, in any case, only with the Chinese Cultural Revolution, when the definition of the world was most thoroughly revamped."[6]

Mao's theoretical texts, such as *On Contradiction* (1937), and the mass movement of the Cultural Revolution (1966–76), which he led, provided an occasion for Western Marxists to rethink a host of key issues related to traditional Marxism. Radical student movements and many intellectual endeavors in the West during the 1960s were bolstered by the antiestablishment rhetoric of China's Cultural Revolution. Mao's description of the multilayered structure of contradictions in Chinese society and his emphasis on the importance of ideology and culture in the revolutionary process encouraged theorists such as Althusser to reconsider the traditional Marxian concept of the relationship between the base (economics) and the superstructure (ideology and culture). Althusser's notion of "overdetermination" allowed him to move away from "Hegelian Marxism," or Stalin's economic determinism, and to restore culture to its proper place. Althusser stressed Mao's understanding of the complexity, specificity, and unevenness of contradictions and wrote the following in regard to Mao: "And then we suddenly come upon three very remarkable concepts. Two are concepts of distinction: (1) the distinction between the *principal contradiction* and the secondary contradictions; (2) the distinction between the *principal aspect* and the secondary *aspect* of each contradiction. The third and last concept: (3) the *uneven development* of contradiction."[7] In his "structuralist" revision of traditional Hegelian Marxism and crude economism, Althusser appropriated Mao's analysis of the various kinds of contradictions in a given society (antagonistic, nonantagonistic, principal, secondary, and so forth).

Building on early thinkers, including Mao and Althusser, Fredric Jameson has attempted to learn from the Chinese revolutionary tradition, more specifically, from the idea and historical experience of "cultural revolution." Jameson envisions the crucial importance of such ideas for the future of humanistic studies. His arguments in *The Political Unconscious* (1981) need to be quoted at some length:

> We will therefore suggest that this new and ultimate object may be designated, drawing on recent historical experience, as *cultural revolution*, that moment in which the co-existence of various modes of production becomes visibly antagonistic, their contradictions moving to the very center of political, social, and historical life. The incomplete Chinese experiment with a "proletarian" cultural revolution may be invoked in support of the proposi-

tion that previous history has known a whole range of equivalents for similar processes to which the term may legitimately be extended.

The concept of cultural revolution, then,—or more precisely, the reconstruction of the materials of cultural and literary history in the form of this new "text" or object of study which is cultural revolution—may be expected to project a whole new framework for the humanities, in which the study of culture in the widest sense could be placed on a material basis.[8]

Here Jameson lays out a new materialist concept of what became known as "cultural studies," a concept that permits better analysis of the totality of social, political, and historical life—the coexistence of various modes of production, antagonistic and nonantagonistic contradictions, residual and emergent formations, and interrelations of history, politics, economics, ideology, and culture (autonomous, semiautonomous, nonautonomous) at both the synchronic and diachronic level. As I shall discuss later, this leftist, utopian, romantic appropriation of the Cultural Revolution, which is seen as nothing less than a colossal disaster by many Chinese citizens who lived through it, has had repercussions in the contemporary debate on Chinese postmodernism.

Beginning in the late 1960s and early 1970s, the revolutionary paradigm emerged and challenged the modernization paradigm in Chinese historical studies in the United States. In view of the revolutionary movements around the world, including China's Cultural Revolution, "the failure of traditional society was accompanied by the success of the revolutionary struggle, which also promised an alternative modernity."[9] According to the new paradigm, revolution was not an obstacle on the path to China's modernization, but overcame the obstacles to social progress.

Three years after publication of *The Political Unconscious*, Jameson put forth his theory of postmodernism in the influential essay "Postmodernism, or the Cultural Logic of Late Capitalism," published in the *New Left Review* (1984).[10] Yet even here, revolutionary and socialist China still figures prominently in the cultural and geopolitical imaginary of the left. The socialist experiment of the New China, "Number Three," provides a fresh alternative to the impasse of the two superpowers during the cold war era. Commenting on a poem titled "China" by the San Francisco–based poet Bob Perelman, Jameson writes:

Many things could be said about this interesting exercise in discontinuities; not the least paradoxical is the reemergence here across these disjoined sentences of some more unified global meaning. Indeed, insofar as this is in some curious and secret way a political poem, it does seem to capture something of the excitement of the immense, unfinished social experiment of the New China—unparalleled in world history—the unexpected emergence, between the two superpowers, of "number three," the freshness of a whole new object world produced by human beings in some new control over their collective destiny; the signal event, above all, of a collectivity which has become a new "subject of history" and which, after the long subjection of feudalism and imperialism, again speaks in its own voice, for itself, as though for the first time.[11]

Here Jameson enthusiastically speaks about the appearance of "the New China" during the cold war era, which was dominated by the two superpowers. What seems to be remarkable about China is its "social experiment," the formation of a new "collectivity," and the emergence of a new "subject of history" upon the world scene. Yet Jameson soon informs us that the poem to which his comment refers is very much an evacuated text. The sentences of the poem are the poet's captions to pictures in a book of photographs of China. The real China in the poem is only a representation of a representation of an absent object. The unified global meaning of China is made of "discontinuities" and disjunctions.

Jameson was then describing the features of American postmodernist culture by analyzing the poem as an example. The "New China" under discussion then was the remotest thing from postmodernism and late capitalism. However, the situation has changed drastically in post-New China during the age of global capitalism after the cold war. Critics today face not only the deconstruction of the textual meaning of a poem about China, but the very undoing of the Chinese historical subject. Something that formerly appeared to be a singular Chinese collectivity is now an ensemble of heterogeneous, discontinuous, and disjunctive elements, an entity that lacks a unified global meaning. It seems that the emergent cultural logic in contemporary China is postmodernism within a dominant capitalist world system.

In the post-Mao era, or the New Era (*xin shiqi*, ca. 1977–89), China's paramount leader, Deng Xiaoping, whom Mao once called a "revisionist," embarked on a new path of modernization that gradually pulled China away from the legacies of Marxism, Maoism, and socialism, although these were

still the "cardinal principles" that the Communist Party staunchly defended. As a result, the perception of China under Deng's economism and pragmatism became unclear among members of the Western left.[12] It is no coincidence that by the mid-1980s, in pace with the economic progress of China itself, the modernization paradigm in China studies prevalent in the United States replaced the revolution paradigm and became predominant.

In this new paradigm, the revolutionary legacy is sometimes thought to be an aberration in the modernization process. Deng's economism was a direct reversal of Mao's culturalism and his pragmatism was summed up in his own phrase: "It does not matter whether it is a black cat or white cat. It is a good cat if it catches mice." By emphasizing the economic, the state avoids debates on ideological and cultural issues. According to the official line of the Communist Party, Chinese society is in the "primitive stage of socialism" (*shehuizhuyi chuji jieduan*). Yet Western scholars customarily call contemporary China a "postsocialist" society. It is precisely because of such terminological/conceptual anomalies, as well as lack of articulation of the cultural, that a theory of the postmodern may fill a gap and provide a description of contemporary China.

It is my basic contention that a properly historical materialist theory of culture—"postmodernism"—must be built on and correlated to an analysis of the socioeconomic foundation as a whole—to "postmodernity." Under Deng's economism, since the late 1970s to the 1990s profound changes in modes of production and forces of production gradually gave rise to a new social totality—to a Chinese postmodernity. Even in the early 1970s, when China advocated its own "Three Worlds theory," China classified itself as a "developing country" belonging to the third world. As Jonathan Arac acutely points out, "China's self-recategorization in relation to its economic development seems thoroughly part of the world that Jameson delineates, in which the global logic of capital is 'dominant'—which does not mean at every moment triumphant."[13]

Deng's new economic policy moved China away from the Stalinist model of industrialization adopted during the Mao era. Priority in economic development was no longer one-sidedly given to heavy industry and the industrial base of production. It is interesting to recall that in the interim period of 1977–78 Mao's chosen successor, Hua Guofeng, still adhered to the Maoist model of industrialization and modernization. Hua promoted such slogans

as "build a dozen Taqing-style Oil Refineries" (*jianshe shilaige Taqing*), "build a dozen Tazhai-style communes" (*jianshe shilaige Tazhai*), and "the mechanization of agriculture" (*nongye jijiehua*). However, Deng's premier, Zhao Ziyang, who was ousted from leadership in 1989, gave priority to decentralized, flexible, "post-Fordist" modes of accumulation, production, and consumption in contrast to the Mao-era practices of high-handed central planning, collectivization, nationalization, and state ownership.

Growth in light industry, export, the service sector, and the private sector has fundamentally changed China's economic and social infrastructure, which was highly centralized and tilted toward investment in heavy industry in the past. Foreign investment, transnational capital, joint enterprises between Chinese and foreign businesses, township enterprises (*xiangzhen qiye*), and individual entrepreneurs (*geti hu*)—these various forms of ownership and entrepreneurship have created an extremely diversified economic and social reality. Moreover, in opening up coastal cities, setting up Special Economic Zones (SEZs) such as Shenzhen, and adopting the idea of "one country two systems" as a model for Hong Kong's return to the mainland, Deng and his followers have recognized the tremendous socioeconomic disparity between various regions of China and the fact that no single model of development suits the entire country. As a consequence, the Chinese economy has been transformed into a consumer-oriented economy at the expense of the state sector, which was in shambles in the late 1990s and badly in need of cleaning up. The reforms in the Deng era and beyond have set in motion a steady process of "postmodernization."

Against the background of such social, economic, and historical changes, postmodernism as a new cultural, literary, and artistic formation has taken place in China. It was first manifested in small, elite circles of avant-garde experimental writers and artists, then expanded to popular and mass culture (TV, film, pop music, popular literature, fashion). Today, anyone who takes a walk down a main street or visits a department store in a Chinese city immediately notices that he/she is immersed in a sea of commodity signs, advertisements, electronic images, and simulacra. Postmodern culture permeates vast spheres of social existence and becomes a way of life. What is described by Mike Featherstone as the "aestheticization of everyday life" is also an apt depiction of China in the 1990s.[14] One witnesses the collapse of the boundary

between art and life, the saturation of daily existence with the constant flow of commodity signs, and the reworking of desires through images.

Periodization, or the Advent of Postmodernity in China

The present study will try to answer three interrelated questions: (1) How and to what extent is China "postmodern"? (2) What are the constitutive aesthetic features of Chinese postmodern culture in literature, avant-garde art, film, and popular TV programs? (3) What is the politics of postmodernism in the Chinese context?

Post-1989, post-Tiananmen, and "post-New Period" are all terms that cover the postmodern moment. Generally speaking, intellectual discourse about the "New Period" (ca. 1977–89) revolves around the issues of modernization, modernity, humanism, and reconstruction of a new subjectivity.[15] The New Period came to an end in 1989 with the Tiananmen debacle, which is considered a watershed in contemporary Chinese cultural and intellectual history. Some Chinese critics have called the period from the death of Mao Zedong and the beginning of Deng Xiaoping's reform in the late 1970s through 1989 the "New Era" (*xin shiqi*). They name the period after 1989 and up to the present the "post–New Era" (*hou xin shiqi*).[16] A deep sense of cultural crisis in the People's Republic of China has followed the tragedy of June 4, 1989, in Tiananmen Square.

Two closely related developments seem to indicate a new phase of culture in modern Chinese history. First, the rapid ascendancy of commercialized popular culture in an ever expanding consumer society signals the beginning of a new age. Second, perhaps for the first time in modern Chinese history, the role of the intellectual must be redefined as a result of his/her diminishing position and influence among the populace. In addition, major differences in literary and cultural realms exist between the New Era and the post–New Era. The latter period is distinguished from the former by several major interrelated manifestations: the emergence of postmodern discourse, the commercialization and transformation of popular culture, and the changing role of the intellectual.

Although I give primary importance to the year 1989 to conveniently

demarcate historical changes in this study, the periodization could be sharpened further: even though 1989 is fundamentally important, especially for intellectuals, some of the phenomena to be investigated predate 1989. Other phenomena and developments gained impetus with the unbridled commercialization sanctioned in early 1992, when Deng Xiaoping, China's aging supreme leader, toured southern Chinese cities, including Shenzhen, his most prized Special Economic Zone, in order to give full support to all-out economic liberalization and save a legacy he himself had inaugurated more than a decade earlier. The "socialist market economy," a code phrase for capitalist economy, was legitimized as an official principle at the party congress in 1992. After nearly three years of wavering and uncertainty, the Chinese economy gathered momentum again and expanded at a high rate. Therefore, there may be two turning points here: 1989 for intellectuals, who in their disillusionment turned to a search for material success and celebrity status, and 1992, the opening of an era that provided conditions that made such "success" possible.

Cultural, economic, and intellectual developments in China during the 1990s were not unrelated to transformations in the global cultural economy. Thus, it seems imperative to situate these developments in this larger context, which has been described by critics such as Arif Dirlik as "global capitalism."[17] This term signifies the emergence of an age of transnational production, distribution, and consumption, with the transnational corporation as the locus of economic activity, and change in the function of the nation-state from a scene of domestic conflict to manager of a global economy. The 1990s was a time of unprecedented mobility for people, technology, capital, images, and ideas across the world.[18] "Globalization" and the supremacy of a "market economy" have provided, in part, the conditions for the recent changes in China, which is fast turning itself into an active player in the network of transnational capital.

The study of postmodernism was first introduced to China by Fredric Jameson when he taught at Beijing University in 1985. Although his lectures opened up a new field of knowledge in China, many Chinese students did not fully grasp the relevance of postmodernism for their situation.[19] At that time, they had just become acquainted with modernism. Outside China, a few scholars in American sinology during the mid- and late 1980s used postmodern theory to study traditional Chinese philosophy and literature.

Postmodernism as a style of thought was considered similar to important aspects of classical Chinese philosophy and literary discourse such as Taoism, the writings of Zhuangzi, and narrative fiction.[20] Not until the early 1990s, with both the suppression of political activism and the integration of the Chinese economy into global capitalism, did critics begin to understand postmodernity as a palpable contemporary socioeconomic reality in China.

"Globalization" in the 1990s is at one and the same time the *postmodernization* of the globe. There is no society in the world today completely untouched by transnational capital and postmodern culture. Having said this, one must also hasten to add that the cultural logic of postmodernism in a third world country is significantly different from that of an advanced Western society like the United States. "Postmodernism is what you have when the modernization process is complete and nature is gone for good," writes Fredric Jameson in the introduction to his book *Postmodernism, or, the Cultural Logic of Late Capitalism*, which is by now an artifact of Euro-American postmodernism.[21] Yet, when speaking of postmodernism in a non-Western context such as China, we must revise this statement. Nature might be gone for good, but the modernization process is far from complete, and modernity is still an "incomplete project."

One cannot periodize historical processes neatly in the Chinese case, and there is no clear temporal pattern for the successive states of the ancient world, modernity, and postmodernity, as in the West. Contemporary China consists of multiple temporalities superimposed on one another; the premodern, the modern, and the postmodern coexist in the same space and at the same moment. Paradoxically, postmodernism in China is even more "spatial" and more "postmodern" than its original Western model. Spatial coextension, rather than temporal succession, defines non-Western postmodernity. Hybridity, unevenness, nonsynchronicity, and pastiche are the main features of Chinese postmodern culture. A consideration of recent non-Western experiences thus allows us to modify the unilinear Euro-American paradigm and envision alternative postmodernities. Postmodernity on a global scale then necessarily becomes a hybrid postmodernity: a palimpsest of nonsynchronous, emergent, and residual formations, a mixture of various space-times, and an overlap of different modes of production.

More specifically, in case of contemporary China, one should exercise extreme caution in describing its social, economic, and cultural conditions.

As a major socialist/postsocialist state, as well as the largest developing country, China is radically different from both Euro-American capitalism and former Soviet-style socialism. China does not fit into the postcolonial paradigm in the same way as such other countries and places as India and Africa, nor is it an exemplary manifestation of the spirit of "Confucian capitalism," as are the "mini-dragons" in East Asia (Korea, Taiwan, Hong Kong, and Singapore), even though China has consciously adopted many aspects of the East Asian development model. Furthermore, unlike Japan, China is far from being an embodiment of global capitalism. Here lies the heterogeneity and complexity of more than twenty years of gradual economic reforms and institutional innovations since the late 1970s: China's alternative modernity/postmodernity comprises a mixture of the indigenous socialist legacy (Mao Zedong's thought plus Deng's reforms), East Asian modernity (also known as "Confucian capitalism," via Hong Kong, Taiwan, South Korea, Singapore, Japan), and global capitalist practice (through the operation of such transnational corporations as Volkswagen, Motorola, General Motors, Kodak, and Nike). The Chinese economy contains both (residual) socialist and (borrowed) capitalist forms of ownership and production. (These issues will be explored fully in Chapter 2.)

Although modernity seems to be indefinitely deferred in China, postmodern formations have arrived. The belated, yet premature, arrival of postmodernity in China in the 1990s has caused a radical reconceptualization in critical circles about the role of the intellectual. In the socioeconomic realm, China is experiencing the throes and euphoria of a transition to a capitalist market economy, or what is officially called a "socialist market economy." Officially still a socialist state, post–cold war China is a hotbed of consumerism and commercialization. To a large extent, China, like many other developing countries, is an integral, inseparable part of a post-Fordist global economy and operates in accordance with mechanisms of transnational production, subcontracting, marketing, and consumption.[22] However, economic liberalization does not necessarily bring about political liberalization, and the existence of a capitalist economy does not change the socialist character of a state.

At the same time, there is a general depoliticization and deideologization of everyday life. The state has adopted a pragmatic orientation quite unlike Mao's heavy-handed political and cultural/culturalist approach to gover-

nance. In the cultural realm itself, genres of popular culture are on the rise, and cultural production is undergoing unprecedented commercialization. Commercialization and commodification have loosened the control of the state, but have also put cultural workers at the mercy of another equally merciless factor: capital. This disjuncture of realms in postsocialist, postrevolutionary China has caused severe social and cultural disorientation among Chinese intellectuals. The urgent task for them is their *repositioning*, the remapping of new kinds of spatio-temporal coordinates in the social landscape.

The Politics of Postmodernity

After a perceptive examination of several prevalent paradigms in the historiography of modern China—the revolution paradigm, the modernization paradigm, the antimodernization paradigm of "China-centered history," and postcolonial historiography—Arif Dirlik asks about the "new possibilities for a radical history that is postrevolutionary without being antirevolutionary."[23] To rephrase the question, we may ask, What are the possibilities of postmodern politics in a Chinese context? Evidently, the postmodern occasion is also the postrevolutionary, postcolonial moment. The postmodern paradigm thus questions the teleologies of modernization, revolution, the Enlightenment, and the nation-state.

In its political implications, the discourse of Chinese postmodernism appears to be an attempt to reevaluate the universal claims of the West with an "Asian difference." Postmodern politics as such is conservative in the sense that it eclipses the Enlightenment's "universals," which are still not fully at home in China; at the same time, it revises the Eurocentric teleology in the narrative of the history of global capitalism by granting agency to non-Western economic and cultural formations.

The Janus-faced nature of the politics of Chinese postmodernism is unique among third world countries. As Terry Eagleton puts it,

> What do you do, in short, if postmodernity arrives on your doorstep before you have fully experienced the delights and disasters of modernity itself? How do you deal with the time warping consequent on having your current

history elided between autocratic traditionalism on the one hand and the ambiguous promises of postmodernism on the other? How do you deal with the paradox that your own "modernity" means joining a club which is now at the point of leaving modernity scornfully behind it?[24]

As just mentioned, Chinese postmodernism is perceived by some as a conservative discourse because it lessens movement toward the ideals of the Enlightenment, which are still not realized in China. Modernity, with its attendant values of human rights, democracy, and freedom, and modernization, in terms of material progress, are yet to be achieved in China. Critics of Chinese postmodernism also question the genealogy of neo-Marxist discourse about China that I briefly outlined in an earlier section. If the Cultural Revolution was an *inspiration* for Western Marxist theory, it was a *nightmare* for the majority of Chinese citizens who lived through it. Radical Western theory about China and Mao was in part based on a misapprehension of Chinese reality. Hence, some see no need for Chinese intellectuals to follow Western critical trends such as postmodernism or to use them to dissect Chinese reality.[25]

Admittedly, it is high time to reexamine the context of the appropriation of the Cultural Revolution in Western critical theory and those moments of insight and misprision generated in the process. The current reassessment of the period is bound to be sharply divided. The Cultural Revolution, in its intial phase, was a time of passionate ideals for the youth and the Red Guards. It was also a period of carnivalistic liberation and merriment, as revisioned in the film *In the Heat of the Sun* (*Yangguang canlan de rizi*, 1995), directed by China's post–fifth generation director, Jiang Wen. The Cultural Revolution also had a sinister and inhuman side that destroyed both the bodies and souls of China's young generation, as depicted in the film *Xiu Xiu: The Sent-Down Girl* (*Tian yu*, 1999), directed by former Chinese actress Joan Chen (Chen Chong).

However differently the past is reevaluated by posterity, we must try our best to grasp the peculiar twists and turns of the present. It seems as though Mao's concept of contradiction could still serve as a helpful tool in analyzing the "unevenness" of the social, economic, and cultural formations in contemporary China and elsewhere. From his analysis of global contradictions in the Three Worlds theory, to his grasp of Chinese reality as exemplified in

such classic essays as "Analysis of the Classes in Chinese Society" (1926), "On Contradiction" (1937), "On Ten Major Relations" (1956), and "On the Correct Handling of Contradictions among the People" (1957), Mao's thought may still offer much methodological insight for probing the multilayered sedimentations of social life in today's China.[26]

The view that discourse about Chinese postmodernism is purely conservative and reactionary forgets the other half of the story: namely, the decentering, democratizing effects unleashed by postmodern forces. The infusion and impact of Western popular culture (music, film, fashion), new telecommunication and audio-visual technologies (TV, fax, internet, mobile phone, VCD [video compact disc]), and private and transnational investments—all these heterogeneous forces have weakened the grip of the state. Postmodernity opens up the way to diaspora, fragmentation, hybridity, and divergence from the temporal logic of the modern Chinese nation-state.[27] The situation is further complicated by the geopolitical fracturing of China itself, that is, the existence of separate yet interrelated Chinese communities: the mainland, Taiwan, Hong Kong, and a large diasporic population all over the world. Moreover, within mainland China the relation of ethnic minorities to the twentieth-century form of the modern Chinese nation-state has become increasingly problematic and critical.

Media, Medium, Visuality

At the center of the present interdisciplinary investigation is a concern with various media of Chinese "visual culture" in the postmodern, post-1989 period. Examples of cinema, TV, and art (painting, sculpture, installation, video, body, performance, mixed media) are treated as important, integral elements of Chinese postmodern culture. Visual culture is understood as "both a partial description of a social world mediated by commodity images and visual technologies, and an academic rubric for interdisciplinary convergences among art history, film theory, media analysis, and cultural studies."[28]

Moreover, an examination of diverse manifestations of visual culture must be situated in the context of image production, distribution, and consumption across national and regional borders at the end of the century. As media

theorist John Fiske claims, "Globalization always provokes localization, and one result of these forces has been the erosion of that middle level of organization, the nation-state, and consequently, of a national culture. The nation-state is being eroded from outside by globalization and from within by subnational or transnational localization."[29] Transnational visuality is a central feature of postmodern culture, global or Chinese. It further accentuates the characteristics of the media in postmodern society in terms of transparency, instantaneousness, and space-time compression. (In retrospect, the political melodrama of Tiananmen in 1989, a pivotal point between the 1980s and the 1990s, was instantaneously broadcast to global audiences through TV networks and consequently affected the course of world history. In a way, the image and the media changed the world.)

Observers have asserted time and again that postmodern culture is one of "specularization," or the "society of the spectacle," in the words of Guy Debord. Insofar as everyday life is governed by the circulation of commodity images, the human being is a "Homo Spectator." As Debord reminds us, "The spectacle is NOT a collection of images; rather, it is a social relationship between people that is mediated by images."[30] Seen in another light, postmodernity is the state of "simulation," or the condition "after the orgy," as playfully described by Jean Baudrillard. In *The Transparency of Evil*, Baudrillard writes the following:

> The orgy in question was the moment when modernity exploded upon us, the moment of liberation in every sphere. Political liberation, sexual liberation, liberation of the forces of production, liberation of unconscious drives, liberation of art. The assumption of all models of representation, as of all models of anti-representation. This was a total orgy—an orgy of the real, the rational, the sexual, of criticism as of anti-criticism, of development as of the crisis of development. We have pursued every avenue in the production and effective overproduction of objects, signs, messages, ideologies and satisfaction. Now everything has been liberated, the chips are down, and we find ourselves faced collectively with the big question: WHAT DO WE DO NOW THAT THE ORGY IS OVER?[31]

Baudrillard suggests that now we can only simulate the orgy, simulate liberation, and "hyper-realize" all the signs, forms, and desires that have taken place. We are condemned to live in a state of being in which direct contact with objects, or the "real," has become impossible. The real consists of

appearances, images, and interfaces, and comes to us only in indirect and mediated forms. As Paul Virilio puts it, "The question of *modernity* and *post-modernity* is superseded by that of *reality* and *post-reality*: we are living in a system of technological temporality, in which duration and material support have been supplanted as criteria by individual retinal and auditory instants."[32]

We are also alarmed by the fact that in the age of simulation, which is dominated by the transparency of the televisual media, the traditional visual arts are endangered. The media replaces the medium. Rosalind Krauss describes the situation in the following words:

> Whatever the cause, the late twentieth century finds itself in the post-medium age. Surrounded everywhere by media, which is to say by the technologically relayed image, the aesthetic option of the *medium* has been declared outmoded, cashiered, washed up, finished. Painting is a possibility we can barely remember; sculpture is so far in the past that it seems indifferent whether we weld in steel or cast in bronze; drawing seems obviously best left to computers.[33]

Such is the state of affairs in the postmodern, postorgy, postmedium age. The media advances into such space of popular culture as the multiplex movie theater, while the medium retreats into the museum, the classroom, and specialized journals. Forms of media-oriented entertainment such as Hollywood films sweep across geographic boundaries and reach audiences worldwide. The "global popular," a phrase used by Simon During, becomes a deterritorialized, transnationalizing force that penetrates the remote corners of the world and claims audiences and viewers in various localities.[34] Cultural critics confront a "newly wrought conception of the visual as disembodied *image*, re-created in the virtual spaces of sign-exchange and phantasmatic projection."[35]

Postmodernization in the 1990s occurred simultaneously with the globalization of visual culture. Transnational visuality in the Chinese case can be seen at several levels. There is first the unprecedented transnationalization of the mechanisms of production, distribution, and reception of visual works of art.[36] For instance, joint production across national borders occurs frequently in the Chinese film industry. Films produced in this manner are made for foreign film festivals and the international audience. On another

front, citizens of China have gained more access to Western cultural products through public showings, pirated VCDs, videotapes, and the computer. Hollywood blockbusters have been directly exported to and screened in China since the mid-1990s. For instance, *Titanic*, the global box office hit of 1998, was also a big sellout in China. The film was even praised warmly by President Jiang Zemin, who admitted at the National People's Congress that he was moved by the movie, and said: "Let us not assume that we can't learn from capitalism."[37]

In contrast to the mass media, avant-garde art is not officially promoted by the Chinese state and is often subject to censorship. The Chinese nation-state was rarely a site, locus, or market for experimental art in the 1990s. Exhibitions were organized principally in transnational settings outside China and private, nonofficial space within China. Experimental Chinese art, if the word "Chinese" could still be used, was mainly funded and supported by galleries, museums, foundations, and grants outside the People's Republic of China—from money that came from Europe, America, Australia, and Hong Kong.

In the hands of Chinese artists, transnational visuality entails different strategies of representation and self-representation. First of all, there is the representation of the self for the gaze of others, namely, the familiar spectacles of the New Chinese Cinema (by way of Chen Kaige, Zhang Yimou, and the like) and Chinese avant-garde art ("political pop" for instance). "China" is exoticized, eroticized, or politicized to create visual effects for the international community. China as an object of signification is reduced to a set of internationally recognizable and consumable symbols, political icons, and anthropological details: Mao, the Cultural Revolution, Chinese opera, traditional rituals and customs, and so forth. China remains to a large extent either a cultural object (ancient Eastern tradition) or a politicized entity (revolutionary legacy).

Local culture, global market, and transnational visuality characterize both the constraints and possibilities under which artists of Chinese origin operate. Their tactics and goals can be summarized as follows: (1) the insertion of a strategic cultural localism, an aura of "Chineseness" in the global marketing and exhibition of artistic products; (2) the construction, mediation, evocation, and interrogation of (conventional, orientalist) cultural identity in the East and the West, that is, the staging of "identity politics" in

the artistic medium; and (3) the contribution to the formation of international postmodernist art.

As for domestic production inside China, the strategy runs the opposite. In Chinese soap operas and movies aimed at the domestic audience, the other, or the foreign, is exoticized, eroticized, differentiated, and yet ultimately domesticated on Chinese soil. (See my discussions of such soap operas as *Russian Girls in Harbin* and *Foreign Babes in Beijing* in Chapter 10.) Contrary to the strategy of self-othering and self-exoticization, Chinese TV programs project a different kind of global cultural and geopolitical imaginary by way of, say, stories of interracial, transnational romances between Chinese and foreigners.

Transnational visuality is subject to various kinds of appropriation in China and the West. In many instances, a residual cold war antagonism between the East and the West dominates the politics of representation in popular culture and the mass media. The nation-state still tenaciously holds its ground, as was demonstrated during the eventful year of 1997, when Hong Kong reverted to mainland China and Chinese president Jiang Zemin visited the Unites States to repair Sino-American relationships damaged after the Tiananmen incident in 1989. In China, the biggest film productions are *The Opium War* and *Red River Valley*. These patriotic films bring back memories of imperialist aggressions against China in the past and inspire nationalistic sentiments for the present. They fashion images of nationhood and national identity vis-à-vis the West and Tibet from a Chinese point of view. The same kind of cold war politics can be seen in products of Western popular culture, despite their diametrically opposed ideology. From late 1997 to early 1998, a series of highly publicized Hollywood films about China and Tibet were released to world audiences in a rapid succession: *The Red Corner* (starring Richard Gere), *Seven Years in Tibet* (starring Brad Pitt), and *Kundun* (directed by Martin Scorsese). In these films, China is portrayed as a menacing, cruel body politic that oppresses ethnic minorities, foreigners, and its own people.

A more interesting case is the 1997 Christmas season James Bond movie *Tomorrow Never Dies*, featuring Pierce Brosnan and Hong Kong/Malaysian action heroine Michelle Yeoh, which renders a more nuanced, ingenious representation of East-West politics. In this movie, a media mogul schemes to create a war between China and Britain in the oil-rich South China Sea, an

area of intense territorial dispute between China and various Southeast Asian countries. If successful, he would win a media war by manufacturing a story of a military confrontation between two major powers. Collaboration between a British secret service agent and a Chinese beauty uncovers the plot and prevents the catastrophe. No one can miss the historical subtext of the James Bond film, namely, the return on June 30, 1997, to China of Hong Kong, an island that Britain wrestled away from the declining Qing Empire by military force in the nineteenth century.

Thus, *Tomorrow Never Dies* not only continues what seems to be an unending series of Bond films, but it is also a subtle reassertion through the media of popular culture of an undying Britain. In weaving a tale of an encounter between a British hero and a Chinese heroine the film heals an old wound between China and the West and offers an imaginary solution to potential future conflicts. It seems that battles are not necessarily fought on the front lines between nations and empires but on the screen and within the cultural imaginary. Military and political confrontations between East and West have turned into a media war in the post–cold war era. (As Baudrillard claims, the "gulf war did not take place"; it was a fabrication of the media.)[38]

On another level, the internationalization of action films produced in Hong Kong constitutes a challenge to the global popular, which has been synonymous with Hollywood. Most noticeable is Jackie Chan's martial art film genre, produced by the Hong Kong studio Golden Harvest, along with the productions and appearances of other directors, actors, and actresses of Hong Kong origin in transnational circuits (John Woo, Tsui Hark, Ringo Lam, Stanley Tong, Yuen Woo-ping, Peter Chan, Sammo Hung, Chow Yun-fat, Jet Li, Maggie Cheung, Michelle Yeoh). So far, Chan's is one of the few non-Hollywood film genres, Asian or otherwise, capable of competing with Hollywood in terms of box office success in America. Jackie Chan has transformed the martial art film from a traditional genre to a new kind of transnational film whose setting is no longer Hong Kong, China, or even Asia, but the whole world—Australia, Africa, Europe, and America. The new persona of Jackie Chan in certain films is patterned after, alludes to, and indeed aims at replacing James Bond in global entertainment. (See, for instance, the transformation of *The Police Story* series, especially *First Strike*.) Stories originally set in the locales of Hong Kong and China have been transformed into stories of a globe-trotting Hong Kong cop/detective.

The subject of China, as a locale of culture, history, tradition, and alterity, leads to perennial fascination in the West in both popular and high culture. In 1998, *Mulan*, the Disney picture based on Chinese folklore, became a box office hit in the United States. In the same year Puccini's opera *Turandot* was finally brought back to its other home—China. Conducted by Zubin Mehta and directed by Zhang Yimou, the opera had several live performances inside Beijing's Forbidden City in September, with genuine traditional Chinese settings as mise-en-scènes. Advertised as a major cultural event, the opera not only allowed dedicated fans of Western opera to fly to China to fulfill their fantasies about the other on location in the Orient, but also allowed privileged Chinese viewers who could afford the horrendously expensive tickets to confront a specular orientalist image of themselves through the cream of Western high culture.

The media and the medium, the global popular and the avant-garde, were all facets of postmodern culture at the end of the twentieth century. Together they offer us unique vantage points to glimpse the fast-changing faces of China and the world.

Local, Global, National, Transnational

> Think globally
> Act locally
> Eat noodles

This little ditty is not meant to poke fun at key words of cultural studies *au courant* in academia or at the strategy of transnational corporations. These words are printed on the back of uniforms worn by waitresses in Lulu's, a fast-food Chinese restaurant in Pittsburgh. The thriving restaurant is located two blocks from the Cathedral of Learning, an imposing forty-story building completed in the 1930s in the architectural style of American gothic, which houses the various humanities departments at the University of Pittsburgh. The restaurant manager knows who her customers are, namely, humanists who eat lunch at her place now and then. The worn-out cliché has been given a new life, and the syllogism makes perfect sense: "think globally" means thinking about ethnic food such as Chinese noo-

dles, which certainly does not constitute the standard diet in cities of America's interior—like Pittsburgh; and "act locally" means eating at a nearby restaurant, Lulu's. Again, this small example tells us something about our general living condition without being sarcastic. Assertions of ethnicity, or "Chineseness" for that matter, are not necessarily tied to the locus of the nation-state in the age of globalization but occur within transnational and local settings.

> We are a trans-national family, with a foot in each country
> The Americanization of China
> Far East Pittsburgh[39]

These are the headlines of a cover story in a Sunday edition of the *Pittsburgh Post-Gazette*. The story is about a Pittsburgher who opened a bar/restaurant—Frank's Place—in Beijing, met his Chinese wife, established a "transnational" family, and created a bridge between China and the United States.[40] When Frank's Place first opened in 1990, it was the first American bar in China. On the menu of the restaurant owned by the Pittsburgher are hamburgers, cheeseburgers, bacon burgers, chili burgers, Philly cheese steak, club sandwiches, and so on. The restaurant provides a place for American expatriates to gather, eat, and watch the Super Bowl, despite the fact that most of the 1.2 billion Chinese don't care about such games. "The expatriate population has roughly quadrupled in the past 10 years, to about 100,000."[41]

Frank's monopoly of Western food business in Beijing was short-lived. Now a flood of bars and restaurants managed by Americans and Europeans has come to Beijing; Hard Rock Cafe, John Bull Tavern, and Xanadu Bar and Grill are only a few. Frank's Place is in a section of Chaoyang District known for its bar culture. Not far from Frank's Place is an alley, Dongdaqiao xiejie, where the number of bars grows yearly. The most famous of all is Sanlitun Bar Street (Sanlitun jiuba jie), also located in this part of the city, which is filled with Western-style bars run by locals. On balmy summer evenings, customers sit and drink in the open air outside bars that line this legendary street. Under the glitzy neon signs a truly mixed and international crowd of customers—men and women, lovers, businessmen, diplomats, foreign students, tourists, the new rich, artists, yuppies, and prostitutes—

drink, sip, watch, and trot their way into the street. Chaoyang District is the center of the international community, corporate culture, and foreign business, and boasts some of the most expensive real estate anywhere in the city—or in the world. Foreign embassies are located here, and the new headquarters of China's Ministry of Foreign Affairs has moved nearby. The construction of Beijing Central Busines District (CBD), designed to be the largest of its kind in the world, will soon begin. More and more office buildings, shopping malls, hotels, and luxury apartment buildings will be added to this area.

Beijing has become an alluring melting pot of people, ethnic food, and international entertainment. Large numbers of international students study the Chinese language and other subjects at various universities in Beijing, most of which are located in the Haidian District, the northwestern part of the city. Beijing Language and Culture University (formerly Beijing Language College) alone has about five thousand foreign students from all over the world on a regular basis. However, wealth, money, lust, sin, and pleasures are found in great profusion in the Chaoyang District, the eastern part of the city, where the transnational corporations (TNCs) and embassies are based. One can eat Xinjiang Muslim food while watching Arabic belly dancers at such restaurants as 1001 Nights and Red Rose; one can also dance salsa and merengue with the help of a foreign disc jockey any time of the week at Havana Café, or better still, dance to a Latin band from Columbia at Salsa Cabana in Lufthansa Center (Yansha).

A visible symbol of Americanization is undoubtedly the massive "McDonaldization," the opening of McDonald's restaurants. Since 1992, when the first store opened in Beijing, more than forty have been added in the city and the plan is to increase that figure in the future. For some time, one unique feature of McDonald's restaurants in Beijing is that at the entrances there are maps that show the locations of all McDonald's restaurants in the city. A red Tiananmen stands at the center of such maps, and the Avenue of Eternal Peace (Changan jie) forms the horizontal axis of the city. Expanding from this center, McDonald's restaurants fan out to various other locations in the city, including the suburbs. Such a graphic mapping of McDonaldization-in-progress in Beijing vividly signifies the rapid march of transnational capital in China as whole.

Bar culture and Western food, it seems, came to represent a new wave of Americanization, globalization, commercialization, and aestheticization of everyday life in Beijing in the 1990s. The localization of ethnic Chinese food in Pittsburgh, a postindustrial city that long ago lost its glamour as a world-class metropolis, and the globalization of American food and drink in Beijing, one of the fastest growing mega-cities in the world, were two sides of the same coin in the late twentieth century. "Glocalization" is our fate. We live in "a new world-space of cultural production and national representation which is simultaneously becoming more *globalized* (unified around dynamics of capitalogic moving across borders) and more *localized* (fragmented into contestatory enclaves of difference, coalition, and resistance) in everyday texture and composition."[42] Our task is to analyze closely how these processes of large-scale globalization, which are driven by transnational capital across regional boundaries, are mediated, reflected, or resisted in actual texts of art through both the traditional medium (avant-garde art and writing) and the mass media (film and TV).

We are fortunate to have the rare opportunities in our lifetime to witness and live through two historical endings: the ending of both a century and a millennium, according to the Gregorian calendar. Yet, as the twenty-first century and the third Christian millennium approach, our thoughts seem to be singularly unprepared for a new beginning. We live in the aftermath and aftershocks of the foundational events of past centuries. Rather than preparing for the dawning of a new era, we are immobilized, unable to step out of the impasse of "post-" thought. Indeed, one may say that the last decade of the twentieth century and of the second millennium is the age of global "post-ization."

My discussions of the Chinese situation in this book are intended to be fragments of centennial and, at an even more basic level, *millennial* thought. They are intended to illustrate the larger picture, that is, to pinpoint a crucial change in the function of the intellectual and the artist in what was formerly called the "third world" during the age of post-Fordist, transnational capitalism, and to forecast future configurations of the local, the national, and the global. Throughout the twentieth century, until its last decade, third world intellectuals and artists were very much national intellectuals and artists because they were more or less anchored in an "organic" relation to

the nation-state. Although they may have been dissatisfied with, or even persecuted by, the nation-state, it was still the nation that provided them with a sense of identity and a platform for expression. With the advent of globalization and commercialization at the fin de siècle, the nation-state lost its position as the principal site of activity for third world intellectuals and artists.

As we shall see, Chinese intellectuals have retreated into "subnational" institutions, such as the academy, as a way to opt out of domestic politics. In the meantime, they have participated in critical activities and academic politics in "transnational" settings, which supersede their links with the nation. Chinese artists seem to have made similar choices as intellectuals. Third world artists have stepped directly onto the supranational scene and operated in the global art market, more so in the Chinese case because avant-garde art is still generally not supported in the nation's public arena. Yet, paradoxically, their international credibility rests on an indigenous appeal, a cultural localism, a certain Chineseness. This double orientation of the local and the global that besets intellectuals and artists, with all its contradictions, points to a predicament for postmodern transnationalism. What we have witnessed in the last years of the twentieth century, and perhaps also at the beginning of the third millennium, is the continual fading of the primacy of the national and the increasing importance of the transnational and the local in cultural, artistic, and intellectual spheres, as well as in economic realms. It remains to be seen if what I call *transnational postmodernity* will persist into the new millennium, or if we will move beyond the deadlock of "post-" thought and awaken to an unspeakable, sublime new beginning, a veritable "Second Coming."

In his poem "The Second Coming," W. B. Yeats wrote,

> Things fall apart; the centre cannot hold;
>
> ... but now I know
> That twenty centuries of stony sleep
> Were vexed to nightmare by a rocking cradle

Yeats's poem evokes the disintegration of grand metanarratives in the early twentieth century and renders a terrifying apocalyptic vision. Yet, as an

exemplary high modernist poet, Yeats believed in the redemptive power of such things as art and nationalism (loyalty to Ireland). As the bonding between art and the nation erodes, my question is this: Will there be anything left besides global capital in the twenty-first century and the third millennium?

PART ONE

Theory, Criticism, Intellectual History

ONE

Intellectuals in Transition: The Academy, the Public Sphere, and Postmodern Politics

The Intellectual Transition from Modernity to Postmodernity

In broad terms, the intellectual discourse of the New Era (ca. 1977–89) centered on the question of modernity. Its main themes were enlightenment, humanism, and the establishment of the new subject. Immediately after the historical trauma of the Great Proletarian Cultural Revolution (1966–76), Chinese intellectuals took up the unfinished project of Chinese modernity again, a project that had been inaugurated half a century earlier in the historic May Fourth Movement of 1919. At that time, students at Beijing University had taken to the streets to protest against the government, which had given away Chinese sovereignty to the imperial powers. What was initially a patriotic movement for national salvation soon became a nationwide intellectual movement of enlightenment, a movement founded upon the Western values of democracy and science.

As the Cultural Revolution ended in the late 1970s, Chinese intellectuals

came to realize that modernity had still not emerged and that enlightenment was as imperative for the masses as it had been earlier. Cultural critique, the examination of cultural and social patterns entrenched in China for centuries, was pursued relentlessly during this period by Chinese theorists, critics, writers, and artists. A decade of "historical-cultural reflection" came to a logical conclusion when students in Beijing went to Tiananmen Square in 1989 to commemorate the seventieth anniversary of the May Fourth Movement. One month later, on June 4, the Chinese regime brutally suppressed the Democracy Movement, and with that development the intellectual style characteristic of the period came to an end.

Since the May Fourth Movement of 1919, Chinese intellectuals—writers, artists, critics, and educators—had been endowed, or had endowed themselves, with a sense of historic mission. They had assumed a position at the vanguard of "enlightenment" and "national salvation" for the uneducated masses.[1] They claimed to write and speak as the conscience of the nation. Under the pressure of aggression from Western imperial powers their task was to engage in a radical critique of China's cultural tradition and to establish a new China founded on the principles of the advanced West.[2] In the words of modern writer Lu Xun, they tried to cure the "spiritual diseases" of the people and to save the country. The dual role of savior/educator was not unique to participants in the May Fourth movement, but reached back to the enduring tradition of the Confucian literati. In premodern China, Confucian scholar-officials served as guardians of culture (*wen*) and knowledge. They spoke and acted as the moral guides of the nation, occasionally rising to the height of self-sacrifice for sometimes (self-) righteous causes. The figure of the Mencian, the self-righteous, self-sacrificial, and moral intellectual has persisted throughout ancient and modern Chinese history. In the Confucian division of social classes, literati-gentlemen-officials stood at the top of the ladder.

After the founding of the People's Republic in 1949, Mao adopted measures to allow intellectuals from the "Old Society" to function within the new socialist system. His approach was both "institutional" and "discursive."[3] First, he made all "intellectuals"—artists, writers, professors, and scientists—work in newly established administrative units: the Ministry of Culture, the Writers Association, government departments, universities, professional schools, and so forth. Formerly independent intellectuals, each

receiving a fixed salary from the state, became the cadres and staff of their workplaces. Thus, the government placed institutional constraints on intellectuals and none were permitted to work outside the system. Second and equally important, the state demanded "ideological (re)education" so that intellectuals could master the new discourse of Marxism-Leninism-Maoism. Intellectuals were asked to engage constantly in criticism and self-criticism to remold their thinking. In addition, Mao launched a series of political campaigns to bring them into line. For example, they were expected to learn from the advanced consciousness of workers, peasants, and soldiers. Intellectuals who transgressed institutional and discursive constraints were disciplined. Predictably, they encountered criticism, exile, imprisonment, and forced labor.

After the era of Mao ended in 1976, Chinese intellectuals rose again to a preeminent position. The slogan "Emancipation of the Mind," launched in the late 1970s, called for liberation from Maoist dogma, which had dominated China's intellectual life for two decades. In the "New Era," "Marxist humanism," "cultural reflection" (*wenhua fansi*), and "historical reflection" (*lishi fansi*) became main intellectual currents that swept across China. Intellectuals assumed the important task again of launching a cultural critique of the past and constructing a new China. This implied criticism of both the "feudal" past and the immediate past of the Cultural Revolution. Writers, filmmakers, and theorists alike became fascinated with the "deep structure" of Chinese culture. They engaged in a self-reflexive, critical examination of China's entrenched cultural, psychic, and aesthetic patterns and traits.

Closely related to this process of cultural reflection was the construction of a free subject, or a new subjectivity. Chinese Marxist theorists had already begun discussing the issue of the "alienation" of the subject during the Cultural Revolution. During the 1980s, philosopher and aesthetician Li Zehou became the leading figure in this process of "enlightenment."[4] Combining Kant and Marxism, he wrote about the construction of a new subjectivity, highlighting the importance of the subject in social practice. For him, a much-neglected area in the form of Marxism practiced in China was the freedom of the subject. He believed that the neglect and subsequent suppression of the subject in China had resulted in alienation during the Cultural Revolution. Enlightenment, salvation, and the emancipation of

individuality, therefore, became as urgent as they had been in the May Fourth era. Modernity and modernization still remain an "incomplete project" in China.[5]

Literary critics such as Liu Zaifu followed the lead of Li Zehou and began to discuss "subjectivity" in literature. Liu offered a humanist, romanticist, and subjective theory of literature as a counterpoint to the official doctrine of socialist realism. For people like him, the true purpose of literature was the restoration of a whole, free subjectivity, something that had been lost in the Cultural Revolution.

Because intellectuals perceived the Cultural Revolution as a decade of alienation and dehumanization, they hoped for the dawning of an era of humanism that would restore hope, humanity, and dignity to the people. Genres of socially conscious literature such as reportage flourished and gained currency among a large sector of the population.[6] In the academy, Western philosophy and thought were introduced or reintroduced to college students. In the resulting intellectual ferment and "fever" (*re*), Kant, Nietzsche, Freud, Heidegger, and Sartre became topics of heated discussion. Chinese New Wave cinema also emerged as an important participant in this movement of "cultural reflection." The introspective, abstract, avant-gardist early films of some "fifth-generation" directors (the first class to graduate from the Beijing Film Academy after the Cultural Revolution), such as Chen Kaige, actually served as anguished reflections on Chinese tradition.

For political reasons, the regime did not tolerate this sort of cultural reflection in the aftermath of the failed Democracy Movement in 1989. Thus, the main intellectual currents of the 1980s were effectively brought to an end. In the early 1990s (or the post–New Era), the most significant development in critical theory was the belated appearance of the discourse of postmodernity in China, which filled the vacuum left by the previous cultural critique. The theorists associated with the debate on postmodernity are mainly a group of junior scholars based in Beijing. The discourse of postmodernity and postmodernism, then, along with the debate on "postcoloniality," occupied center stage in Chinese theoretical circles after the exit of "cultural reflection," which had flourished in the 1980s.

The term "postmodernism" was first introduced into China by Fredric Jameson when he lectured on the subject at Beijing University in 1985.[7] At that time, postmodernism did not attract much attention; it was just another

refreshing new theory from the West, far removed from China's cultural climate. However, the scene changed dramatically in the late 1980s. Though China is still very much a premodern society in many ways, some theorists have noticed the emergence of postmodern elements. One example can be seen in the literary avant-garde, which has exhibited self-conscious postmodern features: opposition to mainstream culture and conventional language, deconstruction of meaning, metafiction, playfulness, pastiche, and parody, and obliteration of the boundary between elite and popular literature.[8] Another, more important illustration is popular culture, which is undergoing an unparalleled process of commercialization in an ever-growing consumer society. The interest of the people has turned toward the burgeoning arena of mass media and mass entertainment (soap opera, TV serials, MTV, popular literature, pop music, fashion shows, karaoke, and so forth). This expansion of popular culture has marginalized intellectuals who stood at the very center of culture a short time ago. More decisively, their social status and financial well-being have been significantly lowered by a rampantly capitalist market economy. Because of this development, the opposition between "elite culture" (*jingying wenhua*) and "popular culture" (*dazhong wenhua*) has become an important topic of the postmodern debate.

In contemporary China, there is an "uneven modernity," or a hybridization of different cultural traditions, which includes the legacy of traditional Chinese culture (Taoism, Buddhism, and most significantly Confucianism), modern Western thought (centered on science, democracy, and humanism), Chinese Marxism, and newly introduced postmodernism. These cultural formations sometimes overlap and interpenetrate.[9] In distinguishing between the New Era (ca. 1977–89) and the post–New Era (1989–present), critics have characterized the former as dominated by a "grand narrative" (*grand récit*) of "enlightenment" and "salvation." Obviously, this "grand narrative," to borrow Jean-François Lyotard's term, continues the discourse of the May Fourth Movement. The postmodern turn can be characterized as the dissolution and decentering of "hegemonic discourse," whether expressed in enlightenment, humanism, or subjectivity.

For some, postmodernity should be celebrated in China insofar as it deconstructs any central discourse and any authoritative ideology: it has the power to demystify the claims of the dominant cultural force. However, for others, the belated appearance of postmodernity in China is premature, for

the agenda of modernity and modernization remains unfinished. According to this argument, postmodernity deconstructs the already weak, shaky tradition of humanism, which hardly existed in the tradition of early Chinese "feudalism" or more recently during the Cultural Revolution. Because the discourse of enlightenment still needs to be situated at the center of culture, intellectuals must resume their former position as subjects of enlightenment and again take up their roles as the guardians, transmitters, and creators of high culture. Thus, the conflict between high and popular culture turns into competition for power, which resides in the control of knowledge and the discourse of culture.[10]

As with its English counterpart, the Chinese term for "intellectuals" (*zhishi fenzi*) has an embedded vagueness. The term may refer in the narrow sense to academic and culture intellectuals (humanists), or to a broader concept that embraces all intellectuals (professionals and so forth), or to both. Chinese critic Wang Yuechuan has attempted to arrive at a typology of Chinese intellectuals in the consumer society of the 1990s based on their "axiological choices." He defines four major types: (1) "Intellectuals of authoritarian discourse" are part of the ruling class; their knowledge serves the politics of the state. (2) "Technocrats" use their "instrumental rationality" to advance science and technology and to make a profit for themselves. (3) "Business-type intellectuals" transformed themselves into businessmen overnight in the irresistible tide of commercialism during the 1990s. Finally, (4) there are "humanists," who have a duty to think critically about consciousness and society. The humanists include teachers (transmitters of knowledge in the humanities and social sciences), thinkers, social critics, and serious writers.

The last category is separated from the first three, and is far removed from the centers of power, technology, and business. The use-value of the intellectuals in this group is questioned, and they face a veritable "legitimation crisis" in an age of ever-expanding consumerism. The humanists' archrivals are the fashioners of popular culture, who operate according to the economic principles of the "cultural market." Because popular culture caters to the tastes and standards of the masses, it has lessened high culture's former share of readers and followers. This development has led critics like Wang to assert that humanists have been plunged into the midst of another major crisis of consciousness.[11]

The anguish, confusion, and disorientation of Chinese humanists should not be surprising. At this moment they are apparently experiencing a historic change in the function of the intellectual, or precisely the same kind of transition that Michel Foucault describes as that of the "universal intellectual" to the "specific intellectual" that took place in the West after World War II. As Foucault states, the universal intellectual "spoke and was acknowledged the right of speaking in the capacity of master of truth and justice. He was heard, or purported to make himself heard, as the spokesman of the universal. To be an intellectual meant something like being the consciousness/conscience of us all."[12] The figure of the writer represented the intellectual par excellence. "Specific intellectuals" are on the other hand savants of particular branches of knowledge and local truth rather than spokesmen of universal truth. For a long time, Chinese intellectuals, especially humanists, were only capable of political intervention by envisioning themselves as "universal subjects." They have yet to discover tactics related to local, specific struggles.

Critical Debates

Indeed, the crisis that envelops anyone who still has the courage to regard himself/herself as an "intellectual" endangers the category of *intellectual*. In the 1990s, the Chinese or third world intellectual is no longer the *other* of the first world intellectual, as Jameson rightly observed in the mid-1980s. Commenting on the stories of Lu Xun, the greatest Chinese writer of the generation of the May Fourth Movement of 1919, Jameson wrote that "in the third-world situation the intellectual is always in one way or another a political intellectual. No third-world lesson is more timely or more urgent for us today, among whom the very term 'intellectual' has withered away, as though it were the name for an extinct species."[13] Today, Chinese intellectuals experience the same danger of extinction, but with more anguish, for two reasons. First, the political intellectual was forcefully silenced in the aftermath of the events in Tiananmen Square in May–June 1989. Second and no less important, a rampant market economy is redefining social classes and their functions. The development of capitalism and the process of modernization have created a sharper division of labor and skills, entailing the trans-

formation of intellectuals into specialists in various technical and professional fields. Today there are perhaps only professionals, no intellectuals.

From the May Fourth Movement until the 1980s, Chinese intellectuals consciously searched for a new social role in the modern tradition and positioned themselves at the forefront of enlightenment and national salvation. Intellectuals aspired to speak for their own class, the people, and the entire nation. They were often called upon to represent the conscience of the people. An organic, unbreakable relation existed between Chinese intellectuals and the modern Chinese nation-state. Even in the late 1970s through the late 1980s, one could cite a long list of public, "universal" intellectuals.[14] At present, either because of the state's intolerance, or the omnipresence of capital, or both, there seems to be no place for the political intellectual in the public arena. Post-1989 China has witnessed the professionalization of formerly "organic intellectuals," their retreat into the academy, and their (self) imposed exile overseas. Given the impossibility of raising political questions, who can be said to represent the conscience/consciousness of the Chinese people at large today?

It is no surprise, then, that the major debates in contemporary Chinese humanities, or "cultural studies," tend to turn around the theme of the intellectual's position in society.[15] Broadly speaking, one can notice several prominent types of critical discourse and cultural criticism in post-1989 China: the debate on the "humanistic spirit" (*renwen jingshen*); theory of "post-ism" (*houxue*); "Chinese national studies" (*guoxue*); and notions of Asian modernity (that is, "Asian values" [*yazhou jiazhi*], New Confucianism [*xin ruxue*], and so on).

Humanists with a background in the Chinese humanities—"literature, history, and philosophy" (*wen shi zhe*)—as well as teachers in higher education, editors, journalists, and writers, have been engaged in a nationwide debate on the nature, function, and possibility of what they call the "humanistic spirit."[16] The term implies both the philosophical tradition of humanism and the academic discipline of the humanities in China. The occasion for this debate is the "loss and downfall" (*shiluo*) of humanism, as well as the decentering of the humanities in an increasingly commercialized environment. The participants raise such questions as whether Chinese humanists can still assume a place at the vanguard of enlightenment and culture; whether there currently is or ever was such a thing as a transhistorical, tran-

scendent, universal humanist spirit in the classical Chinese world, the ancient West, and the modern world; and, in the 1990s, whether humanism could still be possible as both an ethical imperative and a real social practice.

Given the trend of academicization and commercialization, a strong nostalgia exists for the figure of the organic modern Chinese intellectual who was exemplified by the May Fourth tradition and resurfaced all too briefly in the 1980s. In his book *Houxiandai zhuyi wenhua yanjiu* (A study of postmodernist culture), Wang Yuechuan argues that one can accept the critical, negating character of postmodernism and its multidirectional cultural orientation on the conceptual level, but one must reject postmodernism for its "nihilistic" notion of life and art and its lack of humanistic spirit on the axiological level.[17]

The pursuit and reconstruction of the subject in Chinese humanism contrasts sharply with the discourse of what is called "post-ism" in China. Chinese post-ism finds its source of inspiration in Western "post-theory" (poststructuralism, postcolonialism, and most important, postmodernism), and takes the cultural condition of the "post-New Period" (*hou xin shiqi*, post-1989 China) as its object of investigation. The "post-masters" (*houxue dashi*) take the latest fashions in critical theory from the West and apply them to the Chinese situation. Post-ism radically historicizes Chinese humanism and dismisses it as the "last myth."[18] Post-ism regards the humanistic spirit as yet another universalizing, essentializing discourse that is hollow and bankrupt in contemporary China. Post-ism does not take China as an isolated object of interpretation, but endeavors to situate it in the historical context of globalization in the late twentieth century, when China became a new market for world trade, and another locus in the network of transnational capital. Thus, popular culture and mass media are important phenomena to study. The return to a pristine humanist discourse unaffected by global changes is only an illusion.

The post-ism debate has turned into a transnational debate waged not only by academics based in China but also by Chinese "transnationals"— overseas Chinese based in American and European institutions of higher education. The Chinese-language journal *Ershiyi shiji* (Twenty-first century), a bimonthly periodical published in Hong Kong, the middle ground between China and the West, has been the site of the debate since the mid-1990s. There have been many rounds of exchanges and confrontations

between post-ist advocates from the People's Republic of China and their opponents in the Chinese diaspora. The debate in the transnational context began in early 1995, when the journal featured two articles critical of the appropriation of postmodernism and postcolonialism by Zhao Yiheng (Henry Zhao) and Xu Ben, two academics born in mainland China who received academic training in the West and now teach at Western universities (in London and California, respectively).[19]

Since 1995, the journal has featured other articles that continue the debate. Zhao, Xu, and others like them criticize post-ism for being just another form of conservatism in China. For them, Chinese postmodernism eclipses the critical, negating function of independent intellectuals, subjects them to the reign of popular culture, and ultimately dissolves the unfulfilled problematic of modernity (freedom, democracy, human rights, and so forth). According to these critics, Chinese appropriation of the critique of postcoloniality/orientalism sets up an opposition between an oppressed East and a hegemonic West, but displaces the real sources of domestic oppression. What might be an initially progressive discourse in the Western context is turned into an expression of Chinese nationalism. This debate serves as an interesting case of global intellectuals in the Chinese diaspora vs. local intellectuals in China proper. While indigenous Chinese critics attempt to reexamine the object of China through the critical lens of recent Western theory (its various post-isms), overseas Chinese academics hold on to an earlier mode of humanism.

The backlash against post-ism is also evident in another academic discourse: "Chinese national studies" (*guoxue*). This reaction represents a turn inward to Chinese tradition, a complete withdrawal into the academy in view of the unbridled commercialization of cultural activities. Advocates of Chinese national studies promote independent scholarship in the "ivory tower," and advise scholars to return to the legacy of great modern masters such as Wang Guowei and Chen Yinke. Thus, independent, autonomous scholarship responds to the decline of the humanistic spirit and the onslaught of commodification.[20]

The problematic relationship between globalization and Chineseness in postcoloniality finds theoretical expression in yet another type of discourse—the revival of Confucianism and Asian values. Debates regarding the relationship between Confucianism and Asian modernity are not limited to the

mainland, but extend to overseas Chinese communities, the Chinese diaspora, and Asian countries with a history of Chinese influence. One major event worth mentioning is the founding of the International Confucian Association (ICA) in October 1994. The association consists of constituencies in mainland China, Taiwan, Hong Kong, Singapore, Korea, Japan, the United States, and other countries and regions.[21] The *ICA Bulletin* regularly reports the latest activities in Confucian studies. The endless reports, symposia, and publications bring to the foreground the question of Asian identity in global cultural awareness.

Are distinct "Asian values" at work in the enduring Confucian tradition, as well as in the strong performance of contemporary Asian economies? The debate on "Asian values" vs. "global values" attempts to revise and mediate the universal claims of Western, Enlightenment values (individualism, freedom, democracy, human rights, and so forth). Putatively communitarian, Confucian, East Asian values are then called upon to redress the excesses of Western values and account for the "economic success" of East Asia. Confucianism is no longer taken as an obstacle to modernization in Asian societies, as it formerly was, but rather its driving force. The revival of Confucianism is thus the occasion for the reassertion of Chinese cultural identity and resistance to the Eurocentric conception of modernity and modernization.[22] Predictably, one of the most popular books in China in 1996 was the Chinese translation of *Megatrends Asia: Eight Asian Megatrends That Are Reshaping Our World*, by futurologist John Naisbitt.[23] In the book, Naisbitt made the prediction that the twentieth-first century will be Asia's century, a prediction that pleases readers throughout the Chinese-speaking world. This book is another telling example of contemporary foreign works that speak in support of Chinese tradition.

The several types of critical discourses briefly described above exemplify the loss of intellectual orientation among Chinese cultural workers. The debates attempt to formulate a new intellectual identity. "Specialization," "academicization," and "professionalization"—processes that have characterized the decline of the public, independent intellectual in the West since the 1960s—have befallen the Chinese intellectual today.[24] What might become of the intellectual in China? As Bruce Robbins simply puts it, "we must consider the intellectual as a character in search of a narrative."[25] The combined pressure of restrictions enforced by the state and the flow of transnational

capital after the end of the cold war aggravates the Chinese situation further. Does the advent of postmodernism and postmodernity imply a "universal abandon," an abandonment of certain Enlightenment "universals" still not fully at home in China? In the United States, postmodernist politics has been depicted as a politics of difference and a critique of universalism "wherein many of the voices of color, gender, and sexual orientation, newly liberated from the margins, have found representation. . . ."[26] Jonathan Arac lucidly explains the relationship between postmodernism and politics as follows: "The crucial contemporary agenda is elaborating the relations that join the nexus of classroom, discipline, and profession to such political areas as those of gender, race, as well as nation."[27]

Chinese intellectuals face a similar and yet different set of domestic, historical conditions. Thus, it is natural for them to formulate their own agendas of critical intervention. Their response is as varied as it is contradictory. However, several features seem evident. First, several expressions in Chinese postmodernist politics ("humanistic spirit," "national studies," and so forth) involve a critique of capital and commodification, and such a critique comprises part of Chinese rethinking about modernity. Second, Chinese postmodernist politics can also be described as a relationship between "universality" and "difference." The humanist reconstruction of subjectivity, as exemplified in the debate about the "humanistic spirit" and the critique of "post-ism," aims at the realization of the still unfulfilled Enlightenment universals on Chinese soil. "Humanism" is in part a code word for the long-awaited advent of "Western values" (human rights, democracy, freedom, individualism, and so forth). However, this longing for universality must be imbued with a Chinese difference. The postmodern politics of difference, or "identity politics," boils down to the issue of "cultural identity"—the issue of "Chineseness" in relation to the Eurocentric narrative of history, modernization, and capital.

The Confucian revival in the Chinese/Asian world stands as an important case, not because of the substance of its discussion, but because of the kind of issues it raises. The revival attempts to rewrite the narrative of world capitalism.[28] The centers of modernity and capital are no longer confined to the metropolises of the West, but extend to formerly peripheral Asian countries. Traditional Asian values become a "cure" of the one-sided Enlightenment "universals" emanating from the West. Asian modernity is not a derivative, simulated modernity, but an alternative modernity in its own right. In such

a critical maneuver, Asian societies are no longer passive recipients and imitators, but *subjects* and *agents* of capitalism, modernization, and change in contemporary world history.

The Academy and the Public Sphere

My discussion above briefly outlines a major shift in the self-understanding of intellectuals in contemporary mainland China. What about praxis? Given the significance of cognitive *mapping* in postmodernist politics, the question of *siting* is also fundamentally important in the struggle of Chinese intellectuals. What does it mean to move out of the compartmentalized, commodified existence, to extend the political into all domains and practices of everyday life in the Chinese setting? Does public space exist to carry out such activities? With the infiltration of public culture by the forces of the state and the market, is there any room for relatively independent, critical debate and dissemination of social and cultural issues? To be sure, there is no ideal public sphere completely detached from any political, social, and economic constraints. Yet it seems necessary to explore possible and actual shapes of public sphere(s) in contemporary China. As we recall, the issue became especially pertinent among scholars after the fall of the former socialist states at the end of the cold war and in the wake of the tragic fate of the Democracy Movement in China in 1989. Much critical scrutiny focused on tracing the possible origins and historical transformations of "civil society" and the public sphere in late imperial China and modern China, and comparing them with Western counterparts.[29]

One of the spaces is that of commercialized popular culture and mass media (cinema, television, audio cassettes, magazines, advertisements, billboards, and so forth). New forms and technologies of twentieth-century mass communication have made this space possible. Popular culture as such simultaneously expands and constricts the public sphere.[30] It brings with it into the realm of culture the logic, principles, and values of the market. In doing so, it threatens to subjugate the space for critical thinking to the forces of the market. At the same time, the "socialist market economy" introduces a new space for cultural activities, and in effect loosens the grip of the state, which has moved quickly to adapt forms of popular culture such as popular

music, TV dramas, and film for its own purposes. To a certain extent, it has successfully appropriated elements of popular culture to legitimize its rule. Both the state and the market contend for the control of the public sphere.

It is equally important to keep sight of what may appear to be a relatively autonomous "critical public space" in contemporary China. This space consists of critical journals, avant-garde literary works, art exhibits, academic symposia, and the classroom in some institutions of higher education. Intellectuals (academics and humanists) occupy this terrain. They try to preserve an enclave of free thinking in drastically changed social, economic, and cultural circumstances.

Some have argued that "there have been two or three moments in the past century when a nascent public sphere began to emerge in China—1880–1917, 1930s, and the mid-1980s—each time to be crushed."[31] The "proto-public space" that has evolved over the course of the twentieth century consists of bookstores, journals, study circles, salons, teahouses, coffeehouses, and theaters. Today, there seems to be an expansion of critical public space, however small, limited, and fragile it may be. Transnational crossings in the age of global capitalism have widened this space further, by the flows of ideas, images, people, and capital between China and the West, between China and overseas Chinese communities, and within the area of "Greater China" (the mainland, Taiwan, and Hong Kong).[32]

Realization that intellectuals "have gone to the margins of society" for the first time in Chinese history leads to the question of how one should operate from within the margins vis-à-vis the twin centers of consumer culture and the state. As many critics believe, they have a "cultural mission" to stay within the academy, to do "pure criticism," and to oppose the utilitarian mainstream culture. Because of this prescription for the role of intellectuals, the critical public sphere has shrunk to the academy.[33]

Like it or not, specialization and academicization are fates of Chinese intellectuals in the 1990s. Yet, if one believes with Antonio Gramsci that it is desirable and possible to be an "organic intellectual" in his/her society, the urgent task is how one can make a difference from within the academy. "All men are intellectuals, one could therefore say: but not all men have in society the function of intellectuals."[34] To be an intellectual implies the ability to be the organizing and "directive" force of one's own class and profession, and the capacity to effect new modes of thinking.

It is strategically advantageous for Chinese humanists to hold onto the territory of the academy, where they can fill important pedagogic, didactic, and critical functions. "Critical negation" is necessarily a chief practice at the present time.[35] Simultaneously, they should perhaps, not unlike the state and the market, find ways to utilize for their own needs space that the mass media and popular culture have created. An effort should be made to mediate the space of the intellectuals and the space of the populace. Not only should Chinese intellectuals act and struggle from their own specific, situated locales, but they should also intervene in the global postmodern space.

At this point, I would like to quote the concluding passage from Jonathan Arac's introduction to *Postmodernism and Politics*. His observations about the plight of American academic life also has relevance for the situation of Chinese intellectuals.

> Mass culture is our element, neither a sudden and welcome liberation from a worn-out high culture, nor the threat to corrupt all that we most treasure. Since we come late enough not to confuse ourselves with the modernists, we can accept our condition as postmodern. . . . Finding ourselves, as if from birth, in the academy, we can work there without the shame of ivory-tower isolation or the euphoria of being at the nerve center of a brave new world. We will not transform American life today, or tomorrow, but what we do to change our academic habits and disciplines, the questions we dare to ask or allow our students to pursue, these are political and make a difference, too, for the academy itself is in the world.[36]

The Chinese academy is also in the world, and Chinese academics can make a difference in their continuous struggle for suitable identities and new ways of raising questions.

Coda

In conclusion, it is instructive to reexamine the short history of the reception and metamorphosis of the discourse of postmodernism in China. These developments have much to tell us about the contemporary cultural condition. As said above, in the mid-1980s, when Fredric Jameson gave lectures on postmodernism in Beijing, the Chinese audience viewed it as merely another new theory from the West, along with, say, structuralism, poststructuralism,

semiotics, and so on, though to be sure, new theories may subvert official literary doctrines.[37] The literary avant-garde also experimented with postmodernist techniques and styles, but postmodernism was discussed primarily as a literary phenomenon and was confined to a small circle of avant-gardist writers.[38] In America, the belief existed among some scholars that, despite the flourishing of a Chinese literary postmodernism, postmodernism as a cultural formation could not take root in China.[39]

In my view, the decisive change in the Chinese reception of postmodernism occurred at the same time as the rise of consumerism in China and the nation's integration into global capitalism, a time that basically corresponded to the post-Tiananmen era. The unchecked commercialization of culture provided fertile ground for the discourse of postmodernism in post-Tiananmen China. Such Chinese critics as Wang Ning then systematically translated and introduced "foundational" Western theoretical texts of postmodernism. Other academics, most of whom had been educated in China, had limited knowledge of European languages, but had superb training in theoretical speculation, then began to "sinicize" postmodernism. Foremost among these figures were Chen Xiaoming, Zhang Yiwu, Wang Yuechuan, and Wang Yichuan, all of whom held positions in elite academic institutions in Beijing. Since then, the debate about postmodernism has occupied the center stage of critical discourse in China.

These new discussions consider postmodernism a global cultural theory applicable to Chinese conditions, not just another Western theory or literary style. After bemoaning the unparalleled decline of the intellectual under the weight of a market economy, Chinese intellectuals are slowly repositioning themselves by describing contemporary China as postmodern. However, when it comes to political and cultural intervention, it has been difficult for them to imagine themselves as anything other than subjects of enlightenment and guardians of culture.

The urgent question that we might ask therefore is what role the Chinese intellectual has as a third world intellectual—and as a cultural worker—under the realities of postmodernity and global capitalism that now appear on the horizon in China.[40] As we have seen, the Chinese intellectual is fast losing his/her former privileged position as the holder of knowledge/power because of the impact of a market economy. While forfeiting his/her cultural "hegemony," he/she will need to devise strategies to resist new hegemonic

formations characteristic of the reign of transnational capital. Currently, he/she confronts a new situation that, as Arif Dirlik explains, has "the power to appropriate the local for the global, to admit different cultures into the realm of capital (only to break them down and remake them in accordance with the requirements of production and consumption), and even to reconstitute subjectivities across national boundaries to create producers and consumers more responsive to the operations of capital."[41]

It would be self-defeating to assert that Chinese intellectuals, especially the "humanists," will have no role to play in this new world (dis)order. They must come to terms with their new position and find their place. Fredric Jameson calls this process "cognitive mapping"—for us to obtain "some heightened sense of [our] place in the global system," "to grasp our positioning as individual and collective subjects and regain a capacity to act and struggle" in the postmodern space.[42] The socioeconomic conditions for the Chinese intellectual to recover the position of the subject of history and enlightenment no longer exist. The intellectual needs to recognize that he/she is "no longer a [universal] subject, a representing or representative consciousness," but an intellectual engaged in local, specific struggles of resistance.[43]

Thus, the important question one should raise for the Chinese intelligentsia in the postmodern age is whether it can deliver a searching criticism of its own ideology and social position and formulate practices of resistance against the system of which it is a part and product. This does not imply a return to older Chinese forms of cultural elitism. Instead, it calls for readiness to deal with a reality whose enormity Chinese intellectuals on the mainland, unlike those in Taiwan and Hong Kong, have become aware of rather recently. Although some of them have already engaged in the ongoing debate about postmodernism, others still need to sort out their own responses, search for suitable identities, and develop strategies of intervention.[44]

TWO

Universality/Difference: The Discourses of Chinese Modernity, Postmodernity, and Postcoloniality

In his mammoth study *Confucian China and its Modern Fate*, Joseph R. Levenson concludes that Chinese culture in the form of Confucianism is doomed to failure in the modern world because it is fundamentally incompatible with the ethos of capitalism and modernity. He writes:

> Why should Confucianism have withered into this anomaly? Why should it be Europe and not China that has been able to sustain its self-image as a history-maker coterminous with the world—at least in culture, regardless of political recession?
>
> My own suggestion . . . , as a partial answer, is that Confucian civilization was the apotheosis of the amateur, while the genius of the modern age (evil or not) is for specialization. In the modern world the "middle" character of Confucianism was lost; it was no longer a mean among alternatives, but opposite, on the periphery, to a new spirit from a new centre of power.[1]

Levenson's statement follows a tradition of Western thought about the development of capitalism and the nature of "oriental" society most notably

expressed by Max Weber. If the rationality of specialization stands at the core of the capitalist spirit, the amateur ideal of the Confucian gentleman becomes totally irrelevant in the modern age. Levenson's interpretation and essentialization of Chinese culture, by way of Weber, inevitably falls within a Eurocentric, orientalist discourse in defining the West as the norm and China as peripheral in the narrative of the history of global capitalism. Such a teleological, universalist conception of the modern world system based upon the Euro-American experience has lost much of its credibility in recent critical studies. In a dramatic reversal, such self-orientalizing terms as "Confucian capitalism," "East Asian modernity," and "Asian values" suggest that traditional Chinese culture is not seen any longer as an impediment to progress, but as an Asian form of the "Protestant ethic" and as the driving force of modernization in Asian societies. Such revisionist narratives of global and local capitalism are attempts to provide alternative models of historical interpretation.

In this chapter I wish to discuss the formation of several significant types of discourses of modernity and postmodernity about contemporary China. It is my understanding that the construction of a Chinese modernity has been inescapably the construction of an alternative and hybrid modernity since the beginning of modern Chinese history. Furthermore, the emergence and appropriation of the discourse of postmodernity in China in the 1990s can be seen as a renewed effort to rethink China's difference from the West at the end of the twentieth century. By appropriating the postmodern self-critique of the West, Chinese intellectuals have been able to articulate their own distinct national and cultural condition.

Ironically, a critical reflection on the self can only be accomplished by participating in a Western discursive formation: postmodernism. Once again, Chinese intellectuals at the fin de siècle are deadlocked in an aporia that infected them throughout the twentieth century. It appears that embedded in the Chinese discourse of modernity and postmodernity is an ambivalent, uneasy relationship between universality and difference, between the unfolding of modernity/postmodernity as a universal process in world history and the specific, local condition of China. Chinese attitudes often oscillate between the inscription of an evolutionary, teleological metanarrative of world history and the possibility of a different scheme of historical development dictated by the indigenous culture and tradition of China. In the fol-

lowing pages, I will first give a brief overview of the discourse of alternative modernity in twentieth-century China, then identify several major currents in the debate about modernity, postcolonial modernity, and postmodernity in the contemporary period.

Alternative Modernity in Modern Chinese History

Alternative modernity can be seen as a non-Western country's reaction to the West's post-Enlightenment model of modernity. The quest for an alternative Chinese modernity—or an Asian modernity—represents China's response to the dominant Euro-American paradigm. This response to the Western model may involve a wide spectrum of processes and attitudes ranging from acceptance, adaptation, appropriation, and application, to revision, resistance, and rejection. The response entails a critique of capitalism and the post-Enlightenment universals of reason, progress, development, capital, and modernization.

Writing about the modernization of Greece and non-Western countries, Gregory Jusdanis states: "Belated modernization, especially in non-Western societies, necessarily remains 'incomplete' not because it deviates from the supposed correct path but because it cannot culminate in a faithful duplication of Western prototypes.... The project of becoming modern thus differs from place to place. That is why it is possible to speak of many modernities."[2] The Chinese case is similar. Although the search for modernity has never been given up, the Chinese critique of modernity has always searched for construction of an alternative modernity. Western modernity cannot be simply transferred to Chinese soil. The story of Chinese modernity comprises multiple temporalities, historical variations, and cultural differences. Chinese modernity is not a unilinear, evolutionary sequence, but is pregnant with alternatives to the post-Enlightenment European paradigm.

In his provocatively titled book, *Rescuing History from the Nation: Questioning Narratives of Modern China*, Prasenjit Duara tries to recover multiple strands of history obscured by the discourse and formation of the modern Chinese nation-state.[3] He points to various histories of modern China buried under the grand narrative of the linear, teleological Enlightenment history of the Chinese nation/subject. Not unlike Duara's

study of modern Chinese history, I intend here to give a brief account of the transformations and various layers of discourse about Chinese modernity amidst developments in global capitalism during the 1990s.

China's quest for an alternative modernity is as old as modern Chinese history.[4] China was forced to reckon with the values, institutions, and technology of the West in the aftermath of the Opium War in the mid-nineteenth century. Since then, Chinese intellectuals, politicians, and the populace have subscribed to various versions and visions of a Chinese modernity, whether in pursuit of some Chinese essence, nationalism, or wholesale Westernization. In the latter half of the nineteenth century advocates of "self-strengthening" believed that Western learning was needed for practical matters, but that Chinese learning was necessary for the nation's cultural foundations (*zhongti xiyong*). In other words, China should absorb the fruits of Western science and technology (for example, knowledge to make advanced weapons and warships), but maintain Chinese culture and institutions. There was also the aborted 100-Days reform movement, led by Kang Youwei, to adopt Western institutions without changing the Chinese monarchy.

The 1911 Republican Revolution overthrew the old imperial system, yet it was the May Fourth Movement of 1917–21 that fundamentally challenged traditional Chinese culture. The writers and thinkers of the movement questioned and attacked basic aspects of traditional Chinese culture and society. Some of them even went so far as to suggest the abolition of the Chinese language in favor of romanization.

The founding of the Chinese Communist Party (CCP) in 1921 has proven to be one of the most enduring legacies of the May Fourth Movement. The CCP embraced Marxism-Leninism as its guiding philosophy and adopted a Western, Marxian, linear, teleological conception of history. It is evident that in its long and arduous struggle to final victory in 1949 and beyond the CCP did not have a readily available Western revolutionary model to copy. The Chinese condition differed radically from the advanced industrial European countries that Marx and Engels had described. Official communist historiography diagnosed China as a "semi-colonial, semi-feudal, and bureaucratic-capitalist country."

Furthermore, the lessons of the Bolshevik Revolution could not be applied to the Chinese experience. "Maoism" in Western parlance, or "Mao

Zedong Thought" in official Chinese appellation, resulted from the Chinese Communist search for a Chinese solution to Communist revolution. The familiar tale of the sinification of Marxism represented nothing but a manifestation of the CCP's search for a suitable, alternative, Chinese modernity. Mao's revolutionary guerrilla warfare, that is, the model of "encircling the cities from the countryside," became the trademark of Chinese Marxism, a unique version of Marxism that Marx himself could have never foreseen. During the Cultural Revolution, Mao Zedong and Lin Biao extended this model into a global revolutionary strategy for the "people's war," with the "countryside" of Asia, Africa, and Latin America encircling the "metropolises" of North America and Europe.

After 1949, Mao began a series of socialist experiments. Unfortunately, experiments like the Great Leap Forward and the Cultural Revolution proved to be colossal failures, as even the state admitted, and brought disaster after disaster to the Chinese nation, even though the Cultural Revolution and Maoism ended up being catalysts to revolutionary movements throughout the rest of the world. China's vision of "continual revolution" (*jixu geming*), or "revolution within revolution," ended with Mao's death in 1976.

From the mid-1970s to the mid-1980s, first under the leadership of Premier Zhou Enlai and then under Vice Premier Deng Xiaoping, a blueprint of state-sponsored modernization emerged. *Modernity* was envisioned as *modernization* in material production. More specifically, the official slogan emphasized the realization of "Four Modernizations" in China by the end of the twentieth century: the modernization of industry, agriculture, national defense, and science and technology. Modernization was understood primarily as modernizing outdated technology, production methods, and management systems and raising the material living standard of citizens. The acquisition of Western learning (in the areas of natural and applied sciences, technology, and business management) was important to the extent that it might quicken the modernization process. Modernity/modernization did not—and still does not—include extensive political and institutional change.

It should be no surprise that, through the appropriation of Western modernity for construction of a Chinese modernity, the West has been essentialized and homogenized in the post-Mao era. The system of representing the Occident, or "Occidentalism," is the reverse of what Edward Said calls "Orientalism." Different groups have represented, invented, inter-

preted, and utilized the Occident for various purposes. There is the official Occidentalism of the Chinese state, which constructs specific images of the West to advance its own modernization project. There is also a counter-official Occidentalism that questions the state discourse of Western modernity and offers an alternative reading of the West's history, values, and institutions.[5] Indeed, throughout modern Chinese history, the constantly shifting configurations and refigurations of the West have been an integral, indispensable part of the Chinese imaginary of modernity.

Beginning in the 1990s, the discourse of modernity underwent new transformations in the age of transnational capitalism. In what follows, I will outline four prominent expressions and reformulations of the idea of modernity in the inter-China area (Taiwan, Hong Kong, and the mainland). These are: (1) the state discourse of modernization and socialist modernity; (2) the inter-Chinese, transnational discourse of Asian modernity or Confucian modernity; (3) the humanist critique of modernity and postcoloniality in some circles of Chinese intellectuals, and (4) Chinese *post*modernity and *post*modernism.

The State Discourse of Modernization and Socialist Modernity

The project of Four Modernizations, originally proposed by the Chinese *nation-state*, appears to be out of sync with the rapid expansion of *transnational* capital. What was once a most inspiring slogan is heard no more. China itself has become an active player in world trade. The economic role of the Chinese nation-state has needed to be redefined in view of the globalization of the mechanisms of production, subcontracting, distribution, marketing, and consumption. "Socialist market economy" (*shehuizhuyi shichang jingji*) was the new catchword in the 1990s. The supreme goal of the Chinese nation was to "build socialism with Chinese characteristics" (*jianshe you Zhongguo tese de shehuizhuyi*). Once again, what was regarded as a "universal" experience in world history, "socialism," needed distinctive local, indigenous, "Chinese characteristics." The "socialist market economy" borrowed and appropriated the latest business practices and rules from the advanced capitalist societies. Although the Chinese economy is still in transition to capitalism, there is little change toward a capitalist political system.

"Socialism with Chinese characteristics" is expected eventually to prove superior to Western capitalism.

For a long time, the government subsidized state-owned industries and such necessities of people's daily lives as public housing, transportation, and health care. It managed to keep large sectors of the population sheltered from cutthroat capitalist competition, which has rapidly spread to the private business sector. However, beginning in late 1997, the government allowed state-owned enterprises (SOEs) to go bankrupt or be purchased by interested buyers. It kept the big SOEs in its hands while letting the small and medium ones "sink or swim" in the market. "Public shareholding," private businesses, and foreign investors replaced state ownership. Massive layoffs of tens of millions of workers occurred as a result of inefficient management of SOEs, and critical and painful changes have taken place in state ownership, central planning, and socialist economics—which in China is characterized by government subsidy and protection. As China and the United States concluded their agreement in late 1999 on China's future admission to the World Trade Organization (WTO), the Chinese economy seemed destined for fuller integration into the capitalist world economy, which would lead the nation even further away from its socialist legacy.

For passionate defenders of Chinese socialism, the economic practices of China during the last fifty years have presented a genuine alternative to both Western capitalism and Soviet socialism.[6] In the 1950s, China learned central planning from the Soviet Union. However, due to China's unique circumstances, the state never effectively implemented central planning from top to bottom, from the central government to the provinces, counties, towns, and villages. In fact, Mao attempted to transcend the Soviet model of industrialization by promoting spontaneous, grassroots efforts at the local level during the Great Leap Forward. Such a decentered, flexible mode of accumulation and production might be considered the economic counterpart of his revolutionary guerrilla warfare. But because the Great Leap Forward failed and "capitalist roaders" were curtailed, economic activities at the township level did not reach their potential.

Since the era of Reform and Openness (*gaige kaifang*), township enterprises (*xiangzhen qiye*), often in the form of collective ownership and communal management, sprouted up throughout China. Such enterprises have little to do with central planning from the government. They instead rely on

cheap labor, flexible accumulation and production, and short-term investment, and thus constitute a driving force in China's overall economic growth. They also make up a large share of the GNP. However, the problems of such economic organizations also became apparent as economic reforms deepened. The social benefits of these small and medium-scale factories and businesses, often built with primitive, antiquated facilities, are indisputable: industrialization, urbanization, economic prosperity, employment, improvement in family and individual income, to say nothing of the fact that they prevented the rural population from migrating to already overcrowded cities. However, the price of these achievements has been exorbitant: environmental destruction, waste of materials, shoddy products, blind repetitive production, disorderly markets, and so forth.

The combination of various forms of production and ownership—small-time private entrepreneurship; private, collective, or communal township enterprises; state-owned enterprises; Sino-foreign joint ventures; foreign ventures; and transnational corporations (TNCs)—makes the Chinese "socialist market economy" a diversified and dynamic force. Unlike the the Russian economy, which has recently experienced "shock therapy"—a path of Westernization and privatization ill advised by Harvard economists—the Chinese economy successfully weathered the first wave of economic storms in the post–cold war years. Aspects of a socialist planned economy, that is, the opacity and insularity of the finance sector, also miraculously saved China from the Asian financial crisis of 1997–99. With all its advantages and shortcomings, China's unique socialist legacy will be tested once again with China's impending admission into the WTO.

The Transnational Discourse of Asian Modernity and Confucian Capitalism

The second discourse of Chinese modernity, to which I now turn, is much more fluid. It moves well beyond the boundaries of the Chinese nation-state; it is a pan-Chinese, pan-Asian, trans-Pacific, and transnational phenomenon. The idea of "Asian modernity" offers an alternative to the dominant paradigm of Euro-American modernity. For about two decades a series of interrelated terms such as "East Asian modernity," "industrial East Asia,"

"Confucian capitalism," "Neo-Confucianism," and "Post-Confucianism" have circulated one after another in the inter-China area, overseas Chinese communities, East Asia, Southeast Asia, and the West.

The idea of Asian modernity undermines Max Weber's verdict that such Asian forms of spirituality as Confucianism stand as obstacles to the development of capitalism. In fact, the idea recognizes Confucianism as the driving force behind the capitalist economies of such Asian societies as Japan, the so-called four "mini-dragons" (Taiwan, Hong Kong, Singapore, Korea), and more recently the economy of China. The economic success of East Asian societies may point to an "East Asian development model" unique in the global history of capitalism.[7]

In the attempt to avoid such shortcomings of Euro-American modernity as ecological disaster and unbridled individualism, the discourse of Asian modernity creates a new myth of Asian capitalism. It establishes a teleology of its own: the Asian tradition (Chinese, Confucian, and so forth) ceaselessly mediating, perpetuating, and renewing itself. While registering high economic growth rates, East Asian societies are supposedly capable of bringing about the unity of tradition and modernity, humanity and nature, and the individual and the collective.

In a perceptive new study of the Confucian revival in the 1980s, Arif Dirlik pinpoints some of its underlying ideological factors. He takes the discourse of Confucian modernity, first of all, as "a functional component of an emergent Global Capitalism," and second, as "a problem in Chinese intellectuals' identity."[8] The assertiveness of inter-Chinese intellectuals and their identification with the native tradition are signs of their resistance to the hegemony of the Euro-American intellectual tradition. At the same time, the logic of "Asian modernity" does not question the fundamental premise of capitalism, but rather extends the domain of the emergent global capitalism.

In offering an alternative narrative of capital the discourse of Asian modernity at times indulges in essentialization of Asian values and self-orientalization. (Lee Kuan Yew, Singapore's former prime minister, is the most notable exemplar.[9]) It is not without some irony that, while reviewing the discourse of Asian modernity, observers see one financial failure after another in countries of the region during the so-called "Asian financial crisis" (1997–99). The weaknesses and deep structural problems inherent in these economies were fully revealed as stock markets tumbled again and

again. Economic turmoil further led to political changes. Suharto, the longest-reigning Asian leader, was brought down in Indonesia, and the rule of Malaysia's strongman, Mohamad Mahathir, was challenged from within his own country. The Japanese economy, thought to be a model worth emulating, entered a prolonged recession. The International Monetary Fund had to bail out the troubled economy of South Korea. (The quick recovery of South Korea's economy after a short period of readjustment and structural reform was as astonishing as its decline.)

But these developments should not let us forget that the Asian discourse raises several important questions: Are non-Western societies capable of constructing a non-Western, alternative modernity? Should third world societies follow the Western critique of modernity and completely abandon their own project of modernity and modernization? Can they ever become the agency of modernity/modernization? If a non-Western, Asian, even "Confucian" modernity actually comes into existence—however absurd that may sound—what will it be like?

To be sure, the discourse of Asian modernity may either lapse into some kind of pan-Asian/pan-Chinese centrism or extend the domain of global capitalism even further. However, I argue that it has already opened up a set of issues, such as the question of the agency of modernity in non-Western countries, that Western theories (modernism, postmodernism, and even postcolonialism) have not adequately reflected upon. With the integration of mainland China into global capitalism in the 1990s, the Confucian revival finally hit home and has become an important subject in academic discussions on the mainland.

In contrast to abstruse theoretical debates, some historical facts may help clarify the issues at hand. Since the beginning of the era of Reform and Openness, China's economic planners under the leadership of Deng Xiaoping and Premier Zhao Ziyang have consciously looked up to the "four mini-dragons" as a model for solving China's problems. Following their examples, China quickly developed its own export-oriented, labor-intensive sectors of the economy (textiles, toys, electronics, and so forth) and eventually replaced the little dragons as the world's leading exporter of low-tech products. By the end of the twentieth century, China had surpassed all four little dragons in terms of total volume of exports per year. Thus, "Confucian capitalism" returned to its original home after a long sojourn overseas.

The Incomplete Project of Modernity and the Critique of Postcoloniality

Apart from the national and transnational discourse of modernity, a strong, resurgent humanist tradition exists in reflections on Chinese modernity. In this critical tradition, modernity and modernization are accepted because they still represent an "incomplete project" in China; what is called for is a critique of the dialectic of modernity and a revision of modernity as envisioned in the West. Here I would like to mention the recent work of two representative figures in particular, Li Zehou and Liu Zaifu. In the 1980s, Li was the leading Chinese philosopher and aesthetician, and Liu the foremost Chinese literary critic. Both were known for their shared theory of subjectivity—a humanist, romanticist "Marxist theory" that attempts to rescue the subject from decades of Maoist socialist realism. Most recently, they have jointly published a series of dialogues titled *Farewell Revolution* (*Gaobie geming*).

In their dialogues, Li and Liu write about a fundamental "time-lag" (*shijian cha*), a temporal difference, and an epochal difference (*shidai cha*) between China and the West. China and the West are at different stages of development. Modernity is not a unilinear, monolithic process, but embodies multiple temporalities. Li and Liu oppose the postcolonial notion of "contra-modernity" (*fankang xiandaixing*). For them, a full-fledged modernity has yet to arrive in China. However, Chinese modernity is neither a wholesale replication of Western modernity nor a total opposite of modernity. It appropriates some elements of Western modernity while rejecting others. To the extent that Chinese society is still premodern in many ways, "instrumental rationality" (*gongju lixing*) is yet to develop. Before China becomes a fully modern society, the Enlightenment universals of reason, science, and progress need to be upheld. The position of Li and Liu can be seen in the following dialogue:

> *Liu*: Western intellectuals' reflection on instrumental rationality comes after the high development of instrumental rationality, but not before this. When instrumental rationality is developed to an extreme, it imprisons humanity, and creates the problem of alienation. Therefore, Western intellectuals' critique of modernity is based on the condition of the high development of instrumental rationality. But China has never got to the point of the full

development of instrumental rationality. Even Habermas in Western Marxism still defends modernity, and opposes postmodernity. If China opposes modernity now, we would easily merge with the stubborn traditionalists.

Li: If we do not realize this but launch a massive critique of instrumental rationality and modernity, we will become nationalistic romanticists and go toward conservatism. . . .[10]

Capitalism, modernity, modernization, development, and material progress have resulted in the West in mass destruction, war, and ecological catastrophe. A reflection on the "dialectic of Enlightenment" is pertinent to the Western situation. Yet it is premature, as Li and Liu argue, to speak of "contra-modernity" in China. For them, a major improvement in material production and sufficient development of rationality are the prerequisites for a better future. Fundamental institutional and political change can happen only after a substantial improvement in the material conditions of living. "Democracy" is, and will remain, an empty slogan if the social and economic infrastructures have not been modernized. Consistent with his own brand of Chinese Marxism as formulated in the 1980s, Li advises that China at present does not need Max Horkheimer's "dialectic of Enlightenment" or Theodor Adorno's "negative dialectic," but concrete efforts to bring about modernization.[11] Evidently, Li considers modernity an emancipatory rather than exploitative force.[12]

For Li and Liu, there have been too many revolutions in modern Chinese history. None of these revolutions, including Mao's Cultural Revolution, has brought real change to Chinese society. There have been "revolutionary changes" in abstract theory, but little improvement in the concrete conditions of production and living. The Cultural Revolution had enough "passion," but too little "rationality." For Li and Liu, it is high time to "bid farewell" to revolution and radicalism. What China needs is not premodernity, postmodernity, or "postcoloniality," but modernity governed by reason.

The dialogues of Li and Liu, which represent one kind of thought, encourage us to consider the intellectual genealogy of postcolonial theory and its relation to China's condition. Where does China fit in the picture of postcolonial cultural studies? In the formulation of postcolonial theory and actual postcolonial criticism discussion of mainland China has been conspicuously absent. Postcolonial discourse appears to be another totalizing

discourse that purports to redescribe the world's situation and rethink the Three Worlds theory. Yet there seems to be a singular mismatch between this globalizing theory and a geopolitical space as vast as China, which constitutes one-fifth of humanity.[13]

As suggested by the term itself, "postcolonial" refers back to a primal event in modern world history, namely, European colonization. Thus, the editors of one postcolonial studies reader caution that the term has been used and abused to cover phenomena and issues much too broad and nebulous and that it may lose its historical and geographic specificity. They argue that

> Postcolonial studies are based in the "historical fact" of European colonialism, and the diverse material effects to which this phenomenon gave rise. We need to keep this fact of colonisation firmly in mind because the increasingly unfocused use of the term "postcolonial" over the last ten years to describe an astonishing variety of cultural, economic and political practices has meant that there is a danger of its losing its effective meaning altogether.[14]

In a special issue of the *PMLA* titled "Colonialism and the Postcolonial Condition" Linda Hutcheon also suggests that the term "postcolonial" may be misleading with respect to both focus and agenda. She writes: "The universality implied in any such naming risks homogenizing as well as totalizing and thus may mask the complexity of the colonial and postcolonial experiences of diverse individuals and societies in various times and places."[15] One may take another step and pose this question: What happens if a society is mainly, to be historically and technically accurate, *outside* postcoloniality? What if it was neither colonial in the past nor postcolonial at present?

It is a "historical fact" that the West neither colonized nor was colonized by China proper. To be sure, China was not exempt from Western imperialism, and was often its victim. China suffered a series of territorial losses to Western colonial powers. Hong Kong, Macao, and sections of several coastal cities such as Shanghai and Tianjin were subject to Western colonial rule and extraterritoriality. (It is well known that Hong Kong, a former British colony, returned to China on July 1, 1997; Macau, a Portuguese colony, reverted to Chinese sovereignty in December 1999. Only then did they become "postcolonial" in the technical sense of the word.) The Qing Empire

lost vast amounts of its northern frontier to Czarist Russia in the nineteenth century. After losing a war to a new Asian colonizer, Japan, China ceded Taiwan to Japan, and Korea became a Japanese colony. Yet China proper was never a colony and emerged as an independent, modern nation-state. Thus it is inaccurate to speak of contemporary China as postcolonial. Postcolonial theory remaps the first and third worlds, the West and the East, but leaves out China. So far, the theory has offered little to explain the Chinese difference. Thus, China remains the aporia that contemporary Western theory cannot theorize.

Although the term "postcolonial" is a misnomer when applied to Chinese reality, some of the themes and topics of postcolonial studies are relevant to the Chinese scene. China faces many of the same problems as the colonized countries of the world have since their first encounters with Western imperialism in the mid-nineteenth century. Questions concerning national and cultural identity, nationalism, ethnicity, Westernization, indigenousness, and other prominent issues in postcolonial studies—as well as concepts that have come to be known as "hybridity," "in-betweenness," and "mimicry"—have always been of paramount importance to Chinese intellectuals.

Recently, in the 1990s, postcolonial criticism was introduced to mainland China. In addition, some Chinese cultural critics attempted to describe certain Chinese events in terms of the postcolonial. Postcolonial thematics seem to lend themselves readily to Chinese critics when they discuss Western cultural and discursive hegemony, Western orientalism, and the self-orientalization of the Orientals/Chinese. The postcolonial is most visible in such cultural processes as the globalization of cultural production (the New Chinese Cinema, for instance), and the import, spread, and "hegemony" of Western critical theory in the Chinese academy. Still, it seems that the term "postcolonial" has rather limited currency in Chinese cultural studies.

In the postcolonial critique, modernity, modernization, capitalism, and development tend to be defined as events originating from the West and mechanisms imposed on the third world by the first world. Accordingly, third world history cannot be read in terms of the logic of capitalism.[16] Moreover, the ideas of modernity and development constitute a veritable discourse, a "regime of truth" by which the first world manages and develops the third world. For example, in Arturo Escobar's critique of "develop-

ment" in the context of Latin America, the term is understood "as a particular set of discursive power relations that construct a representation of the third world, whose critical analysis lays bare the processes by which Latin America and the rest of the third world have been produced as 'underdeveloped.'"[17] Development becomes a discourse and a strategy by which the rich first world represents, domesticates, and controls the poor third world.

Admittedly, the processes of modernity and capitalism are inextricably associated with Western colonialism, with the domination, suppression, and exploitation of indigenous peoples. However, the appropriate issue for postcolonial criticism to raise is not modernity, but "contra-modernity," as Homi Bhabha aptly puts it. Bhabha wishes to pose "questions of a contra-modernity: what is modernity in those colonial conditions where its imposition is itself the denial of historical freedom, civic autonomy and the 'ethical' choice of refashioning?"[18] Inasmuch as China had experiences similar to other third world countries in modern world history, the story of modernity is as much a narrative of exploitation and enslavement as of "reason" and "progress." The dialectic of modernity was, in many ways, more oppressive than emancipatory for the peoples of the third world due to the historical experience of Western colonialism and imperialism.

Having said all this, I believe that the discourse of alternative modernity—not postcolonial "contra-modernity"—may open new doors in the theoretical exploration of one vast "third world," postsocialist country: China. It is important to ponder the question of Asian modernity and modernization, for it points to the possibility of alternatives to colonial and Western modernity. Given the modern capitalist world system, especially contemporary global capitalism, modernity in any part of the world is necessarily a *hybrid* modernity in some measure, a mixture of Western and indigenous forces. As early as the "Manifesto of the Communist Party," Marx and Engels described the interdependence of nations in the capitalist world system in terms of both material and intellectual production. "The bourgeoisie has through its exploitation of the world market given a cosmopolitan character to production and consumption in every country."[19] The exploitation of the world market by TNCs has intensified in the age of global capitalism after the end of the cold war. Yet it is problematic to reduce Asian modernity or modernities to a single colonial, postcolonial, Western modernity. Tetsuo Najita writes:

> Despite the aversion many of us might have for the subject of modernization, it cannot be avoided as it is not likely to disappear from the East and Pacific Asian landscape. We may abandon the idea of it as a simple replication of Western experiences. We may also discard the perspective that modernization is unilinear, an unfolding of reason or the lack thereof. We may see it instead as multilinear and simultaneous processes of change and transformation. The main point is that we cannot remove time and change from modern history....[20]

Modern Asia is a "hybrid," "multicultural" space that we need to historicize rather than essentialize. Asian modernity is not a pale replica of Western modernity. More important, the question of *agency* in Asian modernity is not merely an issue of "enunciation," "utterance," "signification," and "discourse," as sometimes suggested in postcolonial criticism, however critically important those concepts are, but a matter of social praxis, the possibility of changing the material, economic, and cultural condition of living third world subjects. It is true that the centers of global capital have attempted to manipulate and control third world countries through the discursive regime of "development." However, the opposite side of the issue is equally important. Is there a possibility for third world agency and self-determination? Will Asia perpetually remain the passive object of representation in the West's global lens? Will Asia do anything other than mimic the West? The stubborn adherence to the project of modernity/modernization on the part of Chinese intellectuals such as Li and Liu clearly expresses a strong desire to address these questions. Aihwa Ong's analysis of the discourse of Asian modernity is particularly apt at this point. She writes,

> The "alternative" in alternative modernities does not necessarily suggest a critique of, or opposition to, capital.... Asian tiger countries consider themselves as belonging to a *post* postcolonial era—one characterized by state developmental strategies, rising standards of living, and the regulation of populations in a post–cold war order of flexible capitalism. They would not consider their own current engagements with global capitalism or metropolitan powers as postcolonial but seek rather to emphasize and claim emergent power, equality, and mutual respect on the global stage.[21]

Although they share certain themes, the postcolonial and the idea of Asian modernity differ in important ways. To some Chinese proponents, Postcolonial theory is rather foreign to Asian modernity.[22] In some respects,

the two discourses diverge diametrically on issues such as modernization, development, and capitalism. Unlike the postcolonial, the discourse of Asian modernity never overlooks the pursuit of modernity and modernization in the poverty-stricken third world countries. Asian modernity attempts to offer a re-vision of and an alternate vision to the dominant Western model of modernity.

This revisionist Asian notion of modernity is double-edged. Although still adhering to the Western, post-Enlightenment teleology of capital, progress, and development, it questions and rejects the Eurocentric view of such teleology, as well as the Euro-American model of modernization. According to this perspective, Asian economies and societies are no longer passive objects of representation by the West but active players of world capitalism that are considered subjects and agents of historical change. However, to say "we are modern too" would be merely a feeble and desperate attempt on the part of Asians if discourse had nothing to do with practice. More importantly, alternative modernity in the case of China—as both a major socialist state and an Asian country—implies a search for alternate, concrete models of social and economic development. The *Chinese socialist paradigm* (from Maoism to Deng's reforms) and the *Asian paradigm* (Confucian capitalism) offer such alternates to Euro-American capitalism in real historical time.

Postmodernity and Postmodernism in China

From Modernism to Postmodernism, a lengthy anthology edited by Lawrence E. Cahoone, purports to be a comprehensive collection of major statements on modernism and postmodernism made throughout the history of the West. The book ends, significantly, with an essay on China by David Hall, as if the history of modernity and postmodernity originated in the West and spread outward to the non-Western periphery. However, the reader soon discovers that this seeming progression of ideas is very much a retro-teleology, for what the essay does is work backward and uncover common ground between contemporary postmodern theory and ancient Chinese philosophy by using such ideas as difference/différance as examples.[23] In this essay there is an uncanny kinship between deconstruction and postmodernism, on the

one hand, and Confucianism, Taoism, and the philosophy of Zhuangzi, on the other. If premodern China was in a curious way profoundly postmodern, Hall understands postmodernism itself to be primarily a style of thought. In actuality, postmodernism in China and Asia today is no longer a residue of some ancient mentality, but a real socioeconomic presence. This 1996 anthology aspires to have a global reach, but it actually leaves out appropriate discussions of contemporary postmodern formations outside the West and seems inadequate to the task.

Appropriation of the discourse of the postmodern in China studies can be divided into two stages. In the first (mid- to late 1980s) postmodernism offered a heuristic guide to a small number of scholars in the field of premodern China. Postmodernism was considered relevant to the Chinese condition mainly as a philosophy and style of thought. Three years after publication of the English edition of Jean-François Lyotard's book *The Postmodern Condition: A Report on Knowledge* (1984), I myself found connections between the postmodern turn of thought and traditional Chinese narrative fiction. In my view, Lyotard's key ideas (legitimation, delegitimation, paralogy, knowledge, grand narrative, and small story) serve as suitable tropes to analyze the Chinese scene.[24] In 1987, in reference to Lyotard's book, I wrote the following about differences between traditional Chinese historical narrative and fictional narrative:

> Here, we would borrow Jean-François Lyotard's heuristic distinction between "grand narratives" of legitimation and "small stories" (*les petits récits*) of delegitimation to differentiate the narrative functions of Chinese historiography and fiction. Historiographic works are the grand Chinese narratives of legitimation. The monologic, official histories legalize the existing feudal orders, Sovereign, the imposed "Social Contract," genealogical succession, State, the Central Realm, Father, Patriarch, Husband, and Law. In actuality, the dynastic histories guarantee their right of narrative truth by telling the great stories of the founding fathers, the rises and falls of hereditary houses, power transitions, the beginnings, and the peak-moments of national history. The function of the "small stories" (*hsiao-shuo*) is then the delegitimation of the master codes of the grand stories. The fictional pieces are small operations, guerrilla wars against the giants of historical narrative. The written texts, the acts of oral storytelling, or the extended novels dislocate and deconstruct historical texts, produce heretical, apocryphal records, unofficial documents, and create ideological instabilities, moral vacuums, and aporias in

the vast inescapable meshes of Confucian society. At their best, the local small stories inflict a "paralogical," debilitating, and anarchic effect upon the functioning of Chinese official culture and induce a vital forgetfulness of historiography/history.[25]

I expanded these ideas in a study written later about the poetics of Chinese narrative.[26] However, postmodernism/postmodernity as a socioeconomic condition or cultural force was irrelevant to China in the 1980s.

The second phase in the evolution of the discourse of postmodernism among China scholars came in the 1990s, when postmodernism arrived in China as a full-fledged reality. With the advent of transnational capitalism around the globe, many Asian countries—including China—suddenly became "postmodern" or displayed postmodern characteristics. The distinctive economic and cultural features of Asian postmodernity and postmodernism added a new dimension to the discourse of Asian modernity.[27]

At this point, an examination of the postmodernism issue in the Chinese context will be offered to answer three interrelated questions, however sketchy and flawed that effort may be: (1) Is China postmodern? Or how and to what extent is China postmodern? (2) What are the cultural and artistic features of Chinese postmodernism in relation to modes of production and the socioeconomic "base"? (3) What is the axiology of Chinese postmodernism? In other words, what is the politics of postmodernism in the Chinese context?

Under Mao, modernity was experienced as a revolutionary, socialist modernity. As China moved into a postrevolutionary, postsocialist, and postmodern (but not postcolonial) society, it retained traces of its legacies. Today, Chinese postmodernity builds on a sedimentation of various modernities and hybrid temporalities. The premodern, modern, and postmodern coexist in the contemporary. Formerly a socialist country, though now so only in name, China itself has started to generate global postmodernism out of its specific historical experiences.

Seen in another light, Chinese *postmodernity* is a marker of profound social anomalies and ideological contradictions in contemporary China, and Chinese *postmodernism* is the most forceful expression of these anomalies and contradictions in the realm of art and culture. Today, China is an important, integral site for the flow of transnational capital. Such deterritorialized

capital penetrates all corners of the world, and currently operates even in the deep recesses of post–third world countries, not only in the heartland of advanced postindustrial Western societies. In 1998, there were more than forty McDonald's restaurants in Beijing and the number was growing. The success of McDonald's in a country that still fiercely resists Western ideology suggests the extent of transnational capital in our time. To Chinese citizens, the rapidly growing foreign fast-food industry, which includes such businesses as McDonald's, Pizza Hut, and Kentucky Fried Chicken, is an unmistakable cultural symbol of the West. "McDonaldization" is a concrete embodiment of globalization throughout such post–third world countries as China.

Having said all this, I should point out that much of China remains in a premodern state of labor and production. In the backward interior of China, the highly rationalized, organized mode of production—"Fordism" according to Antonio Gramsci—is still out of sight. As in southern Italy during Gramsci's time, residual "feudal" social and cultural formations that hinder capitalist development still exist in many parts of China. Naturally, China is a mixture of pre-Fordist, Fordist, and post-Fordist modes of production. "Non-synchronicity," to use a phrase from Ernst Bloch, is the condition of the post-third world.[28] A unilinear, Eurocentric conception of historical processes would fail to give an adequate account of global postmodernity. A case parallel to China is postmodernism in Latin America. Ella Shohat and Robert Stam write:

> For us, "postmodern" is not an honorific, nor are Third World postmodernisms necessarily identical to those of the First World. A more adequate formulation would see time as scrambled and palimpsestic in all the Worlds, with the premodern, the modern, the postmodern and the paramodern coexisting globally, although the dominant may vary from region to region. Thus the Pennsylvania Dutch and Silicon Valley technocrats both live in "postmodern" America, while the "Stone Age" Yanomami and the hyper-sophisticated Euro-Brazilians of Sao Paulo both live in Brazil, yet the Yanomami use video while the sophisticates adhere to "primitive" Afro-Brazilian religions.[29]

If China can be rightly described as an example of transnational and global postmodernity, what is its corresponding cultural form? To answer, it is imperative to arrive at an adequate inventory of the diverse features that

constitute postmodern culture (literature, art, architecture, film, TV, video, and so forth), a task that I hope to accomplish in Part II of this book. At the moment, however, I will repeat and elaborate what I have already said in regard to the question of the politics of postmodernism in China.

First and most obvious, the postmodern is a reaction against and critique of the modern. It questions the validity of Enlightenment "universals" (democracy, human rights, and so forth), which are, ironically, still not fully at home in China. Chinese postmodernism can be seen as an attempt to mediate the universal claims of the grand metanarratives of the West and the local condition of China. Moreover, it allows for a re-vision not only of the Enlightenment, but also of China's own Enlightenment projects (the May Fourth Movement, the Communist Revolution, socialist construction, "cultural critique" of the 1980s, and so forth). Chinese postmodernism opens up again the possibilities of difference, alterity, multiplicity, and heterogeneity in historical and cultural development. The postmodern turn arrives in the aftermath of a century of modernization deferred, interrupted, resumed, and redefined. The Chinese postmodern differánce, in the Derridean sense of both differing and deferring, implies that modernity throughout the entire course of the twentieth century has been perpetually sought after and deferred. The postmodern is also a movement away from the teleology of modernity and modernization based on the nation-state toward deterritorialized transnationalism, from unilinear national and universal history to heterogeneous and multiple employments of change.

The implications of postmodernist politics in contemporary China are thus twofold: on the one hand, it eclipses certain Enlightenment values that are absent in China; on the other hand, it resists the hegemony of the Eurocentric teleology of temporality and modernity by looking for alternative narratives. This "blindness and insight," a contradictory, two-way orientation, will endure as long as China remains in a state of interregnum. For China to advance beyond the present interregnum it must enter an entirely new era of history that will impact both China and the world—a new era, a sublime moment, that no "post-" word can adequately describe.

In the first three discourses of Chinese modernity that I have briefly reviewed there seems to be newfound confidence among proponents in the formation of a counterhegemonic, Chinese, Asian modernity vis-à-vis the

West. There is recognition that modernity cannot be built on some absolute, fixed, unilinear model from the West. Modernity is an uneven process subject to spatial-temporal fluctuations and cross-cultural differences. That China has a "time lag" in relation to the West means that modernization in the Chinese experience must have its own unique mechanisms and characteristics. The discourse of "Asian modernity" is a critique of the universalism of Western modernity and a recognition of the uniqueness of "Chineseness" and "Asianness" in the history of capitalism. This critical enterprise seriously takes up the theme of "difference" and its implications in contemporary world cultural politics.

According to these discussions, the project of modernity is not to be rejected, but completed. Modernity, if successfully implemented in China, integrated into a world capitalist system, and fueled by global capital, is thought to be a potentially liberating force that will open the way to freedom and prosperity. On one level, these discourses of Chinese modernity obviously subscribe to Western, post-Enlightenment teleology and ideals of modernity, capital, development, and progress. However, on another level, they challenge Eurocentric narratives of history and grant non-Western societies equality as important agents, movers, and shapers of world history.

Here we see another difference between postcolonial criticism and Chinese modernity. As Anne McClintock puts it, the term *postcolonial* "confers on colonialism the prestige of history proper; colonialism is the determining marker of history. Other cultures share only a chronological, prepositional relation to a Euro-centered epoch that is over (post-), or not yet begun (pre-)."[30] In the Chinese case, especially in the Confucian revival, there is an effort to mediate the past, present, and future of Chinese history, which is as long as European history, and to situate capitalism as a new chapter in the continuum of Chinese and world history. Yet, while overcoming the Eurocentric narrative of world history, there is also the danger of an emergent Sinocentric worldview as old as history itself.

It is also evident in these discussions that there is little reflection on the possible negative consequences of modernization. It soon becomes clear that euphoria, narcissistic self-gazing, and unthinking acceptance of "instrumental rationality" will extract a huge price. Modernization, industrialization, and urbanization may lead to ecological ruin of the most enormous proportions. The anthropological attitude of modernity still adopted by many

Chinese intellectuals aims at the exploitation and instrumentalization of nature for human purposes. The conquest of nature as a supreme manifestation of modernization reveals the limits of Chinese modernity.

The discourse of Chinese postmodernism at the end of the twentieth century was a response to both the legacy of Western modernity and China's own modernization project. The postmodern indicates an overlap of uneven historical, social, and cultural formations. Its emergence in China during the last decade of the twentieth century occurred at the same time as the rise of consumerism and the advent of transnational capital. Postmodern art, then, as we shall see in the next part of this book, represented the occasion to rethink, and caricature, the project of Chinese modernity and modernization, as well as their promises, potentials, and limits.

THREE

Theory and Criticism: Economic Globalization, Cultural Nationalism, Intellectual Identity

Globalization or Nationalism?

On March 3, 1998, Chinese president Jiang Zemin spoke to the Hong Kong delegation at the Ninth People's Congress about the need to study the phenomenon of globalization.

> We must thoroughly and correctly understand and confront the issue of economic "globalization." Economic "globalization" is an objective tendency in world economic development. Nobody can avoid it, and we must all participate in it. The key to the issue is to look at it in a dialectical way, and to recognize not only the positive but also the negative side. This is especially important for a developing country like China.[1]

These remarks were made at the height of Asia's economic crisis, just when Hong Kong's economy had entered recession. At that moment, China was considering the pros and cons of total economic globalization. China had

long sought to be a member of the World Trade Organization, formerly the General Agreement on Tariffs and Trade (GATT), but wanted to enter the organization as a developing country to protect some of its vulnerable industries from foreign competition. However, the United States had insisted that China open its economy fully before being considered for membership. Until the end of the 1990s large sectors of the Chinese economy, especially finance and the stock market, were closed to foreign investors.

The Asian financial crisis made abundantly clear the consequent danger of complete integration into the world economy. Western speculators like George Soros took advantage of weaknesses in the finance systems of countries like Thailand, Indonesia, and South Korea, pulled money out of the countries, and quickly crushed their economies within a short period. Even more troublesome for some Asian leaders was the fact that economic crises might lead directly to political turmoil, as occurred in Indonesia, where President Suharto, who had ruled his country with an iron fist since the mid-1960s, was toppled. People within his own ranks questioned the firm rule of Malaysian prime minister Mahathir and challenged his economic policies. Economic turmoil also led to changes of leadership in Japan and Korea. Japanese prime minister Ryūtarō Hashimoto and Korean president Kim Young Sam both had to step down because they failed to come up with effective measures to save their countries' economies.

Throughout the 1990s the hard reality of Asian economics heightened tension in Chinese national consciousness between nationalism and globalization. The debate about Asian modernity took a new turn. The collapse of the Asian economy shattered long-cherished myths about the "Asian economic miracle," "Confucian capitalism," and "Asian values." For some time, so-called "Confucian capitalism" had been seen as a dynamic driving force behind rapid social and economic development in countries like Singapore, Taiwan, South Korea, and Hong Kong. Economics was seen as the result of more basic cultural factors. Communitarianism, as opposed to Western individualism, was perceived to be the core of Asian values. However, the collapse of the Indonesian and South Korean economies exposed the underlying illnesses of Asian economic and social practices: nepotism, corruption, massive short-term debt, unsafe banking policies, heavy governmental support for big corporations, poor infrastructures, lack of transparency, secrecy, and so forth. Overnight, Confucian capitalism was

perceived as "crony capitalism," and Asian values seemed to be synonymous with nepotism and totalitarianism. Hence, economic and political crises lead to a crisis in culture.[2]

The International Monetary Fund (IMF), which is dominated by the United States, took steps to provide loans to the troubled economies of Indonesia and South Korea. But to receive such aid these countries needed to meet terms and standards demanded by the IMF, all of which favored the interests of Western and American businesses. To some people, this seemed to be another instance of Western powers telling Asians what to do. Could such foreign interference in domestic affairs be a new manifestation of imperialism and neocolonialism? The fact that the financial storm harmed China less than other Asian countries was largely due to the semiclosed nature of its economy, which was not yet totally globalized. Speculators could not intervene in China's financial market and wreak havoc. The case of Hong Kong was different, however, because its economy was inextricably tied to the international market. To minimize Hong Kong's losses, the Hong Kong and Chinese central governments pledged to prevent devaluation of the Hong Kong dollar by continuing to peg its value to that of the U.S. dollar.[3]

The financial crisis in Asia exacerbated the political, economic, and cultural contradictions inherent in the process of globalization, especially tension between the local and the global. Generally understood as the universalization of the particular and the particularization of the universal, the effect of globalization is double-sided. Globalization implies standardization and uniformity in economic and cultural activities throughout the world; at the same time, globalization can open the path to democratization and liberate the local from domination by the party-state.[4]

Chinese leaders, economists, and critics were forced to rethink a dilemma at the end of the twentieth century: the issue of whether to globalize. What would have been the price of globalization? What degree of economic globalization would have been suitable at that point? Contemporary history has apparently just taught a lesson that preservation of national interests and sovereignty against the perils of all-out globalization is important in a world system still dominated by the economies of North America and Europe. In the name of the free market, global capitalism as manifested in the Asian financial meltdown has redistributed wealth and financial resources between East and West. It has made Asian people poorer while enriching Western

financiers, speculators, and businesses. Therefore, economic globalization has two dimensions. On the one hand, it exposes deep structural problems embedded in Asia's economy, politics, and "culture," and calls attention to the urgency of reform and change. On the other hand, globalization creates an opportunity for more advanced Western economies to take advantage of weaker economies and devour their already meager resources and wealth.

After a prolonged series of intense negotiations, China and the United States finally reached agreement in 1999 on China's admission to the World Trade Organization. China agreed to open all of its markets in the next several years. Those markets include industry, agriculture, finance, the sensitive areas of telecommunication and the internet, and the area of "cultural production and consumption," which will lead to big increases in the number of Hollywood blockbusters exported to China each year. In return, the United States promises to open further its vast markets to Chinese goods. After weighing the pros and cons, China's reformers felt that the WTO deal would help economic growth in their country.

While gradual and irreversible economic and cultural globalization was underway, nationalist sentiments reached a new high at the end of the twentieth century. NATO's war in Kosovo and its bombing of the Chinese embassy in Yugoslavia in May 1999 outraged Chinese leaders and the populace. A massive wave of anti-American feelings surfaced in the months afterward. China fiercely resisted the notion that human rights take precedence over sovereignty.

The Kosovo War set a new precedent for the resolution of international conflicts. The powerful West led by the United States operated on the assumption that it could invade sovereign nations in the name of stopping brutal human rights violations. The long-established principle of the sovereignty of the nation-state was brushed aside in favor of the sanctity of human rights. In the eyes of China's leadership, the implication is that the West can legitimately interfere in China's domestic affairs, most notably in Tibet and Taiwan. Thus, the Chinese government heated up its rhetoric over the unification of China and Taiwan and proclaimed that the motherland would finally be unified in the twenty-first century. It also took drastic measures to modernize its military forces in preparation for a potential conflict in the Taiwan Strait. At the same time, China defended its vision of a "multipolar world order" and took the lead, along with Russia and the European Community, in resisting the global hegemony of the United States.

Cultural Radicalism or Conservatism?

Broadly speaking, cultural theory and criticism in the last decade of the twentieth century in many ways turned away from the radicalism of previous critical traditions toward a more conciliatory, accommodating approach in regard to China's cultural and intellectual legacy. To put things in a proper context, a quick review of modern Chinese intellectual history is in order.

The May Fourth Movement of 1919 has usually been regarded as the foundational event in modern Chinese intellectual history; in fact, it established the mainstream intellectual discourse of modern China. Founded upon such agendas as enlightenment, national salvation, democracy, and science, the May Fourth Movement posited a fundamental opposition between the old and the new, between tradition and modernity.[5] The task of enlightenment was to clear away the vestiges of feudalism, superstition, and tradition on the path toward construction of a modern culture. For many decades after the historic May Fourth Movement the urgency of national salvation and anti-imperialism eclipsed the discourses of democracy and enlightenment. After 1949, the state suppressed the original agenda of the May Fourth Movement. Official discourse appropriated the movement itself as a great "patriotic movement" that inspired nationalistic, patriotic, and anti-imperialist sentiments among the Chinese people. The ultimate purpose was to enhance the legitimacy of the regime.

During the Cultural Revolution Mao skillfully manipulated the rhetoric of the May Fourth Movement for his own political ends. A revolution in the area of ideology and culture necessitates a radical departure from the past. Mao also launched an all-out attack on Chinese tradition to establish a new proletarian culture. Mao's antitraditional rhetoric made Chinese youths enthusiastic and mobilized them during the early days of the Cultural Revolution.

In the 1980s, a second wave of enlightenment swept across China. Characterizing itself with the terms "cultural reflection" and "historical reflection," this wave engaged in its own critique of entrenched patterns of Chinese culture and history. Establishment of a new subjectivity and completion of the unfinished project of modernity/modernization were the main goals. Once again, relentless critique of the past was considered essential for the formation of a new culture. On the seventieth anniversary of the

May Fourth Movement, the students of Beijing marched to Tiananmen Square to emulate a historic event; however, they could not fulfill their dreams. With the failure of the student movement, Chinese history entered a new phase, and a style of "cultural reflection" characteristic of the 1980s came to an end.

So far in this short narrative, the major moments in modern Chinese intellectual history, the May Fourth Movement and cultural reflection in the 1980s, have been accepted as mainstream discourses in cultural criticism. Such discourses are predicated on a fundamentally iconoclastic, critical stance toward the past. (Obviously, the Cultural Revolution was a very antitraditional discourse, and in this sense was an heir to the May Fourth Movement.) Furthermore, mainstream cultural criticism is also accepted as establishing a new, free subjectivity. Chinese intellectuals have a huge stake in this agenda. In fact, they have been hailed as agents of enlightenment, moral guides of the people, and consciences of the nation.

The newest trend in "post-New" thought departs from this mainstream critical tradition. A more reconciliatory stance toward tradition, an ambivalent attitude toward the position of the intellectual, and an academic politics more conservative in nature seem to characterize its main discussions and debates. Major critical attention now focuses on East Asian modernity, the postmodernism debate, third world criticism, postcolonial criticism, and "national studies" (*guoxue*). While examining these discussions, one can detect certain shared assumptions and trends. Our purpose is to come up with a map that allows us to traverse the difficult terrain of Chinese culture during the "post-" era.

As mentioned previously, one prominent topic in recent years is the role of Confucianism in modern Chinese and East Asian society. The discourse of East Asian modernity did not originate in mainland China. A series of interrelated terms—such as "East Asian modernity," "industrial East Asia," "Confucian capitalism," "Neo-Confucianism," and "Post-Confucianism"— were invented and circulated in the West, the inter-China area, and overseas Chinese communities.[6] Yet in the cultural climate of the mainland itself few critics pursued this line of thought during the 1980s.[7]

In the 1990s, "Confucian capitalism" and other related terms appeared frequently in journals in the inter-China area and the West. "Confucian capitalism" is sometimes used to refer to the economies of countries throughout

the East Asian and Southeast Asian regions.[8] Again and again in academic and quasiacademic journals—and in journals published for the general reader—Neo-Confucianism is considered a direct cause of capitalist economic development in Asia.[9]

The process of rethinking Confucianism's legacy in relation to the issue of East Asian modernity is no longer confined to Chinese communities outside the mainland, but is also carried out within it. In a radical reversal of assessments, Confucianism is now regarded as the driving force of modernity behind East Asian societies. Confucianism is considered an enduring legacy that ceaselessly mediates, adapts, and renews itself. In this view, China should follow the suit of Japan and the four Newly Industrialized Economies (Taiwan, Hong Kong, Singapore, and South Korea). The Confucian revival in the mainland and the inter-China area represents a return to "cultural conservatism" and a repudiation of "cultural radicalism" in twentieth-century Chinese thought. It is a major attempt to resolve the tension between tradition and modernity.[10]

As Arif Dirlik has argued, the Confucian revival can be seen as a function of global capitalism.[11] The concept of a Confucian revival also addresses the issue of intellectual identity in twentieth-century China. The reversal of Weber's verdict on Confucianism is not a rejection of capitalism. The discourse on Eastern modernity actually articulates an alternate vision of modernity, and thus further extends the global domain of capitalism. At the same time, Chinese intellectuals, as third world intellectuals, are able to present a counterhegemonic discourse in contrast to Euro-American hegemony and realign themselves with a native, non-Western cultural tradition. At this point, Aihwa Ong's suggestion of two notions of Chinese modernity helps illuminate the issue at hand. There is a state-sponsored modernity based the assumptions of territoriality, fixity, and the nation-state; then there is a deterritorialized, fluid, hybrid, transnational modernity centered in the area of Greater China.[12] Both notions provide alternate modernities that challenge the domination of Euro-American capitalism.

It is highly ironic that euphoria about the newfound strength of Confucian capitalism turned sour as Asian economies went bankrupt at the end of the twentieth century. Critics and others had to confront the vagaries of finance capitalism. George Soros, the "arch-villain" who destroyed careers and economies across East and Southeast Asia, became the focal point of

public interest in China. Several books about this man were published in Chinese or translated into Chinese in 1998.[13]

Critical Styles or Popular Currents? National Studies, Nationalism, Third World Criticism

The assertiveness of indigenous critics vis à vis the West is evident in such varieties of contemporary Chinese cultural criticism as "national studies" (*guoxue*) and "third world criticism" (*disan shijie piping*). In national studies, the task of the scholar is to focus on his/her own scholarship rather than getting directly involved in politics. He/she tries to stay within the academy and out of politics. The intellectual is no longer a spokesperson for humanity at large; he/she speaks and writes as an ordinary scholar. To remain in the "ivory tower" is, in itself, an act of defiance against commercialism and political corruption.[14] At this juncture, national studies is more of a critical stance and humanist persuasion rather than an actual style of sustained academic research.

In fact, the advocates of national studies have not produced much impressive new scholarship comparable to that of their towering predecessors. A lot of effort has been given to republish the works of the early masters, for instance, Zhang Taiyan's *Guoxue gailun* (Introduction to national studies), and *Wang Guowei xueshu jingdian ji* (Collection of the canonical works of the scholarship of Wang Guowei).[15] The biography *Chen Yinke de zuihou ershi nian* (The last twenty years of Chen Yinke) has been reprinted several times since its first publication in 1995.[16] This popular book details the defiant, independent personality of Chen, who achieved greatness as a humanist amidst adverse political conditions during the last years of his life. National studies is a clear indicator of the academicization and professionalization of humanists and their detachment from social activism, which was previously evident in the May Fourth Movement and events in Tiananmen Square in 1989.

In the booming field of third world criticism, critics take up such themes as "postcolonialism" and "Orientalism." The Chinese style of third world criticism implies resistance to Western cultural and discursive hegemony. Third world criticism seeks to empower indigenous critics vis à vis the dom-

ination of Western theory and culture. Among its tasks are the writing and rewriting of people's history and the release of their "repressed memory." According to these Chinese critics, postcolonialism represents the latest phase of Western colonialism. Whereas *colonialism* is seen as the West's invasion and subjugation of the third world, they consider Western economic exploitation of the third world as characteristic of *neocolonialism* and view Western cultural hegemony at the center of *postcolonialism*. Thus *postcolonial criticism* returns to indigenous sources to create a discourse counter to Western domination.

It is necessary to note an important difference between third world criticism as practiced in a third world state like China and in a first world power like the United States. Third world criticism, postcolonial criticism, and the critique of orientalism may well be progressive, oppositional discourses in the historical, political, and academic contexts of contemporary America. However, when these critical projects are taken up by indigenous scholars within China, the effect can be quite different. As suggested above, an implicit alliance might result between such indigenous critical pursuits and state nationalism. In advocating an academic discourse of resistance to the cultural and discursive hegemony of the West rather than to the internal power of the state, postcolonial critics in China may have misidentified the source of oppression. Thus, sensitive domestic issues are elided. The Chinese style of third world criticism may very well play into the hands of conservative politics and cater to the sentiments of Chinese nationalism.[17]

In 1996, the visit of Taiwan's president, Lee Teng-hui, to Cornell University, his alma mater, brought Sino-U.S. relations to their lowest point since 1989, and the two countries stood at the brink of war. The mainland conducted military exercises and fired missiles close to Taiwan, and U.S. aircraft carriers moved into the Taiwan Strait. At that time, the U.S. Congress also investigated alleged illegal campaign donations from Chinese sources to the Democratic Party. As cold war–style rhetoric surfaced in realpolitik between East and West, nationalistic sentiments intensified in the Chinese media. The most notable example was the popular text *Zhongguo keyi shuo bu: lengzhan hou shidai de zhengzhi yu qinggan xuanze* (China can say no: political and emotional choices in the post–cold war era), which was circulated widely.[18] The book voices the anti-U.S. emotions of a young generation that feels the United States is determined to contain China as a rising super-

power. Another book, *Yaomohua Zhongguo de beihou* (Behind the demonization of China), attacks the U.S. media for vilifying China.[19]

Such nonacademic and quasiacademic popular texts reflect critical discussions within academia. Neither politics nor occurrences in the U.S. media helped assuage antagonistic feelings between the two giants. Books such as *The Coming Conflict with China* and *The Clash of Civilizations and the Remaking of World Order* single out China as a potential rival or, even worse, dangerous enemy of the United States and the West.[20] Hollywood blockbusters such as *Red Corner, Kundun,* and *Seven Years in Tibet* seem to offer concrete proof that the U.S. media has demonized China. The people of China, as well as Asian Americans living within the United States, see examples of American paranoia in allegations of Chinese espionage of U.S. nuclear technology, which culminated in the arrest of Chinese-American nuclear scientist Wen-ho Lee. More than anything else, the accidental or planned bombing of the Chinese embassy in Belgrade by U.S.-led NATO forces during the Kosovo War in May 1999 elevated anti-American feelings.

Postmodernism or the Humanistic Spirit?

In the 1990s, indigenous and overseas Chinese critics seized on postmodernism as a theory to describe effectively the contemporary cultural scene in China. They first noticed a Chinese literary postmodernism, and later saw postmodernism as a cultural force that has permeated all spheres of life in China.[21] The post–New Era has witnessed the rise of consumerism, the commercialization of cultural production, and the expansion of the mass media and popular culture. The populace is bombarded with the sound, images, simulacra, and messages emitted from the electronic media. The ponderous, reflexive cultural critique of the Chinese nation's "deep structure" in the style of the 1980s is largely over. On the surface, there is general depoliticization in both public culture and critical discourse. Central to the postmodernism debate is the tension between popular culture and elite culture, or the relation between consumer culture and the intellectual elite (humanists, academics).[22]

As could be expected, there is nostalgia among intellectuals for the preeminent status they enjoyed shortly before the advent of global capitalism in China. Yet they have also begun to assume new responsibilities. In distin-

guishing between the New Era (ca. 1977–89) and the post–New Era (1989–present), postmodern critics have characterized the former as the "grand narrative of enlightenment and salvation." This grand narrative continues the discourse of the May Fourth Movement. Thus, postmodernism in China is defined by the dissolution and decentering of "hegemonic discourse," whether in the form of enlightenment, humanism, or subjectivity. There seems to be an implicit celebration of the disintegration of subjectivity. Because of this, the axiology of postmodernist discourse is not entirely clear. For the postmodernists, mass culture and consumer society are ineluctable conditions in China and the modernity project is over whether or not people like it. Furthermore, the postmodern "avoidance of the sublime" (*duobi chonggao*) is apparent in the popular, cynical, irreverent, and playful stories and novels of Wang Shuo.

In response to the "Beijing postmodernists," the die-hard "Shanghai humanists" launched another type of discourse—the "humanistic spirit" (*renwen jingshen*) in 1994 by publishing their views in journals such as *Reading* (*Dushu*). In their opinion, the postmodernists had declared the death of humanism prematurely. The Shanghai humanists believe that academics should continue to stress humanism and the humanities precisely because culture has been commodified in the market economy. The humanistic spirit never died in the past and will never die in the future. Whereas the postmodernists accept (and possibly celebrate) popular culture, consumerism, and commercialization as the given condition of contemporary China, the humanists point to the importance of "concern with the ultimate" (*zhongji guanhuai*). Rather than yielding to the allure and pressure of the market economy, academics are urged to continue the pursuit of enlightenment, subjectivity, idealism, and humanist values. It should be pointed out, however, that this resurgence of humanist discourse in the mid-1990s was mostly a matter restricted to academe, a far cry from the kind of social activism embodied in the humanism and enlightenment movements of the 1980s.

Liberalism or the New Left?

Beginning in late 1997, a new debate occupied center stage, namely, the debate between so-called "liberalism" and the "New Left."[23] Whereas the ear-

lier discourses of national studies, the humanistic spirit, and postmodernism were primarily concerned with issues of culture, literature, mass media, and intellectual identity, the liberalism/New Left debate extended critical discussions into the realms of the political, economic, and social. Chinese liberalism in the 1990s embraced such traditional bourgeois principles as the market economy, human dignity, private property, individual rights, the autonomy of civil society, limited government, constitutionism, and republicanism.

The advocates drew on the Anglo-Saxon liberal tradition, appropriating the writings of John Locke, Alexis de Tocqueville, Karl Popper, Isaiah Berlin, and Friedrich A. von Hayek, and reassessed strains of liberal thought in the Chinese tradition. For example, Hayek's books, *The Road to Serfdom* and *Constitution of Liberty*, were translated into Chinese and became a source of liberal thought for Chinese readers. The journal *Gonggong luncong* (Public forum) became the leading journal of liberalism, and its chief proponents came to include Li Shenzhi (Chinese Academy of Social Sciences), Xu Youyu (Chinese Academy of Social Sciences), Xu Jilin (Shanghai Normal University), Zhu Xueqin (Shanghai University), and Liu Junning (a Beijing-based scholar). The liberals seem to focus on the interests of the new middle class—the protection of private property, the autonomy of the market economy, and the rights of citizens to participate in a democratic civil society.

In the view of the opposing camp, the New Left, Chinese liberalism really represents the interests of the nouveau riche. To the New Left, China's social and economic reality after twenty years of gradual, sustained marketization includes a new class of rich people, appalling disparity between rich and poor, endemic corruption among officials, and unfair distribution of wealth as a result of the union between multinational capitalism and totalitarian socialism. The Chinese market economy is not fair and open—the nouveaux riches are the only ones who have access to both the power structure of an opaque totalitarian system and the benefits of multinational capital. At the heart of the New Left critique is capitalism in the Chinese style. The Marxian discourse of *class* becomes a central problematic, and questions of economic inequality and social injustice come to the front. The New Left purports to represent the interests of the exploited, low, marginal classes of society. Using such terms as "politics of distribution," "politics of recognition," and "identity politics," it claims to be concerned with the rights of the

dispossessed in contemporary China. In the words of Wang Hui, a leading New Left critic, liberalism faces three main challenges:

1. Issues of ethnicity and gender and the specific demands of certain cultures and communities challenge the authority and theory of liberalism based on the individual.
2. The decline of the nation-state and global interdependence raises questions about the validity of a form of liberalism based on the unit of the nation-state. Liberalism must offer a new explanation for the guarantee of equal rights in changed national and international circumstances.
3. The Marxist economic analysis and its critique of liberalism has not disappeared but has become quite relevant in the age of global capitalism. Marxism offers an understanding of unequal relationships created by transnational capital in the areas of international politics, economics, and the military.[24]

Critics associated with the New Left include Wang Hui (Chinese Academy of Social Sciences), Gan Yang (the Universities of Hong Kong and Chicago), Cui Zhiyuan (MIT), Dai Jinhua (Beijing University), and others. Their sources of inspiration are prevalent critical theories in Western academia—Western Marxism, the Frankfurt School, cultural studies, multiculturalism, postmodernism, and so forth—acquired during frequent travel between China and the West or residence in Western universities.

In many ways, Chinese liberalism in the late 1990s continued aspects of the aborted Chinese enlightenment project in the 1980s and expanded the discourse of the "humanistic spirit" (*renwen jingshen*) movement in the mid-1990s. Most important, it carried the debate into the contested areas of the social, the economic, and the political through such issues as private property, market economy, and civil society. Ironically, opponents of liberalism accused it of being conservative because it supported the status quo and the gains of the nouveau riche at the expense of the have-nots. They also accused it of legitimizing the structure of exploitation and oppression due to the combination of totalitarian politics and capitalist profiteering. However, in the view of the liberals, the problem with the New Left's critique of capitalism was that it short-circuited the process of modernization because capital-

ism was still under development in China; thus, the New Left had supposedly missed the real target—authoritarian polity. As with one of its main intellectual sources—the Frankfurt School, which has transformed Marxism as revolutionary practice into a critical theory—the New Left supposedly offered nothing but empty theory incapable of effecting real social change in China. Paradoxically, the two sides sometimes accused each other of the same sins: conservatism and alliance with the status quo.

Globalization and nationalism, cultural radicalism and conservatism, national studies and native criticism, postmodernism and the humanistic spirit, liberalism and the New Left—these critical debates addressed the main paradoxes that Chinese intellectuals faced in the 1990s. Cultural theory and criticism in the post–New Era has developed in directions different from previous mainstream intellectual movements. These new developments have come first of all in response to the social, political, and economic changes in China after the traumatic Tiananmen Square incident; second and perhaps even more important, they are closely related to events in the global arena, or what has been called "transnational capitalism" or "global capitalism."[25] The emergence of contemporary Chinese cultural studies has resulted from formations and transformations at both the national and transnational levels. The altered position of the Chinese intellectual, or "cultural critic," was critically important in this context. What kind of new role the intellectual may play remains to be seen.

Critical debates in the the 1990s, even in their most passionate and idealistic expressions, remained largely restricted to academia, with little direct social and political impact. In all these debates and discussions there seemed to be a retreat from the previous model of the intellectual as the agent of enlightenment.[26] Intellectuals were advised not to take direct social and political action. Their new role restricted them to the academy.

As mentioned in an earlier chapter, this moment of historic change in the function of the Chinese intellectual compares to what Michel Foucault has described as the transition from the "universal intellectual" to the "specific intellectual," which happened in the West after World War II. Chinese intellectuals are in the process of renegotiating their identity under combined pressures from the market, the state, and TNCs. At the same time, they are redefining the relation between tradition and modernity, between China and

the West. As we have seen, the role of the intellectual has become a key issue. Indeed, perhaps for the first time in Chinese history, the legitimacy of the intellectual is being seriously questioned. There is a strongly felt need for, in Jameson's words, a "cognitive mapping," a critical, spatial reorientation amidst the confusions of the global postmodern culture.[27]

Given the omnipresent forces of the state and transnational capitalism, contemporary Chinese cultural critics have admirably begun searching for new identities and suitable manners of engagement. Considering the ominous economic and political constraints, the theoretical positions taken by indigenous Chinese critics become understandable. It is sometimes painfully difficult for them to make certain choices, and their decisions are ultimately brave ones. Having said this, however, it is appropriate to emphasize the *critical* function of the academy in contemporary China. As Masao Miyoshi writes, "In order to regain moral and intellectual legitimacy, scholars in TNC societies need to resuscitate the idea of opposition and resistance."[28] This statement is not only true of intellectuals in the capitalist West, but also relevant for Chinese academics as China globalizes its economy.

With changing socioeconomic circumstances in China, academics can no longer position themselves as "universal intellectuals" and subjects of history. Yet, they still have important functions to perform. The university thus becomes a crucial site for resistance in the global economy. There might still be ways for academics to "speak for the people." "We cannot represent them, nor can we be surrogates. But we can report what we know and seek to counter the information emanating from three other dubious sources: the media, corporations, and the state."[29]

"To intervene or not to intervene" is a choice that humanists face in post-New China. They must decide whether to stay in the academy and do "pure criticism" or to participate actively in social and political events that directly affect the community. It seems to me that a decision either way is bound to be one-sided. Framing the issue as an "either-or" question seems inappropriate. After all, the academy is supposed to be a space for thought and action distinct from other professions. Edward Said poses the issue in this manner: "Is there any possibility for bridging the gap between the ivory tower of contemplative rationality . . . and our own urgent need for self-realization and self-assertion with its background in a history of repression and denial?"[30] As Said suggests, "it is precisely the role of the contemporary

academy to bridge this gap since society itself is too directly inflected by politics to serve so general and so finally intellectual and moral a role."[31] In a period when transnational capital, the media, the market, and the state are poised to penetrate the entire public space, the role of the Chinese intellectual is singularly significant. It is of paramount importance to formulate plans of resistance to oppose the tide of commodification and consumerism and to find ways of mediating the local and the global, the critical and the public, and the political and the contemplative in envisioning the position of the intellectual in contemporary China.

PART TWO
Cinema

FOUR

Ermo: Televisuality, Capital, and the Global Village

COAUTHORED WITH ANNE T. CIECKO

Set in a small village in northern China, Zhou Xiaowen's 1994 film *Ermo* provides a road map of the processes of globalization and capital accumulation produced by economic reform during the Deng era. Through a deceptively simple narrative that focuses on a Chinese peasant woman, Ermo, and her struggle to acquire the biggest TV set in her county to outdo her neighbor, Zhou depicts "televisuality" as the ultimate dream and paradox of China's collective national agenda of modernization and globalization.[1]

In this chapter our analysis of the film will focus on several main levels. First, it appears that *Ermo* adopts a lingering, residual ethnographic approach to the subject of "China" typical of fifth generation directors. The film's representation of the rural, the primitive, and the exotic uses the self-orientalizing strategy of previous master texts in China's New Cinema. Second, the contemporary setting of the film, against the backdrop of economic reform and capital/capitalist accumulation central to the filmic nar-

rative, offers a critique of modernization as a national agenda during the Deng era. The self-reflexive critique of the Chinese nation is nevertheless accomplished by way of gender politics and libidinal dynamics.

Third, the story of the acquisition of a huge color TV set in a remote Chinese village can be read as an apt allegory of global televisuality in the postmodern era of electronic simulacra. *Ermo* diegetically foregrounds the interrelated issues of ownership and spectatorship. The film forcefully stages the contradictions, ironies, and uneven cultural formations between the local and the global, the native and the foreign. It is no coincidence that these layers of analysis correspond to the three basic levels of social, technological, and cultural formations in contemporary China: the premodern, the modern, and the postmodern. The coexistence of these non-synchronous, heterogeneous elements in the same space-time is a marker of the profound unevenness and hybridity characteristic of (post)modernity in a "post–third world," postsocialist country such as China.[2]

Synopsis

Ermo focuses on the quest of the title character, played by Mongolian actress Alia. Married to a sick, frail, and apparently impotent man who was once the village chief, Ermo is now the family breadwinner who supports her husband and young son, Tiger. By night, she kneads dough into twisty noodles and hangs them up to dry; by day, she hawks her wares in the village. Ermo first appears in the movie as a noodle seller crouching on the street with bunches of twisty noodles bound with red paper and crying "*mai mahua mian lou!*" (twisty noodles for sale!), which is repeated like a refrain throughout the film and is echoed by the music. Jealous competition with her lazy neighbor (nicknamed "Fat Woman"), who owns a television set, fuels Ermo, who is industrious, resourceful, and stubbornly determined. The neighbor's husband, Xiazi (nicknamed "Blindman"), an energetic entrepreneur, is the richest man in the village.

The perpetual rivalry between Ermo and Xiazi's wife intensifies, and they taunt each other about their husbands' virility and their abilities to produce sons (Xiaxi and his wife have a daughter). Ermo secretly poisons her neighbor's pig in revenge. Frequently humiliated by lack of a television set—and

Tiger's mealtime excursions next door to watch his favorite shows—Ermo vows to buy an even bigger one. She begins to accept rides from Xiazi into town, at first to sell her handwoven baskets and noodles at the street market. Later, she begins an affair with him, starts to work at the town restaurant, and temporarily moves away from her family. Motivated by the goal of earning enough money to buy the biggest television set in town, Ermo also sells her blood at a hospital and works herself to exhaustion. Learning that Xiazi has subsidized her restaurant wages, Ermo reacts defiantly by paying the extra money back to him and breaking off the relationship. Despite his wife's suspicions and rage, Xiazi sees to it that she does not learn about his fling with Ermo. After Ermo finally has enough money to buy the television set, she and her reunited family and neighbors bring it back to the village, but she is too tired to enjoy her triumph.

Signatures of "China" in Global Entertainment

From 1986 to the present, Zhou has directed some ten films, ranging from a war film, thrillers, detective stories, and melodrama, to a historical epic. However, *Ermo* is his first film released to the U.S. audience. Unique among the Fifth Generation, Zhou was primarily known as a highly successful director of urban films early in his career.[3] His detective thrillers *Desperation* (*Zuihou de fengkuang*, 1987) and *The Price of Frenzy* (*Fengkuang de daijia*, 1988), and the melodrama *The Impulse of Youth* (*Qingchun chongdong*, 1992) were box office hits in China's domestic market. Zhou was thought to have skills as an entrepreneur and as a visionary of art cinema. Yet, some of his more experimental films, such as the war story *In Their Prime* (*Tameng zheng nianqing*, 1986) and the historical/allegorical work *The Black Mountain Road* (*Heishan lu*, 1989), were never released to the Chinese public due to the vagaries of censorship. Despite his reputation within China, Zhou was not well known in the global film market.

Ermo is Zhou's first work on a rural subject, and it brought him instant international recognition. The director was forced to change his style and subject to face the reality and politics of global entertainment. China has a long tradition of urban-based films that date back at least to the 1930s, but the international art film market of the 1990s favored "primitive" rural films

when it turned to the subject of mainland China.[4] Apart from being a masterfully made film, *Ermo* shows dimensions of "China" that Western audiences understand and accept. The cinematic gaze fixes on peasants in China's backward interior, and the director in part adopts the national allegory. This self-orientalizing, ethnographic approach proved successful in the international film market.[5]

Zhou joins other leaders of China's New Cinema, such as Chen Kaige, Zhang Yimou, and Tian Zhuangzhuang, to form what we call a "transnational Chinese cinema."[6] Their works are connected to a transnational network that manufactures, exhibits, markets, distributes, and consumes "Chinese" films.[7] New Chinese Cinema orientalizes and exoticizes itself for the world market, and thus follows an international trend in transnational cinema.[8]

As for the politics and practices of representation, *Ermo*, which is based on a 1992 novella by Xu Baoqi, largely recognizes and participates in the marketing of consumable images of rural "third world" China. The movie does this by reworking images of regionalism, primitivism, and exoticism that have become not only paradigmatic and symptomatic of the Fifth Generation, but also intrinsic to global conceptions and receptions of Chinese art cinema. For example, consider one of the most striking and fetishistic examples of "Chinese" rituals—foot massage—employed by Zhang Yimou in *Raise the Red Lantern*. In *Ermo*, a unique and conscious combination of appetites can similarly be seen with the showcasing of Ermo's distinctive and erotically charged mode of making noodles with her feet. As in other Fifth Generation films, *Ermo* also has frequent long shots of the village and the surrounding landscape, particularly the dusty ridges of dirt into which crude roads have been cut.

In *Ermo*, such traditional Chinese features of the spring festival as fireworks, carnivalistic displays, and folk arts (paper cuts and so forth) enliven the "local color" of everyday peasant life—for example, Ermo's noodles are hung out to dry like the vibrantly dyed cloths of *Ju Dou*, or the bright red chili peppers of *The Story of Qiu Ju*. Furthermore, *Ermo* shares with many films of the same period a focus on the screen image of Chinese women. The film bears a striking similarity to a group of such films produced in the 1980s and 1990s as *In the Wild Mountains* (*Yeshan*, 1985), *Three Women* (*Nüren de gushi*, 1986), and *Women from the Lake of Scented Souls*

(*Xianghun nü*, 1993). All of these deal with issues and images of gender, peasant women, rural life, and modernization in the Deng era.

The most notable connection between Zhang and Zhou's films is the parallel between *Ermo* and *The Story of Qiu Ju*, something that many of *Ermo*'s reviewers have noted. An obvious intertextuality exists in terms of casting: the character of Xiazi (Blindman) in *Ermo* is portrayed by the same actor (Liu Peiqi) who plays Qiu Ju's husband; Ge Zhijun, who plays Officer Li in *The Story of Qiu Ju*, also portrays Ermo's husband. In terms of tone and genre, both films are melodramatic/comic hybrids, with absurdist contemporary social realism; in each, the narrative focuses significantly on the figure of a Chinese peasant woman and her single-minded mission. However, in *The Story of Qiu Ju*, Qiu Ju seeks retribution for the assault on her husband's masculinity, and ultimately, the restoration of the village community as extended family. *Ermo*, on the other hand, problematizes the title character's roles in the nexus of social relations—as wife, mother, and neighbor. Ermo is motivated not by a sense of justice or loyalty, but by naked greed; she is willing to work herself almost to death to achieve her goal. In both films, the women's ambitions lead to regular trips from the rural village into town, which necessitates clashes with forces of modernization in the forms of government bureaucracy and a free market economy.

Capital accumulation was euphemistically known in Deng's China as "socialism with Chinese characteristics," or as the "socialist market economy." Zhou uses the site of the rural community to provide context for the inevitable cultural disruptions that modernization causes and to present picturesque images that participate in cinematic "ethnographic" strategies. The title character of Ermo, forced to support her family, serves as an agency to reflect these tensions. Indeed, the village dramatis personae seem rather ironically typological: Ermo's husband (the "Chief"), "Blindman," his wife "Fat Woman," and even Ermo's young son "Tiger," who will continue the family line. Their names point to key personality traits—powerlessness, capitalist myopia, endless consumption, and aggression.

In Deng's China, TV was "a symbol of the success of the national modernization," and thus it is fitting that TV becomes the object of Ermo's quest.[9] Ermo's desire for the twenty-nine-inch TV set is spurred by consumer one-upmanship and humorously underscores the inadequacy of the

available models of masculinity. The biggest TV set is intended to replace the dysfunctional phallus of her husband, the former village chief, in the symbolic order.

The Libidinal Economy, Gender Politics, and Capital Accumulation

Ermo unsettles gender politics by recognizing the relationship between money and power, satirizing conventional notions of masculinity and femininity, and revealing the corrupting influence of Western popular culture. Gender roles are switched. This change is demonstrated through the dialogue, as well as through visual representation. Ermo's husband at one point asks her "Why can't you act like a woman?" to which she retorts, "Why can't you act like a man?" (Athough her husband repeatedly tells her that a house is a chicken, and that a TV set is an egg, the emerging modern Ermo rejects his folk wisdom.) Ermo fulfills her roles as wife and mother in a perfunctory manner; her central motivation and values come from a spirit of competition at odds with traditional notions of femininity. In *Ermo*, capitalist entrepreneurship is inextricably linked to catalytic and paradoxical effects related to the dynamics of male/female relations and sexual exchange.

The film employs ironic juxtapositions to illustrate this linkage. Initially, Ermo's manner of capital accumulation is ostensibly rather primitive and premodern as she prepares twisty noodles in her home. In contrast to Ermo, who has steely determination and high energy, her husband is unable to do any heavy manual work. Their neighbor Xiazi, his wife, and their daughter appear to offer the exact asymmetry in libidinal, physical, and economic conditions. As the richest man in the village, Xiazi owns a truck and thrives on his trade between the village and the town—although he tells Ermo, "Money's no use without a son." His wife stays at home and plays the role of the domestic housekeeper, albeit one most often seen munching pickled eggs and other snacks. (In fact, she is rather unkindly linked to the pig that Ermo secretly poisons.)

In contrast to Ermo's husband, the bedridden, emasculated former village head, Xiazi, is sexually active, gets Ermo a job in town, and eventually

FIGURE 1. Ermo and Xiazi (Blindman) eat at the "International Restaurant" in *Ermo*. Courtesy of British Film Institute.

succeeds in seducing her. Thus, capital equals libido. Ermo begins to respond sexually to Xiazi when she has had a "taste" of the world outside her village and the things that money can buy—if the consumer can afford them: an extravagantly bountiful meal at a restaurant; a 500 yuan payoff for a hapless peasant whose donkey is sideswiped by Xiazi's truck; and most importantly, the prized model in the town department store's captivating display of TV sets.

The exposure to television and Ermo's increasing sense of self-identity as a consumer seem to have an effect on her sexuality, turning her "on." When her neighbor makes his first brusque physical advances toward her in the cabin of his truck, she resists, but then begins to peel off her many layers of clothing and seems to reciprocate his desire. Later, she becomes a kind of parody of a kept woman, as she moves to town to take the restaurant job and to earn more money to buy the TV set. At first, Ermo appears to participate fully (if somewhat unwittingly) in her crude sexual awakening. After the consummation of her relationship with Xiazi in the cabin of his battered truck, Ermo is roused in fear and wonderment at the spectacle of a sleek,

shiny white Ford parked in front. (China awakens to Fordism!) When Xiazi meets her in a seedy hotel for a sexual liaison, he presents her with a gift of wrinkle cream to keep her from getting as "slack-assed" as his wife. He slathers it generously all over her face and back as Ermo reveals a gaudy "city girl" brassiere she has bought. However, Xiazi's discovery of the bruises on Ermo's arms, made from selling her blood, forces a confrontation. Xiazi wants to support Ermo and worries that she will ruin her health, but he is unable to summon the courage to leave his wife.

Realizing that Xiazi has subsidized her restaurant job wages, Ermo asserts that she is not a whore. However, she has definitely changed. Xiazi's wife notices that Ermo's skin smells nice and is "whiter." The ironic implications of this observation in light of her development as a capitalist (not to mention adulterous woman) are obvious: Ermo has literally become whiter because of her consumption of consumer products.

Despite the Confucian code of ethics, which presumably guides the lives of the peasants in Ermo's village, Ermo does not seem burdened by guilt over her malicious poisoning of the neighbor's pig or her adulterous relationship; nor is she especially loving or maternal in interactions with her son and family. Rather than implying that Ermo has sold her soul for the smell of new money, the film suggests from the start that she is motivated by material gain and constantly lingers on her lack of affect (and the effect of lack) when it comes to family matters. The twenty-nine-inch TV vindicates her lack of "phallus." Ermo, like China, is ripe for capitalism.

During one visit home, Ermo brings her husband and son matching Western-style, crisp white cotton button-down shirts. When she purchased them at the clothing market, the display featured cardboard heads of Caucasian models. As she opens the packages, her husband and son stand before her, both shirtless. Her husband's skinny torso and sunken chest make him seem even more helpless. As a silent and expressionless Ermo dresses her family, she demonstrates a knowledge and power gained from the purchase of and exposure to consumer goods. Her husband is further, and rather pathetically, emasculated as she helps him button up his collar and he pulls out a piece of cardboard, wondering if it's some kind of joke.

Throughout, the film suggests that the traditional Chinese medicines Ermo administers to her husband are supposed to restore potency, but that the process will ultimately be futile. As Ermo massages her husband's

FIGURE 2. Ermo in *Ermo*. Courtesy of British Film Institute.

back with a large heated stick, and as the "Chief" sits wrapped in a floral blanket while his wife works outside, his masculinity is continually undermined.

Ermo's nocturnal ritual of kneading noodle dough with her feet is therefore represented as a displaced expression of female sexuality, and Zhou deliberately films these sequences as a kind of fragmented and elliptically masturbatory experience. Close-ups of Ermo's perspiring face and her preternaturally expert feet highlight Ermo's intense engagement with the work and with other, unseen movements of her body, which are accentuated by jump-cuts. Frustrated by her husband, whom she must constantly nurse by cooking medicines, massaging, and so forth, Ermo recognizes her position as "breadwinner" in an earthly eroticized fashion. (After she starts bringing home substantial amounts of cash, she also enjoys counting her money in bed.) She regularly rises from her place in bed between her husband and son to experience some measure of liberation and pleasure through manual work. In Zhou's representations of the woman at work and the repeated

images of the dough being squeezed and shaped into long, thin twisty noodles, Zhou foregrounds the notion of the doubled eroticization/exoticization of the "primitive"—in terms of the peasant woman's sexuality and the traditional mode of noodle production.

Ermo's incredible industriousness and creative corporeality, which are at times at odds with modernization, complicate her "premodern peasant" status. For example, when a mixing machine in the town restaurant (ironically called the International Grand Restaurant) severs a male coworker's hand, Ermo improvises a more domesticated version of her foot kneading in the restaurant's kitchen. When she discovers that she can make "blood money"—Ermo's logic is that women lose their blood anyway—she devises a subversive and ultimately self-destructive scheme whereby she can make repeated visits in the same day after drinking bowls of saltwater. Her entrepreneurship has vampiric consequences on her body, as Ermo becomes quite literally drained by obsessive efforts to make more money. She increasingly tires to the point of final collapse and loss of consciousness after she has achieved her goal of aquiring the television set, the fruit of her labor. Ermo's absence of pleasure is the most explicit critique of the effects of modernization and capitalism. Thus, as Tony Rayns has suggested, the film asks, "What . . . is the true nature of *satisfaction* in present-day China?"[10]

The narrative structure of the film foregrounds the conflict between Chinese premodern rural life and the forces of modernization. A natural extension of the conflated libidinal/economic dynamic leads Ermo to begin taking rides into town with Xiazi: to avoid "wasting" her labor, she initially sets out to find a wider market for the handwoven baskets she has made all winter. Ermo's repeated cry, "*mai mahua mian lou!*" frames the film and is the sound counterpart to its final image: static on a television screen. The "snow" represents not only the absence of televisual image, but also the emptying out of meaning—a vacuity enhanced by Ermo's blank waking gaze, which is absorbed into the television frame.

Spectatorship and Frames of Vision

Throughout the film Zhou presents the view through the windows of the humble home that Ermo and her husband share as a kind of proto-TV, and

the shape of that screen, the fetish-object, largely frames the viewers' field of vision. One shot early in the film captures Ermo and her husband looking out onto their neighbor's home as masses of villagers vie for a place in line to look at Blindman's television set. The images of Ermo and her husband are framed as if on a television screen, a commentary on the "materialization" of Ermo's desire. "Let's buy a TV for the boy," she tells her husband. As Ermo looks out, her own son Tiger is one of the lucky spectators gathered outside her neighbors' home.

Television is signaled early on as a symbol of Ermo's restlessness and the effects of modernization. The film contains several shots of the village at night, the silence broken by the sounds of her neighbor's TV set. Yet the TV also becomes an ironic mode of community building and perpetuating the extended family. (Socialism with Chinese characteristics?) Children crowd around, attracted by its lure. When Ermo's family finally purchases and brings home its own monumental color set, their home is filled with curious peasants. Ermo's ex-chief husband even suggests that the family fill its small house with children's benches to accommodate schoolchildren (although this gesture provides even more discomfort for the family). Acquiring the television set somehow seems to bond the feuding neighbors. As Ermo and her rival ride together into town with their husbands to purchase the television set, Ermo's neighbor suggests that their children marry some day, which will officially fuse their families.

However, the film continually spoofs the inevitable impact of TV on Chinese culture. At the end of the film, the TV set in Ermo's home takes the literal place of the shared family bed; and as Ermo's noodle strainer becomes a makeshift television antenna, it appears that she has lost her livelihood as well.

As the villagers and Ermo's family watch indiscriminately whatever appears on the set, the rather ludicrous pervasiveness and irrelevance/decontextualization of American popular culture is illustrated. For example, the first broadcast witnessed on the brand-new set is an American-style football game. One of the peasant spectators perceives the televised scene as some sort of battle until a more worldly neighbor chides him, explaining that it's actually a sport: basketball. In fact, throughout the film the images transmitted on television are never purely "Chinese." The medium is indeed a vehicle for capitalist ideology, as well as a source of entertainment. Television

influences the reshaping of the community, the family, and individual lives through the spread of Western popular culture; it also marks the elision or erosion of indigenous folk traditions.

Ermo repeats images of spectatorship throughout and connects them with consumer desire and ownership within the contexts of the town store and the family home. When Ermo first sets her sights on the "biggest" television set and stakes her claim, she needs evidence that the set works. The sales clerk tells her that she must pay first. Ermo worries that continual usage (and, in turn, constant spectatorship) will drain the set of power. (Indeed, Ermo's first glimpse of a softcore love scene dubbed in Chinese is followed by a power failure that shuts off the TVs.)

As Ermo enters the store after finally accumulating sufficient capital to make her purchase, the camera assumes her point of view, zeroing in on the desired TV in the multiset display. Holding her bundle of bills and flanked by her husband and Blindman, Ermo can finally lay claim to the power to turn the set on and off. Fittingly, after purchasing the set, Ermo insists that the consumer label be left on, fearing that the TV may not work, thus reflecting in her logic the way she has participated in the nexus of production and consumption.

At first shocked by the presence of what she can only identify as "foreign language" on TV in China, Ermo increasingly marvels at the precision of the televisual illusion, as she can see every strand of the foreigner's hair. However, it hardly matters exactly what appears on the screen—from aquaexercise demonstrations to English-language lessons—TV teaches Ermo how to be a good capitalist.

Televisuality and Global Postmodern Culture

The popularization of TV was one of the most visible symbols of social and economic reforms during the Deng era (1978–96). "In 1978, there were 1 million TV sets in China. [In 1996,] there were 232 million."[11] Ermo's struggle to acquire the biggest TV set in her county is an allegory of the pursuit of wealth throughout the entire country. The steady diet of foreign soap operas in Chinese TV programming was also a sign of China's opening to global culture. American TV series aired in China since 1979 include *Man*

from Atlantis, Hunter, Falcon Crest, Remington Steel, Matt Houston, and *Dynasty. Dynasty* was supposedly Deng Xiaoping's favorite.[12]

In the short span of twenty years China has moved from being a predominantly agricultural and preindustrial society to standing at the doorway of the postindustrial club and is fast approaching the age of simulation. According to Jean Baudrillard, "three orders of appearance" have existed in human history since the Renaissance. *Counterfeit,* based on the natural law of value, was the dominant scheme of the classical period from the Renaissance to the Industrial Revolution; *production,* based on the commercial law of value, dominated the industrial era; and *simulation,* which is controlled by the code and based on the structural law of value, is the current reigning scheme.[13]

As shown in the film, China arrived too suddenly at the third stage of simulacrum, simulation, as if it had leapfrogged other stages of historical development. The film thus depicts a clash between the forces of the preindustrial and the postindustrial and creates collision and cohabitation between various orders of simulacra: counterfeit, production, and simulation. This process is also masterfully evoked in certain works of visual art, say, Nam June Paik's by now classical installation *T.V. Garden* (1982), which places TV sets (the postindustrial, the urban, and the social) amid green plants (the agricultural, the rural, and the natural).

As Ermo's family lies sleeping at the end of the film, the TV set continues to play, broadcasting images of a titillating romantic scene from an American nighttime soap opera—appropriately enough, a frothy shower scene. This is a love scene from *Dynasty,* a genre of American TV series known for its "excessive style."[14] The episode ends as the female protagonist urges her adulterous male lover to "have more fun." However, the irony of the discourse of pleasure is lost on Ermo and her dozing, oblivious family. At the end of the film, China Central TV (CCTV) concludes a day's broadcast by reporting the weather of the major cities of the world: London, New York, Tokyo, Cairo, Bangkok, and so forth. The whole family has fallen asleep, unresponsive to the TV images. The relation between the global and the local is questioned. Contrary to the promise of instantaneous communication through electronic media in McLuhan's "global village," what happens is a breakdown of communication in the postmodern age.[15]

The film embodies uneven and overlapping modes of production in

Deng's China: the premodern (primitive manual labor), the modern (motorized vehicles, the truck, mechanized production of twisty noodles, electricity, "Fordism" as revealed in a glimpse of the shiny white Ford), and the postmodern (electronic simulacra, antenna, television). The coexistence of these various technological and social forces propels the desires of the protagonists and brings out the contradictions of the Deng era within the narrative frame of the film. The final entrance of Ermo's family into the world of global televisuality at the end of the film reveals the ironies and paradoxes embedded in the process of globalization. On the one hand, the televisual images of foreign lifestyle (soap opera, soft porn dubbed in Chinese) attract the attention of Chinese peasants and townspeople and seem to offer an alternate way out of the drab, daily routine of their existence while inviting them to join a "brave new world" of fun and fulfillment. On the other hand, the daily weather report from world capitals on CCTV does not relate to the life of ordinary local villagers in a meaningful manner, but rather induces them to sleep. At that point, the global homogenization of cultural production and consumption meets serious, stubborn resistance at the local level of a post–third world nation-state such as China. The ultimate question to be raised, after all, is what happens if the ethnic subject in a (self-)ethnographic film does not return her gaze at global televisuality?

The twenty-nine-inch TV set is both the material and symbolic embodiment of Deng's slogan "to get rich is glorious." Yet, the "snow," the blank screen at the end of the film, becomes an index of a problematic, pervasive, existential, and ideological emptiness as a result of the kind of economism and pragmatism of the Deng era, which was the opposite of the extreme "culturalism" of Mao Zedong, as seen in movements such as the Cultural Revolution. The tired, dispirited Ermo and the TV static annul the meaning and joy of her blind capitalistic pursuit of material objects. As the film begins with Ermo's cry of noodle selling and ends with the musical refrain of her cry, the narrative comes full cycle. In such a manner, *Ermo* questions the goals, processes, and results of one-sided modernization and capitalism. At the same time, the instantaneous introduction and airing of foreign TV programs in the postmodern age of communication appears to fill a domestic void, a cultural and ideological need. Thus, the remote post–third world Chinese village becomes a global village. Its televisual culture most vividly stages the disjunctions and contradictions of a global postmodern culture.

Zhou Xiaowen Filmography

In Their Prime (*Tamen zheng nianqing*). 1986.
Desperation (a.k.a. *The Last Frenzy*, *Zuihou de fengkuang*). 1987.
The Price of Frenzy (a.k.a. *Obsession*, *Fengkuang de daijia*). 1988.
The Black Mountain Road (*Heishan lu*). 1989.
No Regrets about Youth (*Qingchun wuhui*). 1991.
The Impulse of Youth (*Qingchun chongdong*). 1992.
The Trial (*Xialu yinghao*). 1992.
The Lie Detector (*Cehuang qi*). 1993.
Ermo (*Ermo*). 1994.
The Emperor's Shadow (*Qin song*). 1995.

FIVE

Diaspora, Citizenship, Nationality: Hong Kong and 1997

Narratives of the Nation-State

As a century and a half of British colonial rule ended in Hong Kong and ownership of the island returned to mainland China on July 1, 1997, the media in the Chinese-speaking world geared up to celebrate, relish, and comment about the event. There was no lack of visual, televisual, filmic, and artistic representations of Hong Kong's past and present. Outside Hong Kong, the motherland itself most conspicuously glorified its return to China. In the realm of cultural production and consumption, Hong Kong's changing status became the main theme in the summer of 1997. The Hong Kong story monopolized TV programming as a flood of related soap operas aired on TV channels across the nation or were hurried into production.[1] The provinces and major cities marked this historic occasion by producing and staging performances, concerts, TV programs, art exhibitions, and plays.[2]

In commemoration of Hong Kong's reversion, two large-scale films produced in China were advertised and screened around the handover day. These were the much publicized *The Opium War* (*Yapian zhanzheng*), by the veteran director Xie Jin, and *The Red River Valley* (*Honghe gu*), directed by Feng Xiaoning and starring Ning Jing. The lavish, expensive epic film *The Opium War* recounts events that led to the Opium War in the mid-nineteenth century and to the Qing Empire's subsequent loss of Hong Kong to Britain. As could be expected, the hero of the film is Commissioner Lin Zexu, who was determined to stop the opium trade by seizing and destroying all British opium in China.

The new production calls to mind an earlier film on the same subject, *Commissioner Lin* (*Lin Zexu*, directed by Zheng Junli and Cen Fan), made in 1959. In mainland textbooks and history books, the Opium War marks the beginning of modern Chinese history. In *Lin Zexu*, the peasant uprising in Sanyuanli at the end of the film inaugurates the beginning of Chinese resistance to imperialism and the revolutionary struggle that ultimately culminated in the founding of the People's Republic in 1949.[3] Indeed, a relief on the Monument of People's Heroes at the heart of Tiananmen Square immortalizes this foundational event as the beginning of a century of struggle for liberation by the Chinese people. Facing the monument at Tiananmen Square is the Museum of Chinese History and Revolution, where a huge clock was installed in the 1990s to count down the days, hours, and seconds in anticipation of the handover on midnight, June 30, 1997, exactly ninety-nine years after China and Britain signed the treaty that leased the New Territories to Britain.[4] This unilinear, teleological concept of modern Chinese history based on the sovereignty of the nation-state is thus most concretely embodied at the heart of Beijing's political space—Tiananmen Square.

The timing of the release of *The Red River Valley* was also carefully coordinated with the handover, for the film narrates the story of Chinese/Tibetan resistance to British imperialism in another part of China—Tibet.[5] The film depicts how the Tibetan people fought the attempt of the British to occupy Tibet and separate it from China early in the twentieth century. The feature reaffirms the status of Tibet as a member of the large Chinese family of nationalities. (It was not without some irony that the famous lead actress of the film, Ning Jing, who portrayed a proud Tibetan princess on

screen, fell in love offscreen with American actor Paul Kersey, who played the role of a young British officer, married him, and emigrated to the United States.) After watching *The Red River Valley*, the viewer is reminded of another film classic from the People's Republic of China (PRC), *Serfs* (*Nongnu*, 1963, directed by Li Jun), in which the Han and its revolutionary government are positioned to liberate the Tibetan people from their repressive theocratic regime and backward customs.

It is interesting to contrast these mainland-produced epics with several highly publicized Hollywood productions on the subject of "China" and "Tibet" released in 1997. The release of two features, *Seven Years in Tibet* and *Red Corner*, which star Brad Pitt and Richard Gere respectively, was orchestrated to coincide with the state visit of Chinese president Jiang Zemin to the United States. Martin Scorsese's *Kundun*, a biopic of the Dalai Lama, offers another take on the issue of Tibet. Although these Hollywood films and the Chinese examples discussed previvously were diametrically opposed to each other in ideology and representations of history, their points of departure were based on the same notions of fixed territoriality, sovereignty, and nationality.[6]

Within Hong Kong, there was also a sense that a new historical era had dawned. The integration of Hong Kong into China demanded new perspectives in ways that Hong Kong represented itself in terms of cultural production and reception. For instance, the joint production of the epic film *The Soong Sisters* (*Songjia huangchao*, directed by Cheung Yuen-ting) covers a span of several decades and depicts the political triangulation of the mainland, Taiwan, and Hong Kong as the three Soong sisters, who drifted apart and settled in three different parts of China after 1949. The eldest sister, Soong Ailing (Michelle Yeoh), and her husband lived in Hong Kong; the second sister, Soong Qingling (Maggie Cheung), the widow of Dr. Sun Yat-sen, stayed on the mainland; and the youngest daughter, Soong Meiling (Vivian Wu/Wu Junmei), wife of Chiang Kai-shek, moved to Taiwan.

Needless to say, national and cultural affiliation has been the most problematic and important issue among Hong Kong residents, for they have lived without a proper nationality, being neither Chinese nor British. Until the handover, most residents of Hong Kong had been denied British citizenship, yet were ruled by the British. The mainland claimed them as its subjects in theory, but played no part in the daily administration of the city.

Even worse, residents of Hong Kong had no say in negotiations between China and Britain that led to the Sino-British Joint Declaration. Was there some guarantee for the autonomy and self-governance of Hong Kong? Was there any substance to such official slogans as "Hong Kong people govern Hong Kong"(*Gangren zhi Gang*), "no change in fifty years" (*wushi nian bubian*), and "one country two systems" (*Yiguo liangzhi*)? What did Hong Kong residents themselves want?

While awaiting the return of Hong Kong to China, how did the average mainland Chinese citizen feel about Hong Kong? What did Hong Kong mean to her or him on a private, personal, subjective level? It is no coincidence that one of the most popular songs in China during the 1990s was Ai Jing's 1993 song "My 1997"(*Wo de 1997*). The lyrics and music of this pop song captured the hearts of mainlanders in ways that official pronouncements could not. To the individual, 1997 meant the following in the words of the songstress:

> When will it be possible to go to Hong Kong without a visa and a stamp
> Let me go to this dazzling world give me a stamp
> . . .
> 1997 please come quickly! What does Yaohan look like?
> 1997 please come quickly! So I can go to Hong Kong
> 1997 please come quickly! So I can stand in Hung Hom Coliseum
> 1997 please come quickly! So I can go with him to see the midnight show
> 1997 please come quickly! So I can see how the clothes in Yaohan are actually like
> 1997 please come quickly! So I can go to Hong Kong
> 1997 please come quickly! So I can stand in Hung Hom Coliseum
> 1997 please come quickly! So I can go with him to see the midnight show[7]

For Ai Jing, evidently, Hong Kong represented a "dazzling world" of department stores, beautiful clothes, night concerts, and fun; and 1997 would be the time when mainlanders could travel freely to Hong Kong "without a visa and a stamp" to enjoy all the things that Hong Kong had to offer. Ironically, the border between Hong Kong and the mainland remained in place after the transfer and traffic between the two was as strictly controlled afterward, although Hong Kong had technically become part of China.

Beyond and beneath the sweeping, grand narratives of unity and sovereignty existed more engaging, noteworthy, localized, small stories of diaspora and displacement. The teleological reading and representation of Chinese/Hong Kong history as a series of losses and recoveries eclipses the private drama of individuals in their daily existence and the formation and deformation of their identity and subjectivity. In this chapter I wish to examine a fluid, deterritorialized, transnational, and mobile mechanism of national affiliation as opposed to the idea of a fixed, territorial, homogeneous, sovereign nation-state. This conception of flexible filiation bespeaks a process of decontextualization and recontextualization of citizenship, nationality, and residence.[8]

In the following pages I will focus on two films about the private lives of ordinary Hong Kong citizens: *Comrades, Almost a Love Story* (*Tian mimi*), by Peter Chan (*Chan Ho San*), and *Happy Together* (*Chunguang zhaxie*), by Wong Kar-wai. *Comrades, Almost a Love Story* has won numerous awards. It took nine prizes at the 1997 Hong Kong Film Awards, including best film, best director, best actress (Maggie Cheung), best supporting actor (Eric Tsang), and best script. In 1997, the Golden Horse Award in Taiwan gave it an award as best picture and recognized Maggie Cheung as best actress. For his work on *Happy Together* Wong Kar-wai won the award as best director at the 1997 Cannes Film Festival.

Comrades, Almost a Love Story

Comrades begins with the arrival of male character Xiaojun (Leon Lai Ming) at the Hong Kong train station in 1986. A native of Wuxi, Xiaojun finds Hong Kong an entirely new, unfamiliar world. (Leon Lai, a popular singer-actor who originally came from mainland China, portrays Xiaojun.) His aunt takes him to her boarding house and finds him a job as a food delivery boy in a Chinese restaurant. His dream is to save enough money to bring his fiancée, Xiaoting, to Hong Kong. One day, while eating at the McDonald's restaurant, Xiaojun meets Li Qiao (Maggie Cheung), a waitress conversant in Mandarin and Cantonese. Li Qiao comes from Canton (Guangzhou), but because of her ability to speak Cantonese, she at first pretends to be an indigenous Hong Kong resident. Newly arrived poor mainlanders are often regarded as second-class citizens in Hong Kong.

FIGURE 3. Maggie Cheung as Li Qiao in *Comrades, Almost a Love Story*. Mei Ah Laser Disc Co., Ltd.

The friendship between the two lonely, dislocated mainlanders develops and deepens. Xiaojun still dreams of bringing his fiancée from Wuxi to Hong Kong some day, but Li Qiao's ambition is to become a rich lady at the top of society. The two emigrants share enthusiasm for the songs of Taiwanese singer Deng Lijun, who was perhaps the single most popular singer on the mainland. While in Canton, Li Qiao was able to sell enough tapes of Deng's songs to make a small fortune. They now decide to do the same in Hong Kong, but their efforts prove disastrous. For a Hong Kong resident to confess his/her love of Deng Lijun and buy her tapes is to reveal his/her lowly mainland origin.

Wanting to become rich, Li Qiao invests in the Hong Kong stock market, but in one stock crash she loses all her savings. To pay her debts she becomes a masseuse in a massage parlor. As time passes, Li Qiao falls in love with one of her clients, Baoge (Brother Bao, played by by Eric Tsang), a boss in the Hong Kong mafia, and the two eventually get married.

In 1990, Xiaojun realizes his longtime dream: he brings his fiancée, Xiaoting, to Hong Kong. The marriage turns sour quickly, for time has proven that the love between Xiaojun and Li Qiao is stronger than that of

the newlyweds. Xiaojun leaves his wife just as Li Qiao is about to separate from her husband. Yet because Baoge is in danger, Li Qiao decides to stay with him, and they leave Hong Kong to escape the police.

In 1993, Xiaojun becomes a chef in a Chinese restaurant in New York City, where Baoge and Li Qiao also reside. However, the murder of Baoge in a New York street changes the lives of everyone again. By 1995, Li Qiao has received her green card, works as a tour guide in New York City, and often takes tourists to the Statue of Liberty. With the security of an American green card, Li Qiao wishes to visit her home in Canton, from which she has been absent for so long. Among tourists at the Statue of Liberty are wealthy ladies from the People's Republic of China, who want Li Qiao to take them to department stores to buy "Gucci bags." They tell her that her homeland has changed tremendously, that overseas Chinese now find it easier to make money in China, and that many of them have gone home.

On May 8, 1995, news of Deng Lijun's death is broadcast. Li Qiao and Xiaojun have not seen each other for years, but both pass by and stop at the same time at the window of a TV store in a New York street to watch news of the life story of Deng Lijun. As they turn their heads, they recognize each other and meet again. Ten years have passed since their initial encounter. Deng Lijun's endearing, enchanting song "Sweet Love" (*Tian mimi*), also the original Chinese title of the film, plays on the movie's sound track. The last segment of the film flashes back through time, ten years before. In a black-and-white sequence, Xiaojun and Li Qiao sit on the same train from China to Hong Kong, unaware of each other's presence. They sit back-to-back, their heads almost touching each other, dozing off and dreaming as the train arrives at its "destination": Kowloon Station.

In contrast to the grand discourse of national unity and Chinese sovereignty that surrounded the handover of Hong Kong, this small melodrama seems to suggest a more ambivalent relationship between ethnic Chinese and their home country. Contrary to the solid anchoring of the self in the soil of some nation-state, the film depicts a state of perpetual diaspora and displacement. Although the two mainlanders, Xiaojun and Li Qiao, leave China for Hong Kong in pursuit of happiness, it soon becomes clear that they are not comfortable in Hong Kong, either. At the end of the film, they drift to New York, an entirely foreign land, to start new lives. Ironically, it is the security of a green card that allows Chinese citizens to travel more freely

and to return to their home country. Yet, even in eternal diaspora, "China" looms large in their lives, perhaps not in the narrow sense of the modern sovereign nation-state, but in the realm of private, emotional attachment, as revealed, for instance, in their love for the songs of Deng Lijun. The popular, deterritorialized, pan-Chinese songs of a Taiwanese singer—more than the national anthem—unites ethnic Chinese and Hong Kongese into some sense of communal bonding. As the TV broadcast states, there is a Chinese saying: "wherever there are Chinese people, you will hear the songs of Deng Lijun."

Earlier in the film, as Xiaojun rides happily in the streets of Hong Kong to deliver food, the Chinese national anthem plays loudly and at full length. The episode points to his early, unproblematic identification with China. However, subsequent events in the story shatter this cultural and national security as he is forced to renegotiate his own identity.

For Hong Kong director Peter Chan, making the film necessarily entailed a process of self-discovery. In an interview, Chan stated that in the past he would have found it impossible to make a story about the collision of values and cultures against the background of the nation-state, for Hong Kong was merely a city, not a state. Hong Kongese did not feel that they belonged to any country. The issue of belonging to a nation, with a national flag and a national anthem, became important with the approach of 1997. However, national affiliation did not solve the crisis of identity. A sense of rootlessness still defined the existential, emotional condition of the ordinary Hong Kongese. Hong Kong has served as the transit point for all Chinese bound for different parts of the world. To find a "home," the characters in the film needed to go a long way. Neither the mainland, nor Hong Kong, nor New York City was the ideal homeland. The immigrants felt Chinese in their hearts without the benefit of Chinese citizenship. The story of the two immigrants in the film is thus the story of every Hong Kongese.[9]

Indeed, the film is also indirectly an allegory of the relationship between Hong Kong and China. The love-hate relationship of Hong Kong to the mainland has been "almost a love story." The ostensive identification of Hong Kong residents with the fate of the mainland is all too touchingly evident in recent history. Hong Kong was a main supporter of the student democracy movement in the spring of 1989. One million Hong Kong residents took to the streets to show solidarity with the students in Tiananmen

Square. In addition, the people of Hong Kong donated funds generously to relieve the flooded areas of southern China in 1991.

Emphatic, temporal markers of history appear in the film as numbering for the years 1986, 1987, 1993, and 1995 directly projected onto the screen. The ten-year span within the diegesis falls into a period of Chinese and Hong Kongese history between the signing of the Sino-British Joint Declaration in 1984 and the handover in 1997. The filmic approximation of the real is nevertheless narrated through the private world of ordinary Hong Kong residents, not by invocation of world-historical, public events, as done by other films on Hong Kong.

Within the film, love is as strong and indestructible as it is fleeting and dislocated. Xiaojun's aunt lives with the memory of her elusive past love affair with William Holden, who portrays the hero in the 1955 film *Love is a Many Splendored Thing* and the 1960 film *The World of Suzie Wong*, both shot in Hong Kong. A white tenant in the house, portrayed by none other than the famed cinematographer Christopher Doyle, falls in love with another tenant, a prostitute from Thailand. He contracts AIDS from her, and both must move out. The differences between these orientalist interracial romances—between a Eurocentric, idealized past and the harsh present always endangered by life-threatening diseases such as AIDS—indicate how times have changed. The marriages and partnerships in the film do not last long. Thus, it is even more remarkable to see a possible reunion between the hero and heroine at the end of the story.

Happy Together

If *Comrades, Almost a Love Story* was a local hit, Wong Kar-wai's *Happy Together* was an international success that once again put Hong Kong on the map of world art cinema. As recipient of an award for best director at the 1997 Cannes Film Festival, *Happy Together* has been much discussed in Hong Kong film circles.

The film narrates the South American adventures of two Hong Kong citizens. Lai Yiu-fai (Tony Leung Chiu-wai) and Ho Po-wing (Leslie Cheung) are two gay lovers who set out to visit Iguazu Falls in South America. The opening shot of the film zooms in on their travel documents, which state "British

FIGURE 4. Leslie Cheung and Tony Leung in *Happy Together*. Mei Ah Laser Disc Co., Ltd.

nationality." As we know, British officials granted Hong Kong residents the right to travel freely to most countries, yet they were not allowed to become permanent residents of Great Britain. The uncertainty of national identity for the Hong Kongese is foregrounded at the beginning of the film narrative.

Unable to carry out their planned trip, the two characters settle in Buenos Aires. Lai becomes a doorman in a tango bar while Ho is entangled in affairs with Latin male lovers. Their difficult, intense relationship ends and resumes as they drift in Argentina. In the middle of the film, they break up and separate. Lai meets and befriends Xiao Zhang (Zhang Zhen), a young man from Taiwan who works in the same Chinese restaurant as a dishwasher. Xiao Zhang is uninterested in women and remains single. (For instance, he declines a date proposed by a fellow Chinese female coworker at the restaurant, and later in the film declines the invitation of a Latin woman to dance in a bar.) After parting with Lai, he travels alone to a lighthouse at the most southern point of the South American continent.

The film accentuates the inability of the Chinese to assimilate in Argentinian society. There is no real contact between the Chinese and the Argentinians, who sometimes appear only in the background. For instance,

one pastime of the Chinese youths is to play soccer among themselves under moonlight. There seems to be no effort on their part to mingle with and to engage the local people in their lives. The migrant Chinese seem to be cultural misfits and sexual mismatches always on the move.

Toward the end of the film Lai saves enough money to leave Buenos Aires and return to Hong Kong. However, before going home, he decides to stop in Taipei. On Liaoning Street in Taipei he discovers the food stall of Xiao Zhang's parents and sees the pictures he has taken at the lighthouse in South America.

Liaoning is not simply a street name, but also refers to a province in northeast China. Thus, one Taipei street maps the geopolitical imaginary of the Chinese nation, just as the Republic of China in Taiwan proclaims itself the only legitimate sovereign Chinese state. In this manner the street sign points to both the unity of the Chinese nation and its fragmentation. The evocation of such a fragmented collective further heightens the sense of displacement among ethnic Chinese across the mainland, Taiwan, Hong Kong, and various continents.

If Liaoning Street is an index of geopolitical dislocation, the other significant reference to history is February 20, 1997, when Lai learns on TV about the death of Deng Xiaopeng, the architect of Hong Kong's return to China. Deng Xiaoping also attempted to lay the groundwork for the eventual unification of Taiwan and China according to the Hong Kong model by proposing the concept of "one country, two systems." (The offhand, oblique reference to history and the absence of direct representations of public, historical events contrasts notably to epic productions in the fashion of Xie Jin's *The Opium War* and Feng Xiaoning's *The Red River Valley*.) However displaced and scattered on the edge of the world, the migrant Hong Kongese is nonetheless linked to China in real or imagined space and time through such devices as Liaoning Street and the death of Deng.[10]

The sound track and musical motif have been significant structural elements in Wong's films. *Happy Together* overtly alludes to a tradition of Western music and art film. The Chinese name of the film, *Chunguang zhaxie*, which may be loosely translated as *The Light of Spring*, is the same as the Chinese title given to Antonioni's *Blow Up* when it was screened in Hong Kong. Antonioni based his film on the script of Argentinian writer

Julio Cortazar. Wong jokingly stated that he decided to shoot the film in Boca, Argentina, with the hope of meeting Madonna, who was making *Evita* there at the same time. Latin tango music is heard throughout the film. Argentinian musician Astor Pantaleon Piazzolla composed the opening and closing tracks, "Tango Apasionado" and "Milonga for Three," respectively. Other tunes include "Cucurrucucu Paloma," by Caetano Veloso. The movie includes live recordings made at local pubs Bar Sur and Three Amigos. Frank Zappa's "Chunga's Revenge" and "I Have Been in You" are also played, although both are rearranged versions by Danny Chung.[11]

The film's sound track concludes with "Happy Together," a 1967 song by the Turtles, replayed by a Hong Kong band. Hence the film's English title. As the ill-fated, tumultuous love affair between Ho and Lai "ends" many times, Lai often finds courage in Ho's catchphrase "Let's have a new beginning." Lai's inspiration to start new relationships is thus revealed as a cavalier attitude toward the future. As Wong Kar-wai confesses, his films are about communication among human beings.[12]

Happy Together exhibits some of the same stylistic characteristics in terms of camera work, music, and narrative as Wong's earlier films, especially *Chungking Express*. The sound track, whether Latin American music or the lyrics of Frank Zappa, serves to create an atmosphere or connect elements of the plot. Part of the film was shot in black and white, and part in radiant color. The fast speed of the camera in shots of the skyline, busy intersections of the city, and in the final sequence renders a sense of exhilaration and wonder typical of Wong and Doyle's best work. More significantly, the visual, structural discontinuities and editing differences within the very same narrative reveal a more pervasive, existential reality, namely, the fragmented, atomized nature of urban life in Hong Kong and in diasporic conditions. The challenge for solitary Hong Kong/Chinese globe-trotters is not to be lost in temporal discontinuity and spatial dislocation, but to connect and reconnect with some sense of homeland and to discover a destination—however transitory it may turn out. The film does not seem to end on a pessimistic, apocalyptic note of impending doom in view of Hong Kong's reversion to China, but with hope in the possibility of a new beginning. At the very least it is safe to say that the ending is more ambiguous than overly negative.

From Nationality to Flexible Citizenship: *Farewell China*, or, *Full Moon in New York*

It is noteworthy that weddings or erotic relationships were favorite tropes of many Hong Kong films during the handover period. Hong Kong filmmakers and citizens alike were exploring the exact nature of the partnership between Hong Kong and its new "colonial" master during the postcolonial period. *The Manual of a Complete Marriage* (*Wanquan jiehun shouce*, directed by Ruan Shisheng) is the felicitous title of another Hong Kong film that describes a tenuous, precarious marriage. The couple's hesitant, uncertain feeling about the future resembled the general mood of many Hong Kong residents.[13]

If epic films such as *The Soong Sisters* and *The Opium War* provide officially sanctioned grand narratives about modern China as a historical and sovereign subject, the kinds of Hong Kong films briefly discussed above seem to offer alternate narratives of ethnicity, identity, and nationhood. These private melodramas reveal little postmodern tales of Chinese people in diasporic conditions without the comfort of national affiliation. Feature movies such as *Comrades* and *Happy Together* partake of a tradition among Hong Kong films that focuses on Chinese in diaspora and displacement. The most notable earlier films in this vein include *Song of the Exile* (*Ketu qiuhen*, 1990, directed by Ann Hui), *Farewell China* (*Ai zai biexiang de jijie*, 1990, directed by Clara Law), and *Full Moon in New York* (*Ren zai Niuyue*, 1990, directed by Stanley Kwan).

Song of the Exile tells the story of a mother and daughter whose sense of belonging is torn among China, Hong Kong, and Japan. *Farewell* depicts a mainland Chinese couple who go to America in search of a new home but meet a tragic end in New York City. *Full Moon* is a story about three Chinese girls from the mainland (mainland/Mongolian actress Siqin Gaowa), Taiwan (Sylvia Chang), and Hong Kong (Maggie Cheung). As New York City becomes their new residence, the three immigrants still lack a homeland and private homes. They each live and enact personal dramas of loss and displacement. The final sequence in the film depicts them being "happy together": the three girls drink, laugh, and toast each other on a rooftop under a beautiful full moon in New York. Although culturally attached to some sense of Chineseness, the daughters of the mainland, Taiwan, and

Hong Kong are together yet separate, at home yet homeless. None of them has entered a fulfilling relationship with lover/husband, the new country of residence, or the region of origin.

The story in *Farewell China* begins in 1988 in Shawan Village, Panyu (Punyui) County, Guangdong Province. Hong (Maggie Cheung) and Zhao Nansheng (Tony Leung Ka-fai) live with their parents and baby son, Shanshan. Hong has dreamt about immigrating to America. The couple travels to the American consulate in Shanghai for an interview to obtain a visa. The American consulate in Guangzhou (Canton) has already denied Hong a visa four times. According to Hong, she was denied earlier because the consul thought she was "too pretty" and would not return to China. She tried to convince him that, since she has given birth to a child and has a family, she will certainly go back to China. The consul poses this question: did you give birth to a child in order to obtain a visa to America?

Hong is determined to earn a green card at all costs so she can take her whole family to America, the land of freedom and opportunity. For the future of their child Hong and her husband are willing to endure any hardship. However, as time passes Nansheng fails to receive any letters from his wife. In May 1989, he enters the United States illegally and arrives in New York City looking for his wife. Having little money and speaking only broken English, he finds himself reduced to a vagabond in the streets of the Bronx, Harlem, and Brooklyn. Jane, or "Jing," as he mispronounces the name, a Chinese-American teenager who runs away from home in Detroit at the age of fifteen, becomes his friend. She lives the life of a prostitute, and Nansheng, an illegal alien at the verge of penniless poverty, becomes her pimp. Out of despair and frustration, he calls his parents in China, telling them that he cannot bear the misery any longer and wishes to go home. The answer from his parents is simple: please do not come back to China, for the sake of the family and Shanshan. At one point, a Taiwanese-American couple that owns a Chinese restaurant in Harlem admonishes Nansheng that he should be "happier than one billion people" in China, even though he is an illegal alien in the United States. In America, there is no limit to how many children one can have. Just wait for the next amnesty for illegal aliens!

During a month of searching, wandering, disillusion, degradation, and humiliation, Nansheng learns that life in America has been difficult for Hong and that she has held many jobs. In order to obtain a green card, she

even marries a Chinese laundryman. Both parties understand the marriage as a relationship of convenience without love. Yet she runs away from the arrangement after a while.

One day, when delivering food for a Chinese restaurant, Nansheng finally meets Hong in an apartment building. This happy reunion turns into a moment of profound sadness. Together they discover events in their lives after separation and realize that their American dream has turned sour. The scene of reunion, their dialogues, and Hong's crying are set against the sound track of the Chinese song "My Motherland" (Wo de zuguo), which Nansheng hums now and then throughout the film. "My Motherland" is the theme song of the PRC film classic *Shanggan Ridge* (*Shanggan ling*). Made in the 1950s, the film deals with the heroism of Chinese soldiers in the Korean War, who fought to resist the "invasion" of Korea by the American troops. Ever since, the song has been regarded as one of the most beautiful, patriotic songs in mainland China. The jarring, climactic juxtaposition between the unspeakable suffering of Chinese nationals in the United States and the idealistic celebration of their motherland deconstructs and dispels any sense of sacredness and innocence associated with the Chinese socialist nation-state. Ironically, these Chinese nationals have escaped to the United States, China's archenemy in the song, in order to start a new life. Yet the Chinese state has caused indescribable, horrible catastrophes in the lives of nationals both inside and outside China.

When Nansheng wakes up the next morning, he discovers evidence that his wife has become schizophrenic and psychotic. First, she never mailed many of the letters she had written to him. Moreover, she does not remember many events in the past that they have shared. Even worse, she denies her Chineseness and despises her "chink" Chinese husband in an attempt to assimilate into the American mainstream culture. Her job is to swindle money from old Chinese men and women living in New York City as a middleman who "helps" them send money back to their relatives in China. In a fateful confrontation Hong stabs Nansheng to death in front of a miniature white Statue of Liberty. The sequence ends with a close-up of Nansheng's red notebook, which has fallen to the ground. The front cover is graced with Mao's calligraphy of his famous saying "serve the people" (*wei renmin fuwu*).

The miniature Statue of Liberty reminds viewers of the original on Ellis Island, as well as of the Statue of Goddess of Democracy that Chinese stu-

FIGURE 5. Schizophrenic Hong (Maggie Cheung) at the end of *Farewell China*.

dents erected on Tiananmen Square in May–June 1989. Chinese immigrants and students have set up such statues all over the world in the aftermath of the incident on Tiananmen Square. Indeed, within the film narrative, Nansheng's stay in New York coincides with the time of the student democracy movement in Beijing in 1989. The concluding shots are those of the small Statue of Liberty, the American Stars and Stripes, and the Chinese landscape: a road, a village, and a man ploughing the yellow earth. The final image is, poignantly, that of a child—the figure of China's future—who could very well be Shanshan himself. Evidently, in this film the fate of China's children must be read against the historical background of China in 1989. The film overtly criticizes the Chinese motherland, which has deprived its citizens of a home. The ideological premise of such films is that the bad policies and practices of the nation-state are pitted against its innocent, powerless citizens and are indeed the cause of their misfortunes.

If *Farewell China* is heavily inflected by the politics of the Tiananmen incident, Hong Kong films made on the eve of the handover in 1997 need not be so. After a hiatus of eight years, both China and Hong Kong seem to have a new face-lift. The memory of Tiananmen has dimmed in the minds

of Chinese and non-Chinese throughout the world, although it has never completely been forgotten, to be sure. In the 1990s, China became a major player in transnational capitalism and an inseparable part of the global economy. The interests of business often came to have higher priority in the calculation of leaders. Hong Kong itself became the biggest foreign investor in China's domestic market and the inflow of Hong Kong's capital fueled the economic growth of the mainland.

A new type of intellectual discourse and popular cultural production has emerged in Hong Kong and China in response to transnational social and economic formations during the post–cold war period.[14] This shift can be described as change among the Chinese away from the discourse, ideology, and geopolitics of the nation-state to a more flexible notion of citizenship. A single national identity and loyalty to one particular nation-state are losing credibility among the people of Hong Kong and China for practical and political reasons. As a *homo economicus* in the age of transnational capitalism, mobile investment, flexible accumulation, and global postmodernity, the Chinese in diaspora renegotiate a flexible set of spatial, geographic, economic, and cultural considerations in the process of identity formation.[15] As Aihwa Ong points out, "Such flexibility of options, whether financial, spatial, social, or legal, constantly destabilizes and even attenuates what it means to be Chinese. The shifting narratives rework global displacements and liminality into a self-inscribed alterity to the western insistence on a single national identity."[16]

This seems to be the difference between a film such as *Farewell*, made at the end of an era in 1990, and a film such as *Comrades*, made in the mid-1990s, although both deal with the Chinese diaspora. In *Farewell*, even though the characters suffer because of the nation-state, the nation-state still provides the emotional basis for a sense of identity and selfhood. In the postmodern, diasporic condition, the nation-state may no longer be the primary arena of activities for ethnic Chinese scattered around the globe.

However, all this does not imply that *Chineseness* in cultural production by and about Hong Kong does not matter today to ethnic Chinese around the world. To the contrary, the question of what it means to be Chinese or Hong Kongese is precisely the subject of all the films discussed in this chapter. The answer to this question has to be sought in a more subtle manner. Interestingly, it was the pop songs of Deng Lijun—not the nation-state of

the PRC, the Special Administrative Region (SAR) of Hong Kong, or the United States of America—that became something of a defining characteristic of being "Chinese" for members of the generation of Chinese–turned–Hong Kongese–turned–New Yorkers represented by Li Qiao and Xiaojun in *Comrades*. (Herein seems to lie the essential difference between the function of the song "My Motherland" in *Farewell* and the effect of Deng's songs in *Comrades*.) A transnational, flexible, diasporic citizenship does not have the blessing of a secure national affiliation, but can be ultimately turned into a source of agency and creative transformation in the post–cold war "new world order."

According to Jürgen Habermas, a double coding of citizenship exists in the modern nation-state. On the one hand, the *state* endows its citizens with civic liberties and political rights as a mode of legitimation; on the other hand, the *nation* speaks to the hearts and minds of the people and gives rise to a collective consciousness by invoking common ancestry, language, and history.[17] However, the model of the nation-state can no longer fully account for the kind of pan-Chinese attachment seen in these films. In the words of Arjun Appadurai,

> The world in which we live is formed of forms of consociation, identification, interaction, and aspiration that regularly cross national boundaries. Refugees, global laborers, scientists, technicians, soldiers, entrepreneurs, and many other social categories of persons constitute large blocks of meaningful association that do not depend on the isomorphism of citizenship with cultural identity, of work with kinship, of territory with soil, or of residence with national identification.[18]

Such new forms of interaction, identification, and attachment bind refugees and immigrants of Chinese and Hong Kong origin into a sense of community, albeit deterritorialized and supranational.

On another related level, the ultimate question that these Hong Kong films poses is as difficult to answer at this historic juncture as it is provocative. That question is the following: Will Hong Kong and China after 1997 be "happy together" and remain close "comrades," and evolve a lasting partnership as sweet as "almost a love story"?[19]

SIX

The Heroic Trio
Anita Mui, Maggie Cheung, Michelle Yeoh—Self-Reflexivity and the Globalization of the Hong Kong Action Heroine

COAUTHORED WITH ANNE T. CIECKO

"Why 'Titanic' Conquered the World" was the title of a major report in the *New York Times* in April 1998. Hundreds of millions of viewers throughout the world saw the Hollywood blockbuster *Titanic*—from Beijing to Moscow to Tokyo and London; from Paris to Warsaw, Istanbul, Cairo, Jerusalem, Buenos Aires, New Delhi, and Bonn. Although much of the film's critical reception ranged from lukewarm to negative because of its trite formulaic storytelling, the movie has proven to be a successful piece of popular culture around the world.[1] Not only did it break the box office record in America, but it was also poised to break records around the world. Indeed, the film has made more money outside than inside the United States—as of April 1998 "about $543 million in the United States and about $933 million more in the rest of the world."[2] Even President Jiang Zemin, the Chinese Communist Party chief, openly admitted to being moved by the film, which led him to say at the National People's Congress: "Let us not assume that we can't learn from capitalism."[3] He was reported to be a big fan of the film and of Hollywood in general.[4]

Titanic seems to be a perfect example of the triumph of the logic of global capitalism in the post–cold war era. Its success confirms the uncontested hegemony of Western media—led by Hollywood—around the world. As Hollywood comes close to being synonymous with global entertainment, it is urgent for us to look into alternative possibilities of entertainment in transnational popular culture. Is the "global popular" a one-way route from Hollywood to the rest of the world?[5] What are alternative sources and epicenters of energy and creativity outside the West? What is the role of popular action and martial arts films from Hong Kong in the post–cold war cultural landscape of simulation, media, and globalization?

The "heroic trio" of this essay—Anita Mui, Maggie Cheung, Michelle Yeoh—are three of the most celebrated female stars in the history of Hong Kong cinema. They appear together in a film by the same title directed by Johnny To and Ching Siu-tung (1993), and in its sequel *Executioners* (also known as *Heroic Trio II*, 1993). Acting in numerous Hong Kong films, Mui, Cheung, and Yeoh emerged as stars in the 1980s and 1990s and have participated in the development of the Hong Kong New Wave, which includes internationally recognized "auteurs" like Stanley Kwan, Ann Hui, and Wong Kar-wai. Mui, Cheung, and Yeoh have gained a wide following by acting in popular Hong Kong film genres, particularly the action film. The film industry noticed their talents for obvious reasons: Mui was a popular singer, and Cheung and Yeoh were beauty queens (Cheung was runner-up to Miss Hong Kong, and Yeoh was Miss Malaysia). They developed credibility as bankable stars and actresses through genre films (and the so-called assembly line of the Hong Kong film industry) and arthouse vehicles.

In this chapter, we analyze the transnational currency of the images produced by three of the most illustrious female stars in Hong Kong's pantheon. In particular, we examine the phenomena of profound self-reflexivity in performance, casting, and marketing—as well as the ways these stars are connected to the status of Hong Kong cinema within the global nexus of production, exhibition, distribution, and reception. We focus especially on *Heroic Trio*, *Irma Vep* (1996), and *Tomorrow Never Dies* (1997).

The globalization of Hong Kong action films can be seen at several levels: first, their transformation into a global cinema from within the Hong Kong film industry itself, for instance, the spread of Jackie Chan's Golden Harvest films across national boundaries; second, the appearance of Hong Kong action

heroes, heroines, and directors in productions outside the Hong Kong film industry, which must still build on a profound sense of intertextuality and self-referentiality. Examples from this second level include John Woo's Hollywood films, which allude to and parody his previous Hong Kong films; the casting of Chow Yun-fat in *The Replacement Killer* (1997), an American remake of the original Hong Kong *Killer* (1986); the debut of Jet Li, another martial arts film superstar, in the American action film *Lethal Weapon 4* (1998); and the appearance of Maggie Cheung and Michelle Yeoh, respectively, in the French and British films *Irma Vep* (1996) and *Tomorrow Never Dies* (1997).

From *Heroic Trio* to *Irma Vep* and *Tomorrow Never Dies*, a pattern in the global development of the Hong Kong action heroine emerges. *Heroic Trio* is still a Hong Kong production and its heroines are local stars, even though the film is targeted at regional and international audiences. However, in *Irma Vep* and *Tomorrow Never Dies* the Hong Kong action heroines appear in non–Hong Kong films that rely on the credibility of their action heroines' status, which catapults them in turn to global and transnational stardom. On a third level, as part of a global strategy the Western film industry also casts popular Asian stars in American and European productions as a way to reach vast Asian markets and audiences.

We believe that in the cases of Michelle Yeoh, Maggie Cheung, and Anita Mui the cultural machinery of star making is predicated on elements of "verité," a blurring of art and life imbricated in the tenuous and tempestuous cultural life of colonial and postcolonial Hong Kong. Here we recognize a conscious link to the intertextual construction of stars and Hong Kong's connection to Europe and Hollywood. Scholarship on the phenomenon of stardom has shed light on the relationships between film audiences and media constructions of the star's image. However, Hollywood-centric production and spectatorial paradigms do not always provide a satisfactory set of critical tools for examining Hong Kong cinema. We would like to complicate the theoretical concept of the star in the context of Hong Kong action cinema and its global "translations."[6]

Internationally, the high/low distinctions made by film distributors and film festivals may have made many Hong Kong action films less available to mainstream audiences, but action films have always been an essential part of the cultural diaspora and have played at theaters and been sold as videotapes in stores throughout Chinatowns around the world. In the 1980s and 1990s,

American audiences that craved Hong Kong action might also seek out specialized video distributors (for example, the California-based Tai Seng Video). In addition, fanzines and Web sites nurtured cult fandom, evidence of which can be seen in the proliferation of shrines devoted to Hong Kong cinema and its stars, who include Maggie Cheung, Michelle Yeoh, and Anita Mui. In the United States, repertory and specialty cinema houses, museums and affiliated institutions (like the Film Center at the Chicago Art Institute under the curatorial direction of Barbara Scharres), university film societies, and a range of film festivals (for example, the Hong Kong–themed series at Cinema Village in New York) have increasingly, though selectively, contributed to the phenomenon.

The movement of Hong Kong action stars and directors to Hollywood suggests a conviction that Hollywood fare will generate global audiences, including some in the huge Asian market, but recontextualization certainly seems destined to entail the loss of richness and ambiguity in gendered representations. In terms of gender performance, two factors that have consistently marked Hong Kong action film narratives in past decades are a crisis of masculinity and a subversion of the heterosexual romance.[7] In the case of female action characters, there has been more of a constructed bisexuality, which a number of critics have noted especially in the work of Hong Kong actress Brigitte Lin. (See, for example, her androgynous roles in films directed by Tsui Hark, such as his genre-blending *Peking Opera Blues*, which includes another trio of strong actresses—Brigitte Lin, Cherie Chung, and Sally Yeh.)[8] Although the woman warrior character has been a recurrent theme in Chinese culture, literature, and film, Hong Kong action cinema with its pastiche of styles and fascinating characterizations of action women opens up new spaces for representation.

The work of Chinese Fifth Generation filmmakers—"auteurs" like Chen Kaige and Zhang Yimou, who in the 1980s and 1990s provided an international arthouse paradigm—exists in this nexus and defines many contemporary perceptions about Chinese cinema. The rise of screen goddess Gong Li helped fix one image of the consummate Chinese female star as muse. However, Western audiences are almost completely unaware of other dimensions in her career that complicate her arthouse image. (She appeared in a number of popular and commercial Hong Kong films, such as the third installment of Wong Jing's action comedy *God of Gamblers*, 1991). Another

significant critical moment occurred in the early 1990s, when British film journal *Sight and Sound* featured an image of Gong Li on its cover with the word *Icons*.[9] Gong is known for her portrayal of strong but socially and sexually oppressed women in China's past, as depicted in such classic Fifth Generation films as *Ju Dou* and *Raise the Red Lantern*. In the words of Berenice Reynaud, the image of Gong Li signifies "Chineseness, femininity, and mystery outside her own culture."[10]

In contrast, Anita Mui, Maggie Cheung, and Michelle Yeoh—huge stars throughout Asia—have always had more fluid pan-Asian cinematic identities, and their "Chineseness" has been considerably more complex. After all, as mentioned earlier, Michelle Yeoh kicked off her career by claiming a beauty queen title as Miss Malaysia. Maggie Cheung, the former runner-up to Miss Hong Kong, moves effortlessly from perfect Mandarin to Cantonese to English with a British accent. Whether taking on modern roles or performing in rapid-fire premodern action films, Hong Kong actresses evoke a different sense of femininity. Reynaud provocatively calls Cheung "an icon of modernity." Cheung represents "a less codified, less traditional, less easily fetishized version of femininity . . . , a smart, sophisticated, modern woman, not an Orientalist icon."[11]

Anita Mui's and Maggie Cheung's performances in such self-reflexive arthouse vehicles as *Rouge* (1987, directed by Stanley Kwan) and *Actress* (also known as *Center Stage*, 1992, directed by Stanley Kwan) can be read as deconstructions of the very idea of the Chinese actress. Superstar Mui is known as the "Madonna of Asia" because of her other career as a pop singer of Cantonese versions of Western and Japanese classics ("Cantopop"), and she performs the memorable *Heroic Trio* theme song on the film's sound track. She sang at the opening ceremony of the 1988 Seoul Olympic Games and has performed in Las Vegas, and her career has been compared to those of Diana Ross and Madonna. In 1992 and 1993, the mayor of San Francisco proclaimed an "Anita Mui Day" out of gratitude for her charity work in the city.[12] In Stanley Kwan's *Rouge*, Mui plays a tragic courtesan ghost named Fleur.[13] In real life, she supposedly became involved in organized crime when one of her producers was murdered by the triads and was later denied immigration papers to Canada.

In *Actress*, Maggie Cheung plays the tragic historical figure Ruan Lingyu, one of the foremost Chinese film stars in the silent era.[14] Both films employ diegetic shifts between past and present: *Rouge* moves back and forth between Hong

Kong in the 1930s and 1980s, whereas *Actress* shifts between 1990s Hong Kong and 1930s Shanghai. The latter film mixes reconstructions of Ruan's life and work, interviews of contemporary Hong Kong stars who act them out, and black-and-white footage of Ruan's actual films. Maggie Cheung's award-winning performance (she was the first Chinese actress to receive a Silver Bear at the Berlin Film Festival) helped build her reputation as a serious dramatic actress.[15]

Heroic Trio and *Executioners*

We consider the films *Heroic Trio* and its sequel *Executioners* (simultaneously shot in 1993 and released within a year of each other) as camp/cult touchstones. These almost overwhelmingly transtextual films feature the stellar trio and, as triple-threat star vehicles, were actually more popular with audiences outside than within Hong Kong. Anita Mui, Maggie Cheung, and Michelle Yeoh play a trio of superheroes in a dystopic world that resembles Hong Kong and is under siege by grotesque supernatural underworld figures. According to Bey Logan's book on Hong Kong action cinema, actress Michelle Yeoh suggested that the films were too dark and depressing for Hong Kong audiences, although outsiders from a more distanced perspective might enjoy these "over-the-top" representations.[16] Instead of appearing as a more realistic triad crime ring, the subterranean shadowy figures that dwell under the city are relics of Chinese history. Indeed, one might argue that the whole triadic structure of characterization within this film resonanates with premodern Chinese narrative, pre-1949 Chinese cinema, and contemporary pan-Chinese cinema.[17]

In *Heroic Trio*, an ancient eunuch commands his subjects to steal baby boys from Hong Kong hospitals to make them into his slaves. The fate of the city rests in the hands of Wonder Woman, played by Anita Mui, a mild-mannered housewife by day and superhero whenever necessary. Invisible Woman (Michelle Yeoh), her long-lost sister, has been forced to use her scientific and physical skills to serve the eunuch. Maggie Cheung plays the outlaw Thief Catcher. The narrative catalysts of *Heroic Trio* and *Executioners* are a desperate water shortage and an apocalyptic war to save Hong Kong as well as the entire planet. Both movies beg somewhat allegorical readings of three women warriors who represent Taiwan, Hong Kong, and mainland China in considera-

tion of the "enactment" of identity and genre hybridity via a fable of reunification.[18] *Heroic Trio* has links to campy Hollywood comic book–based, masked superhero films such as Tim Burton's *Batman*, although *Heroic Trio* also participates in the Hong Kong genre of the supernatural epic spectacle. By the end of the sequel, *Executioners*, a feminist perspective is expressed, as sisterhood between the women becomes the most powerful bond.

Heroic Trio and *Executioners* are pre-1997 Hong Kong films with a subtext of fantastic, fatalistic millennial thought and representations of a chaotic fin de siècle, crime-ridden Hong Kong in need of restored order. The intertextual, self-reflexive star images compound expectations of heroic performance with a combination of feats of extraordinary physical skill and cinematic special effects. Anita Mui's role as Wonder Woman, for instance, follows that familiar superhero paradigm of doubled, contradictory, and disguised identities. Her Wonder Woman is actually a semiretired, domesticated action heroine kept in check by a cop husband, an earnest traditional male authority figure (who, incidentally, is killed in the sequel). Audiences delight as she subverts his authority by transgressing her position as housewife, performing secret daily miracles, ultimately rebonding with a lost biological sister (Michelle Yeoh's character), and connecting with an outlaw renegade (Maggie Cheung's Thief Catcher). Anita Mui's own singing voice on the sound track literally underscores her actions and emotions.

Irma Vep: Self-Reflexivity and Transnationality

> Why a Chinese girl? Do you know? . . .
> I am serious. Why a Chinese? . . .
> I saw *Les Vampires* 30 years ago at the Cinematheque. Irma Vep is Paris.
> She is the Paris underground. She is working class Paris. She is Artelly.
> Irma Vep is the street thugs and slums. *Les Vampires* isn't Fu Manchu, right?
> It's not Fu Manchu. . . .
> I am sure she's [Maggie Cheung's] great. I saw her in that Jack Chan movie. What was the title? What a piece of crap! She was fine. But she's not Irma Vep! . . . That Chinese girl . . . she's really not for me. You'd be much better.

FIGURE 6. *Irma Vep*. Courtesy of Panorama Distributions Co., Ltd.

In Olivier Assayas's film *Irma Vep* (1996) these words are spoken by director Jose Murano (Lou Castel) to a French woman he has chosen to replace Hong Kong actress Maggie Cheung in a remake of the 1916 French film classic, *Les Vampires*, which David Meeker, film archivist at Britain's National Film and Television Archive, has recently called "one of the most seminal films by any criterion."[19] Murano has been called in to substitute for René Vidal (played by French New Wave icon Jean-Pierre Leaud), who first chose Maggie for the role but has experienced a nervous breakdown during filming. Murano's words, symptomatic of a purist's approach to national cinema, argue for the authenticity of an uncontaminated French tradition.

According to such conventional wisdom, the essence of this tradition cannot be recaptured by an alien actress like Maggie Cheung, but can only be reenacted by someone genuinely French. The tautology "*Les Vampires* is not Fu Manchu" seems to make perfect sense. But Fu Manchu belongs to an exaggerated orientalist discourse, a specific way in the past of constructing the East in the popular imaginary of Hollywood. *Les Vampires, Irma Vep*, and *Irma Vep*'s film-within-a-film remake reveal the constructedness of discourses about the self and the other.[20] Director Assayas told Cheung not to play a "more conservative, more 'typical' Chinese girl," but to be what she was, given the fact that she grew up in Britain and was quite Westernized.[21] In regard to her role in this film and many others, Berenice Reynaud states, "No Orientalist fantasy, she is a modern Hong Kong woman, a complex mirror image of postcolonial dilemmas: displacement, racist misrepresentation and partial loss of cultural identity (she speaks English better than she can read Chinese characters)."[22]

The comments about Jackie Chan, his "crappy film," and Maggie Cheung (specifically the director's impression of her triumph as an actress over wildly popular but substandard material) relate to the moment in the 1990s when the Hong Kong action and martial arts film genre—represented by artists such as Jackie Chan, John Woo, Tsui Hark, and Ringo Lam—went through an unprecedented process of globalization. Jackie Chan's films, which are made by his longtime Hong Kong producer Golden Harvest, have had tremendous box office success not only in Asia but also in the United States. For instance, *Rumble in the Bronx* (1995) reaped higher box office revenue in the first two weeks of its release in the United States than any other film shown during that period. Indeed, the Hong Kong action genre, most vibrantly epitomized by Jackie Chan, has served as an exemplar of alternative entertainment cinema, a redefinition of global entertainment as something other than Hollywood.[23] Chan's/Golden Harvest's films are the only non-Hollywood films that can compete with Hollywood in terms of box office success and thus pose a serious challenge to its global hegemony.

In contrast to the international appeal of Hong Kong popular cinema, the once exalted French (art) cinema seems to be losing its worldwide influence. *Irma Vep* suggests one way to revamp and reinvent French national cinema through casting and by cashing in on the star quality of a Hong Kong actress, by hybridizing and transnationalizing the industry. The infusion of

new energy from a contemporary Hong Kong action heroine may reinvigorate the long-forgotten tradition of early French popular films like *Les Vampires* (1916), which Louis Feuillade directed, starred Musidora, and was appreciated by both popular audiences and patrons of the avant-garde.[24]

The glamorization and fetishization of the Hong Kong action hero and heroine in the realm of global entertainment provides an opportunity to examine various aspects of Hong Kong cinema—the industry, patterns of production and consumption, stars, and international reception. It is obvious to us that the study of Hong Kong cinema can no longer be restricted to some notion of a pristine, indigenous industry, of a self-contained national or local tradition in and by itself, especially in an age of postnational or transnational cinema. Such a study entails an examination of the nebulous transnational and cross-cultural contexts of Hong Kong cinema, for instance, the participation of its directors, stars, actors, and actresses in non–Hong Kong productions (American, French, British, and so on), which necessarily allude to and build on the prestige of the Hong Kong tradition. The reception, utilization, and fetishization of Hong Kong film stars and genres in global entertainment gives an extended "afterlife" to Hong Kong cinema, and its transnationalization requires us to redefine constantly and expand our conception of such a cinema.

The recent French film *Irma Vep*, directed by Olivier Assayas, offers a fascinating commentary on the self-reflexivity of Hong Kong film actresses. *Irma Vep* engages in a dialogue with Maggie Cheung's performance in Stanley Kwan's film *Actress* and with her star image and Hong Kong cinema in general. In *Irma Vep*, Jean-Pierre Leaud plays René Vidal, a French director past his prime, who is asked to produce a remake of the silent serial classic *Les Vampires*, which starred the famous actress Musidora. He chooses Maggie Cheung (who plays herself) to play the character named Irma Vep (an anagram for "vampire") based on his affection for her performance in *Heroic Trio*, which he has seen in a cinema in Marrakesh. In addition to making references about the global reach of Hong Kong cinema, the film calls on Maggie Cheung to demystify her own image as an acrobatic action actress—"It's all done with special effects," she insists, "I don't do action."

Costumed in an updated version of Musidora's black bodysuit made out of sexshop latex (ironically modeled after Michelle Pfeiffer's Catwoman in *Batman Returns*), Maggie plays out the fantasy of Irma Vep in a nighttime

adventure where she steals a necklace and throws it away. In the intertextual discourse of the film, Maggie listens to a French reporter (Antoine Basler) who dismisses French cinema as boring and celebrates the masculine and balletic action films of John Woo. The reporter faults French cinema for being too "intellectual," for being a dying cinema subsidized by the state, and for being financed by the money of friends and made for friends. The reporter considers Hong Kong cinema, based in a society that operates on laissez-faire capitalist principles and completely dependent on the box office, a model of dynamism, energy, and renewal. Chosen for the role precisely because she is Chinese (presumably no French actress could remake Musidora), Maggie is fired by her director's replacement, Jose Murano, for exactly the same reason (unable to achieve his film vision, René has a nervous breakdown). Maggie then leaves for a meeting in the United States with Ridley Scott.

Irma Vep is therefore a cinephilic reflection and witty commentary on the fluid boundaries of global media. As we witness Maggie's trajectory from Hong Kong action to French independent art film to an offscreen meeting with a Hollywood director (Ridley Scott), *Irma Vep* confronts, complicates, and allegorizes European art film traditions, the cinematic avant-garde, Hong Kong action, and Hollywood. Maggie Cheung in the role of the title character becomes the vehicle for this process.[25] According to director Olivier Assayas, Irma Vep is more than a character; she is an ever-present force, an archetype in world film history. "You've seen her through the whole history of filmmaking, from Alfred Hitchcock's *To Catch a Thief* to Catwoman in *Batman Returns*. She pops up in Hong Kong cinema and in fashion photography. She's an archetype. The film is about how an archetype is discovered, and how it has to be remade for every generation."[26] *Irma Vep* attempts to recapture the spontaneity and simplicity of early cinema; the handheld camera work and behind-the-scenes look give it a flavor of cinema verité.[27] In addition, Assayas's film simultaneously worships and deconstructs the iconic image of the female (Hong Kong) action star. At the very end of *Irma Vep*, we view the results of director-surrogate René Vidal's manic editing (his thwarted *Irma Vep* as experimental film-within-a-film), which disrupts and abandons narrative entirely, obsessing over Maggie Cheung's image in a manner both disturbing and exhilarating. Her star visage is "defaced" by scratches on celluloid, which, ironically, make her even more superhuman as rays of light appear to dart from her eyes.[28]

Tomorrow Never Dies: Remapping the Geopolitical Imaginary in the Age of Media

In the spring of 1997, Michelle Yeoh was named one of *People* magazine's fifty most beautiful individuals, and many fashion, celebrity, and news magazines touted her as the next and newest incarnation of the Bond girl.[29] Discourse about her as an actress and her willingness to take on Bond was often conducted in the context of her lack of interest in being cast as a passive Asian sex symbol or as a Suzie Wong stereotype and in the context of her physical ability to perform her own stunts. As ultimate evidence of her action credentials, American and European audiences had recently seen her partnership with Jackie Chan in the 1992 film *Supercop* (*Police Story III*), but Michelle had been doing her own stunts since the 1985 Hong Kong action film *Yes, Madam*, where she joined with American martial arts star Cynthia Rothrock to help form a team of policewomen fighting a criminal underworld.

For pan-Asian audiences, Michelle Yeoh had held the title as top action actress until her temporary retirement (due to her marriage—a common phenomenon for Hong Kong action actress); after Michelle Yeoh divorced and returned to the screen, audiences welcomed her comeback as Jackie Chan's on-screen partner. In *Supercop*, the Malaysia-born actress plays a Chinese policewoman who joins Hong Kong cop Jackie Chan in an undercover international chase from China to Malaysia to infiltrate a crime ring. Jackie's girlfriend, played by Maggie Cheung, blows his cover. Cheung and Yeoh play noticeably different female types in the film. Whereas Cheung is cast in traditional, overdetermined, stereotypical femininity, Yeoh takes on a conventionally masculinized persona marked by self-confidence, aggressiveness, and physical strength.

In the action comedy *Wing Chun* (1993, directed by Yuen Woo-ping), Michelle Yeoh acts out the role of the title character, defeats all her male opponents, succeeds in defending her female friends, and excels in martial arts skills. The film's narrative is based on Ming history. Wing Chun is the name of the woman; it also becomes the name of the martial arts style that she invented. This martial arts style ultimately gives the woman an identity, a fame, and an afterlife reenacted again and again by future generations in China, Hong Kong, America, and the world.

Michelle Yeoh's life-imitates-art film, a docudrama called *Stuntwoman*

(1995), which is told from a woman's point of view, almost ended Michelle's real-life career due to serious injuries. The film chronicles the rise of Ah Kam (Michelle Yeoh's character) from stunt extra to action director under the tutelage of action actor/director Sammo Hung. Employing film-within-film action sequences, *Stuntwoman* situates itself within the world of the Hong Kong film industry, itself located within the world of organized crime. Directed by Ann Hui (noted for her work within the Hong Kong New Wave/arthouse tradition), *Stuntwoman* offers a thoughtful and profoundly intertextual examination of Yeoh's position as action star. Of the three actresses discussed in this chapter, Yeoh is the only one who truly is capable of doing her own stunts, and her injuries can be read as signifiers of the "realness" of her labor.

As commentators have pointed out, *Tomorrow Never Dies*, the eighteenth Bond film in a span of thirty-five years, has the least sexual content.[30] The film has more action than sex, and it deliberately constructs such strong female characters as "M" (played by Judi Dench), and especially Wai Lin, Michelle Yeoh's character. "I won't be a stereotyped Suzie Wong," the actress has asserted proudly. "With this movie we're beginning a new generation of Bond girls."[31] This deviation from the normal ratio of action/violence vs. sex/romance marks the influence of the Asian action genre. Again, Michelle reaffirms her status as an *action* heroine above all, not as a sex symbol, in a traditionally rather heterosexual, male-centered, romantic, promiscuous genre of spy stories, namely the Bond genre. In the words of one reviewer, "It is ironic that in a film which equates bigger with better, the most exhilarating moment is the relatively low-tech one where a fabulous Michelle Yeoh as spy Wai Lin shows off her martial-arts expertise."[32]

The background of *Tomorrow Never Dies* is the story of a media mogul Elliot Carver (Jonathan Pryce) and his attempt to provoke a war between China and Britain in South China Sea. He hopes to win a media war and obtain the exclusive right to broadcast in China, which appears to be a potentially huge market for his media empire. It takes a British secret service agent, James Bond (Pierce Brosnan), and a Chinese female agent, Wai Lin (Michelle Yeoh), who operates under the disguise of a journalist, to stop the scheme and prevent the war.

This Bond film is an attempt to remap the place of Britain and China in the geopolitical imaginary of the post–cold war period. As we know, the Bond genre, as a serial narrative of a British secret service agent, is predicated

FIGURE 7. Michelle Yeoh in the James Bond film *Tomorrow Never Dies*. Courtesy of Museum of Modern Art.

upon antagonism between East and West, between communism and capitalism. The question is how to revamp the genre after the cold war has ended. The ingenious solution is to narrate a story of a "media war." The "new world order" is the postmodern era of the media, the simulacrum, the televisual image. As Jean Baudrillard proclaims, "the gulf war did not take place" since it was the result of the fabrication of the international media.[33]

The creation of an imaginary, phantasmal tale about the prevention of an international conflict in this version of the Bond story nevertheless alludes to distinct, real historical events. The film was released in the Christmas season of 1997. Earlier that year, at midnight, June 30, Hong Kong, which had been a British colony, reverted to mainland China, and British sovereignty

on that island-city ended. In the mid-nineteenth century, the navy of the British Empire had come to the South China Sea and wrestled Hong Kong out of the hands of the Qing Empire, a dynasty on a steady course of decline and disintegration.

By the end of the twentieth century and the second millennium, Britain had long ceased to be "the empire where the sun never sets," a status that it enjoyed when it had colonies at different corners of the globe. Given the loss of Hong Kong, *Tomorrow Never Dies*, as the title provocatively evokes, attempts to come to terms with history and the future, and at the same time project a new kind of global geopolitical imaginary. The danger of a potential conflict between China and Britain, and the imaginary resolution of such a conflict through the collaborative work of a British and Chinese agent in the fight against their common new enemy—the global domination of the media, the "simulacrum"—offers a new narrative formula for this new installment in what seems to be an undying cycle of Bond films. Paradoxically, the Bond film remains an "imperial film" after all, with the hegemony of the Western media industry supported by a vast network of distribution systems all over the world.

The tale of what seems to be an equal collaboration between a British male agent and a Chinese female agent, as opposed to the old formula of sexual submission and romantic conquest, reworks gender and political dynamics in the Bond genre. This reconfiguration of the potentially libidinous relation between British masculinity and Asian femininity is a new strategy of containment and cooperation between bygone empires, British or Chinese, in the circumstances of the post–cold war era of global simulation.

Michelle Yeoh's appearance in this film is intriguing in a number of ways. Her participation in this joint British/U.S. production (a product of the Hollywood and European film industries) necessitates a cooptation in the postimperial discourse of the Western media industry in regard to the East and the West. Although Hollywood is succeeding in cracking open vast Asian markets, it is also timely to notice at this juncture the persistence of residual cold-war sentiments, namely, the representation and imaging of China as the demonic other in several highly publicized films released in 1997 and early 1998: *Red Corner, Seven Years in Tibet,* and *Kundun*.

Michelle Yeoh as star must succumb to the conventions and strategies of Western media industry about the "East." Yet, on another level, her absolute

refusal to be cast in the mold of the usual Bond girl—a sexy babe taken in by the charms of the conquering, sexually hyperactive Bond—helps preserve her status as a *Hong Kong action heroine* and maintain her credibility in the eyes of Asian audiences. Although she cannot enact the narcissistic, triumphant trekking of the world in the fashion of Jackie Chan, whose recent films in the role of a globe-trotting "Hong Kong police detective" (for example, *First Strike*) have turned him into a Chinese James Bond whose action is more daring than the original Bond model in terms of the death-defying stunts, Michelle's role in *Tomorrow Never Dies* seems to begin a process of gendered and political repositioning between East and West, masculinity and femininity, within the traditional Bond genre.

As Jackie Chan dallies with beauties of a variety of colors and ethnicities in his stories of global adventures, the centrality of Asian masculinity is firmly established in his martial arts genre. (Witness the ultimate Mr. Nice Guy's relationships with a "heroic trio" of beauties: a Chinese, a black, and a Caucasian redhead, in his film *Mr. Nice Guy* [1997], set in Australia.) By the same token, gender and racial politics in *Tomorrow Never Dies* must be closely examined. Even though "Yeoh proves a worthy equal partner to Bond, displaying snappy martial arts moves and not for a moment falling into the compliant-bimbo mode so common to the series," as one commentator puts it, "China" personified as an action heroine and woman warrior in relation to British masculinity is another episode in the eternal feminization of the East in the symbolic discourse of the Western media.[34] The latest Bond film attempts a balancing act between East and West by presenting an image of a female Chinese warrior who is fierce, combative, competent, and yet cooperative, nonthreatening, and nonsubversive to British masculinity in the new world order.

Coda: The Asian Action Heroine, Disney, and Transnational Popular Culture for the Future

The figure of the Asian action heroine seems to be taking hold in American popular culture. This is further evidenced by Disney's release in the summer of 1998 of its much-awaited film, the animated *Mulan*, and its status as a box office hit. The story is based on the well-known Chinese folktale of Hua

Mulan (Fa Mulan in Cantonese pronunciation). In the ancient tale, Mulan dressed as a man and joined the army for the sake of her father, who was too old to be a soldier, and fought countless brave battles alongside male comrades for many years. The "Ballad of Mulan" has been a fable of empowerment for oppressed womanhood in a male-dominated society. In the PRC revolutionary film classic *The Red Detachment of Women* (1961, directed by Xie Jin), the memorable theme song has the following lines: "In ancient times Hua Mulan joined the army for her father; today the women warriors take up guns for the people."

This legend inspired Maxine Hong Kingston in her fiercely imagined work *The Woman Warrior: Memoirs of A Girlhood Among Ghosts*, and the narrator dreamed of herself as Mulan.[35] Her dream blurs the boundary between reality and imagination, the past and the present. The narrator struggles to fashion a new Asian-American, trans-Pacific, feminist identity for herself out of disjoined fragments from the past and the reality of contemporary America. However, the reworking of such a popular tale in the hands of a media giant at the end of the century seems to have a different purpose: to broaden the horizon of U.S. film industry and break into Asian markets, where animation films find huge numbers of viewers.[36] Mulan, or the action heroine, is subject to a different kind of appropriation. The ancient legend is turned into a globally commodifiable story. A source of both cultural and financial capital for a media empire, the tale of the Chinese action heroine has become an infectious force in American popular culture—with the backing of corporate interests.[37]

On the eve of Hong Kong's return to mainland China, there was nostalgia about Hong Kong's past achievements as well as anxiety about its future—especially about the possible disappearance of Hong Kong culture under mainland rule. Ackbar Abbas's elegantly written book *Hong Kong: Culture and the Politics of Disappearance* acutely captures and analyzes the mood.[38] The distinctive, loving features of Hong Kong culture become evident to inadvertent observers suddenly as if for the first time, yet at the very last moment—the moment of impending disappearance.

However, witnessing ever-widening globalization in the posthandover period at the end of the twentieth century, we see a new phase in the *reappearance* of what Hong Kong stands for, as embodied in the graceful, exciting performances of its action heroines—Anita Mui, Maggie Chueng, Michelle Yeoh, and others—at the dawn of a new millennium.

PART THREE
Avant-Garde Art

SEVEN

Postmodernism and Cultural Identity in Chinese Art

A visitor in Beijing in the mid-1990s could easily pick up a popular weekly titled *Guide to Shopping High-Quality Goods* (*Jingpin gouwu zhinan*) from a street vendor. The newspaper offered all kinds of useful information to Beijing consumers: about car sales, new skin lotion products, the latest fashions, interior design for apartments, tour packages to summer resorts, new affordable models of washing machines, effective diets, office rentals, "romantic connections," and so forth. Interestingly, a regular column of the newspaper was appropriately titled "Cultural Consumption" (*wenhua xiaofei*). It featured news about cultural activities such as performances of *Swan Lake* by the Chinese Central Ballet Troupe and the Moscow Ballet Theater, upcoming films in town, and good books to read. In a June 1996 issue, within "Cultural Consumption: Film and TV" (*wenhua xiaofei: ying shi*), there was also a subheading: "Cultural Fast Food" (*wenhua kuaican*).[1] This section introduced two new TV serials: a thirty-part program titled *Beauty Zhao Feiyan* (*Meiren Zhao Feiyan*, the story of a famous imperial con-

141

sort in the Han dynasty), and a twenty-part program titled *Bright Moon in Another Country* (*Taxiang mingyue*, a tale of two mainland Chinese girls working in San Francisco's Chinatown).

At the information center of newly built, gigantic shopping malls such as Landao, Yansha, Guiyou, and Saite—symbols of Beijing's modernization and Westernization—Beijing residents could book and purchase tickets for a series of art performances in 1996–97. China National Culture and Art Corporation (*Zhongguo wenhua yishu zong gongsi*) and Beijing Professional Performance Marketing and Promotion Agency offered access to a variety of domestic and international events and venues such as *Nutcracker* and *The White-Haired Girl* by the Shanghai Ballet, *Don Quixote* by the Grand Moscow Classical Ballet Theater, *Sleeping Beauty* and *Endangered Species* by the Australian Ballet, Puccini's *Turandot* by the Central Opera Theater of China, Anne-Sophie Mutter's China Tour, Yanni's China Tour, and performances by the Martha Graham Dance Group from America, Canada's Toronto Dance Theater, and Wiener Philharmoniker conducted by Zubin Mehta.

As the Chinese nation furiously modernizes itself to overtake the postmodernity of advanced first world societies, culture and art have inevitably become matters of consumption and marketing handled by corporations and businesses. Beijing residents, newspaper columnists, and art agencies all seem to have a rather savvy, cavalier, and matter-of-fact attitude toward the fate and function of high and popular culture in the new consumer society. Even Mao is on sale. In the domestic market, sacred revolutionary icons and images from the past are up for sale, as are precious objects of traditional Chinese art, literati painting, calligraphy, and antique furniture. The oil painting *Chairman Mao Goes to Anyuan* (*Mao zhuxi qu Anyuan*, 1968) by Liu Chunhua, the most famous painting of the Cultural Revolution period, has been auctioned off in an art fair for about one million Chinese yuan, which set a record.[2] What is at stake, then, for the artist when art itself is a commodity, like a "high-quality good" or a "fast food"?

Experimental avant-garde art in the People's Republic of China began in the late 1970s at the dawn of the post-Mao era. For decades, mainland Chinese artists had lived and worked under the official doctrine of socialist realism. Not until the end of the Cultural Revolution did artists obtain a measure of freedom to explore new modes of expression and creativity.[3] A

decade of artistic experimentation culminated in the "China/Avant-Garde" exhibition at the National Art Gallery in Beijing in February 1989. However, events in Tiananmen Square in the spring of 1989 briefly interrupted the new art movement.

Throughout the 1980s, Chinese artists were concerned with questions of national culture and art. Artistic activities and critical debates were carried out mostly within China. While the nation itself pursued the goal of modernization, cultural workers attempted to create Chinese versions of modernism without losing sight of China's traditions.

By the 1990s, both the world and China had changed. The world entered the post–cold war era, which was characterized by globalization and transnationalism. National boundaries were erased by increasing cooperation between countries in the economic, social, and cultural arenas. In the case of China, political reform slowed down in the aftermath of incidents in Tiananmen Square. However, Chinese society has undergone tremendous transformations. Economic and social development depends more and more on a market economy, foreign investment, and domestic consumption.

The official position of the Chinese state was unfavorable to avant-garde art throughout the 1990s. The general attitude ranged from rejection, disapproval, censorship, and intolerance to indifference. Artists received little support from the state. As a result, the primary site of artistic activities was no longer inside the Chinese nation-state but moved overseas. The production, exhibition, and reception of Chinese avant-garde art happens mostly in either transnational, global contexts, or in private, nonofficial, foreign-owned galleries within China. The recent establishment of the Shanghai Biennial seems to indicate that the state will be more tolerant and supportive of avant-garde experimentation in the future. Consequently, the emphasis has changed from national culture to a flexible notion of transnationalism, from nationhood to cultural identity. Galleries, museums, and foundations outside the People's Republic of China—in America, Europe, Australia, Hong Kong, and other places—have become the supporters and sponsors of Chinese avant-garde art.

What is the position of the avant-garde artist in contemporary China? we may ask. What kinds of Chinese art adequately responded to globalization, commodification, and depoliticization in the 1990s? Severe intellectual dis-

orientation has amplified the issue of representation in contemporary Chinese avant-garde art. To arrive at a new spatial, temporal coordination, and to come up with effective strategies of *mapping* and *siting* have been the main preoccupations of artists in the post-1989 period. In terms of international reception, the blossoming of postmodern art in post-New China has gone through two phases. The first wave has been called "political pop" (*zhengzhi bopu*), a genre of oil painting. The second wave, though not strictly so in chronological order, goes beyond the medium of painting and includes installation, video, body, performance, and mixed media.

The oil paintings of political pop combine American pop art and Chinese politics (icons of Mao, for instance). The juxtaposition of "ontologically different worlds" on a depthless surface (for example, commercial billboards next to or above images of revolutionary workers, peasants, and soldiers) is a trademark of postmodern art in the Chinese style.[4] In appropriating the strategy and style of American pop artists such as Andy Warhol, Chinese artists foreground the pervasive commodity-fetishism in the everyday life of postsocialist and postrevolutionary China and reexamine the legacy of its revolutionary, Maoist past. As an underground, unofficial art in the People's Republic, political pop is a critique and travesty of mainstream art and official ideology. It has become recognized internationally as a genre since its first major exhibition, organized by Hong Kong's Hanart T Z Gallery early in 1993.[5] The artworks have been sold to art collectors and frequently exhibited in galleries and museums throughout the world. Bolstered by the international media and art market, some of the "pop masters" (*bopu dashi*) have become China's new millionaires. Thus, something that began as a critique of commodification turns into a commodity itself.

Some critics of political pop assert that it has gained international visibility mostly for political rather than artistic reasons. Its "success" is built on a residual cold war ideological antagonism between East and West still prevalent in the international news media and art world.[6] An analogy is often drawn between political pop and the New Chinese Cinema (films by Zhang Yimou, Chen Kaige, and others). Both forms are censored in their home country but are immensely popular internationally. Domestic and global politics has in part provided conditions for their popular appeal outside China. Thus, the local is admitted into the global due to the peculiar cultural and political dynamics of the transnational art market.

The Avant-Garde and Political Pop

One clear indication of post-New China's general cultural aura can be seen in its avant-garde art. In February 1989, just a few months before the incident in Tiananmen Square, Beijing's prestigious National Art Gallery hosted the "China/Avant-Garde" exhibition. The show was interrupted and temporarily closed after two artists, Tang Song and Xiao Lu, well-connected children of army generals, fired gunshots at their own installations to complete them through performance. However, this development did not mean that the avant-garde art movement (*qianwei yishu*) stopped altogether in 1989; instead, it has developed even more vigorously ever since.[7] Not unlike the experience of the New Chinese Cinema, these artworks have traveled outside China and been shown throughout the world, despite being forbidden now and then on the mainland.

The new wave of avant-garde art first became known to the outside world in the exhibition "China's New Art: Post-1989," organized by Hong Kong's Hanart T Z Gallery in January/February 1993. This exhibition included some two hundred works by fifty-one Chinese artists. The thematic groupings indicated certain distinctive features and new directions: "Political Pop," "Cynical Realism: Irreverence and Malaise," "The Wounded Romantic Spirit," "Emotional Bondage: Fetishism and Sado-Masochism," "Ritual and Purgation: Endgame Art," and "Introspection and Retreat into Formalism: New Abstract Art." Playfulness, irreverence, irony, wit, cynicism, parody, pastiche, flatness, and comic effect characterize the works.

Chinese avant-garde art was part of the Venice Biennial Art Exhibition, one of many such international exposures since 1993. In June–September 1995, the Spanish government sponsored the exhibition "Chinese Avant-garde Art" (*avantguardes artístiques xineses*) in Barcelona. The event featured works of some thirty Chinese artists. In 1996–97, an American exhibition tour, "New Art in China: Post-1989," was jointly organized by the Hanart T Z Gallery and the American Federation of Arts. Beginning at the University of Oregon, the artworks traveled to galleries in several American cities. At last, the contemporary Chinese art has arrived in the United States, which had been slow responding to the contemporary Chinese art scene. Another major exhibition of the contemporary Chinese avant-garde—"Inside Out: New Chinese Art"—occurred simultaneously at the Asia Society in New York and

the P. S. 1 Contemporary Art Center in Long Island City, from September 1998 to January 1999.[8] The David and Alfred Smart Museum of Art at the University of Chicago hosted yet another productive exhibition of experimental art in 1999.[9] At the 1999 Venice Biennial, Chinese artists made up the biggest group from any single country and totaled as much as one-fifth of the participants. Cai Guo-Qiang's remake of *The Rent Collection Courtyard* (*Shou zu yuan*, 1965), a famous clay work produced on the eve of the Cultural Revolution, was cowinner of the exhibition's grand prize.

Li Xianting, curator, critic, and "godfather" of contemporary Chinese avant-garde art, describes the two most prominent categories of early post-1989 art as "cynical realism" (*wanshi xianshi zhuyi*) and "political pop" (*zhengzhi bopu*). Cynical realism is a roguish, irreverent travesty of the official doctrine of "revolutionary realism" dominant during the Mao era. It includes the works of such artists as Fang Lijun, Liu Wei, and Wang Jinsong. "Political pop" gives a pop touch to revolutionary icons and usually includes images of Mao and contemporary consumerism. Artists within this group include Wang Guangyi, Yu Youhan, Li Shan, Feng Mengbo, Geng Jianyi, and others. Very often, the two types mix and become difficult to distinguish. Chinese avant-garde art, through a skillful appropriation of the language of American pop art, has been able to engage the social and political reality of post-1989 China in an original, forceful, and ingenious fashion. Precisely because the paintings have been shown outside rather than inside China, Chinese avant-garde adds a new face to international postmodernism.

To say that the "avant-garde" is "postmodern" may sound like an oxymoron, for postmodernism as the West knows it implies the "silence of the avant-garde."[10] In the West, the avant-garde has become a matter of historical past. The avant-garde's uncompromising, rebellious character has given way to the eclecticism and pastiche of postmodernism. Yet, in the cross-cultural analysis of art, we must revise preconceived notions of artistic and cultural categories, which are based on the Western experience, in view of sociological formation within third world, non-Western nation-states toward the end of the twentieth century. In the Chinese case, the avant-garde is a distinct feature of Chinese postmodernism. Due to specific social and cultural conditions, twentieth-century Chinese art does not follow exactly the pattern of successive periods and styles apparent in Western art, such as modernism, avant-garde, and postmodernism. As Li Xianting cautions us,

Contemporary Chinese society cannot be considered as either a completely industrial or a post-industrial society, and so obviously cannot have inherent in its sociology Modernist or Post-Modernist trends in the Western sense. However, in the decade since China once again opened up to the West, a peculiar cultural condition has arisen in which elements and messages of a peasant society, industrial society, and post-industrial society co-exist. This does not make for a society that can develop according to the logic of Western Modernist or Post-Modernist theories.[11]

Li notices that the hybridity and unevenness of Chinese modernity poses unique problems for Chinese artists and art historians. Contemporary Chinese art does not repeat the historical sequence of premodernist, modernist, and postmodernist art in the West; rather, it overlaps the premodern, modern, avant-garde, and postmodern at the same time.

Categories of post-1989 Chinese art, such as political pop and cynical realism, could be considered "avant-garde" insofar as state and official artistic doctrine did not tolerate their experimentation. To the establishment, the political content and artistic form of such art were deemed subversive and irreverent. No public exhibition of it was allowed in China. It remained a marginal, oppositional discourse in political and cultural terms.

On another sociological level, the Chinese "avant-garde" soon transforms itself into a "postmodern" commodity in the global cultural economy. Painters such as Fang Lijun and Wang Guangyi have become millionaires and joined China's nouveau riches. Their artworks sell well in the international art market, and art has indeed become profitable for them. Selling a painting at a price as high as $20,000 (which may be low by Western standards), these painters, nicknamed "pop masters" (*bopu dashi*) in Chinese, can own new houses, expensive foreign cars, and expansive studios.

As early as 1985, the American pop artist Robert Rauschenberg held a large-scale exhibition in Beijing. Andy Warhol also visited China in the mid-1980s. Chinese artists were drawn to pop art and played with its style, yet "no one—including artists and critics—really understood the meaning of Pop art."[12] Chinese pop art was regarded at that time as nothing more than a pale and shallow imitation of the original. The decisive change came in the 1990s with the advent of global capitalism in China and the rest of the world. The rapid expansion of a global consumer culture provided the basis for post-1989 Chinese pop art.

FIGURE 8. Wang Jinsong. *Taking a Picture in Front of Tiananmen Square* (*Tiananmen qian liugeying*). Oil on canvas. 1992. 125 × 185 cm. Courtesy of Hanart T Z Gallery, Hong Kong.

The salient features of post-New China art are evident in specific examples. Wang Jinsong's painting *Taking a Picture in Front of Tiananmen* (1992) deserves special comment at this point. One immediately notices a depthlessness in perspective, a comic and parodic effect in the portrayal of human figures in the foreground. The picture shows a group of Chinese tourists— one from Shanghai, indicated by a handbag—taking a picture in front of Tiananmen Square. The presence of the tourists eclipses a full view of the Mao portrait hung over Tiananmen Gatetower. In 1949, Mao had declared the founding of the People's Republic in Tiananmen Square. The state has also organized mass parades in the square year after year.

The square has been the symbol of China's political center. Tens of millions of Chinese citizens have dreamed of taking a picture at this hallowed place. During the Cultural Revolution, visitors customarily held a copy of Mao's Little Red Book while having their pictures taken to express the sincerest devotion to the Chinese revolution. Songs existed about people who

traveled long distances from other parts of China to this holy site to pay tribute at the nation's political center. In the photo albums of countless Chinese families there are well-kept pictures taken in front of the square. Sun Zixi's famous monumental painting *In Front of Tiananmen* (*Quanjia zhao*, also known as *A Picture of the Whole Family*), which was completed in 1964, depicts such a devotional, pious atmosphere. The setting requires from the spectator "a proper attitude toward the central icon: Mao's frontal head portrait—the so-called Helmsman's Portrait—hung on Tiananmen Gatetower in the heart of the country's symbolic center."[13]

In a more immediate historical context, the viewer also remembers a tragic event from the recent past, namely what happened on the square in the spring of 1989. Wang's flat, comic painting amounts to a parody of Maoist iconography, a satire of a time-honored revolutionary tradition, a deflation of idealism, and a sad reminder of the tragedy of 1989. The painting offers a critique and travesty of the oblivion of history and the commercialism of life in post-New China. Indeed, the painting of Tiananmen Gatetower and Square has become a popular genre among these artists, who have produced such pictures in various styles and in great quantities.

Fang Lijun's series of bald, yawning, grinning, idle men against an empty background points to the purposelessness, meaninglessness, and disorientation of everyday life in post-Tiananmen China. Fang is fond of portraying a class of people commonly referred to as *pizi* (hooligans) and often described in the stories of the popular writer Wang Shuo. In Chinese cities, this group consists of idle young men and small-time businesspeople. The pictures strike the viewer with both a sense of humor and profound sadness. The "yawn" or the "howl," as aptly described by Andrew Solomon, not Edvard Munch's existential, anguished *Scream*, best describes the post-1989, postmodern sensibility.[14]

In Wang Guangyi's *Great Criticism* series, one notices a pastiche of symbols and icons: revolutionary workers, peasants, and soldiers—all engaged in criticism of the past—as can be commonly seen in posters during the Cultural Revolution and commercials for Nikon, Kodak, Coca-Cola, Benetton, Philips, and other commodities in the age of global capitalism. The symbolic and real juxtaposition of a residual revolutionary enthusiasm with emergent transnational commodification actually makes up contemporary China. The union of disjoined, contradictory elements of social life marks the unfolding of a postmodern culture in China.

FIGURE 9. Fang Lijun. *Series II, No. 6* (*Di er zu, di liu fu*). Oil on canvas. 1991–92. 200 × 200 cm. Courtesy of Hanart T Z Gallery, Hong Kong.

Chinese political pop in the fashion of Wang reminds the viewer of Soviet Sots Art in the 1970s, which uniquely combined "socialist realism" and American pop.[15] The movement consisted of former Soviet artists such as Vitaly Komar and Alexander Melamid, most of whom now reside in New York City. Alexander Kosolapov's pieces, such as *Lenin and Coca-Cola* and *The Project of Advertisement for Times Square*, are particularly relevant. These pictures brought together a portrait of Lenin and a Coca-Cola sign and prefigured the style of some Chinese artists. Wang Guangyi's paintings offer a Chinese variation to an already international theme.

Yu Youhan, the Shanghai-based artist, loves to paint Mao over and over. In such paintings and series of his as *The Waving Mao* (1990), *With Love, Whitney* (a juxtaposition of Mao and Whitney Houston, 1993), and *Mao and*

FIGURE 10. Wang Guangyi. *Great Criticism: Nikon (Da pipan: Nikang)*. Oil on canvas. 1992. 148 × 119 cm. Courtesy of Hanart T Z Gallery, Hong Kong.

FIGURE 11. Yu Youhan. *The Waving Mao* (*Zhaoshou de Mao Zedong*). Acrylic on canvas. 1990. 145 × 130 cm. Courtesy of Hanart T Z Gallery, Hong Kong.

the People (1995), an otherwise sacred icon during the revolutionary era turns into a flat image. Colorful, decorative flower patterns often seen in Chinese folk art cover and surround Mao, all of which empties the pictures of spatial and emotional depth. The same thing can be said of Li Shan's Mao series. Sometimes Li paints a Mao portrait with a flower growing out his mouth. The poster quality in these renderings of the "Great Leader" pokes fun at

FIGURE 12. Feng Mengbo. *The Video Endgame Series: Taking Tiger Mountain by Strategy* (*Youxi zhongjie: Zhiqu weihushan*). Oil on canvas. 1992. 88 × 100 cm. (Set of 4.) Courtesy of Hanart T Z Gallery, Hong Kong.

revolutionary iconography and makes Mao into an object of public consumption. Indeed, one group of Chinese artists used "Great Consumption 1993" as the theme of their work.[16] The duplication of series of images, such as posters of healthy babies, reminds one of Andy Warhol's series of compositions as shown in his Mao, Marilyn Monroe, and Campbell soup series. Postmodern commodification has itself become the subject of representation in contemporary Chinese art.

Feng Mengbo's series of paintings make video games out of *renminbi* (Chinese currency), revolutionary operas, and ballets of the Cultural Revolution period. They also engage the past in order to describe the present. His

FIGURE 13. Zhang Xiaogang. *Bloodline: The Big Family, No. 2 (Xueyuan xilie: da jiating, erhao)*. Oil on canvas. 1995. 180 × 230 cm. Courtesy of Hanart T Z Gallery, Hong Kong.

grotesque, disproportionate, "electronic" treatment of revolutionary heroes in the "model operas" and "model ballets" of the Cultural Revolution at once reveals a psychic distance and a congenital connection between his generation and the ideals of the communist revolution. The incongruent coexistence of an (emergent) materialism and a (fading) revolutionary ethos in Feng's art is indeed the reality of "postsocialism" in China—the combination of capitalist economy and communist politics.

Zhang Xiaogang's family series is based on black-and-white pictures of Chinese families taken in the socialist period (1950s–1970s). Yet this "photo-realism" is soon transformed into a surrealist, disturbing portraiture of the (un)happy union of Chinese families during the Mao era. Expressionless faces, empty stares, uniform clothes, stiff postures, and the absence of joy, sorrow, and anger reveal a total lack of individuality. Zhang's nostalgia for the bygone era and his childhood (he was born in 1958) is at the same time a criticism of a stifling lifestyle. Liu Wei's deliberately grotesque, distorted

portraits of *Dad and Mum* are an even more direct attack on the awkward and unhealthy state of the Chinese family.

The post-New aura can also be demarcated by looking at how its artistic expressions differ from those of the New Era. One can think of Luo Zhongli's immensely famous oil painting *Father*, produced at the beginning of the 1980s. The frontal close-up of the rough, wrinkled, weather-beaten face of a peasant who holds a bowl represents the search for a new ancestral icon to replace the dominance of the Mao portrait.[17] The painting is marked by a new realism, an uttermost sincerity, and a high seriousness.

In a different vein, Xu Bing's monumental work *A Book from the Sky* (*Tianshu*, also known as *A Mirror to Analyze the World* [*Xi shi jian*]) can be taken as another landmark piece of the New Era. Xu spent many years carving thousands of characters to print a series of books and scrolls.[18] These characters are composed in the same way as regular Chinese characters, and they look like real Chinese characters for those unfamiliar with the language. Yet upon closer examination, they are nonexistent, meaningless words. Sometimes the book format resembles that of a classical text where exegesis and commentary printed in a smaller size follow the text. Xu's manner of engaging Chinese tradition is iconoclastic and "totalistic." He attempts to dismantle thousands of years of Chinese tradition in one stroke. His cultural critique is the very deconstruction of meaning in Chinese. Such a manner of questioning the foundation of Chinese culture characterized the critical style in the 1980s.[19] To take cinema as another example, Chen Kaige's early films, such as *Yellow Earth* (1984), *King of Children* (1987), and *Life on a String* (1991), similarly critique the past. These films endeavor to interrogate Chinese culture from the ground up. The same thing can be also said of many literary works during the period.

In brief, Chinese avant-garde art since 1989 has come up with new styles and ways to express the psychological, social, and cultural currents of contemporary China. If art in the New Era was mainly the relentless, fearless, and direct critique of China's past and present while constructing a new historical subject—a Chinese modernity—art in post-New China involves compromise, indirect intervention, parody, and pastiche. Just as the official slogan of the state in the 1990s stressed construction of a "socialist market economy" and "socialism with Chinese characteristics," one can say that the

FIGURE 14. Xu Bing. *A Book from the Sky* (a.k.a. *A Mirror to Analyze the World, Tianshu/Xi shi jian*). Installation/mixed media. 1987–91. Courtesy of Xu Bing.

culture dominant in the post–New Era is postmodernity with "Chinese characteristics," a "post-socialist postmodernity."

American Postmodernism vs. Third World National Allegory?

Contemporary avant-garde art offers the most graphic and vivid index of China. Sometimes labeled as "political pop," art in this genre is in the most literal sense a pastiche of a residual revolutionary ethos and an emergent capitalist commercialization. These paintings juxtapose images of Mao and the revolutionary past with signs of contemporary commercialization: commercials, billboards, and advertisements. There is no pictorial deep perspective, no depth, but only the flat surface. The pictures erase distinctions between high and low, sacred and profane. Insofar as political pop alludes to the revolutionary past, there is a lingering, minimal degree of "national allegory." More obviously, what one witnesses is the transnationalization and commercialization of cultural production, exhibition, and consumption.

I argue that the postmodern pastiche is on the rise and that the national allegory typical of third world literature, as defined by Fredric Jameson in the mid-1980s, is no longer the dominant mode of literary and cultural expression in post–third world countries like China.[20] The globalization of economic and cultural production has rendered the distinction between third world national allegory and American postmodernist art tenuous.

Nevertheless, this does not mean that political allegory is altogether nonexistent in Chinese postmodern art, for the contrary seems to be true. In his comment on Andy Warhol, Jameson invites us to wonder seriously "about the possibilities of political and critical art in the postmodern period of late capital. . . . Andy Warhol's work in fact turns centrally around commodification, and the great billboard images of the Coca-Cola bottle or the Campbell's soup can, which explicitly foreground the commodification fetishism of a transition to late capital, *ought* to be powerful and critical political statements."[21]

Not unlike Warhol's paintings in a Western transitional period of capitalism, the works of contemporary Chinese avant-garde artists can be read as a series of parodies and cartoons about Chinese reality in the age of global capital. Their images, some rather grotesque, are isomorphic and symbiotic

with, and symbolic and symptomatic of, the contradictions of the "socialist market economy" that is contemporary China. Art becomes at once a pastiche and commentary of bygone revolution, socialist experiment, modernization, and commodity-fetishism. Despite the weakening of the political allegory in Chinese postmodern art, the artists have come to terms with a new way of fashioning, imagining, and imaging the Chinese experience.

Installation, Body, Performance, Video, and Mixed Media

The second wave of post-1989 avant-garde art, which is not strictly speaking chronological but followed the first in terms of international reception, is emergent installation, performance, body, video, and mixed media art. Practitioners, critics, and advocates of such art claim that political pop represents only a small segment of the contemporary Chinese art scene, and has in fact already passed. They proclaim that they themselves will not play the "political card," as the political pop artists did. Some of them attempt to contribute to the creation of an international postmodern art regardless of nationality and ethnicity. Their art aims to generate innovation in ideas, media, and artistic language. These artists explore the very status of art, the interrelations of various media and materials, and the nexus between art and life. In the indefinitely expanding field of avant-garde art, everything is possible for the Chinese artists. Although distancing themselves from the artistic strategies of political pop, their desire for international recognition is no less strong.

It should be emphasized that experimental Chinese art as such in the post-1989 period has been labeled, quite appropriately, I think, as *avant-garde art*. Such art is iconoclastic, subversive, and antiestablishment. It ought to be taken as a political gesture, regardless of content, by virtue of being denied official recognition in China throughout most of the 1990s. Most exhibitions of this art have been organized either as underground events inside China or in legitimate venues outside China. It should also be noted that much installation art, unlike the oil painting of political Pop, is uncollectible, noncommercial, and nonlucrative. Many of its artist-practitioners lack institutional affiliation, and they constitute one of the most marginal, displaced classes in Chinese society.

The Chinese avant-garde includes some artists who live and work in

China, as well others who originally came from China but now reside in the Chinese diaspora (North America, Europe, and so forth).[22] Some of these artists (Gu Dexin and Wang Jianwei, for example) are more engrossed in matters that concern exploration of the human condition and the artistic language of the international avant-garde than in signifying "China." Others, especially overseas artists, tend to confront cross-cultural dilemmas, reflect upon their Chineseness, and search for the relationship between China's heritage and its insertion into contemporary global culture. In a recent study that discusses U.S. and European postminimalist art in the postmodern era Irving Sandler has written the following: "Postminimalists dematerialized the object (process art); spread it out into its surroundings (process art and earth art); formulated an idea and presented that as a work of art (conceptual art); and employed their own bodies in performance (body art). Ephemeral 'situations' in actual space and real time struck the art world as radical because they dispensed with art-as-precious-object."[23] Sandler describes exactly what is happening on the Chinese scene today. The radical expansion of art as a field raises questions, in turn, about what constitutes art in China. To me, the Chinese avant-garde is *postmodern* because it shares the assumptions and strategies of international postmodern art.

For video and mixed media artists such as Zhang Peili, Wang Jianwei, members of the former "New Measurement Group" (*Xin jiexi xiaozu*, Wang Luyan, Gu Dexin, and Chen Shaoping), and many other Chinese practitioners of "conceptual art," art is a process of depersonalization and de-aestheticization. These artists strive to discover a "new structure" of perception, meaning, and the world. The interrelations of various materials and media; the status and function of art; the nature of representation and signification; the relation between the social and the natural, and between humanity and ecology; are among the themes of their art. The postmodern turn, evident in the work of these Chinese artists, can also be described in the words of Fredric Jameson: "Indeed, we may speak of spatialization here as the process whereby the traditional fine arts are *mediatized*: that is, they now come to consciousness of themselves as various media within a mediatic system in which their own internal production also constitutes a symbolic message and the taking of a position on the status of the medium in question."[24] The techniques and experiments of these artists belong to a global avant-garde, postmodern art.

The body art of Zhang Huan provokes the audience to think about the condition of life and art in China. His performance *65 Kilograms* (June 1994) refers to his own body weight. The artist was bound naked with ten iron chains to a horizontal bar three meters above the ground. An electric stove was placed beneath it, on a stack of white mattresses, and the stove heated an iron plate. A doctor drew 250 milliliters of blood from the artist. The blood was then slowly dripped onto the heated plate. It burned right away, and a strong, pungent smell filled the whole room. The self-abuse throughout the performance lasted for a period of an hour and a half. The body of the artist /performer became the material of art. The viewers were involved in the "situation" of the performance and experienced the theatricality of this enactment of postminimalist, postmodern art in time. Viewers need to decide if they want to push the "representational" potential of such art to an extreme. That is, they must decide whether it is possible to force some "national allegory" into the performance, and whether the theatrical in this instance is symptomatic and symbiotic of the "postmodern" stage of the Chinese nation.

Wang Luyan's various installations and mechanical devices play with logic or antilogic, and interrogate ingrained patterns of thought in people's minds. Best known is his installation work *Bicycles*, which he has exhibited on different occasions. Wang changes the mechanism of bicycles by adding two small free wheels to the rear wheel, which causes the bicycles to move backward when people pedal forward. This change creates tension between human beings and machines, and gives rise to doubt and confusion concerning past experience and common sense. Wang's tampering with the mechanisms of machine in what seems to be the common artistic language of the international avant-garde may yet have a distinct Chinese character, for it is known that China is the "country of bicycles." Riding a bicycle is not a leisurely, recreational, and sporty event, as in the United States. Bicycles have long been one of the most basic means of transportation for members of the average Chinese household. Wang's work brings out in sharp relief the conflict between humanity and technology in contemporary China.

Yin Xiuzhen's 1995 installation/performance *Washing the River* (*Xi he*, in Chengdu) is itself an act of cleaning the heavily polluted environment. She attempted to raise the spectator's awareness of the conflicting relationship between the social and the natural in China's ever escalating modernization and industrialization. The installation *Sowing and Planting* (*Zhong zhi*, bal-

loons, socks, clothes hangers, flowerpots, 1995) is another spatialization of interrelationships among nature, culture, and ecology. Her installation *Ruined Capital* (*Feidu*, summer 1996) brings back memories from the past through an assemblage and collage of fragmentary materials. The long stretch of gray tiles, cement, and pieces of furniture (table, dresser, wardrobe, bed, chairs, mirrors, washing basin) are indexes of material objects that made up and were sought by the average Chinese household in the heyday of socialist construction during the Maoist era (1950s–1970s).

As with many Chinese women artists, Yin's works often reveal a feminine touch, a "post-feminist" inclination. Her works suggest concern with domestic and traditionally feminine domains of activity.[25] (See other works of hers that deal with woolen sweaters and women's shoes.) In *Ruined Capital*, the private, interior space of the family in a bygone era is turned inside out for public gaze in the Exhibition Hall of the Capital Normal University. Amidst the shattered, decomposed, strewn fragments of the past, the dream and promise of the wholeness of the modern Chinese family is also broken. This re-collection of familiar familial objects from the past calls to mind an ultimate object, the "sublime object of ideology": "modern China." *Ruined Capital* represents Yin's succinct configuration of the state of affairs in late-twentieth-century China that the author Jia Pingwa laboriously describes in his work by the same title (*Feidu*) through a different medium—the novel.

Zhang Peili's installation *Divided Space* (*Xiangdui de kongjian*, at Centro d'Art Santa Monica, Barcelona, Spain, 1995) immediately evokes a claustrophobic ambiance. The installation divides space into two tiny, boxlike rooms. The activities in one room can be observed at all times from another room through a surveillance monitor placed in the middle wall between the two rooms. Needless to say, such enclosed space severely restricts the movement of human beings. (The cinematic counterpart to Zhang Peili's simple, compact installation would be Bernardo Bertolucci's extravagant, nearly three-hour-long production *The Last Emperor,* or Zhang Yimou's glamorous feature *Raise the Red Lantern*. In both films, walled-in human space threatens to annul temporality. The imprisonment of the inhabitants in physical space turns into a national allegory, and alludes to the situation of the "iron house" that Lu Xun described). Such postmodern Chinese art opens up the issue of possible political intervention.

A reflection on traditional Chinese culture and aesthetics comes into exis-

FIGURE 15. Yin Xiuzhen. *Sowing and Planting (Zhong Zhi)*. Installation. 1995. Courtesy of Yin Xiuzhen.

FIGURES 16 AND 17. Yin Xiuzhen. *Ruined Capital* (*Feidu*). Installation. 1996. Two images. Courtesy of Yin Xiuzhen.

FIGURE 18. Zhang Peili. *Divided Space* (*Xiangdui de kongjian*). Installation. 1995. Courtesy of Huang Du.

tence in Qiu Zhijie's installation/performance *Copying the "Orchid Pavilion Preface" a Thousand Times* (*Shuxie yiqianbian Lantingxu*, 1992–95). The "Orchid Pavilion Preface" was written by Wang Xizhi (fourth century A.D.), one of the most famous Chinese calligraphers. The piece has been esteemed as a rare masterpiece of calligraphy for centuries. Practicing calligraphy by imitating the style of an ancient master, the "Wang style," has always been regarded as an important self-cultivation, a spiritual process, and an awakening experience. One's calligraphic style has been taken as a mark of one's personality and individuality. Yet copying the same text as many as a thousand times on the same piece of rice paper to the extent that the text becomes illegible defeats the very purpose and meaning of calligraphy. The

FIGURE 19. Qiu Zhijie. *Copying the "Orchid Pavilion Preface" a Thousand Times* (*Shuxie yiqianbian Lantingxu*). Installation/performance. 1992–95. Courtesy of Hanart T Z Gallery, Hong Kong.

solemn practice of calligraphy is transformed into a meaningless postmodern game, an absurd play of signifiers without signification. Indeed, the repetitive, mechanical nature of Qiu's work allows the viewer to question the cherished rituals and procedures of traditional Chinese art and culture. Yet on another level, after endless copying the paper has turned into a multilayered, richly textured, painterly surface, which seems to have become a new kind of material and medium for artistic experimentation.

Cultural Alterity and Identity in Diasporic Art

The work of overseas Chinese artists focuses not so much on the search for some common language of the international avant-garde, but on the cultural politics of alterity. Cultural identity in the postmodern and postcolonial world becomes the main theme. The artist functions as an ethnographer. His/her field of experimentation is the ethnic and cultural other. Yet, since the artist is an ethnic Chinese residing in the West, he/she plays the double role of native informant as well as ethnographer. Diasporic art then becomes "self-ethnography" and self-othering.[26]

The ethnography paradigm informs the recent work of such artists as Zhu Jinshi and Xu Bing. A Chinese artist residing in Germany, Zhu travels between Berlin and Beijing, and both places serve as sites for his creations. Zhu explores the delicate balance between artistic media and the environment and the relation between nature and culture in his site-specific installation works completed in Beijing. These works include *Water of Lake Houhai* (*Houhai hushui*) (bamboo baskets, rice paper, cement, paint, water, Lake Houhai, 1995), *Water Clock* (*Shuizhong*) (bamboo baskets, cement, paint, water, 1995), *Boulders and Rice Paper* (*Jushi/xuanzhi*) (at Eight Kings' Tombs in the northern suburbs of Beijing, 1994), *Rice Paper Pile* (*Xuanzhi dui*, 1994), *Stone Wall with Rice Paper* (*Shiqiang/xuanzhi*) (at Baiwang Mountain, 1994), *Rice Paper Floating in a Small Stream* (*Xiaoxi/xuanzhi*) (at Dajue Temple, 1994), and *Sunflower with Rice Paper* (*Xiangrikui/xuanzhi*) (Liyuan Garden, 1994).

Rice paper, the very medium of traditional Chinese art (painting and calligraphy), is the object, material, and medium of representation. Zhu's work exhibits traces of Italian *arte povera*, minimalist features, and the post-

FIGURE 20. Zhu Jinshi. *Water of Lake Houhai* (*Houhai hushui*). Installation. 1995. Courtesy of Zhu Jinshi.

minimalist genealogy. Simple and minimal as his materials and art objects are, they entice the viewer to experience something like a sudden awakening, a grasp of the gestalt of the worldhood of the world. This is not the "objecthood" of some precious minimalist artwork, but the pattern and nature of the inner relationships of the "situation" and its surroundings. This is the "worldhood" of a world made out of spatial arrangements of bamboo baskets, water, cement, stone, and rice paper, a world whose materiality and spirituality can only come to human understanding, not through some disinterested contemplation, but by pacing back and forth around the artwork through time. A work such as *Water of Lake Houhai* brings social labor, nature, art, earth, water, and the sky to an order of meaningful coextension.

The viewer also finds it difficult not to be affected by what seems to be an underlying Chinese, Chan (Zen) aesthetic. The site-specific installations convey an aura of tradition, tranquillity, and "Chineseness," and intend to induce some form of spiritual enlightenment. In such Berlin installations of his as *Impermanence* (*Wuchang*) (sculpture installation, iron plates, a pine tree, stones, *Ruine der Kunste* [ruins of arts], 1995) and *The Word of Chan: Puzzle* (*Chanyu/huo*) (copper plate, trees and chairs, Kauzchensteig 10, 1995), traditional Chinese aesthetics are brought into contact and cohabitation with a European environment. In poeticizing and orientalizing the ruins of Berlin, the artworks purport to materialize an aesthetic fusion between the East and the West, and between tradition and modernity. They also pose the question of how to grasp permanence within impermanence, or how to understand change amidst the ruins and fluctuations of time, a theme perennial to traditional Chinese thought. At the same time, the title *Impermanence* is self-referential in commenting on the artwork itself, namely, the nature of a site-specific installation that is ephemeral, quickly dismantled after the exhibition, and rarely makes its way to become some "permanent" collection.

Zhu's art achieved its purest and clearest expression in his two-part Berlin-China 1996 exhibition *Impermanence* (*Wuchang*), also known as *Square Formation* (*Fangzhen*). In the Exhibition Hall of Capital Normal University, June 29–July 4, 1996, Zhu piled together fifty thousand pieces of rice paper and created a gigantic visual spectacle. Zhu first wrinkled all the pieces, then straightened them out and stacked them in the hall. From an aerial perspective, the fifty thousand pieces of rice paper looked like a huge

FIGURE 21. Zhu Jinshi. *Square Formation/Impermanence* (*Fangzhen/ wuchang*). Installation. 1996. Courtesy of Zhu Jinshi.

square (1,500 × 1,500 × 300 centimeters). A narrow passage allowed the viewer to walk through the installation. As the exhibition ended, Zhu splattered water and ink on the paper and then transported the entire exhibit to a field, where it was burned. He repeated the same procedure in the second leg of the exhibition, which occurred in September 1996 in Berlin's Georg Kolbe Museum. Through such artistic practices, Zhu interrogates traditional Chinese art, its institutions, language, and mode of expression.

One of the best-known and most noted Chinese avant-garde artists in the United States is Xu Bing, who lives in New York City. His international status was publicly acknowledged when he became one of the few recipients in 1999 of the MacArthur Award in the category of artist, which yielded him a sum of more than $300,000 over a five-year period. As mentioned earlier, Xu first shocked the art world with his massive installation *A Book from the Sky* (*Tianshu*, 1987–91). Xu carved some four thousand handsome pseudo-Chinese characters, printed them on Chinese paper, and bound them in the traditional book format. The gigantic installation, which filled the exhibition hall, was a play of signifiers without signifieds and referentiality.

FIGURE 22. Xu Bing. *A Case Study of Transference* (a.k.a. *Cultural Animals, Wenhua dongwu*). Installation/performance. Hanmo Art Center, Beijing, 1994. Courtesy of Xu Bing.

Whereas some viewers appreciated Xu's masterful craftsmanship, others found that this most solemn, meticulous exercise in absurdity amounted to a devastating deconstruction of Chinese language, culture, tradition, and meaning itself.

While continuing to explore questions about language and communication, Xu's later work has taken a *cross-cultural* turn. Cultural identity and intercultural relationhips between East and West come to the forefront in such works as *Post Testament* (1992–93), *A Case Study of Transference* (1994), and *Square Words: New English Calligraphy for Beginners* (1994–96). In *A*

FIGURE 23. Xu Bing. *Square Words: New English Calligraphy for Beginners*. Mixed Media. Copenhagen, 1996. Courtesy of Xu Bing.

Case Study of Transference (also known as *Cultural Animals*, performance, installation), a male and a female pig in their high breeding season were enclosed in a pen strewn with books. Unreadable English words were printed all over the body of the male pig, and the female had nonsensical Chinese characters printed on hers. After a period of courtship, the two mated in the exhibition area, surrounded by spectators. The original title, later abandoned, was *Rape or Adultery?* Although the Beijing audience in this underground exhibition was both amused and embarrassed as observers watched these two "cultural animals" mate, Xu Bing also provoked spectators to ponder the nature of the relationship between China and the West, and to observe the patterns of power imbalance, violence, and complicity involved in any "cultural transference."

In the ambitious project *Square Words* (also known as *Interzones*), Xu matched each letter of the English alphabet with a Chinese word radical, designed a system of translation between Chinese and English, and thus completely converted English words into Chinese characters. Xu gave comprehensive guidelines for beginners to practice this new English calligraphy

in traditional Chinese style. Spectators could practice this writing on the "red line tracing book" (*miaohong*) provided for them, and thus become active participants in a "cultural transference" of sorts. Xu turned exhibition halls in Copenhagen, Uppsala, Pittsburgh, Munich, and other cities into study rooms where the visitors could sit at desks practicing Xu's new English calligraphy and be immersed in a different, unfamiliar sign system. In handling ink and brush and tracing Chinese/English characters on soft-textured rice paper, the Western audience went through an experience of self-othering and self-exoticization within Xu's creation. Later, Xu collaborated with computer specialists to produce software and a database in order to popularize his invention. More textbooks and training sessions will be made available. According to Xu, his enterprise resembles the mass literacy campaigns organized in China during the 1950s to educate illiterate peasants and workers. Xu also claims that his audience has always consisted of enthusiastic learners.[27]

The works of Zhu Jinshi, Xu Bing, and others engaged audiences and invited them to meditate on and to mediate the cultural interface between China and West, the relation between globalization and localism, and the synergies of nature and art. An aura of traditional Chinese aesthetics implicit in their artworks was reconfigured and recomposed through the media and technologies of the late twentieth century. In representing the paradox and enigma of communication, signification, and transference, their works struck viewers as both familiar and strange, traditional and postmodern. Their approach to resolving the tensions brought about by globalization and commodification was through rethinking and redeploying the traditional. In their art one catches a glimpse of something in the order of "utopianism after the end of utopia."[28] Their flight from the contemporary was at the same time the most powerful entry into and critique of our postmodern present.

EIGHT

The Uses of China in Avant-Garde Art: Beyond Orientalism

Contemporary Chinese avant-garde art has received much international attention in recent years. Many prominent artists of Chinese origins have chosen to live abroad in places like the United States and Europe. In the case of artists living within China, international art circuits become their primary vehicles of exhibition because they lack domestic support within the country. Although all these artists are labeled and recognized as "Chinese artists," the ways in which they broach the subject of China or Chineseness in their artworks are rather different.

It is timely to reflect upon the nature of transnational visuality, that is, the conventions and strategies of representing China in the postmodern age of global visual spectacles. Chinese artists seem to have several important ways to image the subject of China, which brings up the issue of orientalism in art, namely, the procedures of representing, mapping, and domesticating the cultural other and the self. It is important to search for alternate strategies that question orientalist habits of thought.

Obviously, one chief strategy clearly demonstrated in political pop is to politicize China. This strategy uses politics as a cultural resource in the international arena. This approach to art resembles that of masters in the New Chinese Cinema, who produced such internationally arresting tales as *Raise the Red Lantern* (1991), *To Live* (1994), and *Farewell My Concubine* (1993).[1] Another closely related strategy is to exoticize China. Paradoxically, transnational visuality requires fabrication of a semblance of the local, the primitive, and the indigenous. To succeed with efforts to exhibit China in the global art market and at international film festivals the artist/filmmaker sometimes adopts such a strategy of self-representation so as to exoticize and orientalize China. One must create some sort of localism, a regional flavor, a certain "Chineseness," an indigenous appeal, an oriental aura, a cultural other.

We can pose the central question rather bluntly: what is Chinese art? Or, what is good Chinese art in the international market? The point is this: what kind of "Chinese" artwork gets exhibited and recognized in the international arena? It should be evident that the "West"—its media, art, popular culture, Hollywood, and so forth—necessarily uses similar strategies of politicizing and exoticizing China and the "East" in order to appeal to a large domestic and international audience. One recalls films that range from Bertolucci's *The Last Emperor*, made in the mid-1980s, to more recent films such as *Red Corner* (1997), *Seven Years in Tibet* (1997), *Kundun* (1997), and Joan Chen's *Xiu Xiu: The Sent-Down Girl* (1999).

In this chapter, I outline and analyze three major procedures in which the contemporary avant-garde has appropriated China. First, it has tended to highlight Chinese culture and tradition directly to provide an alternate to dominant Western modes of representation and thought. I use the examples of Qin Yufen, a Chinese woman artist who now lives and works in Germany, and Ju Ming, a Taiwanese sculptor whose works are regularly exhibited overseas. The second approach uses parody to turn the Chinese tradition against itself to reveal and critique conventional manners of thinking about the Chinese and the East. Here I turn to Xu Bing and Cai Guo-Qiang, two well-known Chinese artists now based in New York, and Chen Zhen, a Chinese artist who resided in Paris. I also go further back to the Chinese-Canadian-American artist Joseph Tseng. The third strategy is to obliterate utterly any trace of China or Chineseness so that the Chinese artist joins a broad international postmodernism that transcends national and cultural specificity. I

briefly discuss the installations of Gu Dexin and Wang Youshen, two Beijing artists whose works have been exhibited internationally, and Wu Mali, a distinguished Taiwanese woman artist.

Signifying Chineseness

Qin Yufen (Zhu Jinshi's wife), a Chinese woman artist living in Germany, mediates between China and the West. In the 1994 two-part installation *Lotus in Wind* (*Feng he*), she spread and "planted" ten thousand Chinese lotus fans, as symbols of withered lotus, in Kunming Lake, at the Imperial Summer Palace in the suburbs of Beijing, and originally planned to do the same at the lake of Charlottenburg Palace in Berlin. Through the mechanism of postmodern installation art she joined the aesthetics of the traditional Chinese garden with the classical European past. In such a postmodern spectacle, Qin invited the spectator to think about questions concerning the relation between high art and low art, between East and West, and between tradition and modernity.

Qin works through a large repertoire of familiar themes and motifs in classical Chinese literature and art, and focuses especially on feminine subjects. Her installation and mixed media works in this category include *Solitary Clouds* (*Gu yun*, 1996), *Spring in the Jade Hall* (*Yutang chun*, 1995), *Light Boat* (*Qing zhou*, 1995), *Silent Wind* (*Wuyan de feng*, 1997), *Chan Juan—Moon Goddess* (1998), *Long Corridor* (*Chang lang*, 1998), *Blue Jade Table* (*Qing yu an*, 1991), and *Zhao Jun* (1993).[2] Some of these works are multimedia texts that involve sound.

The story of *Yutang chun* (literally, "Spring in the Jade Hall") is collected in Feng Menglong's anthology of vernacular short stories *Tales to Caution the World* (*Jingshi tongyan*, 1624) as its twenty-fourth tale. The story of Yutang chun and her lover has remained a popular tale among the people, and has been adapted into local operas. *Spring in the Jade Hall* consists of clothes hangers, washstands, rice paper, CD players, and loudspeakers. Faint, rearranged Peking opera music of *Yutang chun* is heard as an integral part of the exhibition. The jarring yet harmonious blending of traditional Chinese culture and the modern materials of contemporary avant-garde induces the viewer to meditate on the nature of Chinese literati culture and popular cul-

FIGURE 24. Qin Yufen. *Lotus in Wind* (*Feng he*). Installation. 1994. Courtesy of Qin Yufen.

ture, as well as on the fate of women. At the same time, the piece stretches the narrative potential of installation art by incorporating music and sound and through evocation of a classical tale and Peking opera.

Qin says the following about her art: "Calm—that's what I aspire to with my installation. As a matter of fact, I attempt to create a special atmosphere in which the viewer overcomes his everyday life. I want people to rediscover calmness in viewing my work; I want to put them in a meditative mood in which they can see, feel, and breathe the poetry of everyday life."[3] Tranquillity, something perceived as a quintessential quality of classical Eastern art, underlies much of Qin Yufen and Zhu Jinshi's art.[4]

In December 1997 and January 1998, preeminent veteran Taiwanese sculptor Ju Ming (pronounced Zhu Ming) transported eighteen of his sculptural/installation works from the *Tai Chi* series to Paris for exhibition in Place Vendôme. The exhibition was seen as a landmark event for Asian art, and Ju was hailed as Asia's foremost sculptor, "Henry Moore of the East." The overwhelming presence of these monumental figures practicing Tai Chi in various poses instantly took the viewer back to an otherworldly reality—ancient China. In previous exhibitions, these figures in wood or

FIGURE 25. Ju Ming. *Tai Chi Single Whip*. Sculpture. 1985. Courtesy of Hanart T Z Gallery, Hong Kong.

bronze were installed at various sites—in nature, in the woods, in a green field, at the seaside, in the snow, under bright sunshine, and in front of a gigantic office building (Bank of China) in downtown Hong Kong. The bulky yet graceful Tai Chi figures blended harmoniously with the natural surroundings, with "heaven and earth," and transformed the barren cityscape into a new world of equilibrium and peace. The Tai Chi installations appeared at once abstract and familiar, traditional and postmodern, Chinese and Western. "They are tense with life, the movement dramatically arrested; they seem rooted in Chinese culture yet utterly spontaneous. In these striking figures Ju Ming brings modern Chinese sculpture to life...."[5] "Naturalness" and "Chineseness" have been described as the essence of Ju's work. Herve Odermatt, cocurator of the Paris exhibition, wrote the following about Ju Ming:

> In times such as these, when the Western World is viewing the start of a new millennium with trepidation, China remains intriguing and fills us with worry.... We ourselves experience a poetic exaltation in front of these bronze giants which so appeal to our need for order and our belief in harmony and communion.... Because of the freedom and power emanating

from his work, Ju Ming can be considered as the first modern sculptor while remaining quintessentially Chinese.[6]

Ju Ming himself has practiced Tai Chi devoutly for years—and herein lies the unity of art and life. His former teacher suggested that he practice Tai Chi to strengthen his frail physical condition. Since then, he has done it diligently for decades. Throughout Chinese history Tai Chi has been seen as a way to train the body and cultivate the mind. Says Ju, "The artist must live a simple, natural life. He must go back to nature and preserve a playful, childlike heart to keep from becoming jaded." This advice is called "defining the self," something that takes a lot of practice to achieve.[7]

Ju Ming's majestic construction of Chineseness in his art lies at one end of the wide spectrum of visual arts in pan-Chinese communities (Taiwan, Hong Kong, China, and the diaspora). Such a discourse is predicated upon a set of qualities perceived as fundamentally Eastern and Chinese: harmony, self-cultivation, and naturalness, qualities that curators and critics have noticed and that the artist himself has pointed out. No one should doubt the sincerity and unity of Ju Ming's life and work. For a long time a large number of Western art historians have viewed the Chinese art system as the other of Western modernism, as a healthy, defamiliarizing, and regenerating alternative to Western art.[8] The Eastern system may offer a way out of standard Western modes of perception and representation. This possibility is why the works of Qin Yufen, Ju Ming, and others appear so otherworldly and refreshing to those accustomed to traditional Western conventions of configuring reality.

Parodying Chineseness

I will now dwell on another direction in contemporary avant-garde that tends toward a searching critique of Asian art's self-orientalization. This is not to dispense with signifying Chineseness in visual representation, but to use the subject against itself, turn it upside down, and interrogate it. Artists of this persuasion attempt to unmask certain conventions and habits of thought among the Western audience, as well as among Chinese artists. This is not easy. Sometimes the choice between adopting and unmasking these

conventions overlaps, and the viewer must interpret and dissect what he/she sees. There is a very thin line between these two possibilities, and one must carefully distinguish between orientalist discourse and the critique of orientalism.

What might be called "postorientalism" in art is a new way of engaging, questioning, and rehearsing from an ironic distance previous and still prevalent orientalist modes of imaging and fashioning China, the East, and the third world. Gyan Prakash speaks of a "new post-Orientalist scholarship." We may borrow his words to describe a new "postorientalist art":

> The new post-Orientalist scholarship's attempt to release the third world from its marginal position forms a part of the movement that advocates the "politics of difference"—racial, class, gender, ethnic, national, and so forth. Two points are worth noting about this phenomenon. First, it posits that we can proliferate histories, cultures, and identities arrested by previous essentializations. Second, to the extent that those made visible by proliferation are also provisional, it refuses the erection of new foundations in history, culture, and knowledge.[9]

Although Prakash's unequivocal, forceful statement—or any other flat theoretical generalization—may not apply to the subtlety and nuances of experimental art, it does provide some clues for a postorientalist scholarship of art. Postorientalist artworks then become sites of contest between different modes and conventions of seeing the East and the third world. To my mind, two specific areas are most noticeable in this context. First, there is the question of hegemony or unequal power relationships between the East and the West in the processes of transnational transactions that involve the visual arts. For instance, we have witnessed Xu Bing in his *A Case Study of Transference* taking on the structure of domination and complicity between the first world and the third world. Second, postorientalist art and postorientalist scholarship alert us to the question of "perception," namely, how artists, critics, and connoisseurs perceive, reify, commodify, and appropriate "cultural difference" in the global art market. The "politics of difference" or "identity politics," originally envisioned as contestatory acts, must be aware of the danger of slipping into marketable cultural commodities. As we have seen, the commodification of art happens often even though the artwork in question tries to critique commodification itself.

We can take another variation of Xu Bing's pig series as an example. In *Cultural Animal: Panda Pigs*, an exhibition at the Wood Street Galleries in Pittsburgh from August to October 1998, three live New Hampshire breed black and pink pigs were put in the exhibition space, which was transformed into a spacious pigsty. The pigsty had bamboo trees and rocks, the very objects one sees not only in the wilderness, where pandas roam and eat, but also, more importantly, in a traditional literati garden. The background of the pigsty was a large wall/screen, on which a traditional Chinese landscape painting was projected. In the exhibition area, there was a plaque that introduced the panda species, as one would see in a zoo, and two Chinese garbage Dumpsters shaped like panda figurines, as a visitor would find in a park at present in China.

Each of the pigs initially wore a panda mask. However, over the course of their sojourn they helped each other take off the masks, as recorded by a video camera. Obviously, they were unhappy about their new identity and wished only to be themselves. Though largely overdrawn and much too exaggerated, this exhibition of "panda-pigs" challenged the audience to critically rethink popular icons of China. Furthermore, the exhibition raised questions about the nature of interspecies transference between pigs and pandas, or more to the point, "intercultural transference."

Daily Incantations (*zhou*) by Chen Zhen, a Chinese artist who lived in Paris, was part of the *Carnegie International Triennial Exhibition 1999/2000* in Pittsburgh (November 6, 1999–March 26, 2000). Upon entering the main entrance of the exhibition hall, the viewer immediately confronted Chen's gigantic installation, the first piece of the show. One hundred and one chamber pots hang on tiered racks. The setup of these pots and racks directly evoked ancient Chinese bronze bells (*bianzhong*) from more than two thousand years ago. The ancient bells are prized archeological discoveries and the pride of Chinese civilization. The hung chamber pots thus brought up two layers of memories: the ancient Chinese past and the immediate past of Chen's childhood memory in Shanghai at a time when Shanghai residents used them.

In the middle of the installation stood a globe filled with discarded postindustrial waste materials: computers, radios, TV sets, tape recorders, cables, and wires. The "globe," a vivid metaphor of globalization, stood in juxtaposition to the chamber pots and to memories of China's past. The way of life in Chen Zhen's childhood days, along with the chamber pots, are dis-

FIGURE 26. Chen Zhen. *Daily Incantations* (*Zhou*). Installation. Wood, metal, chamber pots, electrical appliances, television, radios, and electrical cable. 1996. 230 × 700 × 350 cm. Courtesy of Chen Zhen.

appearing in the rapid industrialization and development of present-day Shanghai, which is slated to be the most futuristic city in China. Viewers at the exhibition also heard the sound of women washing chamber pots. This was a daily morning ritual for Shanghai women, as Chen witnessed in his childhood. The practice of "daily incantation" also implied daily chanting of Mao's Little Red Book during the Cultural Revolution, which was also part of Chen's upbringing.

Daily Incantations was one of the most richly layered installations produced by Chinese artists. The various levels of juxtaposition, memory, temporality, and spatiality in this multifaceted, overdetermined artifact bespoke the emergent and residual social and cultural formations of contemporary China, which themselves have resulted from a complex series of successive and overlapping historical developments. The installation stood as a powerful commentary on the past, present, and future of China as it utilizes dis-

parate materials and symbolic resources from different periods of Chinese history.

The English translation of this work's Chinese title, *zhou,* as "incantations," misses half its original meaning in Chinese. *Zhou* also signifies the act of "cursing" somebody or something. The Chinese title thus carries a double connotation lost in the English rendition. *Daily Incantations* implied simultaneous prayer and curse, piety and blasphemy. Whereas "daily incantations" cleanse body and soul, "daily curses" condemn the indignities of the Maoist past, as well as the invasion of private space by the forces of present-day globalization.

It is no coincidence that Chen Zhen's work *Daily Incantations* was the first piece that visitors saw as they entered the exhibition hall. The central theme of this piece and its relevance for an international art exhibition at the turn of the millennium seem all too obvious. *Daily Incantations* addressed current international dilemmas in a powerful and provocative way, as have many of Chen's other major works such as *Fifty Strokes to Each* (*Jue chang*), last exhibited at the Venice Biennial in the summer of 1999, and *Dialogue between Nations* (also known as *Roundtable*), which was installed at the United Nations headquarters in Geneva in 1995.

Although based on his personal experiences and grounded in the native soil of his home country—China—Chen Zhen's works resonate with a global vision. They typically consist of ordinary, lowly objects (tables, chairs, and chamber pots), but they engage the most urgent issues of our time: the effects of globalization, the tension between local culture and global homogenization, the danger of the "clash of civilizations" (to borrow a phrase from Samuel Huntington), and the relationship between tradition and modernity, as well as between East and West. Chen's works entice us to ponder the problems and predicaments of transnationalism, immigration, and cross-cultural communication in the so-called "borderless world" after the end of the cold war. Examples of this can be found in such works of Chen Zhen as *The Field of Waste and Chinese Laundry* (1994) and *Prayer Wheel* (1997).

Chen Zhen has exhibited his works throughout the world. The masterful products of his artistic creation belong to sanctified space in major museums of the world. However, beyond the realm of rarefied art, his vision speaks to the viewer in a subtle yet most direct way. Pieces of his such as *Daily Incantations, Dialogue between Nations, The Field of Waste and Chinese*

Laundry, and other works mentioned above keep returning to the viewer's mind as he/she watches daily TV reports on important events in China, the United States, and the world. For example, consider China's admission to the WTO, the war in Kosovo, NATO's bombing of the Chinese Embassy in Yugoslavia, ethnic cleansing in certain parts of the world, international terrorism, Russia's attack on Chechnya, and the arrest of Chinese-American nuclear scientist Wen-ho Lee. While *Fifty Strokes* was on exhibit at the Venice Biennale in June 1999, international conflicts, the theme of this work, occurred next door across the narrow sea as NATO's airplanes dropped bombs in Yugoslavia during the Kosovo War. Chen Zhen's installations invite us to approach and understand the real with a fresh eye. He helps us enhance our ability to perceive variegated reality and the conflict-ridden world and provides us with artistic tools to comprehend the globe in a new light.

Overseas ethnic Chinese artists have subtly explored in visual arts (photography and installation) the problematic of Chinese identity in diaspora. One immediately thinks of self-portraits by Joseph Tseng/Tseng Kwong Chi between 1979 and his death from AIDS in 1990. Tseng must be seen as a precursor of much postorientalist experimentation in the diaspora. An ethnic Chinese, Tseng had a diverse, multicultural background. He was born in Hong Kong, immigrated to Vancouver with his family, studied art in Montreal and Paris, and became an artist in New York City. The black-and-white pictures that he took of himself wearing a gray Mao suit are self-mocking, ironic icons of a "Chinese." Each of these pictures exploits Western stereotypes of China and offers a "concise critique of 'Orientalism'."[10]

Wearing his invariable Mao suit, sunglasses, and an ID badge, Tseng posed in front of well-known tourist sites throughout the world: the Eiffel Tower, Notre Dame, Niagara Falls, the Grand Canyon, Allied Checkpoint Charlie, and so forth. It is no coincidence that others sometimes mistook him as an official from the People's Republic of China. His deadpan serious persona as a "Chinaman" or Maoist was a teasing deflation of puffed-up national, cultural, and ethnic identity. Thus, his photographic art amounts to a deconstruction of ethnicity and a pre-emptying of his self-alleged Chineseness. In a profound way, these self-portraits of the "accidental tourist" taken at world-famous landmarks are "experiences of displacement—geographic, ethnic, and psychic—that shows no signs of becoming less common as the 1990s proceed."[11]

184 AVANT-GARDE ART

FIGURE 27. Wang Ziwei. *Mao and Mickey*. Acrylic on canvas. 1994. 147 × 186 cm. Courtesy of Hanart T Z Gallery, Hong Kong.

One self-portrait of Tseng in particular appears all the more unforgettable after a hiatus of two decades. The 1979 image of Tseng posing with Mickey Mouse in Disneyland, California, is far from "dated," but is rather profoundly relevant to the present condition of global capitalism. The Mao suit as an emblem of the Chinese revolution and Mickey Mouse as a logo of capitalism come from opposite ends of the world. Yet what initially seemed to be a comic, humorous contrast turned into brutal reality in the 1990s. As China busily touted foreign capital and rushed to build Disneyland-style theme parks, Mao, Mickey Mouse, and McDonald's (or "Triple M") became familiar sights next to each other at public sites in China.

With the infusion of transnational funds, the skyline of Beijing itself experienced a rapid process of "McDonaldization," and by 1998 there were some forty McDonald's restaurants in the city. Often, Ronald McDonald greets customers at the front door. Inside, a map on the wall charts the exact locations of other McDonald's in Beijing. The map is a miniature image of China's global economic and cultural imaginary. Indeed, *Mao and Mickey*

(1994/95) is the theme of paintings by political pop artist Wang Ziwei. The orderly, seamless, mosaic-like juxtaposition of Mickey Mouse and the portraits of Mao on a flat surface is more than a figment of the artist's imagination; it is an accurate index of post-Mao, postsocialist, postmodern China.

If the masculine/masculinist quality is too generic and indistinct in Tseng Kwong Chi's solo images, Cai Guo-Qiang's 1996 sculpture/installation, *Cry Dragon/Cry Wolf: The Ark of Genghis Khan*, exhibited in the Guggenheim Soho, made a loud and clear statement about the global presence of Asian art. The artwork consisted of "a herd of sheepskins that was driven by a motor and made to float across the ceiling."[12] Motorized, modern modes of mobility and production further aided the intrusion of Asian masculinity by way of Genghis Khan's Mogol strength. This postmodern collage of the ancient and the modern, the East and the West, represented a renewed effort to construct a global Asian identity with irony.[13] More importantly, the installation evoked, paraded, and parodied the age-old Western perception of Asia as "yellow peril," as a potential threat to Western civilization. Thus the artwork subverted orientalist discourse.

A closely related work is Cai's *Borrowing Your Enemies' Arrows* (*Caochuan jiejian*), which showed in 1998 at the New Chinese Art Exhibition at the P.S. 1 Contemporary Art Center in Long Island. The story of "borrowing your enemy's arrows" comes from the Three Kingdoms era, when Zhu Geliang (A.D. 181–234), commander of the poorly equipped army of Shu, deceived the powerful navy of Wei into firing hundreds of thousands of arrows at straw dummy soldiers. Through this brilliant strategy Zhu Geliang "borrowed" ammunition from the enemy. As accusations against the Chinese-American nuclear scientist Wen-ho Lee develop, one wonders if this story from the past is a fitting commentary on the present. Has China stolen missile and nuclear technology from the West to defeat it?

Although geopolitics is manifested in art, the politics of multiculturalism in the United States also forms part of Cai's diet. *Cultural Melting Bath* (Queens Museum of Art, New York, 1997) was a humorous, relaxing blend of different colors, ethnicities, and genders depicted in a pleasing setting with a hot tub, hydrotherapy jets, Chinese herbal medicine, banyan tree roots, and Chinese garden rocks. A harmonious "culture," Chinese or otherwise, would provide therapy and medicine for conflicts among racial groups in our society.

Cai's works typically utilize traditional Chinese raw materials like gunpowder and fireworks to create spectacles of Asian tradition on an awe-inspiring, massive scale. See, for instance, *Project for Extraterrestrials No. 10: Project to Add 10,000 Meters to the Great Wall of China* (1993; ca. 1,320 pounds of gunpowder and 6,500 feet of gunpowder fuses; duration of explosion 15 minutes); *Project for Heiankyo 1200th Anniversary: Celebration from Chang'an* (1994; ca. 2,600 pounds of burning sake). Identification with tradition on first sight turns into doubt as the spectator ponders a little longer. In the words of one critic,

> Cai's work is fascinating precisely because where it seduces, even deceives, only to reverse our expectations and challenge our habits of mind. Just as what is materially most ephemeral can prove monumental in scale, what begins as uncritical awe can often lead to productive skepticism.... In fact, as much as Cai's work may seem to toy with Westerners' willingness to view it as a contemporary expression of 'ancient Chinese wisdom,' it does so only to reveal a trickster or an ironist at work.[14]

Such a style in the visual representation of the Chinese way is as unsettling as it is celebratory.

Cai's endless explosion series takes the viewer to different sites and countries: Nevada (test site of the first nuclear bomb), Hiroshima (where the first nuclear bomb was dropped), Kassel (Germany), Taipei, Manhattan, Jiayuguan (China), and other places. Jiayuguan (literally, Jiayu Pass) is the western end of the Ming Great Wall, the edge of the Ming empire. Thus, the viewer must seriously consider the challenging question posed by Cai's explosion/installation *Project to add 10,000 Meters to the Great Wall of China* at Jiayuguan in 1993: What does the extension of the domain of Chinese civilization and rule mean in the contemporary world? Is nationalism still relevant in the age of globalization?

In August 1998, Cai's installation *No Destruction, No Construction* (*Bupo buli*) involved bombing the Taiwan Museum of Art.[15] At that time, the museum itself was about to be renovated and needed dismantling and reconstruction. Exploding the sanctified space of a museum was a novel idea and an important statement about art. Mao Zedong had used the famous slogan "No destruction, no construction" during the Cultural Revolution to call on the Red Guards and his followers to destroy the old order so as to usher in a

FIGURE 28. Cai Guo-Qiang. *Project for Extraterrestrials No. 9: Fetus Movement II*. Installation. Kassel, Germany, 1992. Courtesy of Cai Guo-Qiang.

new world. In another significant aspect, the explosion and implosion at the Taiwan Museum of Art referred obliquely to a real bombing near Taiwan. A couple years before, after Taiwanese president Lee Teng-hui visited Cornell University, his alma mater, the relationship between China and Taiwan deteriorated rapidly. China conducted military exercises near the Taiwan Strait and fired missiles in waters around Taiwan. Taiwan, China, and the United States stood at the brink of war. Cai Guo-Qiang, as a native of Quanzhou, Fujian province, and a speaker of the Fujianese dialect, the dialect of many Taiwanese, occupied a unique position to address cross-Strait issues through his art. Although a mainlander, his natural affinity to the Taiwanese people allowed him to probe the troublesome relationship between Taiwan and China.

Explosion does not always need to be ominous and terrifying. Cai's *Dragon: Explosion on Issey Miyake Clothing* (Paris, 1998) offered an enticing variation on the same theme. Western models paraded on the stage while wearing Issey Miyake's new designer clothes, whose pattern consisted of dragon-shaped marks imprinted by Cai's explosions. Fashion, fad, beauty,

FIGURE 29. Cai Guo-Qiang. *Dragon: Explosion on Issey Miyake Clothing.* Installation/performance. Paris, 1998. Courtesy of Cai Guo-Qiang.

commodity, art, racial politics, and gender politics all came together in this uncanny cooperation between the avant-garde artist and the international fashion industry. The high and the low, the avant-garde and the popular, combined elegantly in a postmodern fashion spectacle as beautiful models (blonde, brunette, and black) strutted on stage and worked the audience. Art turned into a fashion show.

Beyond Chineseness

The Asian Art Exhibition at Pittsburgh's Mattress Factory, a museum of contemporary installation art (October 31, 1999–June 30, 2000), displayed works by ten artists from Japan, Korea, China, Taiwan, and Thailand. Gu Dexin and Wang Youshen represented the mainland, whereas Wu Mali, a woman artist, represented Taiwan. At the same time, another kind of exhibition titled *Half of a Century of Chinese Woodblock Prints: From the Communist Revolution to the Open-Door Policy and Beyond, 1945–1998* took place at the Art Gallery of the University of Pittsburgh from September to December 1999.[16] Ordinary visitors could easily discover in the magnificent display of vast numbers of Chinese woodblock prints common tendentiousness, topicality, and commitment to the real world. Art has a clear referentiality to reality, history, the nation, the world, and most important of all, to the ultimate signified: China. However, what puzzled visitors at the Mattress Factory exhibition and what was shared by works of the Chinese and Taiwanese artists—*10-30-1999* by Gu Dexin, *Darkroom* by Wang Youshen, and *Victorian Sweeties* by Wu Mali—was lack of reference to things specifically associated with China, or to anything at all.

Darkroom was literally a darkroom for developing photographs. The room contained various darkroom materials: film, light boxes, photographs, red lightbulbs, film development solutions, water, and so forth. Visitors were invited to bring their own film, develop it, and leave it behind with other pictures by the artist so that all could be shared with other people. A journalist by profession (an editor for *Beijing youth daily* [*Beijing qingnian bao*]), Wang Youshen engaged issues of communication and mass media (print, photography, words, images, and so forth) in a manner consistent with his previous works. He said the following:

> One character of contemporary life is the great variety of restraints imposed upon the individual. For example, television shows are all planned in advance. Only after acknowledging this form of restraint can you make your choice of what programme to watch. I express this restraint in my art, most importantly in terms of the limitations imposed upon the individual by paper and printing. It can be said that the limitations of paper and printing are essentially the constraints imposed on the individual by culture.[17]

Perhaps *Darkroom* also investigated the limitations and potentials, control and dissemination, and distortions and truth embedded in journalism and contemporary technologies of communication.

The setting of Wu Mali's *Victorian Sweeties* was the interior space of two living rooms in Victorian style, with furniture, wallpaper, and curtains, and most important, baby pictures of famous and ordinary people, including the Dalai Lama, Adolf Hitler, Barbara Luderowski (Mattress Factory director), and Michael Olijnyk (Mattress Factory curator). "All the 'babies' were born after the invention of the camera in the mid-1800s. All have already made their mark on history. Mali Wu points out, 'irrespective of what has occurred or what these people have become, there are aspects of human nature that are common to all of us.'"[18] *Victorian Sweeties* thus points to a stage of development in every human being—the time of childhood and innocence sheltered in the family home regardless of nationality and what will become of him/her in the future.

As with many of his previous works, the title of Gu Dexin's piece, *10-30-1999*, refers to the date of the work's completion: October 30, 1999. Walking into the door of a large, darkly lit room, the viewer saw a row of ten pictures in golden frames on either side of the room. These were ink-jet prints of original photographs of the back of the artist's shaved head taken while he resided in Pittsburgh. In the midst of each picture the artist had inserted a partial image of female genitalia, which also looked like a knife cut. At the end of the room was a bed draped in red plastic, on top of which sat a vibrating dildo. The piece lacked any ostensive marker of China or any indication of ethnic or national specificity. It offered an abstract yet humorous look at human sexuality, heterosexual relationships, and possibly sex and violence. Or is this "temple of phallus" a parody of patriarchy? Typical of the artist's earlier pieces, the installation also evoked powerful primal feelings, raw emotions, and primitive physical energies.

FIGURE 30. Gu Dexin. *10-30-1999*. Installation. 1999. Courtesy of Mattress Factory, Pittsburgh.

The same strategy had been evident in the artist's early works, for example, *Feb. 2nd, 1993*, *Summer 1989*, and *August 1990*, all of which involved burning and melting all kinds of brightly colored plastic—pink, blue, green, white, and yellow.[19] (A self-trained artist, Gu worked for some time in a plastic factory.) The texture, color, and twisted shapes of burned plastic sheets in all their exuberance and deformity created "flowers of evil" (*les fleurs du mal*), in Baudelairean terms. Without exception, *10-30-1999* continued the plastic motif and brought out strong simultaneous feelings of attraction and repulsion to its own material and the subject of representation.

Artists in this last category are not narrowly concerned with representing China, the ever-illusive chameleon. They are interested in coming to terms with general human conditions everywhere on the globe. These artists tend to enhance our ability to grasp and perceive the world through innovation in artistic language and materials of representation in the postmodern, late-capitalist, digital, electronic age—at a time when direct confrontation with the real seems to elude humans. Madeleine Grynstejn, curator of the

Carnegie International Triennial Exhibition 1999/2000, describes our current state of being-in-the-world with the following words:

> We experience, in other words, the effects of a distancing from the real—from both self and world. This kind of distancing is the condition of living in an advanced capitalist society situated in an era of heightened technological mediation. The sense of living vicariously rather than viscerally, in a dispersed and fleeting environment rather than a stable one, has been accompanied by intimations of experiential impoverishment, and of a dwindling of control over one's life and destiny—and also, just as important, to an urgent desire to increase one's ability to act upon and influence one's life.[20]

Loss of mooring from the real and hence the urgent need to hold onto it through concrete action are not predicaments only among artists living in advanced capitalist societies, but they also form a dilemma confronted by artists from developing countries, who must negotiate forces and confusions from both the traditional and the postmodern.

In summary, the various artists I have used as illustrations have consciously aligned themselves as part of a broad international postmodernism, and they have taken full advantage of fundamentally postmodernist techniques of representation—collage, pastiche, and parody. In appropriating postmodernism, they have found new ways to engage actively the multifaceted, fast-changing realities of postsocialist China. At the same time, some especially in the Chinese diaspora have brought to the foreground the themes of cultural identity and alterity, or the problematic of the self and the other in the postcolonial, postorientalist world. Even as the artists fabricate semblances and images of Chineseness in the transnational circuits of production, exhibition, and consumption, they have begun to cross-examine, interrogate, and disengage from conventional notions of the self, the other, China, and the West.

PART FOUR

Popular Culture, Television Drama, Literature

NINE

Popular Culture
Toward a Historical and Dialectical Method

My purpose in this chapter is to describe a new phase in the evolution of modern Chinese popular culture, a phase intimately tied to the unfolding of commercialism, commodification, and the mass media from the late 1970s through the 1990s. Popular culture is a defining characteristic of Chinese postmodernity. It has had a double-edged effect on Chinese society, and its relation to high culture, official ideology, and the tradition of Chinese intellectuals is complicated. Insofar as popular culture undermines "hard-line" cultural hegemony, whether state ideology or intellectual elitism, a large segment of the masses has celebrated its arrival. To the extent that it has recently become a major player in the commodification process, it has also become the main target in the critique of postmodernity. In addition, its sugar-coated apoliticism pacifies the masses and represses the memory of China's political reality. In the following pages, therefore, I wish to give a more or less dialectical and historical account of contemporary popular culture's genesis and transformation.

In an effort to make the broad term "popular culture" useful, Mukerji and Schudson state that it "refers to the beliefs and practices, and the objects through which they are organized, that are widely shared among a population. This includes folk beliefs, practices and objects rooted in local traditions, and mass beliefs, practices and objects generated in political and commercial centers."[1] They add that the term "includes elite cultural forms that have been popularized as well as popular forms that have been elevated to the museum tradition."[2] In my account of contemporary Chinese popular culture I basically follow this demarcation of things to be examined. Moreover, a sense of shifting historical relationships between high and low, dominant and subordinate, oppositional and co-optational is needed in order to comprehend the complex patterns of cultural change from the late 1970s through the 1990s.

Historical Overview

Needless to say, "popular culture" has always existed in China, as in any society. The dynamic interchange between elite, high culture and low, popular culture and their mutual appropriation were constant throughout the history of imperial China. In late imperial China and the republican period, new forms of popular culture, or "mass culture," emerged in urban centers and treaty ports such as Shanghai.[3] Journalism, popular fiction, film, cartoon magazines, and spoken drama (as opposed to various traditional Chinese "operas") flourished in Chinese cities. I venture to say that the appropriation of popular culture for political and ideological purposes—nationalistic, revolutionary, or communist—is a distinct feature of modern Chinese political culture. Furthermore, popular culture as a means of political intervention clearly has both urban and rural origins in terms of form, style, and technology. Urban forms of popular culture, as briefly enumerated above, were used for nationalistic (anti-imperialist), revolutionary causes by progressive, left-wing cultural workers who congregated in Shanghai in the 1930s and 1940s.

In rural base areas of the Chinese communist revolution such as Yanan, popular culture, or perhaps more precisely, "culture of the populace" or "folk culture," was utilized and transformed for revolutionary politics in the 1930s

and 1940s.[4] Intellectuals who came from urban areas such as Shanghai to join the revolution turned their attention to rural, local art forms, folk song, folk dance, and traditional theater—and infused into them new revolutionary content to mobilize the masses and raise their consciousness.[5] This formation of a revolutionary popular culture in effect amounted to an oppositional discourse that countered what were perceived as the predominant forces of feudalism, imperialism, and capitalism.

Since the founding of the People's Republic of China in 1949 these humble, "popular" products of revolutionary culture, with origins that date back to the Yanan era, have formed a sacred canon and achieved an uncontested, official, hegemonic status.[6] The song "The East Is Red" (*Dongfang hong*), originally a northern Shaanxi folk song, praised Mao as the savior of China and became the supreme example of the transformation from popular culture into official ideology. The communist regime attempted to bring about artistic synthesis during the era of Mao by combining the technologies of urban culture (symphony orchestra, cinema, ballet, and so forth) with traditional folk forms from the revolutionary rural base and treated cinema as the most important art form in the effort to build a new national mass culture.[7]

In the post-Mao era, especially during the post-Tiananmen era, the transformation and ascendancy of a newly commercialized popular culture based in the mass media has represented a significant shift away from the tradition of official, dominant, Maoist popular culture.[8] This "new" form initially met resistance, but during the first decade of its existence it has completely replaced the "old" popular culture and become the dominant cultural force.

Intellectuals of the late 1970s and the 1980s who engaged in ponderous, solemn "historico-cultural reflections" found nothing worthwhile in popular culture. Nonetheless, amidst opposition and contempt, expressions of popular culture steadily gained ground among the populace. In the late 1970s and early 1980s popular culture seemed to appeal to the people and offer them a new "sign system" completely different from either the official discourse of the party or the language of the intellectuals. More and more people started to wear sunglasses and jeans, listen to the songs of such Taiwanese and Hong Kongese pop singers as Deng Lijun, read romances by Qiong Yao or serials of adventurous knights-errant by Jin Yong, and watch foreign films. These new forms of messages came from Taiwan, Hong Kong, Japan, and the West, signified something different, and touched the hearts

of the people.⁹ Liu Xiaobo, a young philosopher and leader of the Democracy Movement in 1989 known for his radical critique of Chinese culture during the 1980s, describes the impact of songs by Taiwanese pop singer Deng Lijun when he first heard them as a college student in the late 1970s.

> The words and soliloquies in this type of singing, the tunes that express the private, sorrowful, sentimental, and small feelings of life, stirred the depths of my soul. We grew up in a kind of earth-shaking revolutionary slogan, music, and song. In the orthodox communist education we received, we knew nothing but revolution, selfless dedication in the spirit of "fear not hardship, fear not death," the concepts and culture of cold class struggle that lacked any sense of humanity, hatred to others, and the language of violence. We never received an education that was close to life and earthbound, that respected others.[10]

The soft, sentimental, private, and humane melodies found in popular culture struck a note that contrasted with the official language of revolution and class struggle. As emergent and alternative sign systems, these elements of popular culture possessed great potential to undermine the language of the party and state. However, the official media quickly adopted measures to alleviate the impact of popular culture by incorporating and using elements from it.

In the post-Tiananmen era this type of popular culture has assumed a prominent position among the people. Failure of the 1989 Democracy Movement forced into exile many of China's leading thinkers and writers, for example Fang Lizhi, Liu Binyan, Yan Jiaqi, Liu Zaifu, and dozens of others involved in the movement. The mushrooming culture industry has taken their place; TV serials, soap operas, pop music, and best-sellers are easily accessible and have great appeal to vast numbers in China.

Today, "going pop" is certainly one of the latest fashions in China. Forms of literary and cultural production have increasingly experienced pressure from the new market economy. Tastes in art, literature, and culture are no longer dictated by the intellectual elite. Numerous ordinary consumers of cultural production now exert immense influence upon what artists write, screen, sing, and exhibit. As a matter of fact, traditional institutions of high culture have needed to fight for their survival under the onslaught of the market economy. Perhaps unwillingly, they have had to adapt to the tastes

and demands of the culturally "untrained" and "illiterate." According to reports, when the Central Symphony Orchestra gave its historic first concert of popular music in Beijing on March 23, 1993, tickets sold extremely well despite their high price.[11] The Central Symphony Orchestra had certainly been among the highest of high cultural institutions of China. Only reluctantly did it bow to popular culture because of its shrinking audience and its approaching bankruptcy.

Theaters across the nation have also needed to learn the rules of the new market. Strange as it may seem, Harold Pinter's absurdist one-act play *Lover*, written in the 1950s, was tremendously successful when shown in the playhouses and theaters of China's cities early in 1993.[12] What may have appeared abstract and absurdist in the original Western context produced completely different effects. For the Chinese, the play broke silence on the issues of sexuality and prostitution, which had previously been taboo and only recently became subjects of open discussion. Lovemaking and intimacy on the stage are especially refreshing to the Chinese audience. The play has been staged in theaters, teahouses, and cafés in many cities. In this case, there seemed to be an uncanny confluence of ultra-abstract high art and the tastes of the majority of Chinese, which testified to the dynamics of cultural transformation in contemporary China. The example of *Lover* shows an originally elite cultural object being decontextualized, recontextualized, and popularized by the masses.

Socioeconomic conditions in the 1990s brought a profound transformation not only to cultural production, but also to the very vocation occupied by cultural workers themselves. Reports that the writer Zhang Xianliang had turned to business and started his own company in the early 1990s shocked many people in the country.[13] Zhang had emerged as one of the leading writers of the 1980s. His stories, based on personal traumatic experiences under the communist regime, had been compelling testimonies of the indestructible spirit of the Chinese intellectual.[14] That a writer of his magnitude and popularity would succumb to the lure of commercial success appeared odd to many people. This famous or infamous case of the writer turned businessman sent an alarming signal about the fate of the intellectual in contemporary China.[15]

Noticeably, an increasing tendency also exists for Chinese popular culture to move across national boundaries and to take on a transnational, global

character. In 1993–94, some of the most popular novels and TV programs were stories about Chinese abroad. Zhou Li's novel *A Chinese Woman in Manhattan* (*Manhadun de Zhongguo nüren*) and Cao Guilin's novel *Beijingers in New York* (*Beijingren zai Niuyue*) became best-sellers in China's book market. The TV serial *Beijingers in New York*, based on the novel and filmed in New York City, was one of the most popular shows of the year. These examples narrate stories about the "success" of Chinese abroad. The heroes and heroines initially arrive as penniless, poor students from mainland China. However, in the end, through hard work, intelligence, and adaptation to their new environment, they became successful businesspeople in New York City, the financial capital of the world, and thus realize their dreams. These stories are telling because they reveal that the global circulation of Chinese, which exists beside the circulation of global capital and commodities within China, has become a focal point in cultural production and the media.

One of the most visible showcases of contemporary Chinese cultural production in the global arena is undoubtedly cinema. Films produced by formerly experimental, "avant-garde" directors such as Chen Kaige and Zhang Yimou are typically funded by foreign sources and released outside China to an international audience. Critics and viewers in the West have acclaimed these films as masterpieces. (Ironically, many people within China cannot see these "Chinese" films due to limited release or outright censorship!) Whether the subject is concubinage, as in Zhang's *Raise the Red Lantern*, or homosexuality, as with Chen's *Farewell My Concubine*, one can say that spectacles such as these are intended to cater to the West's endless appetite for Chinese exoticism. Chinese film culture as such enters the global network of production, distribution, and consumption, sells to an international populace, and transforms itself into a transnational Chinese cinema.[16] Cultural production of this sort is necessarily part and parcel of the operations of "global capitalism."

Parody in Popular Music and Literature

In the beginning years of the Reform popular cultural forms came mainly from outside China. These included songs, novels, movies, and TV serials

from Taiwan, Hong Kong, and the West. However, popular figures soon emerged from within China. Most conspicuous were pop singers Cui Jian and novelist Wang Shuo, who became symbols of a new "cultural phenomenon" (*wenhua xianxiang*). Cui Jian's rock music represents an indigenous pop music. At first, sound and rhythm from this type of music created uneasiness among the party propaganda apparatus. Aside from its lyrics, rock threatened some party officials because it was a new form of music and signifying system. Among those who resented Cui Jian's music, for instance, was former Chinese vice president Wang Zhen, a veteran of the Long March.

To deal with pressure from the party Chinese pop artists have developed ingenious forms of parody that allow their works to pass state censors, yet permit them to preserve their messages. One case in point is Cui's rendition of an old revolutionary song "Nan ni wan," which he set to the rhythm of rock, in praise of General Wang Zhen. "Nan ni wan" was one of China's holy revolutionary songs, a "pop song" in its own right that dates back to the 1940s and originated from folk songs at the Communist base in northern Shaanxi Province (Shanbei). Yet when played with Western instruments of rock and roll, the song delivers a complex message. On the surface, the pop singer tows the official line, eulogizing the communist traditions of self-sacrifice and endurance; yet, on another level, the song challenges official discourse by wrapping a revolutionary song within a music system that old cadres perceive as unhealthy and Western. Cui's rendition of the song amounts to a musical parody of the original revolutionary spirit's solemnity and holiness.

This disjunction of words and music, as Rey Chow points out, characterizes the strategy that pop singers like Cui Jian have adopted to wrestle with the antagonism of the state bureaucracy. Writes Chow: "There is first of all, the difference between the 'decadence' of the music and the 'seriousness' of the subject matter to which the music alludes. Without knowing the 'language,' we can dance to Cui Jian's song as we would to any rock-and-roll tune; once we pay attention to the words, we are in the solemn presence of history, with its insistence on emotional meaning and depth."[17] The rock tune dismantles and deconstructs the song's revolutionary ethos, as expressed in the words' literal meanings. One might add that the musical effect is spontaneously very Brechtian.

Popular music during the post-Tiananmen era also witnessed a revival of songs about Mao Zedong, or what is called in Chinese *Mao Zedong re* (Mao Zedong fever), at the centennial of Mao's birthday. Popular singers sang old songs about Chairman Mao, this time as light rock music. "Mao fever" swept across the country, and sales of fourteen million cassettes of a collection of his songs "Red Sun" (*Hong taiyang*) set a sales record. Along with the songs, Mao's portraits and badges were also frequently bought and sold.

It is not difficult to see that this new "cult of Mao" differs much from his cult during the Cultural Revolution. The soft, light-hearted, "pop" treatment of originally sincere, earnest revolutionary songs strikes a dissonant note. The disjunction between words and music does not articulate single-minded devotion to the legacy of Mao. Irreverent popularization and vulgarization of Mao music actually disembodies and preempts the word's revolutionary content. As a matter of fact, the words mean nothing to the young singers themselves, who are not old enough to have lived through years of Mao's leadership as adults. Mao has become an object of consumption.

By contrast, Chairman Mao actually does mean something to many older consumers. Many of these people have turned to Mao out of disillusionment with Deng Xiaoping in the wake of the tragic events in Tiananmen Square, frustration at being unable to institute political change and burdened by a market economy. Furthermore, their nostalgia for the Mao era is directly related to the fact that they spent and "lost" their childhood and youth during the heyday of Mao worship. Economic pragmatism, ideological emptiness, and the lack of idealism typical of the Deng era have disheartened groups that grew up on Maoist rhetoric of revolution and communism. To large numbers of peasants and a big segment of workers today on the brink of unemployment in China's "socialist market economy" Mao has become a bodhisattva savior, replete with statues in temples. In both cases, though, "Mao fever" demonstrates popular dissatisfaction with contemporary reality.

Thus, popular music has become a vehicle for the common people to express a wide range of complex feelings and sentiments: discontent with the present, lingering nostalgia for the past, disillusion with both the past and the present, and, simultaneously, the profanation of the sacred image of Mao originally projected in inspiring songs of revolution. At the discursive level, the problem involves the popular/social vs. the state/intellectuals.

As Andrew Jones suggests, Chinese popular music in the post-Mao era has also become a crucial component of mass media and an important participant in the public sphere. As such, it has had a number of political uses. Following a typology first developed by Stuart Hall and Ray Pratt to analyze popular culture in the West, Jones states that the effect of contemporary Chinese popular music can be hegemonic, negotiated, or emancipatory.[18] Hegemonic uses of popular music passively transmit the lyrical and ideological content of state-sanctioned songs. Negotiated uses accord a privileged position to the dominant definition of events while reserving the right to make a "negotiated" application to local conditions. Emancipatory uses of popular music directly subvert hegemonic codes. This last function was evident in songs sung at Tiananmen Square as part of the 1989 Democracy Movement, songs that directly challenged the state. Negotiated application is currently perhaps the most common form in China. The cultural and political effects of popular music on the public sphere often mix oppositional and cooptational energies and messages.

In the realm of literature, Wang Shuo's stories and the TV series that he has scripted became the focus of much discussion in the early 1990s. Some have even claimed that the "Wang Shuo phenomenon" was unprecedented in modern Chinese literary history. His immensely popular writings represented a dramatic departure from the mainstream literary tradition that the May Fourth Movement inaugurated. His writings earned him the title of "China's literary hooligan" in the West.[19] Wang Meng, minister of culture before the Tiananmen Square incident in 1989 and one of China's leading "serious writers," detected the following characteristics, or lack thereof, in Wang Shuo:

> The author never thinks he is greater than the reader (in terms of sincerity, wisdom, awareness, love . . .), and does not believe that there exist superior authors and works. It is a literature that intends neither to raise certain questions nor answer certain questions; that neither writes about workers, peasants, and soldiers, nor about cadres and intellectuals; that neither writes about revolutionaries nor about counterrevolutionaries; it is a literature that does not write about any meaningful historical characters, namely, it is a literature that does not make a character part of history and society. It neither sings the hymn of truth-virtue-beauty, nor does it castigate falsehood-evil-ugliness; moreover, it does not admit there is a difference between the two. It

is a literature that is neither prepared nor promises to dedicate something to the reader; neither is it "progressive" nor "reactionary," neither is it noble nor does it avoid being dirty. Neither red, nor white, nor black, nor yellow, nor terribly gray, it does not admit there exists something weighty.[20]

Obviously, Wang's style is a far cry from that espoused by the educator/savior, "the architect of the soul," usually associated with the modern intellectual-writer. (In fact, Wang himself never went to college.) The characters who inhabit Wang's stories are usually "hooligans," disenchanted urban youth, idlers, private businessmen, and small entrepreneurs.[21] These are new social categories that emerged under the open economic policy of the Reform, yet they remain at the margins of Chinese culture. Parody, satire, play, humor, blasphemy, and cynicism fill his stories. Most resourceful is perhaps his language, a language of slang, jokes, satire, parody, and obscenity: a contemporary language spoken by the people in the alleys and streets of Beijing.

Particularly significant is the intertextual relation between the "subculture" Wang presents and the central culture. One critic analyzes the situation as follows:

> Relative to the mainstream culture that occupies the central position, hooligans form a kind of subculture (*ya wenhua*) or counter-culture (*fan wenhua*). This kind of subculture or counter-culture naturally feels the discrimination, exclusion, and oppression from the central culture (which uses means ranging from ideology to state apparatuses). It does not tread the hall of refined sensibility, and is far from the central culture. Such condition determines the relation between the subculture and the central culture. It is sometimes a twofold relation of rejection and envy.[22]

What the critic terms "mainstream culture" or "central culture" is basically official culture, Maoist culture, the culture of the party. Official culture consists of the myth, discourse, language, and ideology of Maoism, the communist revolution, and to a lesser degree the legacy of the May Fourth Movement. Yet the end of the Cultural Revolution brought nothing but disillusion to the youth and "hooligans" of the "subculture." All traces of faith and idealism are, therefore, subjected to parody in the mouths of these marginal social figures. In a sense, Wang's writing embodies the "end of ideology" and the disappearance of grand myths. His dialogues often insert typical discourse of official culture into the discourse of the subculture, making

the former a "quotation without quotation marks." More often than not, this approach results in a devastating subversion of official culture. Wang's style can be glimpsed in the following, a dialogue between a newlywed couple, the narrator "I" and Fatty Wu, in Wang's story *Playing with Heartbeat* (*Wan'er de jiushi xintiao*):

> [Fatty Wu:] "He not only writes books but also acts in plays and films, several times. He ain't very well known in China, but real famous in Europe."
> "Whom does he play?" That silly bride was again on the hook.
> [Fatty Wu:] "Young Gorky and young Zhou Shouren (Lu Xun)—before they grew mustaches."
> "Really?" The bride and bridegroom together looked at me carefully. I smoked, and turned my face to act in character.
> "He sure looks real."[23]

In this passage the narrator "I" and Fatty Wu mock the hallowed images of Gorky and Lu Xun, and with them the legacy of socialist realism and May Fourth literature. When the sublime, self-righteous language of high culture comes from the mouths of hooligans, the effect produces nothing less than satire and sacrilege. The internal parodic relation in such a multilayered discourse actually subverts two high cultures: the official discourse of Maoism and the time-honored tradition of the Chinese intellectual.

Even the academic subject of postmodernism does not escape Wang's scathing satire. The following passage comes from his novel *No Man's Land* (*Qianwan bie ba wo dang ren*):

> "Stop arguing." Liu Shunming clapped his hands and yelled. "Let's play a game next, OK? The rule of this game is really simple. Everyone says a line to Yuanbao, but you mustn't say what's already said by others. You are only allowed to say your own words."
> The boys were silent for a while. Then, each opened his mouth.
> "Angry youth."
> "Lost generation."
> "Structur . . . structur . . . structural realism."
> "Postmodernism."[24]

The scene parodies the notions of originality, copy, and game, and makes fun of faddish literary concepts and academic terms. Literature itself turns into a postmodern game for kids as well as adults to play.

The effect of Chinese popular culture seems to be double-edged, and as such it should be grasped dialectically. One should be aware of both the decentering potential embedded in it and its appropriation by the state. On the positive side, popular genres such as rock music and storytelling may, to borrow the words of M. M. Bakhtin, produce a carnivalistic effect that subverts and parodies high official discourse, and break down the distance between the high and the low.[25] This act of "crossing the border" and "closing the gap" is in fact what Leslie Fiedler described in the late 1960s as the distinguishing hallmark of postmodernism.

In the specific Chinese case, popular culture's rebellion against high culture is twofold. First of all, it rebels against official communist, Maoist ideology and language. Second, it rebels against an equally tenacious force in Chinese culture: elitism. The Chinese intelligentsia, which is nothing less than a modern version of the Confucian literati, has ruled and monopolized the sphere of culture. As Liu Xiaobo claims, this "cultural autocracy" may be no less repressive than "political autocracy."[26]

Incorporation of Popular Culture in Official Discourse

The government's propaganda apparatus initially responded to the rise and spread of this new type of popular culture with a mixture of uneasiness, embarrassment, opposition, and denigration. As we have seen, the party was not only perplexed with the message of popular culture, but, more important, it was also confused by an emergent, unfamiliar system of signification. The party assumed that official ideology would be eroded even more severely if it did not take action to contain the subversiveness. As the party has learned, the best way to fight emergent, unfamiliar cultural forms is to incorporate, appropriate, and "domesticate" them. In this, it has proceeded rather successfully. Unlike the fiery, untactful, angry reaction of people like former vice president Wang Zhen, the propaganda machine skillfully neutralized and assimilated many of the resurgent forces in popular culture. A good case in point is the subtle manipulation of China's rising TV serials. Since 1989, TV serials (soap operas, or "indoor drama" [*shinei ju*]) have blossomed in China.

To the end of the 1980s China imported serials from Taiwan, Hong Kong, Japan, Latin America, and the West. Chinese TV industry, however, eventu-

ally realized the importance, both moral and financial, of developing its own TV dramas. *Yearnings* (*Kewang*), a fifty-part dramatic serial, by far the most successful, was shown one year after the Tiananmen Square tragedy. The story gripped the entire nation. Whenever the serial appeared on TV, the streets were deserted and for a period people seemed to forget Tiananmen Square, as well as the pain and bloodshed of their immediate collective past.

Yearnings told the story of the ups and downs of two Beijing families, one a working family, the other a family of intellectuals, during the Cultural Revolution and the Reform years of the 1980s. In retrospect, the popularity of the story arose from a strategy that its scriptwriters followed. To make sure that the audience shed enough tears during each segment, they adopted a formula that appealed to the values and morals of the majority of viewers. They decided that the series should focus on the family, and that "the central character must be a virtuous, filial woman," "a woman in the prime of her beauty," so as to satisfy different sectors and age groups of the audience.[27] As Jianying Zha informs us, Wang Shuo, one of the scriptwriters, was rather forthright and sarcastic about the formula: "We tortured all these characters, making everyone suffer. We made sure all the good guys had a heart of gold, but we made them as unlucky as possible; and the bad guys are as bad as you can imagine—that's the sure way to a good drama."[28]

The result was by no means a gross caricature, or a story of cynicism. The serial achieved unprecedented success. At the same time, it momentarily soothed the viewers, and allowed them to submerge themselves in a drama of love, separation, perseverance, and faithfulness, a personal drama they had all more or less lived through during the years of the Cultural Revolution and the Reform. The Communist Party quickly saw the effectiveness of such a formula. By letting the audience shed tears at the unfair fate that good people suffer, and by making them identify with the virtues of tolerance, harmony, and faithfulness that the working class possessed, the series softened viewers and detached them from immediate political action. Li Ruihuan, at that time boss of ideology and propaganda, praised *Yearnings* highly. He considered it a literary model that all artists and writers should learn. He reportedly had the following thoughts after watching the show: "It tells us that an artistic work must entertain first, or it is useless to talk about educating people with it. The influence we exert must be subtle, imperceptible, and the people should be influenced without being conscious of it. In order

to make socialist principles and moral virtues acceptable to the broad masses, we must learn to use the forms that the masses favor."[29]

Just as the Communist Party effectively mobilized the masses to overthrow the Nationalist Republican government decades before, now it saw the importance of new "mass culture" to rule the masses. It should be pointed out that *Yearnings* included an implicit attack on intellectuals. The series depicted members of the intellectual family lacking the qualities of perseverance, faithfulness, and purity that the workers' family possessed in abundance. Under adverse circumstances the intellectuals often proved fickle, snobbish, arrogant, and ungrateful. As we recall, intellectuals—university students, teachers, and journalists—spearheaded the Democracy Movement of 1989.

Obviously, it would be a mistake to assume that such authors as Wang Shuo and their works openly oppose the regime. In fact, as can be seen in the example of *Yearnings*, these authors collaborate with the government to a certain extent. Each party gets something it desires. Yet they are locked in a position of stalemate, compromise, cooperation, and respectful distance, and the equilibrium between the two sides seems to be subtle, fragile, and temporary. Of course, one of the benefits for the writers of producing within the government-sanctioned system of public TV is the ability to reap huge financial profits.[30]

Consequences

As a new cultural phenomenon in post-Tiananmen China, popular culture deserves close attention. In years to come it will remain one of the most interesting, protean, fluid, and important forces in China. It is fraught with opportunities and dangers, and subject to appropriation and use by all interest groups. Liu Xiaobo and others believe that popular culture could be the most effective means of changing the lifestyles and value systems of ordinary Chinese, and hence of undermining orthodox ideology, because it constitutes a challenge to the language and discourse of hegemony for both official ideology and the intellectual elite.[31] As we have seen, the party has much at stake in its use of popular culture. Applied in the appropriate way, popular culture can neutralize any remaining opposition to the party's rule. The

sweet, entertaining messages of this new mode of expression and consumption promise prosperity and good life for the people. Popular culture brings with it instant gratification and leads one to forget history.

The spread of tabloid journalism in China and its effect upon the public sphere also exemplify the double-sided nature of popular culture. Gossip columns now cover such topics as money, sex, violence, celebrities, and the secret lives of communist leaders. "They are taking over virtually all the newsstands on the streets."[32] For the average reader, the gossip columns substitute well for the dull, phony official newspapers that print material about party policies, economic developments, and state affairs, but say nothing about human rights and political oppression. Tabloids, like the new TV drama, offer the masses a soothing experience and make them forget the pains of Chinese politics. They are the "opium of the people." Yet, at the same time, these papers, which come and go, may "play an important role in the eventual freeing of the press: they've broken up the official news language, shifted the concerns from the government and state affairs to ordinary people and their social lives. They are already affecting the big papers, forcing them to loosen up a bit, to compete, to be more attractive to readers. Isn't this a victory in itself?"[33]

In an unusual fashion the mass media may in fact contribute to the widening of the public sphere in China. The effect of mass/popular culture on society is more complex and multidimensional than Jürgen Habermas has suggested in his seminal work *The Structural Transformation of the Public Sphere*.[34] In a society such as China, where sedimentation of various social formations exists and where the party gives license to capitalist economic pursuit but severely constricts freedom of the press, popular culture may have a unique role to play.

It seems to me that the role contemporary popular culture plays can be seen as a continuation of the function of popular culture (narrative fiction, popular storytelling, and so forth) in imperial China. For a long time fiction, popular stories, and novels were literally called "small story" (*xiaoshuo*), "unofficial history" (*baishi*), "supplemental history" (*bushi*), and "rumor" and "gossip" (*daoting tushuo*). These were denigrated, low narrative genres in comparison to elevated "official historiography" (*zhengshi*) and Confucian Classics (*jing*). Confucian gentlemen doubted their factuality and credibility, yet these popular stories created unofficial versions of events, circulated

information not readily available, and disseminated forbidden knowledge, whether told in teahouses or sold in the marketplace. "Small stories" and "gossip" in the streets or private houses have always been a challenge to the Chinese state's monopoly of information and knowledge.[35] "Small papers" competed with and provided an alternative to the official channels of news. Thus, the makeup of the public sphere in imperial China prefigures the public sphere organized through the mass media in contemporary China.

Raymond Williams claims that "in any society, in any particular period, there is a central system of practices, meanings and values, which we can properly call dominant and effective."[36] At the same time, alternative and oppositional cultural forms exist in relation to the dominant and effective culture. Williams also writes about "residual" and "emergent" cultural forms. "Residual" implies that experiences, meanings, and values remain from some previous social formation. "Emergent" implies that "new meanings and values, new practices, new significances and experiences, are continually being created."[37]

It seems evident that in China, the effective and dominant culture, or simply "central culture," is the official ideological system of the ruling Communist Party. By contrast, the discourse of the intellectuals contains elements of residual culture, namely, it has inherited the legacy of the May Fourth Movement, as well as aspects of the traditional literati. Nourished in such an environment, members of the intelligentsia often oppose and resist the claims and practices of the dominant social force, the party apparatus. In this respect, intellectuals have provided an oppositional and alternative culture in China. However, on another level, intellectuals form an effective and dominant culture of their own as they insist that they are the legitimate and rightful representatives of Chinese culture. They tend to present themselves as the enlightened few who set out to raise the consciousness of the broad masses. Intellectuals consolidate their hegemonic position further when they occasionally make alliances with the party.[38]

Undoubtedly, the new popular culture is the emergent culture in contemporary China, and it is full of potential and risk. In challenging the dominance of the party's and intelligentsia's discourses and sign systems, it surely provides alternative and oppositional models of social life. As is also clear, political forces such as the party can use the strategy of incorporation to contain and neutralize the spread of popular culture's language and signification.

The processes of incorporation and accommodation dilute, reinterpret, and even turn around the originally defamiliarizing and subversive effects of popular culture. The party thus "co-opts" the people. Hence, popular culture may serve the dominant culture and work for the domination and prolongation of the ruling party. An oppositional force in the beginning, it may be on its way toward embodying a new dominant culture. Popular culture is itself then the space of commodification as well as the site of appropriation by state ideology. It partakes of the communist/capitalist pacification project. A globalized terrain emerges where the liberal subject (Chinese or otherwise) is interpellated into commodity forms and movement.

It should be clear by now that contemporary China is fraught with social, political, and economic contradictions. Beneath the stability of the state rule, China stands on the verge of a great cultural and social transformation. Fluid and unpredictable as it appears, the "phenomenon of culture" surely deserves the closest observation and analysis. Although popular culture has gone through a wave of expansion in the reality of the post–Tiananmen Square era, its future development should especially concern all China watchers. Given the current policy of the regime to open the door for economic reform but tighten the grip on political freedom, popular culture occupies a unique niche in the life of Chinese people. Both those who attack and those who defend it will scrutinize its future development.

As an increasingly important player in Asia and the Pacific—a vast space of economic and cultural production—China is already an integral constituent of the age of global capitalism and transnational production. Infiltration of capital into the daily lives of ordinary people is loosening the state's direct control. After the strength of state hegemony diminishes greatly, what will be the role of popular culture, which was once such an important *oppositional* discourse, especially in its early stages during the late 1970s and early 1980s? The new question that needs to be raised seems to be this: "do social and cultural differences finally make any difference in the transnational formation of postmodern markets whose aim is to generate the same fantasies, localize the same products, and infiltrate a mythic banality of social progress and shared prosperity . . . ?"[39]

Perhaps without exception, cultural productions in China already partake of this process. Chinese popular culture may actually become the *dominant* culture in the frenzy of China's growing consumerism, and multinational

capital may soon turn it into a hegemony in its own right. Thus, although popular culture has partially fulfilled its historic role of radically undermining the hegemony of the state and intellectual elitism, its complicity with the rising tide of consumerism will inevitably be a major concern in the future. It is precisely this unchecked commercialization of culture that provides a fertile ground for the discourse of postmodernism in post-1989 China.

TEN

Soap Opera
The Transnational Politics of Visuality, Sexuality, and Masculinity

Television Drama in China: A Historical Overview

This chapter studies Chinese soap opera, a new form of TV drama that emerged and flourished in the People's Republic of China during the 1990s. Television drama is the most popular form of entertainment in contemporary China in terms of audience numbers because a high percentage of Chinese households own TV sets. Although TV drama dates back to 1958, the year in which the TV was born in China, only since the 1990s has there been an explosion in the production, broadcast, and consumption of soap operas. Statistics show that in 1994 more than 6,000 episodes of TV dramas were produced in China; in 1995, there were more than 7,000; and in 1996, more than 10,000. In 1978, China had only 1.5 million TV sets; but as of 1996, 280 million TV sets existed and the estimated TV audience was 800 million.[1] The exponential growth of TV ownership and the spread of TV programs is also a direct cause for the decline of film audiences.

Television broadcasts began in China at 7 P.M. Beijing time, on May 1, 1958, during the era of the Great Leap Forward. The first Chinese TV drama, a thirty-minute play titled *A Veggie Cake* (*Yikou cai bingzi*), was produced and directly aired on Beijing Television Station, on June 15, 1958. Hu Xu, director of this first TV drama, coined the term *dianshi ju* (television drama) for the new form. He created this term because *guangbo ju* (radio drama, radio play) already existed in Chinese. It was only fitting to have a parallel name for TV.

For him, as well as for many critics, the birth of Chinese TV drama was an indigenous phenomenon, not one that imitated the foreign. In addition to Beijing TV and China Central TV (CCTV), other stations like Shanghai TV, Harbin TV, Guangzhou TV, Changchun TV, and Tianjin TV have produced and broadcast their own dramas since 1958. From 1958 to 1966, on the eve of the Cultural Revolution, China produced almost two hundred TV dramas. All of these were single-episode dramas, each simultaneously produced, performed, and telecast without being previously recorded. Chinese TV historians call the period from 1958 to 1966 "direct telecast period" (*zhibo qi*). Television drama production came to a halt during the Cultural Revolution and did not resume until 1978.[2]

Throughout the late 1970s and the 1980s Chinese TV stations produced indigenous dramas and aired foreign ones. American TV serials included *Man from Atlantis, Hunter, Falcon Crest, Remington Steel, Matt Houston*, and *Dynasty*.[3] The Japanese soap opera *Oshin* became tremendously popular when aired on CCTV in the summer of 1986. Since 1981, China has produced its own serials as opposed to the previous pattern of single episode dramas. *New Star* (*Xin xing*), a twelve-episode drama produced in 1986 by Taiyuan TV and telecast on the national network, was one of the most widely watched programs in the 1980s. The drama gained popularity by taking on the timely topical issues of economic and social reform.[4]

Television drama experienced unprecedented growth and popularity in the 1990s. Since then, it has firmly occupied the preeminent place in contemporary cultural entertainment. Given the vast output, Chinese critics attempt to grapple with subgeneric distinctions and terminological differences within the form. They speak of *lianxu ju* (television serial), *tongsu ju* (popular drama), *qingjie ju* or *yanqing ju* (melodrama), *shinei ju* (indoor drama), *feizao ju* (soap opera), *xiju* (comedy), *qingjing xiju* (sitcom), *lishi ju* (historical drama), *wuxia ju* (martial arts drama), *jingfei ju* (detective and

crime drama), and so forth. The longest Chinese drama to date, *The Great Qin Empire* (*Da Qin diguo*), has 136 episodes. Such top-rated and widely watched dramas as *Yearnings* (*Kewang*, fifty episodes, 1990) and *Beijingers in New York* (*Bejingren zai Niuyue*, twenty-one episodes, 1993) marked the maturity of soap opera as a full-blown Chinese genre. Similarly, *Stories of the Editorial Office* (*Bianjibu de gushi*, twenty-five episodes, 1991) has been regarded as marking the birth of situation comedy, Chinese style.[5]

A variety of sources in China, both private and public, finance and produce TV serials. Yet they are all aired on public and state TV stations at the national, provincial, municipal, or county level. Advertisements constitute a regular part of TV programs and provide a major source of income. The televisual text is a "supertext" that consists of the particular program and such introductory and interstitial materials as announcements and advertisements.[6] As we know, the name "soap opera" as a designation for a type of TV drama in America originates from the fact that the programs often advertised detergents and cleaning products. The genesis of soap opera in China also can be examined in this light. As mentioned earlier, *Yearnings*, the most successful Chinese TV drama, marks the beginning of Chinese soap opera. The serial's narrative intertwined the stories of two families. Most of the episodes took place in the setting of a house and were shot in a studio. Therefore, the drama is also credited for the beginning of "indoor drama"(*shinei ju*) in China. Interestingly, critics astutely point out an indissolvable link between the insertion of a commercial for a cleaning product and the story itself. Xie Mian and Zhang Yiwu write the following about the drama:

> There was always a commercial before the drama was telecast every time. This was a commercial for a detergent to be used in the water tank of the toilet in the home—a commercial for "Dailaoli" (literally, "Save your labor"). The commercial was like a by-product of this enchanting television drama. It traveled to almost every home in mainland China along with the drama. The commercial was like part of *Yearnings*. We seemed to be used to the commercial when we watched the drama. If we did not see Dailaoli first, *Yearnings* would not begin. A commercial for Dailaoli seemed to exist at the margins of the story of *Yearnings*. Only when the two were connected, things became a whole.[7]

In an uncanny way, such TV drama was "soap opera" in the classic sense that commercials of soap products are built into the very fabric of the television

supertext. American in origin, soap opera has now become a global form of television programming in many parts of the world, including (post)socialist China.[8]

Imaging National Identity in the Age of Transnationalism and Globalization

Because full-fledged soap opera developed relatively late in China compared to other parts of the world such as North America, Latin America, and Europe, the subject has received very little critical attention in the West. In fact, critics have pointed out that even in the West "it was not until the 1980s that soap operas began to be taken seriously as texts."[9] Soap opera has often been dismissed as a denigrated form of mass culture. In the context of television studies, media studies, and cultural studies during the last two decades a variety of approaches have been adopted in regard to TV drama: textual analysis, ideological analysis, ethnographic research, genre study, gender analysis, and so forth. In analyzing the political economy of TV programs, critics have attempted to determine correlations and antagonisms between the televisual text, audience response, commodification, capitalist hegemony, and the status quo. Critical positions often fall somewhere in the middle on a wide spectrum between two extremes: on one hand, populist celebration of potentially emancipatory moments of some TV programs and, on the other, condemnation of the TV industry for its role in perpetuating capitalist ideology.[10]

In attempts to move beyond purely textual and ideological studies much emphasis has been placed recently upon ethnographic research that focuses on the audience's reception of given TV programs.[11] Critics thus dwell on changing configurations of resistance, struggle, and negotiation among viewers in relation to the text and the industry.[12] Within the leftist critical legacy, a desire has existed to avoid reductive oversimplifications and binary oppositions and to build on and revise such earlier traditions as the denunciation of mass culture as ideological deception, in the fashion of the Frankfurt School, or the enthusiastic embrace of youth culture by British Cultural Studies. Thus, Jane Feuer points out in her study of American TV during the 1980s the importance of "deconstructing three sets of opposing terms that have structured leftist discourses around Reaganism and around

television: populist/elitist, complicity/critique, and commodity/art."[13] The need exists to take a balanced critical stance that follows "neither John Fiske nor Jean Baudrillard," neither "the ahistoricism of Jean Baudrillard's concept of resistance," nor "the totalizing endorsement of the subordinate resisting reader in John Fiske."[14]

Advances in critical studies of Western soap opera may offer some heuristic guides for examination of the contemporary Chinese scene, but they cannot be transferred wholesale to a different cultural and social setting. As a postsocialist, developing country, China poses a unique set of problems for cultural studies. If one continues to speak in terms of "resistance," "opposition," "negotiation," and "pleasure," one might ask: What exists in China to resist and oppose? Capitalist hegemony? Socialist politics? What kind of pleasures do audiences want? Officially, China is a socialist/communist state; yet, it has increasingly steered toward a capitalist market economy. Official slogans of the state capture this basic contradiction between politics and economics: "build a socialist market economy," "build socialism with Chinese characteristics."

While analyzing the social condition of contemporary Chinese TV drama during a time of depoliticization, globalization, and consumerism, some critics have identified three major forces that operate in public culture: (1) official discourse and state ideology, (2) elite culture (*jingying wenhua*), and (3) emergent "plebeian culture" (*shimin wenhua*), the culture of the masses and the populace.[15] Official discourse and state ideology refer to the cultural policies and regulations of the socialist regime, as well as to state-sponsored artworks and cultural activities. Elite culture consists of the discourse of intellectuals and humanists who purport to be the guardians of knowledge and high culture and are committed to the reconstruction of humanism and subjectivity. Commercialized popular soap opera is more allied with the forces of mass culture, yet it needs to negotiate with all three constituencies. The televisual text necessarily embodies a mixture of opposition, co-optation, negotiation, and confluence all at once. In analyzing a TV serial, the critic must be attentive to a number of concerns: state ideology and censorship, capitalist commodification, humanist discourse, and the sentiments of the masses.

In this chapter I wish to address the specific issue of national identity in a particular type of soap opera. What was "China" in the global cultural

imaginary at the end of the twentieth century? As an abstract social totality, or "a thing in itself," China remains inaccessible to the cognitive cartographer. China is visible to the human eye insofar as it projects itself as an image or self-image, or more precisely, as an endless series of images and simulacra. The task at hand is to investigate the production and consumption of China's self-image in contemporary Chinese visual and narrative texts, and more specifically, prime-time TV soap opera. In everyday life the Chinese consumer is swamped day and night in a vast, inescapable sea of visual images: TV, video, film, billboards, magazines, and so forth. Out of this fragmented, schizophrenic collective of simulacra, an illusory image of China is constructed in both public space and the private fantasy world. Whether it is the picture of a Western fashion model on the front cover of a magazine sold by a peddler on the street of any Chinese city, or the representation of "foreign babes" in a prime-time TV program, the Chinese nation fashions images of itself and the other on its map of global cultural geography. In such a manner, visuality in contemporary China partakes of a transnational, cross-cultural politics of representation.[16]

In a post–cold war era characterized by both globalization and fragmentation, it may no longer be feasible to speak of the old divide between third world "national allegory" and American postmodern culture.[17] No country, certainly not China, can be treated as a homogeneous entity. Yet it is all the more important to analyze the need on the part of Chinese visual and narrative texts to fashion images of national and cultural identity, or to create a semblance of an "imagined community" precisely because of culture's fragmentation and transnationalization at present. To borrow a term from Fredric Jameson, one must inquire into the *geopolitical unconscious* of contemporary China, that is, the projection of a vision of the social, the public, and the national-within-the-global, through the tales and images of the private, the sexual, and the psychic in media representation. We may not treat the texts as national allegories, but as images of *imagined national identity* in the paradoxically *transnational*, postmodern hyperreality.[18] Transnational flows of capital, images, and people between China and the world open up new avenues of inventing nationhood and creating self-understanding.

In the domestic and global arena of image production and consumption, we can distinguish two opposite yet complementary strategies in the politics of China's self-representation. In the global cultural market Chinese artists

offer localized narratives and images of China. They employ the strategy of self-exoticization and self-eroticization for the gaze of the Western spectator. China appears as an ethnic other. Such a "(self-) ethnographic" approach is most evident in the New Chinese Cinema.[19] (Consider films of Chen Kaige, Zhang Yimou, Zhou Xiaowen, and Xie Fei that circulate in the international market.) Othering the self sells in global consumption; art-*cum*-commodity must be stamped with some intrinsic "Chineseness" to be purchased and consumed across the world.

However, the domestic cultural market has the opposite strategy. In order to fulfill the expectations, fantasies, desires, and self-knowledge of indigenous, local Chinese, the media must project a sense of, not "tribalism," but globalism. The media brings the other, the foreign, to the Chinese screen, and exoticizes, eroticizes, and at times subalternizes it. (For instance, the story of Russian girls looking for work in a Chinese city such as Harbin, which I will analyze later.) Moreover, the initial exoticization of the foreign is ultimately accompanied by a domestication, a taming, and literally a marrying of foreigners and Chinese within Chinese space, say, the quintessentially traditional courtyard (*sihe yuan*). (One example is the TV serial about American girls in Beijing, a topic to which I will return later.) Thus, China as both a latecomer nation-state and an ancient empire vindicates itself in the narrative of the universal history of capitalism and modernity. In such a politics of visual representation it should be emphasized that the public, national agenda of modernization and globalization must be nevertheless narrated through the private fantasy world of transnational libidinal economy.

The course of my analysis of interrelations among the media, popular culture, and the public sphere focuses on the formation of what I call a new "transnational male imaginary" in China during the 1990s. I examine the mass media's attempt to reconstruct a male subjectivity in the condition of transnational public culture. The recuperation of masculinity constitutes a crucial component of popular culture in contemporary China.

The Emergence of Transnational Libidinal Economy

Broadly speaking, the popular discourse of masculinity in the New Era (late 1970s to late 1980s) played a subversive, critical, and antihegemonic role in

the public sphere. In the 1990s, new popular genres, which were initially introduced from Hong Kong, Taiwan, and the West, largely supplanted older forms of literary, artistic, and cultural production. Ironically, the triumph of this new type of popular culture also implied its gradual acceptance and co-optation by the state in general. China's integration into global capitalism in the 1990s brought about new possibilities, desires, and anxieties in the discursive and social space of the male gender. The construction of a male imaginary or the establishment of a male subjectivity has been an urgent task for the mass media and public culture at large. What would be an effective strategy to recuperate a functional masculinity?

In the post-Mao era the liberation and reassertion of individuality-*cum*-masculinity became a major concern in public culture. During the mid-1980s the "search for men" dominated both intellectual discourse and popular culture. "Men" (*nanzi han*), here understood as "tough," "rough," "masculine," "manly," is a redundant expression indicative of the very problematical nature of the Chinese discourse of masculinity under construction. A critique of masculinity forms part and parcel of the critique of Chinese society. For instance, one of the most celebrated writers of the 1980s was Zhang Xianliang, who lived in prisons and labor camps for two decades. Stories of his such as *Half of Man is Woman* (*Nanren de yiban shi nüren*) depict the emasculation and sexual impotence of Chinese men caused by political oppression. The story turns the theme of dysfunctional masculine sexuality into an allegory of the nation's fate as a whole.

The critique of injured masculinity is necessarily accompanied by its positive reconstruction. In 1988, Zhang Yimou's film *Red Sorghum* (*Hong gaoliang*) was a box office hit in China. The film told a story of psychical and libidinal liberation among Chinese men during a legendary past; it reenacted the resurrection of Chinese masculinity. Popular song singers later took up such theme songs from the film as "Little Sister, Go Forward Bravely" (*Meimei ni dadan di wanqian zou*). Cassette collections of popular songs titled "Northwestern Wind" (*Xibei feng*) and "Shaanbei 1988," both of which deal with the Shaanxi area, the cradle of Chinese civilization in northwestern China, have swept across China and galvanized tens of millions of young Chinese. Sung in a hoarse male voice, these songs relate myths of regained virility and revival of the ancient land. In this popular refashioning of the image of men, masculinity is no longer depicted as refined, reserved,

and effeminate in accordance with the scholar-intellectual image prevalent in Chinese culture, but as a projection of primitive vitality.

The 1990s marked a continuing "search for men" in Chinese culture. Xie Fei's film *Women from the Lake of Scented Souls* (Xiang hun nü), cowinner with Ang Lee's *Wedding Banquet* of the Golden Bear Award at the 1993 Berlin Film Festival, contains a strong critique of masculinity. Set in a village in contemporary China, the film tells the story of a Chinese woman, the owner of a sesame oil store. As typical in the Chinese "socialist market economy," she starts a joint venture—in her case with a Japanese investor to export high-quality sesame oil to Japan. Despite her success as a well-respected businesswoman, she must struggle with a dysfunctional family that includes a crippled husband and a mentally retarded son. Male impotence in the family results in lack of libidinal and emotional fulfillment for her and her daughter-in-law. Similar situations can also be seen in Zhang Yimou's later films.

Contemporary Chinese discourse about masculinity in the era of transnational capitalism necessarily has its "Chinese characteristics." A strong "socialist market economy" has created a new agenda that the state and popular culture share, namely, the Chinese economy should ultimately catch up with those of the advanced Western countries. Competition between China and the West represents rivalry in the accumulation of capital and economic development. In terms of gender representation in popular culture, the rivalry between nations and economies turns into a libidinal economy. The reassertion of Chinese masculinity takes the form of transnational fantasy, the wish fulfillment of competing with foreigners for the possession of capital and women. A triumph in the libidinal economy will be directly linked to struggle in the financial arena. This transnational male imaginary manifests a collective geopolitical unconscious and amounts to the psychic counterpart to the economic. In the case of gender discourse, a danger exists that the establishment of a new masculinity in the mass media will be appropriated for nationalistic, patriarchal causes.

In the 1990s, a cluster of narrative and visual texts—stories, novels, films, and nighttime soap operas—described trafficking between Chinese and foreigners in China and the Chinese diaspora. The texts usually unfolded as titillating, sensational dramas of transnational, transcultural love between Chinese and foreigners in China, or between ethnic Chinese and non-

Chinese in diasporic settings. Products of this fledgling culture industry include, to name a few titles, autobiographical novels such as *Beijingers in New York* (*Beijingren zai Niuyue*, by Cao Guilin), *A Chinese Woman in Manhattan* (*Manhadun de Zhongguo nüren*, by Zhou Li), *He Married a Foreign Woman* (*Quge waiguo nüren zuo taitai*, by Wu Li), and *My Experience as a Lawyer in the United States* (*Wo zai Meiguo dang lüshi*, by Zhang Xiaowu and Li Zhongxiao). Among nighttime soap operas were *Beijingers in New York* (based on the novel by the same title), *Chinese Ladies in Foreign Companies* (*Yanghang li de Zhongguo xiaojie*), *Shanghainese in Tokyo* (*Shanghairen zai Dongjing*), *Russian Girls in Harbin* (*Eluosi gunian zai Harbin*), and *Foreign Babes in Beijing* (*Yangniu zai Beijing*). Representative films included *A Wild Kiss to Russia* (*Kuangwen Eluosi*). In the following pages I will focus mainly on examples of soap operas to detect certain shared strategies of imaging the self and the other in the Chinese media.

In 1993, the most popular TV program was the twenty-one-episode serial drama *Beijingers in New York* (directed by Zheng Xiaolong and Feng Xiaogang and aired on CCTV and Beijing TV).[20] The film captivated the entire nation. This was the first Chinese television drama shot entirely outside China, on location in New York. Director Zheng Xiaolong had already gained fame for producing such top-rated dramas as *Yearnings* and *Stories of the Editorial Office*. Yet it was still an ordeal for him to finance this new drama. The production budget stood at 1.5 million U.S. dollars, or the equivalent of 10 million yuan at that time. Beijing Television Art Center and CCTV signed a contract as copartners in the production. China Central TV agreed to allow three minutes of advertising in each episode during the serial's first run, up to a total of sixty minutes for the entire show.

The production team at Beijing TV Art Center borrowed 1.5 million U.S. dollars from the Beijing branch of the Bank of China. At first, the Bank of China balked at lending the money, afraid that Beijing TV might not be able to pay back the loan if the drama failed. In despair, Zheng and his associates took the daring step of writing to the Central Committee of the Chinese Communist Party, asking it to intervene on their behalf. Li Ruihuan, a reform-minded leader, was then in charge of artistic and ideological matters in the party hierarchy. At the urging of the Central Committee, the Bank of China loaned the money and the production team went to New York.[21] After its first run on CCTV in the fall of 1993 the serial proved popular

enough to be aired on Chinese-language TV channels in the United States during the spring of 1994.

The main narrative strand of the drama details the life story of Wang Qiming (Jiang Wen), a Chinese artist and new immigrant in New York City, his wife Guo Yan, daughter Ning Ning, mistress Ah Chun, and business competitor David McCarthy. Wang Qiming comes to the United States as a viola player but cannot find a suitable job. He and his wife then become laborers in a sweater factory. His wife later leaves him for the factory's owner, David, a white male. Wang subsequently establishes his own business and becomes an entrepreneur himself. At the end of the film he defeats David in financial competition and takes over his factory.

The story encapsulates the ambitions and frustrations of Chinese males in the 1990s and relates the very tale of transnational capitalism itself. It tells about the transformation of an artist-intellectual into a capitalist who would do anything to survive and win. It situates a Chinese male in competition with a white male for possession of capital and women. Finally it announces the victory of that Chinese male on the financial, economic, and libidinal battlegrounds vis-à-vis his American competitor.

In one scene, Wang Qiming pays a local symphony orchestra to perform with him. His newfound financial power enables him to resume his artistic career for a moment and command a large orchestra. Another telling sequence occurs when a white prostitute entertains Wang. He holds a large number of bills in his hand and asks the half-naked, buxom prostitute to say "I love you." Compromising scenes such as these invite the viewer to speculate about some possible deep collective political unconscious of Chinese nationals in the global arena.

The TV serial ends with a scene at a street intersection after Wang Qiming has gambled away his entire fortune at Atlantic City. A white woman driver yells at him for blocking traffic and he sticks out his middle finger as if to say "fuck you." Wang's lover has been Ah Chun, a Chinese-American restaurant owner. This open ending invites viewers to imagine what Wang might do next. Perhaps he has just revealed his desire subconsciously in the obscene gesture. The insertion of Chinese males in the global circulation of capital, people, and desire in this TV program has provided the Chinese male audience with potent images of wish fulfillment and self-caricature. The audiences' responses to and assessments of the main male

character diverged drastically, but the show generally fascinated viewers because it represented an attempt at Chinese self-definition in the global cultural imaginary of the 1990s.[22]

Because it was shot entirely in the United States, the drama offered Chinese viewers a close look at the sights, sounds, scenery, and landscape of New York. Yet, as critics have pointed out, these postcard images of New York have less to do with America than with Chinese sentiments. A Chinese woman journalist, now resident in the United States, has described the drama as one that "sees Western scenes through tinted glasses." For her, the drama was concocted with the formula "xenophobia + patriotism + patriarchy + anti-imperialism and the criticism of capitalism." A propaganda set piece, the serial has nevertheless won the applause of officials, ordinary people, and intellectuals alike in China.[23]

Critics have also pointed out that Wang's mindset resembles the character Ah Q in Lu Xun's masterpiece *The True Story of Ah Q (Ah Q zhengzhuan)*, written early in the twentieth century.[24] Ah Q has been seen as an archetype of the Chinese national character who lives in the illusion of an exaggerated sense of greatness but is in reality a pathetic weakling and loser in the modern world. Likewise, Wang grows up in the era of the Cultural Revolution and then goes to America looking for opportunities. At times he detests capitalism and exploitation and makes fun of his own transformation into a capitalist; yet at other times he wants to be rich and stand on top of the world. He often curses America: "What is America? When we [Chinese] were human beings, they were still apes!" Yet he brings his own family to America to fulfill his dream. He is ashamed of China's backwardness, yet proud of its civilization. As an artist-intellectual-capitalist-hooligan, he embodies a dual, split, Ah Q–esque character. Through him, the drama reveals the contradictory nature of Chinese national identity and nationalism in a trans-Pacific setting.

An equally popular novel about successful overseas Chinese is Zhou Li's autobiographical novel *A Chinese Woman in Manhattan* (1992). The novel also relates a rags-to-riches tale about a Chinese in New York City, the financial capital of the world. It differs from *Beijingers*, however, because the protagonist is a Chinese woman who marries a white man. Despite the tremendous popularity of the novel, it never became a TV program. Given the libidinal dynamics of Chinese transnational public culture, I suspect that

the story of a Chinese woman being "taken" by a white man, however successful she may be in New York, would not fare well with a large share of China's domestic male TV audience.

Romancing the Other: Russian Girls in Harbin and Chinese Men in Russia

Due to the success of *Beijingers*, a number of soap operas followed suit on the theme of Chinese abroad or foreigners in China. In fact, the very names of these soap operas indicate the influence of *Beijingers: Shanghainese in Tokyo, Russian Girls in Harbin*, and *Foreign Babes in Beijing*. However, none of these later dramas had the same kind of impact and shocked audiences as much as the original program.[25] Sometimes regarded as pale imitations of *Beijingers*, they have not received due critical attention.[26]

Most Chinese TV serials are miniserials, not as long as many in other countries that may last years. Nevertheless, seriality is a fundamental feature of Chinese television dramas, and they have relatively open-ended narratives. The appearance of various characters with contrasting beliefs and personalities, commercial interruptions, narration in serial installments, and the seemingly perpetual delay of ending and closure make these dramas more or less multivoiced dialogic discourses and polysemic texts. Although it is difficult or impossible to offer a definitive decoding of their meanings, issues of national and cultural identity in the age of transnationalism and globalization loom large in these dramas.

Chinese tabloid journalism and mass media have reported that dire economic circumstances in the former socialist bloc countries have caused large numbers of their citizens to go to other countries, including China, in search of better jobs. One of the most sensational currents of related news tells stories about young Russian women who work in China's entertainment business, a phenomenon that last occurred in Shanghai during the republican era of the 1920s and 1930s. At that time many Russian men and women fled the Bolshevik Revolution to live and work in other countries such as China. Once again, after the collapse of the Soviet Union, stories tell about Russian women who have appeared in numerous Chinese cities, not only along the coastline, but also in places in the hinterland that have never seen any for-

eigners in the past. These women, cast with stereotypical "blonde hair and blue eyes" (*jinfa biyan*), work in restaurants, bars, dance halls, hotels, and fashion shows. Business thrives wherever they work because Chinese men patronize these places to be served by "exotic" Western women.

To be sure, the figure of the Western woman is not new to Chinese gender discourse. Whereas the Chinese peasant woman often serves as a signifier of feudal oppression, throughout the twentieth century the white woman has been a trope of Western lifestyle and the incarnation of modernity itself.[27] In contemporary China, popular magazines frequently feature pictures of white fashion models to attract the gaze of males. The white woman functions as an object of both male desire and female mimicry. A good example can be seen in Zhou Xiaowen's 1994 film *Ermo*. The comedy juxtaposes scenes from an imaginary world of romance and lovemaking as seen in American soap operas such as *Dynasty*, which has run and rerun on Chinese TV since the 1980s, and the drab, ordinary, real world of daily struggle in rural China. Ermo, the title character, in her illicit love affair with her neighbor reenacts a subconscious mimicry of televisual images that depict the lifestyle of the foreign. This does not suggest that Chinese women did not have sexual desires prior to viewing *Dynasty*, but points instead to the catalytic effect of media images in contemporary China.

A good example of transnational trafficking of Chinese men and foreign women in contemporary Chinese mass media is the twenty-episode TV serial drama *Russian Girls in Harbin* (*Eluosi gunian zai Harbin*, directed by Sun Sha, CCTV and Heilongjiang Studio/Tian'e Film, 1994). The drama narrates the tale of a group of Russian girls who go to Harbin looking for work and wealth. Harbin is a large city with a long history of Russian influence near the Sino-Russian border in northeast China; today it is a major trading center between the two countries. The drama consistently foregrounds the (imaginary) central position of Chinese men in relation to women, whether Chinese, Russian, or otherwise. The centrality of the Chinese masculine gender is established, confirmed, and reconfirmed as the drama positions Chinese men as owners of power and capital. Foreign women are the "subalterns," subject to the gaze and desire of Chinese men.

Multiple narrative strands, plots, and characters exist in *Russian Girls*. One overarching narrative thread is the triangular love story between Fang Tiancheng (Jiang Wu), a young Chinese entrepreneur, his former Chinese

girlfriend Liu Ying, and newcomer Olia, a Russian girl. The serial begins with Olia's story. Olia's family suffers because of Russia's economic decline. Although a caring parent, Olia's father is a helpless alcoholic who cannot pull the family out of poverty. Olia leaves her family and boyfriend for China hoping to find a good job. At Suifen River, she finds herself in danger of attack by Chinese mobsters. At a critical moment Fang Tiancheng appears, beats back the bad guys, saves Olia, and then leaves the scene. As time elapses, they run into each other in Harbin. Overjoyed by their reunion, Tiancheng helps Olia find a job and an apartment.

One particularly provocative scene occurs during a dinner that Tiancheng and Olia share. Tiancheng brings back the bitter memory of past events in Sino-Soviet history and tells Olia that China has always been a generous country. However, during the difficult years following the Sino-Soviet split in the late 1950s and early 1960s the Soviet Union unfairly demanded that China pay back its debt, and thus caused hardship and hunger to tens of millions of Chinese. The ungratefulness of the Soviets contrasts sharply with the generous manner in which Tiancheng treats Olia to a bountiful dinner. While Tiancheng goes on, Olia listens silently. At one point, she tells him not to be so cruel to animals since Tiancheng has shot a pigeon to prepare her a special Chinese dish. Although such conversations reveal a degree of self-mockery and irony, they also suggest that the "cunning of history" has given China the right to teach its long-time rival Russia lessons through the mouth of Tiancheng. It is no coincidence that similarities exist between the personae of Fang Tiancheng in *Russian Girls* and Wang Qiming in *Beijingers*, for Fang Tiancheng is performed by none other than Jiang Wu, the younger brother of Qiang Wen, who portrays Wang Qiming in *Beijingers*. The resemblance between the two actor-brothers is all too obvious.

The last episode of the serial depicts most of the Russian girls leaving Harbin for Russia by train to return home for Christmas. Tiancheng and Olia, who off and on have had a love affair, find the moment of parting agonizing. The final climactic sequence unleashes the pent-up feelings and anxieties between the two lovers. Olia runs toward Tiancheng from a distance in slow motion, while Tiancheng waits for her with his motorcycle. The final shot shows the two riding into the horizon. The soap opera concludes on the happy note of union between two lovers and, metaphorically, between two cultures and two countries.

FIGURES 31 AND 32. Tiancheng gazes at the sleeping beauty Olia in *Russian Girls in Harbin*. Courtesy of Heilongjian Film Studio.

Throughout, the serial exoticizes and eroticizes Russian girls.[28] Most of them work as waitresses and entertainers in a modern hotel in Harbin. All can sing in a beautiful voice, and all look sensuous and vivacious. The manager of the hotel, a Chinese woman, has to teach them about Chinese demeanor. She tells them to be modest around guests rather than flirtatious. Although Olia stands out from the rest as a virtuous and intelligent girl, her body is eroticized in numerous shots. For instance, during a scene in which Tiancheng brings Olia breakfast in bed, his gaze fixes on her voluptuous body; she becomes the "sleeping beauty." In a shower scene, the camera slowly caresses the upper body, the back, the hair, and the neck of Olia as she washes herself. The Russian woman on screen, as the ethnic other, in her "being-looked-at-ness," thus bares and surrenders herself to the eyes of the local Chinese spectator.

Another noteworthy visual text is the film *A Wild Kiss to Russia* (*Kuangwen Eluosi*, directed by Xu Qingdong, Beijing Film Studio, 1995). Ranked as the tenth best-selling Chinese-made film in 1995, it is a comedy about the romantic adventures of two Chinese businessmen in Russia.[29]

Chinese comedy star Feng Gong portrays the protagonist, Da Jiang. At the beginning of the film, Da Jiang, a poor intellectual, has just ended a seven-year marriage. His wife has left him for a rich man. Da Jiang then decides to go to Russia with his friend and business partner Shuang Cheng to sell Chinese goods and pursue his dreams. Shuang Cheng has an affair with Natasha, as he has with other Russian women, while Da Jiang falls in love with Natasha's younger sister Katya. An aspiring ballet student, Katya wishes to go to Moscow to pursue studies, but has no money.

For some time Da Jiang is determined to make enough money to send Katya to Moscow. Yet the two remain separated for various reasons. At the film's end, after completing their business deals in Russia, Shuang Cheng and Da Jiang return to China. Shuang Cheng becomes the owner of a bar where Russian dancers regularly entertain guests. When Da Jiang visits the bar, Katya suddenly appears to his surprise and performs a segment of *Swan Lake* for the guests. The film ends with a sequence in which Da Jiang and Katy are reunited, and the two lovers "wildly kiss."

Many things can be said about this comedy. First, it portrays the economic ascendancy of Chinese men vis-à-vis their former Russian "big brothers." Moreover, their ownership of capital soon entails an overflow of libidinal energy. Chinese wealth can be exchanged for Russian love. Throughout, the film depicts Russian men and women as paupers all too eager to receive *renminbi* (Chinese currency). They work for Chinese bosses, who are invariably male, of course. In one scene, Katya prepares to sell her piano to survive. Da Jiang comforts her and holds her in his arms while saying "there will be bread, there will be milk, there will be everything" (*mianbao hui you de, niunai hui you de, yiqie dou hui you de*).

Many Chinese viewers would immediately recognize this line as a verbatim quote from the film *Lenin in 1918* (directed by Mikhail Romm, 1939), one of the most popular Soviet films in the Mao era. Lenin says this in the movie to comfort an old Russian woman during a very difficult time in Soviet history. Da Jiang's words here, as in many other contexts, become a parody of Lenin's original. Numerous instances like this not only mock the former relationship between China and Russia but also reverse that relationship. The Russian revolution is no longer a model and inspiration for the Chinese; it is now the Chinese who provide "bread," "milk," "piano," and "everything." Although the element of self-parody and self-deflation form part of the humor of the comic star Feng Gong, his reiteration of a familiar line from a sacred revolutionary text heightens the changed circumstances between now and then, and between the two neighboring countries.

Thus, it is easy to discern the underlying nationalist, sexist undertone in such media representations of the gender relationship between China and Russia. In the nineteenth century, Czarist Russia bullied, humiliated, and defeated China many times. In the twentieth century, Stalin's Soviet Union held itself as the model society to be emulated by the Chinese communist revolution. The Chinese Communist Party was a little brother under the shadow of the big brother. In the 1960s and 1970s China considered the Soviet Union its ideological rival and number one enemy. Yet at the end of the century, China seemed to remain intact and has emerged with a flourishing capitalist economy in contrast to social and economic disintegration in the former Soviet Union. The victories that Chinese men score with foreign women are meant to represent not only a resurrection of Chinese masculinity but also a triumph of the Chinese nation itself.

Domesticating the Foreign: American Babes in Beijing

In 1996, China's prime-time TV aired a twenty-episode soap opera titled *Foreign Babes in Beijing* (*Yangniu zai Beijing*, directed by Wang Binglin and Li Jianxin, Beijing Film Studio). As a top-rated program in a country where "TV penetration . . . is at over 95% or so, . . . *Foreign Babes* had a first run audience of about 600 million viewers" and has had several reruns since.[30] This melodrama focuses on the lives of several ordinary Chinese families living in a traditional Chinese compound (*sihe yuan*) and the adventure of a group of foreign students in present-day Beijing. The program has numerous characters and several plot lines, but the main narrative strand involves entangled love affairs between two brothers of the Li family, Tianming and Tianliang, and two American students, Louisa and Jessie.

The first episode of the serial begins with a scene in a typical crowded bus in the streets of Beijing. Among the passengers are two American students, Robert and Louisa. As the passengers push their way around in the congested bus, Robert comments that people in Beijing lack civility (*wenming*). A Chinese youth, Li Tianliang, overhears the remark and becomes enraged. After they leave the bus, Tianliang and Robert get into an argument, lecturing each other about civility and civilization. Tianliang scolds Robert, telling him that, judging by his attitude in the bus, Robert is the one who is rude and lacks a sense of decorum. Robert refuses to apologize and asks Tianliang if he has the courage to beat him up, so Tianliang throws Robert a heavy punch and knocks him down. Meanwhile, Robert's friend Louisa stands nearby, feeling nothing less than "love at first sight" toward the Chinese man. From that moment, Louisa turns down the courtship of Robert, her American classmate, but persistently pursues Tianliang, marries him, and eventually lives with Tianliang and his extended family in the traditional Beijing family compound. Throughout, the film portrays Louisa as a virtuous, lovely, dutiful wife living harmoniously with her Chinese in-laws.

Louisa's friend, Jessie (Rachel DeWoskin), is another kind of character. Aggressive and impetuous, she relentlessly pursues Tianliang's elder brother, Li Tianming. Unfortunately, Tianming is a married man and lives with his wife, Qin Fen, and their small son, Huzi or Xiaohu (Little Tiger). Subsequently, Tianming and Jessie have an extramarital affair. Yet their relationship proves stronger than infatuation and obsession. The two seem to be

genuinely in love. At the end of the serial, Tianming divorces his wife and leaves for America with Jessie.

The two brothers, the two "American babes," and the two pairs of transnational lovers are opposites, and thus seem to present a varied and complex picture of the Chinese themselves, as well as of foreigners. The younger brother, Tianliang, is a patriotic, righteous, and straightforward young man. Although he remains a faithful and loving husband after marrying Louisa, the interests of his country and his state-owned company always come first.

In one episode, Louisa's father, Jack, the head of an American company that does business in Beijing, stands at the verge of bankruptcy and desperately needs to sell his company's technology and equipment to a Chinese buyer. Tianliang's family urges him to help their in-law by buying his equipment. However, Tianliang decides to buy instead from a Japanese company at a cheaper price to save money for his own company and for China. Apparently, the episode shows that Tianliang places national interest above personal interest. Although his course of action seems cruel and incomprehensible to members of his family (father, mother, brother, and so forth), Louisa loves him all the more for his incorruptibility and professionalism. Later, Tianliang manages to take care of both ends by introducing Jack to another Chinese buyer. In one scene, after the crisis settles, Tianliang and Louisa go out to the suburbs to relax. With the silhouette of the Great Wall in the background, Tianliang proceeds to teach his attentive American wife a few things about the "Chinese way," about the fact that Chinese people really "respect human rights."

The older brother, Tianming, has different characteristics. Opportunistic and self-promoting, he seizes any chance to move up the social ladder. Likewise, his American lover, Jessie, differs from Louisa. She appears impetuous and irresponsible at first. Their extramarital love affair certainly puts their moral character in question. Jessie's action breaks a Chinese marriage apart, causes a Chinese woman to suffer, and brings shame and disgrace to the Li family. Yet as the story develops, their love and self-determination become the saving grace for Tianming and Jessie.

Although this family melodrama dwells on the commonality of human feelings across racial and national boundaries, it also attempts to discover the comedy of cultural differences between China and the West. For instance,

the Li family is heartbroken to find out that their eldest son has had an illicit affair with a Western woman. Not only has he dealt cruelly with their beloved daughter-in-law, Qin Fen, but he has also disgraced the family, its ancestors, and its neighbors. In one episode, Mr. Li, a rather traditional father, as well as a comic figure, seeks out Jack, Tianming's boss at that point, to dissuade Tianming from divorcing his wife for the sake of Jessie. In Mr. Li's traditional Chinese reckoning, Jack can certainly stop Tianming since he is Louisa's father and, more important, the "leader" of Tianming's "work unit" (*danwei lingdao*). To the surprise of Mr. Li, Jack responds that he has no right to interfere with Tianming's personal life and must respect the separation of private and public spheres even as his boss. As a matter of fact, he himself has married four times. For Jack, divorce is the "beginning of new life" (*xin shenghuo de kaishi*)! The mindsets of the two parents, though now related by marriage, could not be further apart.

In the libidinal arena, the drama necessarily positions the American boy, Robert, as the loser. Although he has known Louisa since childhood, he loses her to Tianliang. At the end of the serial, Robert has contracted a kind of cancer incurable in America, and the only hope for a cure is traditional Chinese medicine and exercise. One final shot of the serial shows Robert practicing physical exercise amid a group of Chinese people.

The marginalization of Chinese women, represented by the character of Qin Fen, should also be noted. As Tianming's wife and Huzi's mother, she is a traditional Chinese woman. Even after her divorce from Tianming, she does not rebel against the Li family, but stays on good terms with them and remains dedicated to raising her son in the absence of his father. As far as the audience knows, Qin Fen does not remarry. The finale of the soap opera shows the characteristic New Year Chinese family dinner, a time of reunion. As her ex-husband Tianming leaves for America with Jessie, Qin Fen shows up at the Li family house to join in the happy gathering, still a member of the Li family. In general, the image of Qin Fen is that of a local Chinese woman who silently swallows the sorrow, bears the suffering, and accepts whatever fate has in store for her. This image of the self-sacrificing, suffering, devoted, young Chinese woman, created to win the sympathy and affection of broad segments of TV viewers, can be traced back not only to traditional Chinese literature and modern film, but also more specifically to the archetype fashioned by the character Liu Huifang in *Yearnings* (Kewang). Rachel

DeWoskin, the actress playing Jessie who steals Qin Fen's husband in the soap, writes the following about Qin Fen's character:

> All of my writhing, naked love scenes with Tian Ming are juxtaposed to scenes of his wife doing virtuous things—walking down rows and rows of the factory, working overtime, and patiently teaching their baby how to read. She breaks her back in a factory and then runs home to cook beautiful dinners for the family. She watches the clock, waiting for Tian Ming, refusing to believe what she suspects might be true. I actually cried watching the show when his wife leaves the family home.[31]

In this soap opera the "American babes" are clearly winners as opposed to the Chinese women. Furthermore, in contrast to *Russian Girls in Harbin*, the drama represents Louisa's and especially Jessie's families as wealthy in comparison to their Chinese counterparts. In *Russian Girls*, Russian families are told to be poor. Even worse, Olia's father is an irresponsible alcoholic. The comparative financial situations of the Chinese, Russian, and American families form an allegory of the three countries' uneven economic strength during the post–cold war period.

The Transnational Politics of Sexuality and Masculinity in the Chinese Media

In the racial, transnational politics of Chinese men, whose desire and gaze motivate the flow of the respective narrative, *Russian Girls* and *Foreign Babes* undeniably marginalize local Chinese women in favor of white women.[32] The foregrounding of white female sexuality stands as a symptom of insecure male subjectivity. The imaginary conquest of the white woman is a male defense mechanism, an attempt to do away once and for all with the stereotype and self-perception of inadequate Asian/Chinese masculinity and sexuality.

The psychosexual dynamics in these Chinese soap operas can also be understood in light of the writings of Frantz Fanon, a foundational figure in the genealogy of postcolonial studies. In his seminal book *Black Skin White Masks*, Fanon theorizes the subject-positions of black men and women, and their sexual and marital relationship with white men and women. Psycho-

analysis provides him with a vantage point to investigate colonialism and racism. On the one hand, he criticizes black women in the Antilles for their desire to marry white men. He accuses these women of being complicit in the emasculation of the native black male. Fanon contemptuously describes their wish to gain white acceptance through marrying white men as "whitening lactification." On the other hand, he expresses more sympathy with the desire of black men to marry white women. In chapter three, "The Man of Color and the White Woman," Fanon writes, "I wish to be acknowledged not as black but as white. Now—and this is a form of recognition that Hegel had not envisaged—who but a white woman can do this for me? By loving me she proves that I am worthy of white love. I am loved like a white man."[33]

Through such a dialectical reversal the third world subject, whether an "oversexed black male" or "undersized Asian male," as popular stereotypes go, proves able to reassert his manhood in terms of sexual, political, and economic power. This type of anticolonial, counterhegemonic thought is obviously embedded in masculinist, patriarchal, nationalist discourse. Mary Ann Doane points out that "For Fanon, a psychoanalytical understanding of racism hinges on a close analysis of the realm of sexuality. This is particularly true of black-white relations since blacks are persistently attributed with a hypersexuality."[34] The relationship between race and sexuality becomes equally important in the Chinese context, since racist discourse and some popular perception has dismissed the Chinese or Asian as lacking in masculinity. Historically, in Hollywood fiction the "Chinaman" has always been a creature of problematic masculinity.[35] When interracial romance does happen in a positive light, it usually occurs in the context of a "white knight" taking a submissive Chinese lady (Susie Wong and others).

In the international film market, Hong Kong action and martial art films give expression to the heroics and antics of Asian masculinity. Yet, even in such genres, libidinal economy is kept at a minimum, and the male heroes appear to be single-minded, desexualized fighting machines.[36] Hence, the resexualization of Chinese masculinity through the white woman on primetime national TV in mainland China marks a significant development in the self-imaging of China. Although these TV programs are not intended for international primary audiences, they serve the function of reversing existing images of interracial relations on the home front.

If the white woman has represented a figure of "modernity" and "beauty," and has most of all served as a trope of "alterity" in the Chinese public culture, her latest transformation and domestication within China betokens a new moment in the self-other binarism of the male imaginary.[37] She is no longer an "other," an object of gaze, a figure distant from the self. She stands now within reach, and turns into a vehicle of the male ego's self-aggrandizement. If Western soap operas such as *Dynasty* offered titillating televisual images of the romantic other for mass cultural consumption and yet held that "fantasy world" at arm's length away from the local Chinese consumer during the 1980s—as vividly reenacted in a fictional film such as *Ermo*—Chinese media has recently created its own tales of wish fulfillment. Meanwhile, the Chinese male, purportedly bearing the burden of the entire collective, displaces his erstwhile subalternity and replaces it on the foreign female.

Circulation of these stories and images of regained masculinity in the mass media reveals something about the nature of contemporary Chinese public culture. Although no official pronouncement on these matters exists, the state acquiesces in such portrayals in national TV stations, newspapers, and magazines. In contrast, the censors have been rather strict with other representations of Chinese masculinity in international film culture. Here I refer to, for example, films by Zhang Yimou and Chen Kaige. Zhang's depiction of Chinese men has changed radically since his first film, *Red Sorghum*. In his later works—*Ju Dou*, *Raise the Red Lantern*, *The Story of Qiu Ju*, and *To Live*—Zhang depicts Chinese masculinity in dysfunction and crisis. The spectator sees impotence, incest, concubinage, polygamy, injured male organs, and the inability of men to save their spouses and children.

Some Chinese critics point out that these films cater to the taste of Western audiences by selling out spectacles of the exotic Orient. Although images of dysfunctional, impotent Chinese masculinity may fare well with Western audiences, for whatever reasons they run counter to public discourse and the mass media in China. If there is still any use for the notion of "national allegory" as formulated by Fredric Jameson in his discussion of third world literature in the era of multinational capitalism, one can tentatively conclude that the libidinal economy of public culture in a "post–third world" country (a former third world country in the cold war era) such as China in the era of transnational capitalism is a fable of the embattled situ-

ation of the post–third world in relation to the dominant Euro-American political and libidinal economy. Soap operas such as the ones I have mentioned offer an opportunity for us to map the Chinese *geopolitical unconscious*, namely, the correlation between the psychic, sexual, private, and the social, political, public. As the Chinese economy becomes integrated into a competitive global economy, such tales of libidinal adventures will continue to figure prominently in Chinese popular media.

The cultural, political, and libidinal economy in contemporary China necessarily relates to developments in the global arena. Events in China function as part of a world situation described by critics as "global capitalism" or "transnational capitalism."[38] The alliance between popular culture, patriarchal discourse, and transnational capital should raise concern among media critics. At this juncture, my critical project shares goals with something that has been termed "transnational feminist practices"—that is, "an attention to the linkages and travels of forms of representation as they intersect with movements of labor and capital in a multinational world." In other words, "we are interested in how patriarchies are recast in diasporic conditions of postmodernity—how we ourselves are complicit in these relations, as well as how we negotiate with them and develop strategies of resistance."[39] We should be more aware of the intersection and imbrication between libidinal economy, global capital, social labor, private fantasy, nationalism, and patriarchy.

The extended serial form of Chinese soap opera, which involves complicated plot lines and different personalities, may not offer a single, hardened message. The meaning of a soap may vary from audience to audience, especially if that audience is heterogeneous and includes several hundred million, as in the Chinese case. Moreover, these visual texts contain ironies, parodies, and self-deflations that insiders could easily spot. Yet Western critics sometimes take these texts as expressions of a wave of neonationalism in China.[40]

Such a reading sees only one side of the political dynamics of visual and narrative representation. In that case, the transnational male imaginary in the 1990s would be seen as an unabashed self-assertion of the male ego. Public culture would then reinforce and perpetuate the dominant position of the patriarch-state-capital. Thus, we would need to rethink the condition, possibility, and necessity of maintaining a critical public space both inside and outside China. However, I argue that these television dramas, as prod-

ucts of mass media and popular culture, contain enough variety and complexity to be more than packaged nationalism. The description in these texts of the private passions of Chinese masculinity, often expressed at the expense of indigenous women, explores the possibilities, limits, and fluid boundaries of *national identity*, not necessarily *nationalism*, in the circumstances of an increasingly *transnational*, deterritorialized global economy in the post–cold war era.

ELEVEN

Literature
Intellectuals in the Ruined Metropolis at the Fin de Siècle

For the sake of clarity and schematization, Chinese cultural and literary critics have helpfully drawn a number of main distinguishing contrasts between literature of the New Era and the post–New Era. In the post–New Era literature is divorced from social utility and the mission of enlightenment in the general climate of consumerism, commodification, mediatization, and entertainment. It is deideologized and no longer functions as a mouthpiece of the large collectivity. No particular kind of literature constitutes the mainstream, nor is literature itself the mainstream of cultural production and consumption. Multivoicedness and decentering characterize the literary and cultural arenas. Since the post–New Era coincides with the last decade of the twentieth century, its literature reveals a fin de siècle sensibility, and the following features represent departures from the fundamental premises of the New Era: the reestablishment of subjectivity, the return to humanism, and the quest for aesthetic autonomy independent of political constraints. During the Mao era, the slogan is "literature and the arts serve politics." In

the post-Mao era (New Era), the task is to salvage literature from subordination to politics and to restore its autonomous status. Yet the idea of some sanctimonious, pure literature in and for itself became largely irrelevant in the post–New Era during the last decade of the twentieth century.[1]

The decentering of literature in the cultural arena has accompanied the dissolution of the modern intellectual in society. As argued above, Chinese modernity is based on a structure and discourse of knowledge and has been intimately tied to the construction and self-articulation of intellectuals since the May Fourth Movement. The crisis of the intellectuals thus marks the crisis of Chinese modernity. To the extent that such demythologization of the sacred position of the intellectuals is the delegitimation of the modernity project itself, the post–New Era heralds the end of Chinese modernity and ushers in postmodernity.[2]

In the mid- and late 1980s, the literary avant-garde experimented with postmodernist forms of narration. Celebrated writers of "experimental fiction" (*shiyan xiaoshuo*) such as Ma Yuan, Can Xue, Ge Fei, Yu Hua, and Su Tong created a corpus of works that might be named "postmodernist literature" on aesthetic and formalistic grounds.[3] If one can speak of postmodernism in China at that point, it was a sensibility limited to a small group of elite writers. Postmodernity had not developed into a pervasive cultural force. The literary avant-garde largely withered and faded away during the 1990s, or else its practitioners adopted more popular styles of narration. "Pure literature" (*chun wenxue*) has suffered considerable decline and retreated further to the margins of society. On an even more fundamental level, the print media has lost a large share of its readers to the visual media because of the invasion of a flood of simulacra: TV, videos, films, and so forth.

During the transitional period between the late 1980s and early 1990s a new type of writing styled as "new realism" (*xin xieshi*) arrived on the literary scene. Moving away from the rarefied style of the avant-garde writers, the new realists focused on trivial details of the everyday and were interested in describing the ordinary facts of life in a seemingly naturalistic, realistic style.[4] Some view post–New Era literature as "post-allegorical writing," however idiosyncratically defined.[5] The post-allegorical (*hou yuyan*) phase marks the crisis of the "allegory," which has been identified as the main literary strategy from the May Fourth period to the 1980s.

Building on Fredric Jameson's theory of third world national allegory while reexamining modern Chinese literary history, Xie Mian and Zhang Yiwu outline several characteristics of modern allegorical writing: (1) the "author" as an intellectual is a spokesperson of enlightenment and seeks to establish a subjectivity for the large collective; (2) the literary work is often created in the name of "cultural reflection" and the search for "universal humanity"; and (3) the national allegory or the national subjectivity ultimately becomes part of a large attempt to incorporate China into a utopian modernity project. Through allegory, the third world intellectual mediates and bridges the West and China, the private individual and the national collectivity. Even in the mid-1980s, the so-called "cultural fever" (*wenhua re*) and "root-searching literature" (*xungen wenxue*) were only manifestations of the allegory in a different set of circumstances.

The postallegorical impulse occurs the moment writers no longer believe in the grand metanarrative of the modernity project. They question and repudiate the self-prescribed role of the author-intellectual as the moral authority of society and the people. Today, the populace—not the intellectuals—leads and directs culture. Writing itself faces a crisis in the age of the media.

In the postallegorical phase, "antiallegorical writing" and "new state-of-affairs fiction" have been identified as the two most prominent types of literature. Antiallegorical writings can be traced to Wang Shuo's 1989 novel *No Man's Land* (*Qianwan bie ba wo dang ren*, also known as *Whatever You Do, Don't Treat Me As a Person*). Such writings employ parody and satire to deconstruct the myth of the national allegory. In comparison, new state-of-affairs fiction develops new awareness of the narrator, time, and the world. According to Zhang Yiwu, this form of fiction has the following characteristics: (1) change from an external to internal focal point of view in which the mythic subjectivity of yesterday has given way to an infinitely symbolic individual; (2) the tendency for mixing photographic realism with abstract impressionism, resulting in incoherence of time and loss of solid subjectivity; (3) the breakdown of the barrier between the popular and the refined; and (4) rejection of depth of meaning as central to allegory.[6]

Chinese writers found it impossibly difficult to grasp history during the 1990s. The 1990s was a time without history. A cluster of stories labeled as the "new historical novel" (*xin lishi xiaoshuo*), written by a young generation

of writers, reveals the elusiveness of the past most symptomatically. The new historical novel, contrary to its name, has lost a sense of historicity. Such writing imagines history, escapes from history, and sees history as nostalgia. The historical novel does not confront the past as it was but rather plays games with it. Likewise, a multitude of historical TV dramas were produced in rapid succession during the 1990s. Such televised costumed history was not concerned with history as such but offered itself as a spectacle for mass consumption.

I will not begin by looking at examples of new state-of-affairs fiction or the so-called "new historical novel," but rather start by examining a major novel of the 1990s that reached out to the past for inspiration. The novel utilizes premodern narrative conventions to evoke a fin de siècle sensibility. Depicting the life of intellectuals and other social strata in the city of Xijing (literally "Western capital," modeled after Xi'an) in the 1980s and early 1990s, Jia Pingwa's 1993 novel *Ruined Capital* (*Feidu*, also known as *Abandoned Capital* or *City in Ruins*) became the best-selling Chinese novel soon after its publication.[7] High demand for legitimate and pirated editions existed in bookstores and street bookstands across the country. In fact, Jia replaced Wang Shuo in 1993 as the most popular Chinese writer and literally ended the so-called "Wang Shuo heat." Beijing Press (Beijing chubanshe) supposedly paid one million yuan to purchase the novel's copyright, and some have estimated that it sold more than two million copies in 1993.[8] The novel defies easy classification: it is neither strictly new realist, modernist, historicist, nor postallegorical; nor does it belong to "new state-of-affairs." However, it does amount to a postmodern reconceptualization of the role of intellectuals in contemporary China.

Jia Pingwa emerged in the 1980s as a major figure in the tradition of "root-searching literature." He was already known for his stories on rural subjects set in his native province Shaanxi. Xi'an, Shaanxi, and the Northwest (Xibei) in general were bastions of cultural production and innovation throughout the 1980s. The area has given birth to some of the best known products of literature, New Cinema (fifth generation film), and popular music. Many of China's aspiring filmmakers and writers started their careers here. As the birthplace of Chinese civilization, the cradle of the communist revolution, and the backward hinterland, the Northwest has acquired layers of symbolic meanings in such cultural and intellectual move-

ments as "historical reflection," "cultural reflection," and "search for the roots." The region is privileged and unrivaled for its ability to inspire awe; it is synonymous with "depth," "tradition," and "history" in China's cultural imaginary. Even as late as the early 1990s, it was still opportune for another Shaanxi writer, Chen Zhongshi, to compose a historical saga about the Northwest. His novel *The White Deer Plains* (*Bai lu yuan*) earned him a place among the most celebrated contemporary Chinese writers, and thus testifies to the enduring myth of the Northwest.[9]

Jia Pingwa has thrived over the years as a Shaanxi writer. His stories contain rich local color. One may indeed say that a nativist, ethnographic, and anthropological tendency underlies his writings, as well as much of Xi'an-based cultural production as a whole, whether in the form of literature, popular music, or film. Although set in rural Northwestern China, *Ruined Capital* is Jia's first urban novel. The shift from the country to the metropolis, from exploration of deep "roots" in the rural homeland to fascination with the surfaces and glamour of the city, was symptomatic of a more general cultural aura in the 1990s.

Given the novel's uncontested popularity in terms of readership and circulation, assessments of the work differed dramatically.[10] Many readers dismissed it as pornography and considered it written in poor taste and filled with vulgarity and commercialism. Yet others have hailed it as a modern *Jin ping mei* (*The Plum in the Golden Vase*) and a new *Hong lou meng* (*Dream of the Red Chamber*, or *The Story of the Stone*) or seen it as reviving the great tradition of the Ming and Qing vernacular novel and reinventing the literati novel (*wenren xiaoshuo*) and the novel of social manners (*renqing xiaoshuo, shiqing xiaoshuo*). Some readers have also applauded *Ruined Capital* for its vivid description of the predicament of intellectuals and other social classes at the fin de siècle. At its best, *Ruined Capital* has been praised as the most accurate literary testimony to the "crisis of the humanistic spirit" (*renwen jingshen de weiji*).[11] As discussed earlier, the nationwide discussion of the crisis of the humanistic spirit represented one of China's most heated debates in the early 1990s. No other major novel seems to join better the main themes of this national debate: the marginalization of intellectuals, the end of the era of heroism and idealism, confusion of values, and spiritual disorientation.

In the following pages I will approach the novel by focusing on a number

of generic, formal, and rhetorical features. I will pay special attention to questions of intertextuality and genre, as well as to the interweaving of realism and fictionality. In this way, I will be in a better position to tackle the meaning of the text and its cultural relevance to the historical moment.

Literary Analysis: Genre, Intertextuality, Realism, Fictionality

A modern novel written at the end of the twentieth century, *Ruined Capital* appropriates the rhetorical and narrative convention of such masterworks as *Jin ping mei* and *Hong lou meng*. *Ruined Capital* does not follow fashionable postmodern literary techniques, but instead adopts the strategy of indigenization. Its approach is resolutely nativist. Some have pointed out that the novel consciously places itself within the tradition of the classical novel. More specifically, the text evokes certain aspects of the novel of manners, a genre that began with *Jin ping mei* and culminated with *Hong lou meng*. As a long-established tradition in the Ming and Qing, novels of this genre described, in the words of Lu Xun, the "joys and sorrows of human life, separations and encounters or sudden changes in fortune . . . the ways of the world and the vicissitudes of life."[12]

It is important to be alert to the intertextual relationship between *Ruined Capital* and previous narrative masterworks such as *Jin ping mei* and *Hong lou meng* and to see how the late-twentieth-century text activates a pre-existing narrative convention. Various dimensions of the novel ostensibly allude to *Jin ping mei* and *Hong lou meng*: the amorous adventures of the male protagonist and his relationship to multiple female lovers; the description of passions, feelings, and the way of the world (*qing*); the depiction of scenes, gatherings, parties, dinners, and dialogues; the significance of dream; a sense of social and spiritual disintegration with or without redemption; and symbolic, fantastic, nonmimetic dimensions of the text.

The author highlights the fictionality of the novel in a brief manifesto at the text's beginning and warns the reader not to take its words literally: "The events are all fabricated. Please do not take them for real. There is only the truth of the heart and the soul. Let it be laughed at, cursed, judged, talked about." In the "Postscript" (*Houji*), Jia discusses the question of artifice in writing and marvels at the artistry of masterpieces in Chinese literature.

"Leave aside examples from foreign countries. Take *Xixiang ji* (The western chamber) and *Hong lou meng* from China. When we read them, how could we feel they are the fabrication of the authors? It is as if they were something we have experienced, as if we were in a dreamland."[13]

At times, Jia Pingwa has explained his ideas about writing within a comprehensive theory of signs, or semiotics/semiology. He wrote the following in 1992–93:

> These days people all talk about semiotics (*fuhao xue*). I have my own views about semiotics. For instance, *Poetic Criticism* (*Shi pin*), and especially *The Book of Change* (*Yijing*), are truly semiotics. In *The Book of Change*, every trigram has a sign (*xiang*). The hexagram has a general sign. In regard to writings, strictly speaking, characters and objects become signs once they enter the work. This is to elucidate something beyond characters and objects through signs. . . . It is only through signs that there can be symbolism and images.[14]
>
> Art is a matter of fabrication. I want to establish a system of signs, a world of images on the basis of reality. Don't be only concerned about whether some detail is real or unreal. It is enough if there is a kind of enlightenment, a kind of pleasure in aesthetic judgment. . . . I endeavor to create a reality in fabrication, create another imaginary reality.[15]

Jia further explained his notion of art in 1996: "Art cannot become art absolutely if there is not the metaphysical. But being too abstract does not make art either. How to fuse the metaphysical and the physical is something I have been seeking after arduously."[16]

Although mainly a novel of realistic description, *Ruined Capital* also contains elements of the fantastic, the mythic, and the allegorical, especially in the beginning. The story starts in the 1980s with the discovery in Xijing of an unusual, beautiful flower. The shape of the flower resembles that of a peony, but it also resembles a rose. The petals branch out into four colors: red, yellow, white, and purple. Although nobody in the city knows anything about these flowers, Master Zhixiang of Xiaohuang Monastery is asked to divine their fate. The resulting divination foretells that these flowers, however extraordinary, will not last long and that their owners will ruin them. Some critics have suggested that the four branches symbolize the fate of the novel's four main female characters, Tang Wan'er, Liu Yue, Huiming, and Ah Can.[17] Such a symbolic prefiguration of female protagonists in the future

harkens back to the structure of *Hong lou meng*, in which Jia Baoyu in his visit to a dreamland in chapter five was told about the future lives of "Twelve Beauties of Jinling."

Also at the beginning, another unusual phenomenon occurs one day. On the seventh day of the sixth month of the lunar calendar, four suns appear in the sky at the same time. The brightness caused by the simultaneous appearance of the four suns creates confusion among Xijing's residents. At the moment an important official happens to be passing through the streets. Police cars escort the official, and the sirens signal to other cars, taxis, and buses to stop and yield the right-of-way. With the four suns in the sky,

> The big and small vehicles didn't dare move but only honked. People were running around in panic, were in a daze, and felt as if they were not in the streets but watching a film. But suddenly the film projector broke down and the images on the screen disappeared, but the sound continued. One person felt this way, and then almost all people felt the same. There was silence, a lifeless silence. There was only the sound of someone blowing the *xun* flute on the city wall.[18]

The novel soon offers a clue for understanding the symbolism of the four suns. It tells the reader about "idlers" in Xijing. Two types exist: social idlers (*shehui xianren*) and cultural idlers (*wenhua xianren*). The social idlers are smugglers, busybodies, and swindlers, all of whom engage in both legitimate and underground activities. Yet they set trends in fashion and food and promote the economy of Xijing. The novel calls the four leaders of this group the "four great wicked youngsters" (*si da eshao*). However, the story deals more with the "four celebrities" (*si da mingren*) among the cultural idlers. The four celebrities are painter Wang Ximian, calligrapher Gong Jingyuan, musician Yuan Zhifei, and writer Zhuang Zhidie. The first three of these have secret dealings with the social idlers, and enjoy backing from bureaucrats inside China and foreigners outside. Zhuang is said to be the cleanest of the four, and thus the most famous. The four luminous suns in Xijing that brought street traffic to a halt might therefore be taken as referring to the four celebrities.

The city of Xijing (Xi'an) served as the capital of twelve dynasties. It possesses abundant cultural capital but lags behind the coastal cities in economic development. Its cadres and citizens are conservative because the city

sits in the backward interior of China. The new mayor tries to develop Xijing not by building a strong economic infrastructure for industry, but by capitalizing on its rich cultural legacy to promote consumption. The city markets itself as a center of tourism, entertainment, indigenous culture, and local food. Yet the prosperity brought by the tourist industry and the influx of people has transformed the city into a haven for thieves, drug dealers, and prostitutes. The novel thus foregrounds the local color of its descriptive details: the sites, sights, language, slang, customs, food, and geography of Xijing (Xi'an) and Shaanxi province.

One of the novel's significant structural elements is the recurrent figure of the old man (*laotou*), who appears within the narrative frame throughout the story. The old man, a teacher turned garbage collector and evidently a social outcast, offers his wisdom and comments about the social mores of Xijing. His ditties satirize the manners of Xijing and China. One that has spread throughout the city is the following:

> People of the first class are public servants, who sit high and enjoy peace and wealth;
> people of the second class are bureaucrat-businessmen, who seize business opportunities and are well protected;
> people of the third class are business contractors, who are reimbursed for eating, drinking, gambling, and prostitution;
> people of the fourth class are creditors, who reap profits while sitting at home;
> people of the fifth class are judges, who swindle money from both plaintiffs and defendants;
> people of the sixth class are surgeons, whose pockets are filled with red envelopes of money;
> people of the seventh class are actors and actresses, who make easy bucks by swinging their butts;
> people of the eighth class are propagandists, who satiate their palates at banquets now and then;
> people of the ninth class are teachers, who do not know the taste of delicious dishes;
> people of the tenth class are the do-gooders, who are docile emulators of Lei Feng.[19]

The insane yet prophetic ditty gives a vivid picture of China's ten classes, at the bottom of which are the educators, intellectuals, altruists, and model workers.

The novel is known for its lavish, repetitive, graphic descriptions of scenes of lovemaking between Zhuang and his lovers. Yet such erotic passages only echo descriptions in other novels such as *Jin ping mei*. The novelty of *Ruined Capital* comes from the authorial deletion of passages that involve obscene scenes. In the midst of an intense erotic scene, Jia Pingwa usually inserts a line in parenthesis: "The author has deleted XX number of words." Readers also customarily encounter deletions ("XX number of words have been deleted in the following") in sanitized modern editions of classic Chinese erotica. Thus, Jia places his story within a long tradition of erotic novels, although selfcensorship of the author is Jia's own invention at the end of the twentieth century.

The classical flavor of the novel can be felt in the descriptions of gatherings among families and friends, dinner parties, and banquets. The atmosphere created in the dialogues, chatter, conversations, and scenes brings readers into the intimate world of the classic Chinese novel. The episodic, loose structure of the novel, with multiple foci on characters and scenes, parallels the style of narration in a traditional vernacular novel. In Jia's own words, Chinese writers face the challenge of writing not in accordance with the linear perspective of the West but of experimenting with the multiperspectival approach of traditional Chinese painting.[20]

The novel contains subtly woven intertextual references to previous works within its seemingly realist narration. The dinner parties, gatherings, and banquets often vividly bring back similar scenes in classical novels, yet they are also appropriate in the contemporary setting. *Hong lou meng*, for example, includes numerous poetry contests at banquets and gatherings where each character is challenged to rise to the occasion by composing a line of poetry to match the phrase of another person. Similarly, in a dinner scene, characters in *Ruined Capital* link up proverbs while dizzy from drinking and eating. Amid chatter and laughter, the novel draws out more clearly the distinct personalities of the characters.[21]

The novel often models seemingly trivial, ordinary, insignificant details of realistic description after early classics. For instance, the long shopping list in the hands of Zhuang for the birthday banquet of Wang Ximian's mother

may appear casual and insignificant at first. Yet the exhaustive, encyclopedic listing of objects has a precise literary model in chapters ten and fifty-three of *Hong lou meng*.

> 2 *jin* (pound) of pork, 1 *jin* of ribs, 1 carp, 1 tortoise, half *jin* of squid, half *jin* of sea cucumbers, 3 *jin* of lotus, 2 *jin* of hotbed chives, 1 *jin* of pods, 1 *jin* of beans (*jiangdou*), 2 *jin* of tomatoes, 2 *jin* of eggplants, 2 *jin* of fresh mushrooms, 3 *jin* of osmanthus rice wine, 7 cartons of Sprite, 3 *jin* of tofu, half *jin* each of miscellaneous vegetables for Korean small dishes, 2 *jin* of mutton, 1 *jin* of smoked beef, 5 chicken eggs, 1 roasted chicken, 1 roasted duck, half *jin* each of cooked pig liver, tripe, smoked sausage . . . 1 bottle of Wuliangye wine, 10 bottles of beer, a pack of peanuts, a pack each of mushrooms and edible fungus (*mu'er*), a bowl of sticky rice, a bag of red dates, a handful of vermicelli (*fensi*) . . . 1 can of peas, a can of bamboo shoots, a can of cherries, 1 *jin* of sausage, 2 *jin* of cucumbers, 1 *liang* (ounce) of dry vegetable (*facai*), 3 *liang* of lotus seeds.[22]

Fidelity to the details of everyday life is a narrative convention that attempts to maximize the effects of realism and verisimilitude. However, the illusion of the real conjured up in this novel can also be understood in the context of traditional Chinese narrative, especially the vernacular novel.

Some critics quickly point out that similarities exist between characters in *Ruined Capital* and those in *Jin pin mei* and *Hong lou meng*. Zhuang Zhidie is a composite of Jia Baoyu and Ximeng Qing, although he cannot match Jia Baoyu in sincerity of love, nor can he measure up to Ximeng Qing in sexual prowess; Tang Wan'er, Zhou Min's wife and Zhuang Zhidie's mistress, is reminiscent of Pan Jinlian and Li Ping'er in *Jin ping mei*; Liu Yue (literally "Willow Moon"), Zhuang's maid who later marries the son of the mayor, resembles Chun Mei (literally "Spring Plum") in *Jin ping mei*; Niu Yueqing, Zhuang's wife, bears similarities to Wu Yueniang in *Jin ping mei*.[23] In some respects, the lively, distinctive individuals of this modern novel seem to come out of stock characters from old master texts. Jia Pingwa himself confesses that *Hong lou meng* and *Liaozhai zhiyi* (Strange tales from the make-do studio) serve as his main literary influences while creating female characters.

> It boils down to the question of how a character is created and how she is destroyed. Lately I am working on a piece, and it mainly dwells on this question. In regard to women, they all go through the same. Once a woman meets a person, she acquires a brand new image, and becomes an entirely

new person. Consequently, she is destroyed in his hands. . . . In a living environment, when suddenly a person appears, she develops a new desire for life, a new feeling. But at the end this thing completely destroys the woman.[24]

The resemblance to these classics nevertheless ends when we look at *Ruined Capital*'s overall theme and its ending. As characteristic of classical novels, *Jin ping mei* and *Hong lou meng* end with the possibility of salvation through religious enlightenment or filial piety, despite all the tragedies and losses in the world. A more meaningful, higher realm of existence surpasses and transcends the world of humanity. In contrast, *Ruined Capital* ends without intimations of redemption in any form, whether through religion or love. The religious figures in the novel (Master Zhixiang, Huiming) are incapable of playing roles in such circumstances.

To be sure, apocalyptic, eschatological intimations fill the novel. The masses in the city like to practice *qigong* (a traditional Chinese physical exercise). Buddha's finger is discovered at the famous Famen Monastery (Famen si) two hundred *li* from Xijing.[25] However, despite such tokens of possible salvation, the daily life of the city's characters remains as decadent and meaningless as ever. Xijing is a wasteland, a Dumpster, a ruined capital. Jia Pingwa says, "Xi'an can be said to be a typical ruined capital; China could be also said to be a ruined capital in the configuration of earth; and earth is in turn a ruined capital in the configuration of the universe."[26]

The cultural resources of Jia's stories usually consist of objects and institutions from traditional China: *xun* flute, bronze mirrors, divination, numerology/semiology, and Buddhist/Taoist monasteries. Yet all these symbols do not add up to a meaningful whole. The novel does not establish a viable historical perspective and does not offer a firm grasp of history. What remains is emptiness, one that does not lead to enlightenment, either. One critic invokes the language of Zhang Zhupo's commentary on *Jin ping mei* to analyze the import and structure of the novel: *Ruined Capital* is a work of releasing one's resentment (*xiefen*); the seemingly obscene descriptions are in effect the author's "pen of hatred, lament, and resentment" (*dubi, yuanbi, fenbi*); the author has no other way to release his anger except to resort to "dirty language"; the first half of the book is "hot," and the second half "cold"; the book's four hundred thousand characters are both a "plain description" (*bai miao*) and an allegory of urban culture in transition.[27]

The novel ends ominously: Zhuang Zhidie loses the lawsuit against his ex-wife Jing Xueyin and decides to leave Xijing; he has a stroke in the train station; the old man reappears with the usual business of garbage collection; and Zhou Min sees the face of Wang Ximian's wife—the love between her and Zhuang is forever unrequited. Only the author is vindicated: he has won because he has written a great work of art.[28] *Ruined Capital* has no depth, no sublimation behind the minutiae of the ways of the world (*qing*). Herein lies the difference between this novel and classical works of this genre.

Meng Yunfang, a close friend of Zhuang Zhidie, has been studying an impossible ancient text: *The Numinous Numbers of Master Shao* (*Shaozi shenshu*). Song Neo-Confucian philosopher Shao Yong reputedly wrote this book, which deals with numerology and semiology. It has been lost for a long time and Meng has the only extant copy. Meng believes that the power of its traditional wisdom will enable humankind to decipher the unknowable and divine the future. Properly understood, the book holds the ancient secret to unlock the mysteries of life in the modern world. Meng is training himself to be a prophet, and ironically his one eye is blind. At one point in the novel Zhuang Zhidie asks him to help discover his own fate, as well as those of Tang Wan'er, Liu Yue, and Wang Ximian's wife.[29] Meng discovers poems in the book that correspond to each of them and reveal the enigma of their fates. The episode resembles the revelation of the lives and fates of the twelve beauties of Jinling in chapter five of *Hong lou meng*.

The name of the protagonist, Zhuang Zhidie, means literally "Zhuang's butterfly." Obviously, it evokes the fable of Zhuangzi's butterfly dream. Precisely because Zhuangzi could not distinguish between dreaming and waking, between being a human and a butterfly, there is the proof for the great transformation of life and being in the Taoist scheme of universal harmony. However, this novel has no Taoist liberation or harmony with nature. Zhuang Zhidie has a dream toward the end of the novel in which he relives his amorous relationship with Jing Xueyin. Upon awakening, "Zhuang Zhidie still could not be clear if his marriage and divorce with Jing Xueyin was an illusion or real experience."[30] The novel concludes with the theme of "life is a dream," a perennial literary theme that culminates in *Hong lou meng*.

If decay and degeneration characterize Xijing, its citizens fare no better.

They are estranged from the source of life and vitality. It is no wonder that a cow offers a rare external perspective on the city. Zhuang Zhidie has a bizarre habit, which seems incomprehensible at first, of sucking milk directly from the cow of Liu Sao (Mrs. Liu), which passes through the city now and then. The cow "looks at the city with an eye of a philosopher":[31]

> But the air of the city makes her suffocate. The mixed smell of smoke, sulfur, and women's powder often causes congestion to her chest and nausea. The hard cement floor has none of the softness of wet, newly tilled land. Her hoofs have begun to deteriorate. What worries her has in fact happened: her strength diminishes by the day and her temperament changes. And she wonders if her stomach has changed too. Without a good appetite, and without a good mood, how much milk will there be left? She wishes that tons of milk could be squeezed out from her, and even imagines that what comes out of the faucet is not water but milk, so that people in the whole city can drink it and become oxen, or at least have the strength of oxen. But this is impossible. She cannot change the people of the city. On the contrary, the city's atmosphere and environment have gradually made her cease to be a cow anymore![32]

Only a non-human, a cow, proves able to mount a critique of the corruption and alienation in city life. Although Zhuang attempts to draw energy and strength from nature—the cow—he cannot escape the bleak outcome of a civilization in decay.

Fin de Siècle Malaise and the Popular Urban Novel

Ruined Capital changed China's literary scene in 1993. The novel expressed popular ideas, values, and attitudes among ordinary Chinese people. On the surface, the novel describes, in graphic detail, the sexual adventures of protagonist Zhuang Zhidie and his lovers. As already pointed out, the explicit and repetitive descriptions of sexual acts in the novel are unequaled in the history of modern Chinese literature. The readers' interest in sex came as a result of long-standing repression in Chinese society, and reading the novel became an act of vicarious defiance against government taboos. More important, the populace's interest in sexuality also resulted from the general climate of depoliticization, deideologization, commercialization, and con-

sumerism during the post-1989 period. Such voyeuristic indulgence/sublimation in sexuality indicated political frustration. The commercial success of the novel was also built on a careful strategy of selling and packaging. The publisher marketed it as a book on a subject that was taboo: sex. Commercials at book stalls in the streets of China advertised it with the enticing words "a modern *Jin ping mei*." Readers were seduced to taste a long-censored subject. Thus, *Ruined Capital* exemplifies the functioning of popular culture in the print media during the early 1990s.

The protagonist is a writer, an "intellectual" in Chinese society. Yet his role departs radically from that of the enlightener, the conscience of the people and the "architect of the soul" as prescribed since the May Fourth Movement. Being a popular writer today brings celebrity status, the ability to make huge financial profits and have multiple lovers. Thus, the character epitomizes a decisive change in the function of the modern Chinese intellectual. (Compare intellectual-writers in the old mold, from the May Fourth generation to the 1980s, with new writer-celebrities such as Wang Shuo, Jia Pingwa, and the novel's character, Zhuang Zhidie.)

The state of mind among modern Chinese intellectuals can be characterized in psychoanalytical terms as a mixture of narcissism and masochism. They are narcissistic because they envision themselves as idealists and cultural heroes. In bad times, they are masochists because they derive pride and pleasure from persecution and torture over a righteous, sublime mission. Zhuang Zhidie and his contemporaries no longer find such self-understanding possible. Their frame of mind is "schizophrenic" in the sense that it cannot adequately grasp its own relation to the social totality. Jia's exemplary novel and the debate on the loss of the "humanistic spirit" speak to the effect of marginalization of intellectuals in Chinese society.

The unrivaled popularity of the novel as a literary work indexed the sentiments of broad segments of Chinese people on the mainland during the 1990s and served as an indication of attitudes and values that can be called "fin de siècle malaise." The novel reflected a host of phenomena at the end of the twentieth century as China transformed itself into a "socialist market economy" and political reform still stood out of sight. Among these factors were money worship, commercialization, corruption, depravity, sexual indulgence, and above all, the impotence of the Chinese intellectual to effect change. Indeed, unlike traditional Chinese eroticas, the novel does not offer

any possibility of redemption—religious, spiritual, or secular—at its end. The "ruined capital" stands for a social, political wasteland. In Jia Pingwa's own words, "Enormous changes, enormous hopes, and the evils of unprecedented materialism co-exist. The stupidity and corruption of materialism severely affect the souls of the people, and are incompatible with the spirit of art. We must resist with literature, and must discover the weaknesses and crimes of human beings."[33]

Whether literature still has a place in the age of simulacra can be questioned. Given the facts that electronic images and billboards dominate and thoroughly work over our lives, and that everything turns into a sign-value, what can "words" do? Writing about the function of literature as a place of resistance at present, Jenaro Talens states the following: "it is here that the political role of writing and theory continues to be important against those who think that the predominance of the images will make the discourse of words disappear. We should recall that only the discourse of words has, until now, allowed us to think and to theorize the world."[34] Ironically, soon after Jia the author positioned himself as the "architect of the soul," with a mission to save humanity against the evils of modernity, his novel showed that the author/intellectual does not possess this traditional power any longer in contemporary China. Jia and his publisher needed to package his novel as modern erotica to sell it to the masses.

More urban novels were written in the 1990s than in the 1980s. These novels, set in major cities such as Xi'an, Jinan, Beijing, and Shanghai, described people and society during the Deng era as they became caught up in the waves of modernization, commercialization, and capitalist development. The novels blur the distinction between serious, pure, refined literature and popular, mass, low literature. *Ruined Capital* poses multiple challenges for any simple demarcation of the popular in contemporary Chinese cultural production and reception. Although set in a metropolis, xiging/Xi'an, in the 1980s and early 1990s, the city belongs to China's backward interior and thus lacks modern consciousness. Even though its explicit erotic descriptions easily appeal to segments of the readership, only the well-trained reader can discover the subtly crafted allusions and parallels to such classics from the Ming and the Qing as *Jin ping mei, Hong lou meng*, and *Rulin waishi* (The scholars), and the play *Xixiang ji*. The language of *Ruined Capital* is polyglot and multiaccented, as seen in the vernacular, literary, col-

loquial, Westernized prose, and standard Mandarin. Hence the seeming contradiction: it was the most popular novel, undoubtedly, based on real or estimated sales figures, yet it was a masterpiece of the modern "literati novel" (*wenren xiaoshuo*) that only the elite can fully appreciate.

The multivoiced literary quality of the novel can be better appreciated if we compare it to a number of other urban novels from the same period that could be more readily defined as "popular": for instance, Li Xianshou's *The Romantic: A Love Story in a Metropolis* (*Saoren: yige dushi de qing'ai gushi*), a modern romance set in Jinan that deals with an aspiring entrepreneur and his entangled love affairs, or Shu Tong's *Being Independent* (*Shisan bukao*, literally, "Thirteen self-sufficient").[35] I picked up copies of these novels in Beijing bookstalls during the summer of 1996 and 1997.

A quick glimpse at the "Synopsis" (*neirong jianjie*) at the beginning of *Being Independent* tells us something about the nature of popular entertainment in contemporary China. *Being Independent* purports to be a popular book written for ordinary city folks by one of their own. It also claims to have penetrated into the previously unrevealed secrecy of daily life. This is how the novel advertises itself:

> This book is not about upper-class people playing mah-jongg. It tells the story of several common people (*pingmin*) in the 90s. It unveils the hidden other side of the normal life of ordinary folks.
>
> The story happens at the secret corner of you and me. Various manners of love among young people and different types of marriage are all in it. Trial marriage and living together, sexual hunger and masturbation, homosexuality and sexual deviation, prostitution and suicide. . . .
>
> . . .
>
> The author has long lived in the streets of the city, and has a profound understanding of the culture of common people. He has written about private things that are the most ordinary and yet the most difficult to talk about. He has spoken the words in the heart of every ordinary person. This is a truly provocative book: once you open it, you cannot stop; after you close it, your thought wanders far.[36]

To a great extent, very much like this book, *Ruined Capital* cashed in on the advertising strategy of a fledgling mass culture industry. Packaged as a "modern *Jin ping mei*," it promised lurid details of sex that cannot be openly discussed. But that dimension comprised only part of the book. *Ruined*

Capital also claimed to be "serious literature" attempting to uncover the "roots" and conditions of cultural malaise in contemporary China.

Novels such as *Ruined Capital* problematize and complicate the notion of the popular in contemporary China. Popular and elite cannot be easily separated when looking at cultural reception. Different audiences have a series of mediations in the varied processes of marketing, packaging, selling, consumption, reception, and criticism of a given literary text. The general reader, the critic, the literary specialist, and the academic should all be taken into consideration when determining the popular, the elite, the high, and the low.

Given the focus on urban life in the 1990s, predictions about the future of the tendency toward "root-searching" are premature, although such a literary movement flourished in the mid-1980s and passed away long ago. A continuation of the concern with origins and roots also emerges in novels such as *Ruined Capital*. A book about the ancient city of Xijing/Xi'an obviously represents a search for tradition and the past. The nativist, indigenous approach of the novel delves deeply into the sources of Chinese civilization.[37]

Consider the work of another well-established author, Shanghai-based Wang Anyi. Critics warmly praised her 1994 novel *Reality and Fiction: A Shanghai Story (Jishi yu xugou: Shanghai de gushi)* as representing the revival of the "Shanghai School" (*hai pai*), which had fallen far since the days of Eileen Chang.[38] However, the novel says nothing about the hustle and bustle of Shanghai, a city described as a "city of desire" in a popular handbook, as an emerging economic and financial powerhouse during the 1990s.[39] Instead, it searches into the roots of the narrator, a person whose family did not originally come from Shanghai but settled there after 1949. By using the last name of her mother, "Ru," as a clue, and combining that with imagination and historical research, the narrator digs deeply into the ancestry of the Ru people, which she takes to be the ancient nomadic Rouran. Whereas the novel's odd-numbered chapters recall the years and life of the narrator and her family in modern Shanghai, the even-numbered chapters trace the rise and fall of her putative ancestors, the Rouran. The final chapter brings the two narrative strands together. In this manner the author synthesizes the multiple roots of Shanghai: the northern and southern, the barbaric and Chinese, the urban and rural, the ancient and contemporary. Thus, the root-searching, or soul-searching, becomes not just a story of Shanghai, but also a story/history of China.

Ruined Capital is not a novel about a truly modern metropolis, and it is hard to situate within the conventional parameters of the twentieth-century urban novel. Literary historians speak of the "Beijing school" (*jing pai*) and the "Shanghai school" (*hai pai*), the two schools founded by such literary giants as Lao She, Mao Dun, and the "New Perceptionists" (*xin ganjue pai*). Shanghai has been perceived and represented as the ultramodern city in much of modern Chinese literature. The city offers a whole array of sensations and experiences understood as uniquely modern: freedom, opportunity, glamour, eroticism, excitement, and so forth. Yet the modern metropolis also has its sins: decadence, corruption, immorality, hedonism, and loneliness. At the opposite end stands a different vision of China: the idyllic small border town of Shen Congwen, or the countryside as the base of revolutionary change in Mao Zedong's communist movement.[40] In the case of Jia Pingwa, we cannot speak of the "symbolic triumph of Chinese tradition," as in the case of the old "Beijing School" writers.[41] *Ruined Capital* literally describes what it sets out to describe: an ancient city in ruins.

The novel does not fit into any of the neat dichotomies. As Meng Yunfang once said to Zhuang Zhidie, "although you have lived in this city for so long, your mind has no modern consciousness." The characters and the city are ineluctably burdened with a heavy sense of history and tradition. The city itself, along with its renovated wall, historical landmarks, and residents' collective interest in things past, is a living embodiment of sedimented layers of ancient tradition.[42] The accumulated cultural resources of Xi'an/Xijing can rarely be matched by other Chinese cities. In short, the urban city in the novel is overdetermined by the *premodern* tradition. The characters experience none of the existential loneliness and anxiety of urban dwellers in a modern metropolis. They move in a web of social, interpersonal, familial networks. Their personal fortunes rise and fall due to social and communal problems of which they form an organic part. *Ruined Capital* does not describe Xijing as a typically modern city, nor is it apparent that the evils of the city result from the advent of modernity, as is often the case in literary, filmic depictions of Shanghai. The city seems to exist in a frozen state of time lag and perpetual belatedness. Temporality becomes spatialized by eternal enclosure within the great city wall, the only surviving and carefully reconstructed ancient city wall in China.[43]

The experience of the modern city, or modernity at large, is largely brack-

eted here. It has been dissected in Western thought and literature, seen, for instance, in Georg Simmel and Walter Benjamin (the *flaneur* via Charles Baudelaire) and vividly presented in the "Shanghai school" of writers.[44] Residents of the city turn the time lag into a source of cultural and symbolic capital: Xi'an/Xijing signifies the glory of China's past. Therefore, when the accumulated, overdetermined legacy of ancient China comes to ruins and the protagonist collapses at the end of the novel, the weight of a centennial and millennial catastrophe becomes all the more overwhelming.

Coda: A New Wave of Urban Writers

In the early 1990s, a few years before Jia Pingwa's *Ruined Capital* became China's best-selling novel, the Beijing-based writer Wang Shuo was the most popular writer in China. He described the peculiar "urban experience" of his generation of Beijingers, a generation of youngsters who grew up and were teenagers in the early and mid-1970s during last years of the Cultural Revolution, an experience adapted from one of his novels in the film *In the Heat of the Sun* (directed by Jiang Wen, 1995). A cynical, playful, "hooligan" attitude toward social mores defines the literary sensibility of his stories and the disposition of his characters as a whole. The new mood that he created was unprecedented in the literary history of the People's Republic of China. The "Wang Shuo" phenomenon was indeed something new in China at that time.

A newer generation of writers emerged from Shanghai and took China's literary scene by storm in the last years of the twentieth century and the beginning of the twenty-first century. These "beauty women writers" (*meinü zuojia*), represented by Mian Mian and Wei Hui, were born in the early 1970s and depict the urban sensations of "generation X" (*xin xin renlei*, literally "new new human beings") in China. The characters in their stories indulge in the pleasures and suffer from the pains afforded by contemporary Shanghai, which is going through a process of modernization and internationalization at breakneck speed. The characters spend their days in the bars, nightclubs, cafés, shops, and streets of Shanghai. Drugs are their ordinary diet, and dating and having sex with foreigners satiate their sexual appetites and emotional needs. After the passing of two-thirds of a century, contem-

porary Shanghai writers have begun once again to capture the feelings and moods of Shanghai as a cosmopolitan ultramodern city, as Shanghai writers first described in the 1930s. The narrators of the stories express the private, subjective thoughts and sensations of the female protagonists in their encounters with various people in Shanghai.

Mian Mian's novel *Sugar* (*Tang*) and Wei Hui's novel *Shanghai Darling* (*Shanghai baobei*) became instant classics of this new wave.[45] These writers did not experience such Maoist socialist movements as the Cultural Revolution and grew up during a period of Chinese history defined by postsocialism and transnational capital. Their stories apparently struck a chord with vast numbers of China's young readers, who are also China's internet surfers. These "ultra-new human beings" heatedly discussed and debated the details and quality of the novels on the internet. Excitement about Shanghai beauty writers alarmed China's propaganda and thought control organizations. The authorities considered the writings of Mian Mian and Wei Hui immoral, decadent, harmful, and unhealthy, and banned their publication in China! The editorial office of the Cloth Tiger Book Series (*bu laohu congshu*), which had published Wei Hui's stories and launched her to national stardom, was ordered shut down.

The state's tight monitoring of the literary scene can be seen again in the official reaction or nonreaction to what would normally be a significant event in the literary world. In 2000, Gao Xingjian, a Chinese writer who lives in France, was awarded the Nobel prize in Literature. This was the first time a Chinese writer had ever received the Nobel prize. When this news broke, authorities forbade any public discussion of the matter in any media in China. The few terse commentaries about the event published in Chinese newspapers criticized the Nobel prize's literature committee for using the literature award as a political tool. Supposedly, such awards do not reflect the real quality of literary works, but only the subjective opinions of the committee members.

The banned works of these writers do not disappear, however, from the Chinese-speaking world by the order of mainland censors. Rather, they are published, sold, and bought in Hong Kong, Taiwan, and the "Greater China" area, circulated and read privately within mainland China, and smuggled across national borders. They maintain a life within the nexus of transnational, trans-Chinese, transregional reading publics.

Postscript
1999

Nineteen ninety-nine, the pivotal year between the twentieth and the twenty-first centuries, marked several important occasions in the annals of modern Chinese history:

1. The fiftieth anniversary of the founding of the People's Republic of China, on October 1
2. The eightieth anniversary of the May Fourth Movement
3. The tenth anniversary of the failed democracy movement in Tiananmen Square, on June 4
4. Macau's return to Chinese sovereignty, on December 20, which signaled the end of the last colonial rule on Chinese territory

These major events constitute enduring legacies of twentieth-century China, and some represent unresolved tensions that China took into the next century. These are the contradictions, ambivalences, problems, and prospects

that China faces today and tomorrow. Continuation of socialist ideology, communist rule, and the suppression of democratic movements still defined the political landscape. Macau's reversion to China after Hong Kong, and disappearance of the last trace of colonial rule had once again affirmed the triumph and integrity of a strong state, although the future of Taiwan remained uncertain. The goals of the May Fourth generation at the beginning of the twentieth century—democracy, science, modernization, national salvation, and independence from foreign domination—remained unevenly fulfilled at its end. At the same time, the Chinese economy had embarked on a calculated yet determined, gradual yet irreversible track toward a complete merging with the global capitalist economy.

Aside from the anniversaries—the memory and reinterpretation of the past—I want to mention three important movements or events with perhaps millennial intimations that happened in China in 1999: (1) the Falungong movement, (2) NATO's bombing of the Chinese embassy in Belgrade, and (3) the Sino-U.S. agreement on China's entry in the World Trade Organization. These events correspond respectively to three vital dimensions of the Chinese nation: (1) the popular, domestic front, (2) the arena of international politics and the predicament of the nation-state on the eve of a new century, and (3) the domain of economic globalization.

In the spring of 1999, tens of thousands of members of Falungong, a *qigong*, quasi-religious organization, peacefully surrounded Zhongnanhai Compound, where the Chinese leaders lived. The members demanded official recognition from the state, which it had never received because the state considers Falungong a devious, superstitious sect. Falungong boasts millions or tens of millions of followers in China and abroad. The swiftness of Falungong's action, its efficient organization, and the fact that Beijing's security forces knew nothing about this mass demonstration in advance alarmed the regime. Falungong, as a grassroot "folk organization" (*minjian zuzhi*), resembles many secret sects throughout ancient Chinese history, such as Huangjin (Yellow scarves) in the Han and Bailianjiao (White Lotus Society) in the Qing, that threatened and even toppled dynasties. Could the Falungong phenomenon be a millennial intimation of a historical pattern? The regime fears Falungong as a great threat and has taken severe measures to eradicate the group. It has arrested countless members across the nation.

Falungong consists of people from all walks of life—unemployed workers,

state employees, government officials, and retired generals. As a type of *qigong*, Falungong can be seen as a particular form of health exercise and is especially attractive to those who lack the protection of health care in a society in transition from socialism to a capitalist economy. As a quasi-religious doctrine, Falungong is a faith that refutes the official communist-Darwinian doctrine that "human beings evolved from apes." Hence, the Falungong movement expresses popular discontent with economic reform and points to the ideological vacuity of postsocialist China. The religious notion of temporality in terms of life cycles, karmas, millennia, and eons reveals a deep-seated fin de siècle spiritual crisis and a severe malfunction in the body politic. The Falungong episode dramatically exposed unhealthy signs in contemporary Chinese society—the loss of faith in communist ideology and the state, unhappiness with the results of economic reforms, and widening social disparity.

The marketization of the economy during the Deng era has given rise to a Chinese form of capitalism that Maurice Meisner has called "bureaucratic capitalism." This form sanctions the "use of political power and official influence for private pecuniary gain through capitalist or quasi-capitalist methods of economic activity. . . . Virtually all Communist leaders (or ex-leaders) of any significance were patrons of children, spouses, and all manner of other relatives who joined the 'business craze,' as capitalist ventures were popularly known."[1] The marriage of a socialist bureaucratic power structure to capitalist profiteering has created great economic disparity in Chinese society. Economic reforms have taken the nation away from the original goals of Chinese socialism: economic equality and social justice. Bribery, nepotism, corruption, and smuggling have become the order of the day. The recent exposure of corruption among officials in such southern Chinese cities as Xiamen and Shenzhen has revealed corruption involving appallingly large amounts of money and goods worth upwards of billions of U.S. dollars.[2] High-ranking officials at the municipal, provincial, and central levels have been implicated. The dispossessed, disenfranchised, and unemployed, as well as average citizens, have reason to complain about the unfair, unequal distribution of wealth.

Another surprise attack—this time on the international front—awakened the regime just as it prepared to cope with the Falungong protest. In May 1999, a U.S. warplane flying for NATO bombed the Chinese Embassy in

Belgrade during military actions in Kosovo. Was this incident a prelude to real or perceived clashes in the future between civilizations, between an old imperialist West and a rising Eastern superpower? A tide of Chinese nationalist sentiment rose in the immediate aftermath of the incident. The outpouring of Chinese patriotism effectively diverted domestic and international attention away from the tenth anniversary of the Tiananmen Square incident in 1989.

Ten years before, students had taken to the streets to advocate Western ideas of democracy and liberty in the tradition of the May Fourth Movement. This time, however, university students protested foreign attacks on Chinese sovereignty, also in the tradition of the May Fourth Movement, which put the West instead of the Chinese state on the defensive. (The state prevented demonstrations against itself in China's premier public arena, Tiananmen Square, by sealing the square off for renovation and repairs to prepare for celebrations of the fiftieth anniversary of the founding of the People's Republic on October 1.) The United States and NATO were obliged to make repeated apologies for the bombing.

On China's national day, October 1, the regime staged an extravagant mass parade in Tiananmen Square and the Avenue of Eternal Peace to express newfound confidence as the country staked out a major role for itself in the new world order of the twenty-first century. As accusations of nuclear espionage escalated in the United States against Chinese-American nuclear scientist Wen-ho Lee China expended valuable foreign currency to beef up its military with purchases of Russian hardware in preparation for a potential conflict in the Taiwan Strait. The rhetoric of unification with the motherland became louder than ever since the Era of Reform and Openness.

As China and the United States vied for power in the area of international politics, they reached an agreement on China's entry into the WTO after more than a decade of negotiations. Both countries will supposedly reap huge benefits from the agreement by successively opening their markets to each other in the following years. The event may indicate formal and substantive integration of the Chinese economy into the capitalist world system.

One of the concessions that China has made for its entry into the WTO is permission for Hollywood to increase the number of blockbusters it exports to China each year. (From ten films prior to the agreement to twenty

films, and the number will increase in coming years.) As cultural products from the West make inroads in China, the Western media also represents, imagines, and co-opts China on the domestic front, though not necessarily always with sinister images, as with, say, *Red Corner*. American cultural production often stages the theme of East-meets-West to the applause of vast audiences. Jackie Chan's *Rush Hour*, a story about successful cooperation between one policeman from Hong Kong and another from America (Chris Tucker) was a major box-office hit in the United States. On Saturdays in 1999 and 2000, CBS broadcast *Martial Law*, a TV serial starring Hong Kong martial art superstar Sammo Hung, Arsenio Hall, and Kelly Hu (the new Michelle Yeoh), and codirected and coproduced by Stanley Tong. A charming, lovable, dutiful, competent Shanghai cop (Sammo Hung)—a far cry from the stereotypes of Charlie Chan and Fu Manchu—works on a daily basis with fellow police officers in Los Angeles to solve cases, defeat criminals, and uphold the law. American viewers see this comedy about Sino-American collaboration weekly, even as contentions in geopolitics and ideology loom large between East and West and occasionally erupt.

Economic and cultural globalization, nationalism, domestic unrest, loss of faith in official ideology, epidemic corruption, suppression of democracy—these are some of the challenges that China faces in the new century. Disjunctions and contradictions caused by political, economic, and social forces have given rise to an emergent cultural phenomenon that can be called the "postmodern" for lack of a better term.

As the common logic of late capital, the postmodern is not dominant everywhere to the same degree at the same moment throughout the entire world or in a specific country. In a formerly third-world country as vast as China, a large agricultural population still inhabits the hinterland and tens of millions of peasants migrate to the cities each year in search of a better life. Meantime, rapid urbanization and industrialization turn large numbers of villages into townships, and the Chinese people encounter forms of life that range from the premodern and modern to the postmodern. Thus, postmodernity in China is not limited to a cluster of aesthetic features exhibited in the architecture of Shanghai or Beijing, or in the works of elite artists and writers. In a balanced assessment of the situation, Perry Anderson writes the following:

> Postmodern culture is not just a set of aesthetic forms, it is also a technological package. Television, which was so decisive in the passage to a new epoch, has no modernist past. It became the most powerful medium of all in the postmodern period itself. But the power is far greater—more absolutely disproportionate to the impact of all others combined—in the former Third World than it is in the First itself.
>
> This paradox must give pause to any over-quick dismissal of the idea that the damned of the earth too have entered the kingdom of the spectacle. It is unlikely to remain isolated. For just ahead lies the impact of the new technologies of simulation—or prestidigitation—whose arrival is quite recent even in the rich cultures.
>
> So long as the system of capital prevails, each new advance in the industry of images increases the radius of the postmodern. In that sense, it can be argued, its global dominance is virtually foreordained.[3]

Therefore, the postmodern can be seen as a decisively emergent formation within a hybridity of cultural forms and technologies in China under the dominant logic of capital in a global system. Well after television entered the majority of Chinese households other new technologies unseen in the modernist stage are rapidly penetrating the domestic and public lives of Chinese citizens. Under the WTO agreement, transnational corporations will have a larger share of the Chinese market in the areas of information and communication (cellular phones, fax machines, long-distance phone service, the internet, and so forth). In 1999, Bill Gates's Microsoft Corporation even launched a new version of personal computer specifically designed for Chinese consumers as a way to break into China's fast-growing market. More American agricultural products are sold in China, and foreign bankers will be allowed to trade Chinese currency. The internet, fax machine, telephone, and television instantly link Chinese citizens to the rest of the world and turn them into active players in the game of "globalization." China's cosmopolises have become part of the "global village." For anyone at any corner of the world anytime, events in Beijing and Shanghai are only a click away on the internet at www.cityweekend.com.cn. Among other functions, cyberspace has even provided a romantic connection that brings together men and women on two different sides of the Pacific Ocean to chat, date, and eventually marry!

The logic of third world postmodernity is fundamentally nonlinear and anachronistic, for it cannot repeat the original historical sequence of mod-

ernization that advanced Western countries have experienced. Different modes of production that evolved successively over a long historical period in the West appear simultaneously in contemporary third world countries. Contemporary China has a broad spectrum of forms of property ownership, ranging from socialist state ownership to the completely private. Observers have pointed out that China has five recognizable forms of ownership: (1) traditional state or collective ownership; (2) the reformed state or collective firm, that is management incentive contracts; (3) the contracted public asset, or government-management partnerships; (4) leased public assets; and (5) privatization.[4] Hybrid forms of property rights and different relations of production account for the unique features of alternative postmodernity in third world countries.

It would be facile to argue that China is postmodern because peasants in remote villages watch TV. However, it would be equally wrongheaded to conclude that postmodernity is not the condition of China as a whole because huge numbers of Chinese people still subsist on agriculture. The fact of the matter is that candlelight, gaslight, electricity, and electronics all provide means of energy and illumination for homemakers within China, a large country with tremendous regional differences.

Outside China, an ever-increasing class of diasporic artists, cultural workers, intellectuals, and academics frequently shuttles back and forth between China and the West. These people of "flexible citizenship"—born in China, Taiwan, or Hong Kong, and now permanent residents and citizens of Western countries—interpret and fabricate the object of China for global audiences through bicultural and multicultural lenses. In addition, large quantities of cultural products "made in China" (subtitled or dubbed films, avant-garde works of art, and stories translated into other languages) are circulated, exhibited, and purchased in transnational circuits. In this sense, Chinese postmodernity is a profoundly transnational postmodernity-in-the-making across boundaries and oceans.

Notes

Introduction

1. Fredric Jameson, "Culture and Finance Capital," *Critical Inquiry* 24.1 (autumn 1997): 246–65.
2. Francis Fukuyama, *The End of History and the Last Man* (New York: Free Press, 1992). For a rebuttal of his position, see Jacques Derrida, *Spectres of Marx: the State of the Debt, the Work of Mourning, and the New International*, trans. Peggy Kamuf (New York: Routledge, 1994).
3. Richard Smith, "Creative Destruction: Capitalist Development and China's Environment," *New Left Review* 222 (Mar./Apr. 1997), p. 3.
4. In regard to Latin America, See John Beverley, Michael Aronna, and José Oviedo, eds., *The Postmodernism Debate in Latin America* (Durham, N.C.: Duke University Press, 1995); in regard to Japan, see Masao Miyoshi and H. D. Harootunian, eds., *Postmodernism and Japan* (Durham, N.C.: Duke University Press, 1989); in the case of Africa, see Kwame Anthony Appiah, "Is the Post- in Postmodernism the Post- in Postcolonial?" *Critical Inquiry* 17.2 (winter 1991): 336–57. For the Islamic world, see Akbar S. Ahmed, *Postmodernism and Islam: Predicament and Promise* (London: Routledge, 1992); Akbar S. Ahmed and Hastings Donnan, eds., *Islam, Globalization, and Postmodernity* (London: Routledge, 1994). For an overview of international postmodernism, see Hans Bertens and Douwe Fokkema, eds., *International Postmodernism: Theory and Literary Practice* (Amsterdam: John Benjamins, 1997).
5. Aijaz Ahmad, *In Theory: Classes, Nations, Literatures* (London: Verso, 1992), p. 31.
6. Ibid., p. 306.
7. Louis Althusser, *For Marx*, trans. Ben Brewster (London: New Left Books, 1977), p. 194.
8. Fredric Jameson, *The Political Unconscious: Narrative as a Socially Symbolic Act* (Ithaca, N.Y.: Cornell University Press, 1981), pp. 95, 96.
9. Arif Dirlik, "Reversals, Ironies, Hegemonies: Notes on the Contemporary Historiography of Modern China," *Modern China* 22.3 (July 1996), p. 257.

10. *New Left Review* 146 (July–Aug. 1984): 59–92.

11. Fredric Jameson, *Postmodernism, or, the Cultural Logic of Late Capitalism* (Durham, N.C.: Duke University Press, 1993), p. 29. From the position of a postcolonial critic, Homi Bhabha calls these lines "disjoined postimperial sentences." See his *The Location of Culture* (London: Routledge, 1994), p. 216.

12. It is timely to note that engagement with the postmodernism debate in Latin America also came at the point of "the crisis of the project of the Latin American left in the wake of its defeat and/or demolition in the period from 1973 to the present." Beverley, Aronna, and Oviedo, *Postmodernism Debate*, p. 5.

13. Jonathan Arac, "Chinese Postmodernism: Toward a Global Context," *boundary 2* 24.3 (fall 1997), p. 265.

14. See Mike Featherstone, *Consumer Culture and Postmodernism* (London: Sage, 1991), especially, chapter 5, "The Aestheticization of Everyday Life," pp. 65–82.

15. For studies of the intellectual and artistic scene in the 1980s, see Liu Kang and Xiaobing Tang, eds., *Politics, Ideology, and Modern Chinese Literature* (Durham, N.C.: Duke University Press, 1993); Jing Wang, *High Culture Fever: Politics, Aesthetics, and Ideology in Deng's China* (Berkeley: University of California Press, 1996); Xudong Zhang, *Chinese Modernism in Era of Reforms: Cultural Fever, Avant-Garde Fiction, and the New Chinese Cinema* (Durham, N.C.: Duke University Press, 1997).

16. The Chinese term "post–New Era" is in part derived from a series of "post-" words in Western theory, such as "postmodern," "poststructuralist," "postindustrial," "postcolonial," and so on.

17. See Arif Dirlik, *After the Revolution: Waking to Global Capitalism* (Hanover, N.H.: Wesleyan University Press, 1994); idem, "The Postcolonial Aura: Third-World Criticism in the Age of Global Capitalism," *Critical Inquiry* 20.2 (winter 1994): 328–56.

18. See Arjun Appadurai, "Disjuncture and Difference in the Global Cultural Economy," *Public Culture* 2.2 (spring 1990): 1–24.

19. See Anders Stephanson's interview with Fredric Jameson, "Regarding Postmodernism—A Conversation with Fredric Jameson," in *Universal Abandon? The Politics of Postmodernism*, ed. Andrew Ross (Minneapolis: University of Minnesota Press, 1988), pp. 24–25.

20. For a more detailed discussion of this issue, see Chapter 2 in this book, "Universality/Difference: The Discourses of Chinese Modernity, Postmodernity, and Postcoloniality."

21. Jameson, *Postmodernism*, p. ix.

22. For a description of the transition from Fordism to flexible accumulation, see David Harvey, *The Condition of Postmodernity: An Inquiry into the Origins of Cultural Change* (Cambridge, Mass.: Blackwell, 1990), especially part 2, pp. 119–97.

23. Dirlik, "Reversals," p. 277.

24. Terry Eagleton, "The Contradictions of Postmodernism," *New Literary History* 28.1 (winter 1997): 5.

25. Guo Jian, "Wenge sichao yu 'houxue'" (Intellectual currents of the Cultural Revolution and "Post-ism"), *Ershiyi shiji* (Twenty-first century) 35 (June 1996): 116–22.

26. For instance, Liang Xiaosheng's book *Zhongguo shehui ge jieceng fenxi* (Analysis of the social strata of China) (Beijing: Jingji ribao chubanshe, 1998) is obviously inspired by Mao's 1926 classic essay "Analysis of the classes in Chinese society."

27. On the question of spatial fracturing and temporal desynchronization in the Chinese postmodern against the teleology of the nation-state, see Arif Dirlik and Zhang Xudong, "Introduction: Postmodernism and China," *boundary 2* 24.3 (fall 1997): 3.

28. Rosalind Krauss and Hal Foster, "Introduction," *Visual Culture*, a special issue, *October* 77 (summer 1996): 3.

29. John Fiske, "Global, National, Local? Some Problems of Culture in a Postmodern World," *Velvet Light Trap* 40 (fall 1997): 57. See also the rest of this special issue, which bears the title *Transnational Media*.

30. Guy Debord, *The Society of the Spectacle*, trans. Donald Nicholson-Smith (New York: Zone Books, 1994), pp. 9, 12.

31. Jean Baudrillard, *The Transparency of Evil: Essays on Extreme Phenomena*, trans. James Benedict (London: Verso, 1993), p. 3.

32. Paul Virilio, *The Lost Dimension*, trans. Daniel Moshenberg (New York: Semiotext[e], 1991), p. 84.

33. Rosalind Krauss, ". . . And Then Turn Away? An Essay on James Coleman," *October* 81 (summer 1997): 5.

34. Simon During, "Popular Culture on a Global Scale: A Challenge for Cultural Studies?" *Critical Inquiry* 23.4 (summer 1997): 808–33.

35. "Visual Culture Questionaire," *Visual Culture*, a special issue, *October* 77 (summer 1996), p. 25.

36. I have explored the implications of transnationalism in Chinese cinemas in "Historical Introduction: Chinese Cinemas (1896–1996) and Transnational Film Studies," in *Transnational Chinese Cinemas: Identity, Nationhood, Gender*, ed. Sheldon H. Lu (Honolulu: University of Hawaii Press, 1997), pp. 1–31.

37. Alan Riding, "Why *Titanic* Conquered the World," *New York Times*, Apr. 26, 1998, sec. 2, p. 28. For a description of Jiang as a lover of Hollywood films, see Zhang Weikuo, "Jiang Zemin de Haolaiwu qingjie" (Jiang Zemin's Hollywood complex), *Shijie ribao* (World journal), May 19, 1998, p. B5.

38. Jean Baudrillard, *The Gulf War Did Not Take Place*, trans. Paul Patton (Bloomington: Indiana University Press, 1995).

39. Bill Stieg, "We are a trans-national family, with a foot in each country," *Pittsburgh Post-Gazette*, Mar. 15, 1998, pp. G11–12; Bill Stieg, "The Americanization

of China," *Pittsburgh Post-Gazette*, Mar. 15, 1998, p. G11; Bill Stieg, "Far East Pittsburgh," *Pittsburgh Post-Gazette*, Mar. 15, 1998, p. G1.

40. I thank Tom Rimer for bringing this edition of the newspaper to my attention.

41. Stieg, "Americanization of China," p. G11.

42. Rob Wilson and Wimal Dissanayake, "Introduction: Tracking the Global/Local," in *Global/Local: Cultural Production and the Transnational Imaginary*, ed. Rob Wilson and Wimal Dissanayake (Durham, N.C.: Duke University Press, 1996), p. 1.

Chapter 1

1. See Vera Schwarcz, *The Chinese Enlightenment: Intellectuals and the Legacy of the May Fourth Movement of 1919* (Berkeley: University of California Press, 1986).

2. See Lin Yü-sheng, *The Crisis of Chinese Consciousness: Radical Antitraditionalism in the May Fourth Era* (Madison: University of Wisconsin Press, 1979).

3. See Huang Ping, "Tizhi guifan yu huayu zhuanhuan: wushi niandai de zhishi fenzi gaizao" (Institutional formation and discursive transformation: the remolding of intellectuals in the 1950s), *Dongfang* (Orient) 4.3 (1994): 30–34.

4. See Liu Kang, "Subjectivity, Marxism, and Cultural Theory in China," *Social Text* 31/32 (1992): 114–40.

5. Although "modernity" is the concept used in academic discussions, "modernization" is a term associated with state-sponsored projects. In the 1970s and early 1980s, the government defined its task during the last quarter of the twentieth century as the realization of "four modernizations" in China: in the areas of industry, agriculture, national defense, and science and technology.

6. Liu Pin-yen (Liu Binyan) stands out as a representative of the figure of a modern/traditional Chinese intellectual at this juncture. See Perry Link, ed., *People or Monster? And Other Stories and Reportage from China After Mao* (Bloomington: Indiana University Press, 1983).

7. Jameson's lectures were collected and translated into Chinese. See *Houxiandai zhuyi yu wenhua lilun* (Postmodernism and cultural theory), trans. Xiaobing Tang (Xian: Shaanxi shifan daxue chubanshe, 1986).

8. See Wang Ning, "Confronting Western Influence: Rethinking Chinese Literature of the New Period," *New Literary History* 24.4 (autumn 1993): 905–26, esp. pp. 920–23; idem, "Constructing Postmodernism: The Chinese Case and Its Different Versions," *Canadian Review of Comparative Literature* 20.1/2 (1993): 49–61.

9. It is helpful to compare the Chinese case with the debate about postmodernism in Latin America. There are similarities between the two. John Beverley and José Oviedo write the following in their introduction to the special issue of *boundary 2*

(20.3 [fall 1993]: 4–5) devoted to the debate about postmodernism in Latin America: "The engagement with postmodernism in Latin America does not take place around the theme of the end of modernity that is so prominent in its Anglo-European manifestations; it concerns, rather, the complexity of Latin America's own 'uneven modernity' and the new developments of its (pre- and post-) modern cultures."

10. For an expression of these positions, see the forum on postmodernism in *Wenyi yanjiu* (Research in literature and arts) 1 (1993): 37–55. The forum features articles by Wang Yichuan (Beijing Normal University), Zhang Yiwu (Beijng University), Wang Yuechuan (Beijng University), Chen Xiaoming (Chinese Academy of Social Sciences), Wang Ning (Beijing University), Wang Desheng (Capital Normal University), and Tao Dongfeng (Capital Normal University).

For the debate about the differences between high culture and popular culture, see Chen Xiaoming, "Tianping honggou, huaqing jiexian" (Close the gap, draw the border), *Research in Literature and Arts* 1 (1994): 42–55; idem, "Houxiandai: jingying yu dazhong di hunzhan" (Postmodernity: the conflict between the elite and the masses), *Orient* 4.3 (1994): 81–86; Wang Yuechuan, "Zhishi diexi zhuanhuan zhong zhishi fenzi de jiazhi xuanze" (The axiological choices of intellectuals in the transition of the genealogy of knowledge), *Orient* 4.3 (1994): 22–27.

11. See Wang Yuechuan, "Zhishi diexi zhuanhuan."

12. Michel Foucault, *Power/Knowledge* (New York: Pantheon Books, 1980), p. 126.

13. Fredric Jameson, "Third-World Literature in the Era of Multinational Capitalism," *Social Text* 15 (fall 1986), p. 74.

14. For instance, astrophysicist Fang Lizhi, nicknamed "China's Sakharov," who spoke for the democratic aspirations of Chinese students; or journalist Liu Binyan, whose work represented a people's battle cry against government corruption; or writer Zhang Xianliang, whose stories in the mid-1980s were testimonies to the indestructible spirit of the Chinese intellectual under state oppression. (It is also instructive to think about the fate of these formerly well-known intellectuals in the 1990s. Zhang Xianliang became a businessman in China, Fang Lizhi took the position of professor of physics at the University of Arizona, and Liu Binyan was forced into exile at Princeton University.)

15. Michelle Yeh offers an insightful analysis of the critical scene in China in her essay "International Theory and the Transnational Critic: China in the Age of Multiculturalism," *boundary 2* 25.3 (fall 1998): 193–222.

16. See Wang Xiaoming, ed., *Renwen jingshen xunsi lu* (In pursuit of the humanistic spirit) (Shanghai: Wenhui chubanshe, 1996).

17. Wang Yuechuan, *Houxiandai zhuyi wenhua yanjiu* (A study of postmodernist culture) (Beijing: Beijing University Press, 1992), p. 405 and passim.

18. See, for instance, Zhang Yiwu, "Renwen jingshen: zuihou de shenhua" (The humanistic spirit: the last myth), in *Renwen jingshen*, pp. 137–41.

19. Zhao Yiheng (Henry Zhao), "'Houxue' yu Zhongguo xin baoshou zhuyi"

("Post-ism" and Chinese neo-conservatism), *Ershiyi shiji* (Twenty-first century) (Feb. 1995): 4–15; Xu Ben, "Disan shijie piping zai dangjin Zhongguo de chujing" (The situation of third world criticism in contemporary China), *Ershiyi shiji* (Twenty-first century) (Feb. 1995): 16–27. See also Xu Ben, *Disenchanted Democracy: Chinese Criticism after 1989* (Ann Arbor: University of Michigan Press, 1999).

20. For an overview of this academic discourse, see Chen Lai, "Jiushi niandai bulü weijian de 'guoxue yanjiu'" (The difficult steps of "national studies" in the 1990s), *Dongfang* (Orient) 2 (1995): 24–28.

21. This transnational academic organization has on its executive board Singapore's former prime minister Lee Kuan Yew, who serves as honorary president; former Chinese vice prime minister Gu Mu, who holds the organization's presidency; Hong Kong business tycoon Li Ka Shing, who is among its funders; and disparate scholars such as Tu Wei-ming, Tang Yijie, and Li Zehou, who serve on its executive board.

22. For coverage of the kinds of issues under discussion, see the *International Confucian Association Bulletin* (*ICA Bulletin*) no. 1 (Mar. 1995); no. 2 (July 1995); no. 3 (Nov. 1995); no. 4 (Dec. 1995); no. 5 (Mar. 1996); and no. 6 (June 1996).

23. John Naisbitt, *Megatrends Asia: Eight Asian Megatrends That Are Reshaping Our World* (New York: Simon and Schuster, 1996); Chinese edition: Yuehan Naisibite (John Naisbitt), *Yazhou da qushi*, trans. Wei Wen (Beijing: Waiwen chubanshe, 1996).

24. For a discussion of these problems and a rethinking of the role of the intellectual in the West, see Bruce Robbins, *Secular Vocations: Intellectuals, Professionalism, Culture* (London: Verso, 1993).

25. Bruce Robbins, ed., *Intellectuals: Aesthetics Politics Academics* (Minneapolis: University of Minnesota Press, 1990), p. xxv.

26. Andrew Ross, ed., *Universal Abandon? The Politics of Postmodernism* (Minneapolis: University of Minnesota Press, 1988), p. xvi.

27. Jonathan Arac, ed., *Postmodernism and Politics* (Minneapolis: University of Minnesota Press, 1986), p. xxx.

28. For a perceptive critique of the Confucian revival, see Arif Dirlik, "Confucius in the Borderlands: Global Capitalism and the Reinvention of Confucianism," *boundary 2* 22.3 (fall 1995): 229–73.

29. Many symposia were held on the topic. For publications, see William T. Rowe, "The Public Sphere in Modern China," *Modern China* 16.3 (1990): 309–29; *Modern China* 19.2 (Apr. 1993), a special issue on the public sphere/civil society in late imperial and early modern China, features contributions from Frederic Wakeman, Jr., William T. Rowe, Mary Backus Rankin, Richard Madsen, Heath B. Chamberlain, and Philip C. C. Huang; Benjamin Lee, "Going Public," *Public Culture* 5 (1993): 165–78; Wang Hui, Leo Ou-fan Lee, with Michael M. J. Fischer, "Is the Public Sphere Unspeakable in Chinese? Can Public Spaces (*gonggong kongjian*) lead to Public Spheres?" *Public Culture* 6.3 (spring 1994): 598–605.

30. In revising his earlier one-sided account of mass media and consumer culture in *The Structural Transformation of the Public Sphere* (Cambridge, Mass.: MIT Press, 1992), Habermas states, "In fine, my diagnosis of a unilinear development from a politically active public to one withdrawn into a bad privacy, from a 'culture-debating to a culture-consuming public,' is too simplistic." See Jürgen Habermas," Further Reflections on the Public Sphere," in *Habermas and the Public Sphere*, ed. Craig Calhoun (Cambridge, Mass.: MIT Press, 1992), p. 438. The role of mass culture on the public sphere in China seems to be double-edged.

31. Wang, Lee, Fischer, "Is the Public Sphere Unspeakable?" p. 598.

32. For relevant studies of interrelations among the media, the public sphere, and democracy in contemporary China, see Yuezhi Zhao, *Media, Market, and Democracy in China* (Urbana: University of Illinos Press, 1998); Daniel Lynch, *After the Propaganda State: Media, Politics, and "Thought Work" in Reformed China* (Stanford: Stanford University Press, 1999).

33. See Zhao Yiheng (Henry Zhao), "Zou xiang bianyuan" (Going to the margin), *Dushu* (Reading) (Jan. 1994): 36–42.

34. Antonio Gramsci, *Selections from the Prison Notebooks*, ed. and trans. Quintin Hoare and Geoffrey Nowell Smith (New York: International, 1971), p. 9.

35. See Paul Bové, *Intellectuals in Power: A Genealogy of Critical Humanism* (New York: Columbia University Press, 1986), especially chapter 6, "Critical Negation: The Function of Criticism at the Present Time," pp. 239–310.

36. Arac, *Postmodernism and Politics*, p. xxxix. For discussions of problems facing the academy, faculty work, and career development in our present age of transnational capital, see *Profession 1996* (New York: Modern Language Association of America, 1996).

37. See Xiaobing Tang, "The Function of New Theory: What Does It Mean to Talk about Postmodernism in China?" in *Politics, Ideology, and Literary Discourse in Modern China: Theoretical Interventions and Cultural Critique*, eds. Liu Kang and Xiaobing Tang (Durham, N.C.: Duke University Press, 1993), pp. 278–99.

38. For a study of modernism and postmodernism as literary phenomena in the 1980s, see Wendy Larson and Anne Wedell-Wedellsborg, eds., *Inside Out: Modernism and Postmodernism in Chinese Literary Culture* (Aarhus C., Denmark: Aarhus University Press, 1993).

39. See Jing Wang, "The Mirage of 'Chinese Postmodernism': Ge Fei, Self-Positioning, and the Avant-Garde Showcase," *positions: east asian cultures critique* 1.2 (fall 1993): 349–88.

40. See, for example, Li Oufan (Leo Ou-fan Lee), "Zhishi fenzi keyi zuoxie shenmo? Gai zenmo zuo?" (What can intellectuals do? How should they proceed?), *Jiushi niandai* (The nineties) (Apr. 1993): 89–91.

41. Arif Dirlik, "The Postcolonial Aura: Third-World Criticism in the Age of Global Capitalism," *Critical Inquiry* 20.2 (winter 1994), p. 351.

42. Fredric Jameson, *Postmodernism, or, the Cultural Logic of Late Capitalism* (Durham, N.C.: Duke University Press, 1993), p. 54.

43. Michel Foucault, *Language, Counter-Memory, Practice* (Ithaca, N.Y.: Cornell University Press, 1993), p. 206.

44. Paul Bové sees the task as "critical negation": "Invested with knowledge and the skills to produce more, it should destroy the local discursive and institutional formations of the 'regime of truth'.... But this 'negation' must have a 'positive' content; it must carry out its destruction with newly produced knowledge directed not only against the centers of the anthropological attitude but, with an eye to its utility, to others in one's own locale and elsewhere." *Intellectuals in Power*, p. 310.

Chapter 2

1. Joseph R. Levenson, *Confucian China and its Modern Fate* (Berkeley: University of California Press, 1968), 3: 108.

2. Gregory Jusdanis, *Belated Modernity and Aesthetic Culture: Inventing National Literature* (Minneapolis: University of Minnesota Press, 1991), p. xiii.

3. Chicago: University of Chicago Press, 1995.

4. The question of Chinese modernity from the late Qing through the twentieth century has been carefully studied in a number of important new books. See David Der-wei Wang, *Fin-de-Siècle Splendor: Repressed Modernities of Late Qing Fiction, 1849–1911* (Stanford: Stanford University Press, 1997); Xiaobing Tang, *Global Space and the Nationalist Discourse of Modernity: The Historical Thinking of Liang Qichao* (Stanford: Stanford University Press, 1996); Lydia H. Liu, *Translingual Practice: Literature, National Culture, and Translated Modernity—China, 1900–1937* (Stanford: Stanford University Press, 1995); Leo Ou-fan Lee, *Shanghai Modern: The Flowering of A New Urban Culture in China, 1930–1945* (Cambridge, Mass.: Harvard University Press, 1999); Ban Wang, *The Sublime Figure of History: Aesthetics and Politics in Twentieth-Century China* (Stanford: Stanford University Press, 1997).

5. See Xiaomei Chen, *Occidentalism: A Theory of Counter-Discourse in Post-Mao China* (New York: Oxford University Press, 1995). Perceptive analyses of cultural dynamics between the East and the West are also given in Zhang Longxi, *Mighty Opposites: From Dichotomies to Differences in the Comparative Study of China* (Stanford: Stanford University Press, 1998).

6. For one example, see Cui Zhiyuan, *Di erci sixiang jiefang yu zhidu chuangxin* (The second intellectual liberation and institutional innovation) (Hong Kong: Oxford University Press, 1997).

7. See Peter L. Berger and Hsin-Huang Michael Hsiao, eds., *In Search of an East Asian Development Model* (New Brunswick, N.J.: Transaction, 1988).

8. Arif Dirlik, "Confucius in the Borderlands: Global Capitalism and the Reinvention of Confucianism," *boundary 2* 22.3 (fall 1995): 265.

9. Lee Kuan Yew expressed his views in an interview with Fareed Zakaria in *Foreign Affairs*. See Fareed Zakaria, "Culture Is Destiny: A Conversation with Lee Kuan Yew," *Foreign Affairs* 73.2 (Mar./Apr. 1994): 109–26. In *Foreign Affairs* 73.6 (Nov./Dec. 1994), there is a group of essays on "Asia-Pacific Myths." Most noteworthy is a rebuttal of Lee's views by another Asian leader, Kim Dae Jung, a leading Korean political leader at that time, who was elected president of South Korea in 1998. See Kim Dae Jung, "Is Culture Destiny?" pp. 189–94.

10. Li Zehou and Liu Zaifu, *Gaobie geming* (Farewell revolution) (Hong Kong: Tiandi, 1995), p. 53.

11. Ibid., p. 64.

12. For a brief overview of the Marxist dialectic of modernity, see Gören Therborn, "Dialectics of Modernity: On Critical Theory and the Legacy of Twentieth-Century Marxism," *New Left Review* 215 (Jan./Feb. 1996): 59–81.

13. A pungent critique of postcolonial criticism can be found in Arif Dirlik, "The Postcolonial Aura: Third World Criticism in the Age of Global Capitalism," *Critical Inquiry* 20.2 (winter 1994): 328–56. For a more sympathetic approach to postcolonial criticism in the Asian context, see Tani E. Barlow, ed., *Formations of Colonial Modernity in East Asia* (Durham, N.C.: Duke University Press, 1997).

14. Bill Ashcroft, Gareth Griffiths, and Helen Tiffin, eds., *The Post-Colonial Studies Reader* (London: Routledge, 1995), p. 2.

15. Linda Hutcheon, "Introduction—Colonialism and the Postcolonial Condition: Complexities Abounding," *PMLA* 110.1 (Jan. 1995): 10.

16. For instance, Gyan Prakash states, "we cannot thematize Indian history in terms of the development of capitalism and simultaneously contest capitalism's homogenization of the contemporary world." Gyan Prakash, "Postcolonial Criticism and Indian Historiography," *Social Text* 31/32 (1992): 13.

17. Arturo Escobar, "Imagining a Post-Development Era? Critical Thought, Development and Social Movements," *Social Text* 31/32 (1992): 47.

18. Homi K. Bhabha, *The Location of Culture* (London: Routledge, 1994), p. 241.

19. Karl Marx and Friedrich Engels, "Manifesto of the Communist Party," *Basic Writings on Politics and Philosophy*, ed. Lewis S. Feuer (New York: Doubleday, 1989), pp. 10–11.

20. Tetsuo Najita, "Presidential Address: Reflections on Modernity and Modernization," *Journal of Asian Studies* 52.4 (Nov. 1993): 849–50.

21. Aihwa Ong, *Flexible Citizenship: The Cultural Logics of Transnationality* (Durham, N.C.: Duke University Press, 1999), p. 35.

22. See Li Shenzhi, "Yazhou jiazhi yu quanqiu jiazhi" (Asian values and global values), *Dongfang* (Orient) 4 (1995): 4–9. In his explanatory note to this essay (p. 99), Li poignantly writes, "I feel that Chinese scholars delight in talking about some academic issues which are perhaps meaningless (such as postcolonialism), but do not pay enough attention to intellectual trends of global significance."

23. See David Hall, "Modern China and the Postmodern West," in *From*

Modernism to Postmodernism: An Anthology, ed. Lawrence E. Cahoone (Cambridge, Mass.: Blackwell, 1996), pp. 698–710.

24. See Jean-François Lyotard, *The Postmodern Condition: A Report on Knowledge*, trans. Geoff Bennington and Brian Massumi (Minneapolis: University of Minnesota Press, 1984).

25. Sheldon Hsiao-peng Lu, "The Fictional Discourse of *Pien-wen*: The Relation of Chinese Fiction to Historiography," *Chinese Literature: Essays, Articles, Reviews*, 9.1, 2 (July 1987), pp. 69–70.

26. Sheldon Hsiao-peng Lu, *From Historicity to Fictionality: The Chinese Poetics of Narrative* (Stanford: Stanford University Press, 1994), pp. 161–68.

27. For a discussion of Japanese postmodernism, which is significantly different from that of the Chinese, although both are "Asian," see Masao Miyoshi and H. D. Harootunian, eds., *Postmodernism and Japan* (Durham, N.C.: Duke University Press, 1989).

28. See Ernst Bloch, "Nonsynchronism and the Obligation to Its Dialectics," *New German Critique* 11 (spring 1977): 22–38.

29. Ella Shohat and Robert Stam, *Unthinking Eurocentrism: Multiculturalism and the Media* (London: Routledge, 1996), 293.

30. Anne McClintock, "The Angel of Progress: Pitfalls of the Term 'Post-Colonialism'," *Social Text* 31/32 (1992): 86.

Chapter 3

1. Quoted in *Makesizhuyi yu xianshi* (Marxism and reality) 4 (Aug. 1998), p. 1.

2. For a discussion of the relationship between values and economics in Asia, see Wang Ruisheng, "Yazhou jiazhi yu jinrong weiji" (Asian values and the financial crisis), *Zhexue yanjiu* (Philosophical research) 4 (Apr. 1998): 23–30.

3. For a story about Hong Kong's financial secretary, Sir Donald Tsang, his crusade against foreign speculators, and his defense of Hong Kong's financial market, see "Banging the Drum for Hong Kong," *New York Times*, Sept. 27, 1998, sec. 3, p. 2.

4. For a new study, see Frederic Jameson and Masao Miyoshi, eds., *The Cultures of Globalization* (Durham, N.C.: Duke University Press, 1998).

5. Lin Yü-sheng calls it "totalistic antitraditionalism." See Lin Yü-sheng, *The Crisis of Chinese Consciousness: Radical Antitraditionalism in the May Fourth Era* (Madison: University of Wisconsin Press, 1979).

6. The term "Post-Confucianism" was introduced by Roderick MacFarquhar. "Like 'post-industrial', the term 'post-Confucian' is used to connote societies which bear the obvious hallmarks of industrialism/Confucianism, but which have been significantly altered by the accretion of new elements." Roderick MacFarquhar, "The Post-Confucian Challenge," *The Economist*, Feb. 9, 1980, p. 68.

7. Chen Lai was one of the few mainland critics who saw Confucian "industrial East Asia" (*gongye dongya*) as a model for China's development. See Chen Lai, "Huajie 'chuantong' yu 'xiandai' de jinzhang—'Wusi' wenhua sichao de fansi" (Resolving the tension between "tradition and "modernity"—reflections on the cultural currents of the May Fourth Movement), in Lin Yü-sheng et al., *Wusi: Duoyuan de fansi* (The May Fourth: pluralistic reflections) (Hong Kong: Sanlian, 1989), pp. 151–85.

8. For instance, the 1995 New Year issue of *Far Eastern Economic Review* featured a "Year in Review" article that discussed the economic situation of various East and Southeast Asian countries, all under the rubric of "Confucian capitalism." See "94 Free Trade: Key Asian Value: 'Confucian Capitalism' Succeeds, but Beware the Labor Shortage," *Far Eastern Economic Review*, Dec. 29, 1994, and Jan. 5, 1995, pp. 26–32. For another interesting discussion of Confucianism as a trendsetter in East Asian economics and politics, which was published in a journal for the general reader, see "Confucianism: New Fashion for Old Wisdom," *The Economist*, Jan. 21, 1995, pp. 38–39.

9. See the special section in memoriam of Neo-Confucian philosopher Mou Zongsan (1909–95), *Ming Bao yuekan* (Ming Bao monthly) (May 1995): 99–104.

10. See Liu Dong, "Zhongguo nengfou zoutong 'dongya daolu'" (Can China go through the "East Asian road?"), *Dongfang* (Orient) (1993): 7–16; Chen Lai, "Ershi shiji wenhua yundong zhong de jijin zhuyi" (Radicalism in twentieth-century cultural movements), *Dongfang* (1993): 38–44; idem, "Rujia sixiang yu xiandai dongya shijie" (Confucian thought and the modern East Asian world), *Dongfang* 3 (1994): 10–13; Gu Xin, *Zhongguo fan chuantong zhuyi de pinkun: Liu Xiaobo yu ouxiang pohuai de wutuobang* (The poverty of Chinese anti-traditionalism: Liu Xiaobo and the utopia of iconoclasm) (Taipei: Fengyun shidai, 1993).

11. Arif Dirlik, "Confucius in the Borderlands: Global Capitalism and the Reinvention of Confucianism," *boundary 2* 22.3 (fall 1995): 229–73.

12. See Aihwa Ong, "A Momentary Glow of Fraternity: Narratives of Nation and Capitalism in East Asia," paper presented at the symposium "The Rise of 'Asian' Capitalism: Class, Nation States, and New Narratives," New York Academy of Sciences, Feb. 25, 1995; idem, *Flexible Citizenship: The Cultural Logic of Transnationality* (Durham, N.C.: Duke University Press, 1999).

13. See, for one example, the Chinese translation of Robert Slater's *Soros: the Life, Times, and Trading Secrets of the World's Greatest Investor* (Burr Ridge, Ill.: Irwin Professional, 1991): Luopote Sileite (Robert Slater), *Suoluosi xuanfeng: lishishang zuiweida jirongjia de shengping yu touzi mijue*, trans. Huang Zheng (Haikou: Hainan chubanshe, 1998).

14. For an expression of this position, see Chen Pingyuan, "Xuezhe de renjian qinghuai" (The scholar's concern with the human world), *Dushu* (Reading) 5 (1993): 75–80.

15. Zhang Taiyan, *Guoxue gailun* (1922; reprint, Shanghai: Shanghai guji chu-

banshe, 1997); Yu Chunsong and Meng Yanhong, eds., *Wang Guowei xueshu jingdian ji*, 2 vols. (Nanchang: Jiangxi renmin chubanshe, 1997).

16. Lu Jiandong, *Chen Yinke de zuihou ershi nian* (Beijing: Sanlian, 1995).

17. For a review of this school of criticism, see Xu Ben, "Disan shijie piping zai dangjin Zhongguo de chujing" (The situation of Third World criticism in contemporary China), *Ershi yi shiji* (Twenty-first century) (Feb. 1995): 16–27.

18. Song Qiang, Zhang Zangzang, and Qiao Bian, *Zhongguo keyi shuo bu: lengzhan hou shidai de zhengzhi yu qinggan xuanze* (China can say no: political and emotional choices in the post–cold war era) (Beijing: Zhonghua gongshang lianhe chubanshe, 1996).

19. Li Xiguang, Liu Kang, et al., *Yaomohua Zhongguo de beihou* (Behind the demonization of China) (Beijing: Zhongguo shehui kexue chubanshe, 1996).

20. Richard Bernstein and Ross H. Munro, *The Coming Conflict with China* (New York: Knopf, 1997); Samuel P. Huntington, *The Clash of Civilizations and the Remaking of World Order* (New York: Simon and Schuster, 1996), an expansion of his original title essay. For a balanced academic study of the issue of Chinese nationalism, see Jonathan Unger, ed., *Chinese Nationalism* (Armonk, N.Y.: M. E. Sharpe, 1996).

21. See, for instance, Wang Ning, "Confronting Western Influence: Rethinking Chinese Literature of the New Period," *New Literary History* 24.4 (autumn 1993): 905–26.

22. For more post-studies in Chinese, see Zhang Yiwu, *Cong xiandaixing dao houxiandaixing* (From modernity to postmodernity) (Nanning: Guangxi jiaoyu chubanshe, 1997); Wang Ning, *Houxiandaizhuyi zhihou* (After postmodernism) (Beijing: Zhongguo wenxue chubanshe, 1998).

23. Numerous articles have been written about the subject. For a few programmatic essays, see, for instance, the forum "Liberalism in the Nineties: the West and China" in *Ershi yi shiji* (Twenty-first century) 42 (Aug. 1997), which includes Wang Hui, "Chengren de zhengzhi, wanminfa yu ziyouzhuyi de kunjing" (The politics of recognition, the laws of people and the predicament of liberalism," pp. 4–18; Xu Youyu, "Chongti ziyouzhuyi" (Liberalism revisited), pp. 19–26; Xu Jilin, "Xiandai Zhongguo de ziyouzhuyi chuantong" (The liberal tradition of modern China), pp. 27–35. Also relevant in the same issue of the journal is the essay by Gao Like, "*Xin qingnian* yu lianzhong ziyouzhuyi chuantong" (*La Jeunesse* and two liberal traditions), pp. 39–46. See also Gan Yang, "Ziyouzhuyi: guizu de haishi pingmin de" (Liberalism: aristocratic or plebeian?), *Dushu* (Reading) (Jan. 1999): 85–94. Jianhua Chen offers an overview of the debate in English in "Local and Global in Narrative Contestation: Liberalism and the New Left in Late-1990s China," *Journal of Asian Pacific Communication* 9.1, 2 (1999): 113–29.

24. Wang Hui, "Chengren de zhengzhi," p. 4.

25. See Masao Miyoshi, "A Borderless World? From Colonialism to Transnationalism and the Decline of the Nation-State," *Critical Inquiry* 19.4 (summer 1993):

726–51; Arif Dirlik, "The Postcolonial Aura: Third World Criticism in the Age of Global Capitalism," *Critical Inquiry* 20.2 (winter 1994): 328–56.

26. This general trend is regarded as "neo-conservatism" (*xin baoshou zhuyi*) by Zhao Yiheng. See Zhao Yiheng (Henry Zhao), "'Houxue' yu Zhongguo xin baoshou zhuyi" ("Post-ism" and Chinese neo-conservatism), *Ershi yi shiji* (Twenty-first century) (Feb. 1995): 4–15.

27. Jameson, *Postmodernism*, p. 54.

28. Masao Miyoshi, "Sites of Resistance in the Global Economy," *boundary 2* 22.1 (spring 1995): 83.

29. Ibid.

30. Edward W. Said, "Identity, Authority, and Freedom: The Potentate and the Traveler," *boundary 2* 21.3 (fall 1994), p. 16.

31. Ibid.

Chapter 4

1. Although Zhou is one of the best-known directors of the so-called "Fifth Generation," few studies of his films in English exist. For studies of his early films, see Tonglin Lu, "How Do You Tell a Girl from a Boy? Uncertain Sexual Boundaries in *The Price of Frenzy*," in *Significant Others: Gender and Culture in Film and Literature East and West*, eds. William Burgwinkle, Glenn Man, and Valerie Wayne (Honolulu: East West Center, University of Hawaii, 1993), pp. 63–74; Elissa Rashkin, "Rape as Castration as Spectacle: *The Price of Frenzy*'s Politics of Confusion," in *Gender and Sexuality in Twentieth-Century Chinese Literature and Society*, ed. Tonglin Lu (Albany, N.Y.: SUNY Press, 1993), pp. 107–19. Fredric Jameson briefly touched upon *Desperation* (1987/1988) in his essay "Remapping Taipei," in *New Chinese Cinemas: Forms, Identities, Politics*, eds. Nick Browne, Paul G. Pickowicz, Vivian Sobchack, and Esther Yau (Cambridge, Eng.: Cambridge University Press, 1994), p. 121. For an informative account of Zhou's career and a review of *Ermo*, see Tony Rayns, "The Ups and Downs of Zhou Xiaowen," *Sight and Sound* 5.7 (July 1995): 22–24; idem, "*Ermo*" (movie review), *Sight and Sound* 5.7 (July 1995): 47–48. Additional studies of Zhou's film art can be found in mainland Chinese film journals. For instance, see the special section devoted to him in *Dangdai dianying* (Contemporary film) 5 (1994): 28–55.

2. Terms such as "postsocialism," "postcoloniality," and "postmodernity" have been used to describe the uneven, hybrid quality of social, economic, and cultural developments in the West, as well as what has been called the "third world." For issues about postsocialism in regard to Chinese cinema, see Paul G. Pickowicz, "Huang Jianxin and the Notion of Postsocialism," in *New Chinese Cinemas*, pp. 57–87; for a discussion of postcoloniality and China's possible relation to it, see Arif

Dirlik, "The Postcolonial Aura: Third World Criticism in the Age of Global Capitalism," *Critical Inquiry* 20.2 (1994): 328–56.

3. In fact, in his comments on Zhou's film urban thriller *Desperation* Frederic Jameson underscored omission of the countryside and its replacement with cityscape, or what amounts to "China's" erasure. To Jameson, this was a "peculiar process whereby the identifying marks of all specific, named cities have been systematically removed, in order to foreground the generally urban.... The high-tech espresso bars and bullet trains of *Desperation* thus dutifully block out a world of contemporary industrial production and consumption beyond all ideological struggle." Jameson, "Remapping Taipei," p. 121.

4. In another telling instance, Zhang Yimou's film *Keep Cool* (*Youhua haohao shuo*), a film about life in contemporary Beijing, was poorly received at the 1997 Venice Film Festival and did not receive any awards. Obviously, international film festivals prefer films by Zhang about rural, primitive China, such as *The Story of Qiu Ju*.

5. See Rey Chow, *Primitive Passions: Visuality, Sexuality, Ethnography, and Contemporary Chinese Cinema* (New York: Columbia University Press, 1995).

6. See Sheldon H. Lu, ed., *Transnational Chinese Cinemas: Identity, Nationhood, Gender* (Honolulu: University of Hawaii Press, 1997).

7. As a matter of fact, *Ermo* was funded by mainlanders–turned–Hong Kong businessmen in the final production stage. The same backers also funded production of Zhou's next film, *The Emperor's Shadow* (*Qin song*, 1995).

8. Zhou recently turned away from filmmaking to direct a TV series titled *The Legend of Empress Lu* (*Lühou chuanqi*), a story based on early Chinese history (second century B.C.). Prime time TV drama is the most popular form of entertainment in contemporary China because a high percentage of average households own TVs. In cashing in on this lucrative entertainment business, Zhou seems to bear certain similarities to the heroine in his own film *Ermo*.

9. James Lull, *China Turned On: Television, Reform, and Resistance* (London: Routledge, 1991), p. 1.

10. Rayns, "*Ermo*," p. 48.

11. Bill Powell, "A Fast Drive to Riches," in the special issue "China after Deng," *Newsweek*, Mar. 3, 1997, p. 32.

12. See Judith Marlene, "The World of Chinese Television," in *China at the Crossroads*, ed. Donald Altschiller (New York: H. W. Wilson, 1994), p. 217. For discussions of China's TV programming, see James Lull, *China Turned On*; idem, "China's *New Star*: The Reformation on Prime-Time Television," in *Inside Family Viewing: Ethnographic Research on Television Audiences* (London: Routledge, 1990), pp. 96–145; James Lull and Se-Wen Sun, "Agent of Modernization: Television and Urban Chinese Families," in *World Families Watch Television*, ed. James Lull (Newbury Park, Calif.: Sage Publications, 1988), pp. 193–236.

13. Jean Baudrillard, *Simulations*, trans. Paul Foss, Paul Patton, and Philip Beitchman (New York: Semiotext[e], 1983), p. 83.

14. For a discussion of this aspect of the American TV series, see Jane Feuer, "Melodrama, Serial Form, and Television Today," in *The Media Reader*, ed. Manual Alvarado and John O. Thompson (London: BFI, 1990), pp. 253–64. For a recent study of televisuality, see John Thornton Caldwell, *Televisuality: Style, Crisis, Authority in American Television* (New Brunswick, N.J.: Rutgers University Press, 1995).

15. See Marshall McLuhan, *Understanding Media: The Extension of Man* (New York: New American Library, 1964).

Chapter 5

1. These TV serials included such titles as *The Story of Hong Kong* (*Xianggang de gushi*, directed by Wang Jin), *The Date of a Century* (*Shiji yuehui*, directed by Wang Fengkui), *Get Wedded on the Return Day* (*Hunli dingzai huigui ri*, directed by Cao Zheng), and *Once in a Thousand Years* (*Qiannian deng yihui*, directed by Wang Dapeng).

2. Massive official art exhibitions to celebrate Hong Kong's return were organized in Beijing. "The Great Exhibition of Chinese Art" (*Zhongguo yishu dazhan*), under the sponsorship of the Ministry of Culture, took place in the Museum of Chinese History, and "The Joint Exhibition of Women Artists of Beijing and Hong Kong" took place at the National Art Gallery. At the same time, against the background of these grandiose state-sponsored projects, art exhibitions of much smaller size were organized in the cramped spaces of Hong Kong's tiny art galleries. Hanart T Z Gallery hosted "Hong Kong 1997—It Must Be Shangri-la," paintings by Han Xin, and the installation "Hong Kong Monument: the Historic Clash" by Gu Wenda (July 1–19, 1997). Schoeni Art Gallery was the site of the exhibition "8 + 8 – 1," selected paintings of fifteen contemporary artists. These art shows and artworks were satires and caricatures of either the politics of the Hong Kong handover itself or, more generally, the social and cultural life of China.

A widely publicized new play in Beijing was *Oh Homecoming* (*Guilai xi*), by the Shanghai People's Theater. This play was the story of a patriotic Chinese/Hong Kong capitalist and his determination to keep alive his own company (an example of Chinese industry) in the face of pressure and competition from foreign companies throughout his career—from the time of Dr. Sun Yat-sen, through the Sino-Japanese War, to the 1980s. Historical figures such as Li Hongzhang, who represented the Qing government, which ceded Hong Kong to Britain, appeared in the play. A climactic moment was the staging of the meeting between Deng Xiaoping and Margaret Thatcher in Beijing in 1982, when Deng declared his intention to take Hong Kong back and return it to Chinese rule.

3. The Opium War and the life story of Lin Zexu have been used for various political, anti-imperialist, and even imperialist causes in different contexts and historical periods. Poshek Fu brings to our attention the case of the Sino-Japanese coproduction *Eternity* (*Wanshi liufang*, 1943) in Shanghai during the Japanese occupation of China. Although imperial Japan intended to make an anti-Western, anti-imperialistic statement to glorify its war efforts against the United States and Britain, the film went through a series of mediations in the hands of the directors and film artists and ended up being viewed much differently by the Chinese audience. For a discussion of such cultural politics, see Poshek Fu, "The Ambiguity of Entertainment: Chinese Cinema in Japanese-Occupied Shanghai, 1941–1945," *Cinema Journal* 37.1 (fall 1997): 66–84.

4. See Wu Hung, "The Hong Kong Clock—Public Time-Telling and Political Time/Space," *Public Culture* 9.3 (spring 1997): 329–54. This entire issue of *Public Culture*, which bears the title *Hong Kong 1997: The Place and the Formula*, edited by Akbar Abbas and Wu Hung, is worth reading.

5. For a series of short reports on the film and its director and cast, see "*Honghe gu* xilie baodao" (series of reports on Red River Valley), *Zhongguo yinmu* (China screen) 112 (Feb. 1997): 14–23.

6. I offer a detailed comparative study of these Chinese and Hollywood films in my essay "Representing the Chinese Nation-State in Filmic Discourse," in *East of West: Cross-Cultural Performance and the Staging of Difference*, eds. Claire Sponsler and Xiaomei Chen (New York: Palgrave, 2000), pp. 111–23.

7. Quoted in Nimrod Bernoviz, "China's New Voices: Politics, Ethnicity, and Gender in Popular Music Culture on the Mainland, 1978–1997" (Ph.D. diss., University of Pittsburgh, 1997), pp. 331–32.

8. For a discussion of the notion of deterritorialized citizenship in the Chinese diaspora, see Aihwa Ong, "On the Edge of Empires: Flexible Citizenship among Chinese in Diaspora," *positions: east asia cultures critique* 1.3 (winter 1993): 745–78.

9. Feng Ruozhi, "Fangwen Chen Kexin (Chan Ho San)" (An interview with Peter Chan), *Zhongguo yinmu* (China screen) 117 (July 1997): 18–19. See also the entire special section on *Comrades, Almost a Love Story*, in *Zhongguo yinmu* (July 1997): 12–19.

10. For a discussion of time in Wong Kar-wai's films, see Chuck Stephens, "Time Pieces: Wong Kar-wai and the Persistence of Memory," *Film Comment* 32.1 (Jan.–Feb. 1996): 12–18. On the question of spatial and temporal discontinuity in Wong, see Curtis K. Tsui, "Subjective Culture and History: The Ethnographic Cinema of Wong Kar-wai," *Asian Cinema* 7.2 (winter 1995): 93–124.

11. The information above is found in "Womanizing Wide Boys," *HMV Music Guide* (July 1997): 14.

12. See Peng Yiping, "*Chunguang zhaxie*: 97 qian rang women kuaile zai yiqi," (*Chunguang zhaxie*: let's be Happy Together before 1997: an interview with Wong Kar-wai), *City Entertainment* (Dianying shuangzhou kan) (Hong Kong), May 29–

June 11, 1997, pp. 41–48. See also special sections about *Happy Together* in *City Entertainment*, May 15–28, 1997, pp. 32–46; and *City Entertainment*, June 12–25, 1997, pp. 68–73. See also Chris Doyle, "To the End of the World," *Sight and Sound* 7.5 (May 1997): 14–17; Charlotte O'Sullivan, "*Happy Together/Chunguang Zhaxie*" (movie review), *Sight and Sound* 8.5 (May 1998): 49.

13. See Ji Jun, "Lun huigui qi dianying de huigui yishi" (On return consciousness in the films of the return period), *City Entertainment*, July 10–23, 1997, pp. 32–33. For a discussion of the state of the Hong Kong film industry during the period of the handover, see Berenice Reynaud, "High Noon in Hong Kong," *Film Comment* 33.4 (July/Aug. 1997): 20–23.

14. For the question of transnationalism in Chinese cinemas, see Sheldon H. Lu, ed., *Transnational Chinese Cinemas: Identity, Nationhood, Gender* (Honolulu: University of Hawaii Press, 1997).

15. On flexible accumulation and postmodernity, see David Harvey, *The Condition of Postmodernity* (Cambridge, Mass.: Basil Blackwell, 1990).

16. Ong, "On the Edge of Empires," p. 772. See also Aihwa Ong and Donald M. Nonini, eds., *Ungrounded Empires: The Cultural Politics of Modern Chinese Transnationalism* (New York: Routledge, 1997). For a series of reflections on the meaning of Chinese, see Tu Wei-ming, ed., *The Living Tree: The Changing Meaning of Being Chinese Today* (Stanford: Stanford University Press, 1994).

17. Jürgen Habermas, "The European Nation-State: On the Past and Future of Sovereignty and Citizenship," trans. Ciaran Cronin, *Public Culture* 10.2 (winter 1998): 397–416.

18. Arjun Appadurai, "Full Attachment," *Public Culture* 10.2 (winter 1998), p. 449.

19. Brief, useful information about the films and directors under discussion in this essay can be found in Fredric Dannen and Barry Long, *Hong Kong Babylon: An Insider's Guide to the Hollywood of the East* (New York: Hyperion, 1997). More comprehensive discussions can be found in Stephen Teo, *Hong Kong Cinema: The Extra Dimensions* (London: British Film Institute, 1997).

Chapter 6

1. For reviews of the film, see, for instance, Jose Arroyo, "Massive Attack," *Sight and Sight* 8.2 (Feb. 1998): 16–19; Laura Miller, "*Titanic*" (movie review), *Sight and Sound* 8.2 (Feb. 1998): 50–52.

2. Alan Riding, "Why *Titanic* Conquered the World," *New York Times*, Apr. 26, 1998, sec. 2, p. 28.

3. Ibid., p. 28.

4. See Zhang Weikuo, "Jiang Zemin de Haolaiwu qingjie" (Jiang Zemin's Hollywood complex), *Shijie ribao* (World journal), May 19, 1998, p. B5.

5. For the idea of the "global popular," see Simon During, "Popular Culture on a Global Scale: A Challenge for Cultural Studies?" *Critical Inquiry* 23.4 (summer 1997): 808–33.

6. For pertinent studies regarding issues of gender in action film, mostly in the Western context, see Yvonne Tasker, *Spectacular Bodies: Gender, Genre, and the Action Cinema* (London: Routledge, 1993); idem, *Working Girls: Gender and Sexuality in Popular Cinema* (London: Routledge, 1998).

7. This issue has been probed especially in view of collaborative efforts between John Woo and Chow Yun-fat. See, for instance, Tony Williams, "Space, Place, and Spectacle: The Crisis Cinema of John Woo," *Cinema Journal* 36.2 (winter 1997): 67–84; Tony Williams, "Interview with Chow Yun-fat," *Asian Cult Cinema* 19.1 (1998): 20–28; Anne T. Ciecko, "Transnational Action: John Woo, Hong Kong, Hollywood," in *Transnational Chinese Cinemas, Identity, Nationhood, Gender*, ed. Sheldon H. Lu (Honolulu: University of Hawaii Press, 1997), pp. 221–37; Julian Stringer, "'Your Tender Smiles Give Me Strength': Paradigms of Masculinity in John Woo's *A Better Tomorrow* and *The Killer*," *Screen* 38.1 (1997): 25–41; Jillian Sandell, "Reinventing Masculinity: The Spectacle of Male Intimacy in the Films of John Woo," *Film Quarterly* 49.4 (1996): 23–34.

8. Howard Hampton, "Venus, Armed: Brigitte Lin's Shanghai Gesture," *Film Comment* 32.5 (Sept.–Oct. 1996): 42–48; idem, "Once Upon a Time in Hong Kong: Tsui Hark and Ching Siu-tung," *Film Comment* 33.4 (July–Aug. 1997): 16–19, 24–27.

9. See the front cover of *Sight and Sound* 3.8 (Aug. 1993). See also Berenice Reynaud's article in the same issue: "Gong Li and the Glamour of the Chinese Star," pp. 12–15.

10. Reynaud, "Gong Li," p. 15.

11. See Berenice Reynaud's interview with Maggie Cheung, "Icon of Modernity," *Cineyama* 37 (1997): 33.

12. See the Web site devoted to her: http://mypage.direct.ca/b/bcheesma/infomui.htm (Friday, Mar. 27, 1998).

13. See David Eng, "Love at Last Site: Waiting for Oedipus in Stanley Kwan's *Rouge*," *Camera Obscura* 32 (Sept.–Jan. 1993–94): 75–101.

14. For an informative discussion in English of Ruan Lingyu's career, see Kristine Harris, "*The New Woman* Incident: Cinema, Scandal, and Spectacle in 1935 Shanghai," in *Transnational Chinese Cinemas*, pp. 277–302.

15. Maggie Cheung captured numerous awards at various Asian film festivals for her performance in the lead role in Peter Chan's film *Comrades, Almost a Love Story* (1996), which narrates a tale of the life and love of two mainlander immigrants in Hong Kong and New York City. She also appears with Gong Li and Jeremy Irons in Wayne Wang's film *The Chinese Box*, a film about Hong Kong during the handover period of 1997. For a report on Maggie Cheung in Wang's film, see "A Human Face for Hong Kong's Identity Crisis," *New York Times*, Apr. 19, 1998, sec. 2, pp. 29, 38.

16. Bey Logan, *Hong Kong Action Cinema* (London: Titan Books, 1995), p. 113.

17. The legend of loyalty among three sworn brothers—Liu Bei, Guan Yu, and Zhang Fei—as told in the classic Chinese novel *Romance of the Three Kingdoms*, has been widely popular in China, East Asia, and Southeast Asia for centuries. In the 1990s, the novel was made into a TV series, which was watched by hundreds of millions of viewers in Asia and the Chinese diaspora. Conversely, the celebration of sisterhood is frequently featured in modern Chinese films. See, for example, titles such as *Three Modern Women* (*San'ge modeng nüxing*, 1933) and *Three Beautiful Women* (*liren xing*, 1949). This triadic structure of sisterhood, explicitly representing China, Taiwan, and Hong Kong, is most evident in the film *Soong Sisters*, a coproduction between China and Hong Kong, released during the handover period in 1997. Soong Ailing (Michelle Yeoh), Soong Qingling (Maggie Cheung), and Soong Meiling (Vivian Wu) represent Hong Kong, China, and Taiwan respectively.

18. For brief discussions of this aspect of the film, see the entries on *The Heroic Trio* in Stefan Hammond and Mike Wilkins, *Sex and Zen and A Bullet in the Head* (New York: Fireside, 1996), 51–52; and Fredric Dannen and Barry Long, *Hong Kong Babylon* (New York: Hyperion, 1997), 243–44.

19. *Les Vampires* is on the National Film and Television Archive list of 360 film "classics" selected for regular screening at the Museum of the Moving Image, London.

20. For studies of broad issues of orientalism and the representation of the East in Hollywood discourse, see Gina Marchetti, *Romance and the "Yellow Peril": Race, Sex and Discursive Strategies in Hollywood Fiction* (Berkeley: University of California Press, 1993); Matthew Bernstein and Gaylyn Studlar, eds., *Visions of the East: Orientalism in Film* (New Brunswick, N.J.: Rutgers University Press, 1997).

21. Reynaud, "Icon of Modernity," p. 36.

22. See Berenice Reynaud's interview with Maggie Cheung, "I Can't Sell My Acting Like That," *Sight and Sound* 7.3 (Mar. 1997): 24.

23. For important seminal studies of this issue, see Steve Fore, "Golden Harvest Films and the Hong Kong Film Industry in the Realm of Globalization," *Velvet Light Trap* 34 (fall 1994): 40–58; idem, "Jackie Chan and the Cultural Dynamics of Global Entertainment," in *Transnational Chinese Cinemas*, pp. 239–62. See also Mark Gallagher, "Masculinity in Transition: Jackie Chan's Transcultural Star Text," *Velvet Light Trap* 39 (spring 1997): 23–41.

24. On this point, see Stuart Klawans's review of the film, "*Irma Vep*," in *The Nation*, May 19, 1997, pp. 35–36.

25. A close-up of Maggie Cheung graces the front cover of *Giant Robot* 9 (1997), which has the title of "The Return of Maggie Cheung." See the special section devoted to her, including the text of an interview with her by Martin Wong and Eric Nakamura, "Maggie Cheung: Actress," pp. 46–52. The text begins with this line, "After acting in 73 Hong Kong movies in a span of 13 years, Maggie Cheung is finally

attracting mainstream attention in the United States for her role in *Irma Vep*" (p. 47).

26. Steve Erickson, "Making a Connection Between the Cinema, Politics, and Real Life: An Interview with Olivier Assayas," *Cineaste* 22.4 (fall 1996), p. 8. For a look at Assayas's overall film work, see Kent Jones, "Tangled up in Blue: the Cinema of Oliver Assayas," *Film Comment* 32.1 (Jan.–Feb. 1996): 51–57. Assayas's 1997 documentary on famed Taiwanese director Hou Hsiao-hsien, which Assayas produced after falling in love with Maggie Cheung off screen in the aftermath of their joint venture, offers further evidence of his fascination with the possibilities of filmmaking that the pan-Chinese cinema has opened. For a review, see David Stratton, "*HHH*: Portrait of Hou Hsiao-hsien," *Variety*, Sept. 22, 1997, p. 58.

27. See Howard Hampton's review of *Irma Vep*, "Heroic Brio," *Artforum* 35.9 (May 1997): 19–20.

28. It is interesting to compare this final image of Maggie Cheung with the facially scarred character she plays in Wayne Wang's *Chinese Box* (1998), a heavy-handed allegory of the loss of Hong Kong, and with another icon, Gong Li, as a mainland whore, opposite Jeremy Irons as a dying Englishman.

29. *A Magazine*, an Asian-American journal, features Jackie Chan as the "last Hong Kong action hero" on the cover of its Oct./Nov. 1997 issue. See the feature article "Local Hero" on pp. 34–37 and 82–83. In the next issue (Dec. 1997/Jan. 1998), a "special year-end issue," the front cover of *A Magazine* presents a smiling picture of Michelle Yeoh wearing a leather jacket and riding a motorcycle, and has the following title: "Action Queen Michelle Yeoh is Bond for Glory." See the feature article, "Tiger Lily," on pp. 37–38. Michelle is also on the front cover of the final issue of *Hong Kong Film Connection* 5.2 (1997). See Clyde Gentry III's interview with her, "The Wrath of Yeoh," on pp. 5–11.

In the spring of 1997, Cinema Village in New York City organized a Michelle Yeoh retrospective titled "Michelle Yeoh: Queen of Action." Cinema Village also programmed "Festival Hong Kong '97–A Cinema in Transition," in the fall of 1997. Similar events were held around the world in 1997, the year of Hong Kong's return to China. The British Film Institute held the series "Once Upon a Time in Hong Kong" in June 1997. As a continuation of its legendary perennial fascination with Hong Kong, the Film Center at the School of the Art Institute in Chicago showed a series of Hong Kong action films in March 1998.

30. See Todd McCarthy's review of *Tomorrow Never Dies*, "'Tomorrow' Says Mañana to Romance," *Variety*, Dec. 15, 1997, p. 57.

31. Richard Corliss, "Everybody Say Yeoh!" *Time*, May 5, 1997, p. 36.

32. Jose Arroyo, "*Tomorrow Never Dies*," *Sight and Sound* 8.2 (Feb. 1998): 53.

33. See Jean Baudrillard, *The Gulf War Did Not Take Place*, trans. Paul Patton (Bloomington: Indiana University Press, 1995).

34. McCarthy, "'Tomorrow' Says Mañana," p. 57.

35. See Maxine Hong Kingston, *The Woman Warrior: Memoirs of a Girlhood Among Ghosts* (New York: Knopf, 1976; reprint, New York: Random House, 1989).

36. For an account of the making of the film and Disney's advertising strategies for its release, see Corie Brown and Laura Shapiro, "Woman Warrior," *Newsweek*, June 6, 1998, pp. 64–66. See also the June/July 1998 issue of *A Magazine*, a special issue on "Women Warriors: Asian American Sisters speak out about work, motherhood, feminism—and men." Included is an interview with Ming-na Wen, the voice of Mulan in the film, whose picture graces the front cover of the issue.

37. Predictably, McDonald's restaurants gave away figurines and toys based on characters in the film as a way to lure customers.

38. (Minneapolis: University of Minnesota Press, 1997).

Chapter 7

1. See *Jingpin gouwu zhinan* (Guide to shopping high-quality goods), June 27, 1996, p. A8.

2. Another oil painting of Chairman Mao during the Cultural Revolution was auctioned at the price of 6,050,000 yuan (U.S. $728,900) at an art fair of the Jiade Auction Company in Beijing. *Shijie ribao* (World journal), Oct. 25, 1997, p. A10.

3. Julia Andrews offers a comprehensive study of art in the People's Republic in her book *Painters and Politics in the People's Republic of China* (Berkeley: University of California Press, 1994).

4. David Harvey takes the "superimposition of different ontological worlds" as a major postmodern characteristic of advertisements as well as of paintings by artists such as David Salle. See Harvey, *The Condition of Postmodernity: An Inquiry into the Origins of Cultural Change* (Cambridge, Mass.: Blackwell, 1990), pp. 50, 64.

5. For a survey of this new wave of art, see *China's New Art, Post-1989* (Hong Kong: Hanart T Z Gallery, 1993), an exhibition catalog.

6. For an expression of such a sentiment in English, see Hou Hanru, "Towards an 'Un-official Art': De-ideologicalisation of China's Contemporary Art in the 1990s," *Third Text* 34 (spring 1996): 37–52.

7. Countless source materials, informative accounts, and criticisms of post-1989 Chinese avant-garde art exist, and it is impossible to enumerate them all. In addition to the pieces mentioned throughout my discussion of Chinese art, the following are useful items that I have consulted over the years: *China's New Art, Post-1989*; Jochen Noth, Wolfger Pöhlmann, and Kai Reschke, eds., *China Avant-Garde* (Berlin: Haus der Kulturen der Welt, 1993); (Chinese ed., *Zhongguo qianwei yishu* [Hong Kong: Oxford University Press, 1994]); *Avantguardes artístiques xineses* (Chinese avant-garde art) [exhibition catalog] (Barcelona, Spain: Departament de Cultura, Generalitat de Catalunya, 1995); Huang Du, "Xin jiaobu" (New steps), *Jiangsu huakan* (Jiangsu art monthly) 172.4 (Apr. 1995): 3–14; Nicholas Jose, "Next Wave

Art: The First Major Exhibition of Post-Tiananmen Vanguard Chinese Art Seen Outside the Mainland," *New Asia Review* (summer 1994): 18–24; Li Xianting et al., "Shenhua—xifang yu dongfang: di 45 jie Weinisi shuangnian zhan canzhan yishujia guilai tan ganxiang" (Myths—the West and China: thoughts of the participating artists upon returning from the 45th biennial Venice art exhibition), *Jinri xianfeng* (Avant-Garde Today) (Nov. 1994): 6–28; Andrew Solomon, "Their Irony, Humor (and Art) Can Save China," *New York Times Magazine*, Dec. 19, 1993, sec. 6, pp. 42–51, 66, 70–72; *Xiongshi meishu* (Lion art) 297 (Nov. 1995), special issue on China's avant-garde art, ed. Gao Minglu, pp. 10–89; Xiaoping Lin, "Those Parodic Images: A Glimpse of Contemporary Chinese Art," *Leonardo* 30.2 (1997): 113–22.

8. See the exhibition catalog, Gao Minglu, ed., *Inside Out: New Chinese Art* (Berkeley: University of California Press, 1998).

9. Wu Hung, *Transcience: Chinese Experimental Art at the End of the Twentieth Century* (Chicago: David and Alfred Smart Museum of Art, University of Chicago, 1999).

10. See Matei Calinescu, *Five Faces of Modernity: Modernism, Avant-Garde, Decadence, Kitsch, Postmodernism* (Durham, N.C.: Duke University Press, 1987), esp. pp. 275–79.

11. Li Xianting, "Major Trends in the Development of Contemporary Chinese Art," in *China's New Art, Post-1989*, p. xxii.

12. Yi Ying, "Choice and Opportunity: the Fate of Western Contemporary Art in China," in *China's New Art, Post-1989*, p. xliv.

13. Yuejin Wang, "Anxiety of Portraiture: Quest for/Questioning Ancestral Icons in Post-Mao China," in *Politics, Ideology, and Literary Discourse in Modern China: Theoretical Interventions and Cultural Critique*, eds. Liu Kang and Xiaobing Tang (Durham, N.C.: Duke University Press, 1993), p. 243.

14. See Andrew Solomon's report in *New York Times Magazine* and the magazine's front cover, which features a painting by Fang of a large figurehead that "yawns/howls" at the reader.

15. See Olga Kholmogorova, *Sots-Art* (Moscow: Galart, 1994); Igor Golomshtok, *Totalitarian Art: in the Soviet Union, the Third Reich, Fascist Italy, and the People's Republic of China* (New York: Icon Editions, 1990); Gao Minglu, "Meisu, quanli, gongfan: 'zhengzhi bopu' xianxiang" (Vulgarity, power, complicity: the "political pop" phenomenon), *Xiongshi meishu* (Lion art) 297 (Nov. 1995): 36–57.

16. See Gao Minglu, "Zou xiang hou xiandai zhuyi de sikao—zhi Ren Jian xin" (Reflections on approaching postmodernism—a letter to Ren Jian), *Ershi yi shiji* (Twenty-first century) (Aug. 1993): 60–68.

17. See Yuejin Wang, "Anxiety of Portraiture," pp. 243–72.

18. Much has been published in English and Chinese regarding Xu Bing's work. See, for instance, Janelle S. Taylor, "Non-Sense in Context: Xu Bing's Art and Its Publics," *Public Culture* 5.2 (winter 1993): 316–27; Charles Stone, "Xu Bing and the Printed Word," *Public Culture* 6.2 (winter 1994): 407–10; Wu Hung, "A 'Ghost

Rebellion': Notes on Xu Bing's 'Nonsense Writing' and Other Works," *Public Culture* 6.2 (winter 1994): 411–18; Tamara Hamlish, "Prestidigitation: A Reply to Charles Stone," *Public Culture* 6.2 (winter 1994): 419–23; Benjamin Lee, "Going Public," *Public Culture* 5.2 (winter 1993): 165–78; Wang Keping, "Xu Bing yu wenhua dongwu" (Xu Bing and cultural animals), *Jiushi niandai* (Nineties) (Mar. 1995): 6–9; Shinoda Takatoshi, ed., *The Library of Babel: Characters/Books/Media* (Tokyo: NTT InterCommunication Center, 1998).

19. Stanley Abe offers an informative study of how the West has received Xu Bing's *A Book from the Sky* in his essay "No Questions, No Answers: China and *A Book from the Sky*," *boundary 2* 25.3 (fall 1998): 169–92.

20. I refer to Fredric Jameson's canonical text, "Third-World Literature in the Era of Multinational Capitalism," *Social Text* 15 (fall 1986): 65–88.

21. Fredric Jameson, *Postmodernism, or, the Cultural Logic of Late Capitalism* (Durham, N.C.: Duke University Press, 1993), p. 9.

22. For an overview of some aspects of the Chinese avant-garde, See Huang Du, "Xin jiaobu," pp. 3–14. Other pertinent exhibition catalogs and informative materials include *Mund auf, Augen zu: Beijing-Berlin* (Open your mouth, close your eyes: Beijing-Berlin), German and Chinese bilingual catalog of an exhibition held in the Exhibition Hall of the Capital Normal University in Beijing, Nov. 10–14, 1995 (Berlin: Oktoberdruck, 1996); *New Asia Art Show—1995, China, Korea, Japan*, catalog of an exhibition held in Osaka, Japan, July 20–Aug. 3, 1995 (Tokyo: Committee of International Contemporary Art, 1995); catalog of Zhu Jinshi's exhibition *Impermanence* (*Wuchang*), held in Beijing, June 29–July 4, 1996, and Berlin, September 1996 (Berlin: Georg Kolbe Museum, 1996).

23. Irving Sandler, *Art of the Postmodern Era: From the Late 1960s to the Early 1990s* (New York: HarperCollins, 1996), p. 11.

24. Jameson, *Postmodernism*, p. 162.

25. An extensive discussion of this piece by Yin is given in Lin Xiaoping, "Beijing: Yin Xiuzhen's *The Ruined Capital*," *Third Text* 48 (autumn 1999): 45–54. One of the largest exhibitions of avant-garde art by Chinese women was held in Bonn, Germany, June 10–Oct. 4, 1998. See the trilingual exhibition catalog (German, English, Chinese), Chris Werner, Qiu Ping, and Marianne Pitzen, eds., *Half of Sky: Contemporary Chinese Women Artists* (Bonn: Frauen Museum, 1998). See also Melissa Chiu, "Thread, Concrete and Ice: Women's Installation Art in China," *Art AsiaPacific* 20 (1998): 50–57.

26. For a discussion of the "ethnography paradigm," see Hal Foster, "The Artist as Ethnographer," chapter 6, in *The Return of the Real: The Avant-Garde at the End of the Century* (Cambridge, Mass.: MIT Press, 1996), pp. 171–204.

27. See Feng Boyi, "Dangdai yishu xitong chule shenmo wenti: yishujia Xu Bing fangtan lu" (What went wrong with the contemporary art system: an interview with artist Xu Bing), *Dongfang* (Orient) 5 (1996): 65–68.

28. See Jameson, "Utopianism After the End of Utopia," chapter 6, in *Postmodernism*, pp. 154–80.

Chapter 8

1. For a discussion of the appropriation of politics as a cultural resource in Chinese film, see Chen Xiaoming, "The Mysterious Other: Postpolitics in Chinese Film," *boundary 2* 24.3 (fall 1997): 123–41.
2. See *Qin Yufen—Xing Yin/Walking Sound*, exhibition catalog (Saarbrucken: Stadtgallerie, 1998).
3. Ibid., p. 30.
4. For more information and commentary about Zhu's art, see *Zhu Jinshi—Kong de kong jian/Space of Emptiness*, exhibition catalog (Saarbrucken: Stadtgallerie, 1998).
5. Michael Sullivan, *Art and Artists of Twentieth-Century China* (Berkeley: University of California Press, 1996), p. 189.
6. Herve Odermatt, "Preface," in *Ju Ming: Taichi Installation, Place Vendome—Paris*, bilingual exhibition catalog (French and English) (Paris: Comite Vendome, 1997), p. 9.
7. Diana Lin, "Paris Plaza Hosts Show of Ju Ming's Sculptures," *Free China Journal*, Dec. 19, 1997, p. 5.
8. Alice Yang, *Why Asia? Contemporary Asian and Asian American Art*, eds. Jonathan Hay and Mimi Young (New York: New York University Press, 1998), pp. 129–46.
9. Gyan Prakash, "Writing Post-Orientalist Histories of the Third World: Perspectives from Indian Historiography," *Comparative Studies in Society and History* 32.2 (Apr. 1990), p. 406. For other relevant discussions of postorientalism in the Asian context, see John D. Rogers, "Post-Orientalism and the Interpretation of Premodern and Modern Political Identities: The Case of Sri Lanka," *Journal of Asian Studies* 53.1 (1994): 10–23; Aijaz Ahmed, *In Theory: Classes, Nations, Literatures* (London: Verso, 1992), esp. chapter 5, "*Orientalism* and After: Ambivalence and Metropolitan Location in the Work of Edward Said," pp. 159–219.
10. Grady T. Turner, "The Accidental Ambassador," *Art in America* (Mar. 1997): 82.
11. Peter Schjeldhal, "Everywhere Man: Tseng Kwong Chi," *Village Voice*, Nov. 19, 1996, p. 77.
12. Barbara Pollack, "West Goes East: A New Generation of Asian Artists Has Become a Force in the International Art Market," *ARTnews*, Mar. 1997, p. 86.
13. For a humorous, satirical show about the erection of Asian manhood in diaspora, see the short report on a modern dance by Slant—"Big Dicks/Asian Men," *Village Voice*, Feb. 20, 1996, pullout sec., p. 1. On stage, the naked Asian actors are strapped on props of huge phalluses.

14. Barry Schwabsky, "Tao and Physics: The Art of Cai Guo Qiang," *Artforum* (summer 1997): 121.

15. See the VCD (video cassette disc) *No Destruction No Construction: Cai Guo Qiang Bombing Taiwan Museum of Art* (Taipei: Taiwan Museum of Art, 1998). I thank Cai for giving me this VCD.

16. See the catalog for the traveling exhibition, *Half a Century of Chinese Woodblock Prints: From the Communist Revolution to the Open-Door Policy and Beyond, 1945–1998*, eds. Iris Wachs and Chang Tsong-zung (Ein Harod: Museum of Art, 1999).

17. Wang Youshen, quoted in Valerie C. Doran, ed., *China's New Art, Post-1989* (Hong Kong: Hanart T Z Gallery, 1993), p. 60.

18. *Mattress Factory Visitor's Guide: Installations by Asian Artists in Residence*, Oct. 31, 1999, to June 30, 2000.

19. See the section on Gu Dexin in Doran, *China's New Art, Post-1989*, pp. 152–55.

20. Madeleine Grynstejn, "CI: 99/00," in *Carnegie International 1999/2000, November 6, 1999–March 26, 2000*, exhibition catalog, ed. David S. Frankel (Pittsburgh: Carnegie Museum of Art, 1999), p. 99.

Chapter 9

1. Chandra Mukerji and Michael Schudson, eds., *Rethinking Popular Culture: Contemporary Perspectives in Cultural Studies* (Berkeley: University of California Press, 1991), p. 3.

2. Ibid., pp. 3–4.

3. See Leo Ou-fan Lee and Andrew J. Nathan, "The Beginnings of Mass Culture: Journalism and Fiction in the Late Ch'ing and Beyond," in *Popular Culture in Late Imperial China*, eds. David Johnson, Andrew J. Nathan, and Evelyn S. Rawski (Berkeley: University of California Press, 1985), pp. 360–95. See also Perry Link, *Mandarin Ducks and Butterflies: Popular Fiction in Early Twentieth-Century Chinese Cities* (Berkeley: University of California Press, 1981).

4. See Chang-tai Hung, *War and Popular Culture: Resistance in Modern China, 1937–1945* (Berkeley: University of California Press, 1994).

5. The very theme of Chen Kaige's first film *Yellow Earth* (*Huangtu di*), which signalled to the outside world the emergence of China's New Wave Cinema, represented an attempt to transform folk songs into revolutionary songs in the Yanan era. The film aspired to be a critical reflection on founding moments of cultural engineering in the communist movement.

6. See Bonnie S. McDougall, ed., *Popular Chinese Literature and Performing Arts in the People's Republic of China, 1949–1970* (Berkeley: University of California Press, 1984).

7. See Paul Clark, *Chinese Cinema: Culture and Politics Since 1949* (Cambridge, Eng.: Cambridge University Press, 1987). Clark also points out that the tension between China's two revolutionary cultural traditions or "factions"—Shanghai and Yanan—or in other words, urban and rural, explains much of the cultural policy and political struggle within the Party's cultural apparatus.

8. For an informative account of popular culture in post-Mao China preceding the period of my main focus, see Perry Link, Richard Madsen, and Paul G. Pickowicz, eds., *Unofficial China: Popular Culture and Thought in the People's Republic* (Boulder, Colo.: Westview Press, 1989).

9. For an informative, critical review of the influence of "Gangtai" (Hong Kong and Taiwan) popular culture on mainland culture, see Thomas B. Gold, "Go With Your Feelings: Hong Kong and Taiwan Popular Culture in Greater China," *China Quarterly* 136 (Dec. 1993): 907–25.

10. Liu Xiaobo, "Wang su li zou he wu linghun" (Going pop and without souls) *China Spring* 120 (May 1993): 28.

11. See Zhang Wentian, "Pops yinyue zhiye" (A night of pop music), *People's Daily*, Apr. 19, 1993, p. 7, overseas edition.

12. See Zhao Yuxiu, "Huaju *Qingren* zhengyi duo" (The play *Lover* aroused many controversies), *People's Daily*, Apr. 21, 1993, p. 7, overseas edition; Tong Daoming, "Daoyan yanli chu *Qingren*" (The *Lover* in the eyes of the directors), *People's Daily*, Apr. 21, 1993, p. 7, overseas edition.

13. See Zhu Qingxi, "Zhang Xianliang xiahai" (Zhang Xianliang turns to business), *People's Daily*, Mar. 12, 1993, p. 7, overseas edition.

14. See my "When Mimosa Blossoms: the Ideology of the Self in Modern Chinese Literature," *Journal of Chinese Language Teachers Association* 28.3 (Oct. 1993): 1–16; Yenna Wu, "The Interweaving of Sex and Politics in Zhang Xianliang's *Half of Man Is Woman*," *Journal of Chinese Language Teachers Association* 27.1/2 (Feb./May 1992): 1–27.

15. Although compromising with the omnipresent force of popular culture, some artists still attempt to preserve a measure of creative independence. For instance, Chen Kaige and Tian Zhuangzhuang, famed directors of China's New Cinema, claimed that their new films did not belong to China's mainstream even as they sent them in 1993 to compete at the Cannes Film Festival. Chen's *Farewell, My Concubine* markedly departs from the avant-gardist, experimental, difficult style of some of his earlier films. *Farewell, My Concubine* won the Golden Palm Award, perhaps testifying to its immense appeal to the "populace" of a different sort. See Liu Xiaobo's interview with Chen Kaige, "Chen Kaige: bu rentong 'zan ye shi ge suren'" (Chen Kaige: I do not consider myself a pop man), *Shijie ribao* (*World journal*), May 11, 1993, p. A10; Liu's interview with Tian Zhuangzhuang, "Tian Zhuangzhuang: pai dianying, zhi pai ziji guanxin de wenti" (Tian Zhuangzhuang: in making films, I only deal with the issues that interest me), *Shijie ribao* (World journal), May 17, 1993, p. A10.

16. For a collaborative book project on this issue, see Sheldon Hsiao-peng Lu, ed., *Transnational Chinese Cinemas: Identity, Nationhood, Gender* (Honolulu: University of Hawaii Press, 1997).

17. Rey Chow, "Listening Otherwise, Music Miniaturized: A Different Type of Question about Revolution," *Discourse* 13.1 (fall–winter 1990–91): 135.

18. See Andrew F. Jones, *Like a Knife: Ideology and Genre in Contemporary Chinese Popular Music* (Ithaca, N.Y.: East Asian Program, Cornell University, 1992), p. 46. In his book, Jones makes a further distinction between "popular music" (*tongsu yinyue*) and "rock music" (*yaogun yinyue*). The relation of popular music to the public sphere has more of a negotiated and participatory nature. Rock music is the product of a *subcultural* group and represents more of an opposition, *cultural opposition*, not necessarily political opposition, to the dominant culture. For a more up-to-date and comprehensive study, see Nimrod Bernoviz, *China's New Voices: Politics, Ethnicity, and Gender in Popular Music Culture on the Mainland, 1978–1997* (Ph.D. diss., University of Pittsburgh, 1997).

19. See Sheryl WuDunn, "The Word From China's Kerouac: The Communists Are Uncool," *New York Times Book Review*, Jan. 10, 1993, pp. 3, 23.

20. Wang Meng, "Duobi chonggao" (Avoiding the sublime), *Dushu* (Reading) 1 (1993): 11.

21. For a study of the world of Wang Shuo's fiction, see Geremie R. Barmé, "Wang Shuo and *Liumang* ('Hooligan') Culture," *Australian Journal of Chinese Affairs* 28 (July 1992): 23–64. Barmé paints a broad picture of Chinese culture in the late twentieth century in his book *In the Red: On Contemporary Chinese Culture* (New York: Columbia University Press, 1999). The appearance of the new Chinese bourgeoisie as more of a "vagabond" (*liumang*) bourgeoisie rather than a respectable middle class, along with other important issues in contemporary China, is studied in Michael Dutton, ed., *Streetlife China* (Cambridge, Eng.: Cambridge University Press, 1998).

22. Yu Bing, "Wang Shuo, ya wenhua, ji qita" (Wang Shuo, subculture, and so forth), *Wenyi lilun yu piping* (Literary theory and criticism) (June 1992): 85.

23. Wang Shuo, *Wan'er de jiushi xintiao* (Playing with heartbeat), in *Wang Shuo wenji* (Works of Wang Shuo) (Beijing: Huayi chubanshe, 1992), 2: 247.

24. Wang Shuo, *Qianwan bie ba wo dang ren* (No Man's Land), in *Wang Shuo wenji*, 4: 374–75.

25. M. M. Bakhtin's discussion of the interrelationship between low, subversive, "novelistic" discourse, and high, official, "epic" discourse seems to bear relevance to this aspect of the cultural scene in contemporary China. See M. M. Bakhtin, *The Dialogic Imagination*, ed. Michael Holquist, trans. Caryl Emerson and Michael Holquist (Austin: University of Texas Press, 1981). The limitation of Bakhtin's vision is that he did not live to see the other side of the phenomenon, namely what was described by the Frankfurt School as the "culture industry" now unfolding rapidly in China.

26. Liu Xiaobo, "Wang su li zou he wu linghun," p. 30.

27. Jianying Zha, "Yearnings: Public Culture in the Post-Tiananmen Era," *Transitions: An International Review* 57 (1992): 38. For a more comprehensive account of Beijing's popular culture, see Zha's book *China Pop: How Soap Operas, Tabloids, and Bestsellers Are Transforming a Culture* (New York: New Press, 1995).

28. Zha, "Yearnings," p. 38.

29. Ibid., p. 29.

30. Some critics point out that the rapid production of new texts by individual authors for financial gain seriously harms artistic quality. See Lao Min, "Wang Shuo, ni shifou gai yangyang shen le?" (Wang Shuo, isn't it time for you to take a break?), *People's Daily*, Apr. 22, 1993, p. 7, overseas edition.

31. See Liu Xiaobo, "Wang su li zou he wu linghun," p. 28. Liu participated in the Democracy Movement of 1989 and became a leader during its last phase. He was arrested for his role in the movement, but released later. In the mid-1980s he was well known for his radical critique of traditional Chinese culture and thought. He has more recently turned his attention to popular culture, realizing its increasing importance as a new force.

32. Jianying Zha, "Beijing Subnotebooks," *Public Culture* 6.2 (winter 1994): 397. See also Zha, *China Pop*.

33. Zha, "Beijing Subnotebooks," p. 399.

34. For Habermas's critique of mass media and consumer culture, see especially parts 5 and 6 of *The Structural Transformation of the Public Sphere* (Cambridge, Mass.: MIT Press, 1992), pp. 141–235.

35. See Sheldon Hsiao-peng Lu, *From Historicity to Fictionality: The Chinese Poetics of Narrative* (Stanford: Stanford University Press, 1994).

36. Raymond Williams, *Problems in Materialism and Culture: Selected Essays* (London: Verso, 1980), p. 38.

37. Ibid., p. 41.

38. Although a significant number of Chinese intellectuals have positioned themselves as progressives during certain periods of modern Chinese history, their discourse has tended to be hegemonic because it pretends to monopolize truth. At this juncture, Paul A. Bové's observations about the Western humanist intellectual tradition may also apply to the case of Chinese intellectuals: "even the most revisionist, adversarial, and oppositional humanistic intellectuals—no matter what their avowed ideologies—operate within a network of discourses, institutions, and desires that, as we can see especially well in the most sublime and powerful of critical projects, always reproduce themselves in essentially antidemocratic forms and practices." See *Intellectuals in Power: A Genealogy of Critical Humanism* (New York: Columbia University Press, 1986), pp. 1–2.

39. Rob Wilson and Arif Dirlik, "Introduction: Asia/Pacific as Space of Cultural Production," *boundary 2* 21.1 (spring 1994): 11. This entire special issue is worth reading because it bears on the problems under discussion.

Chapter 10

1. For statistical figures and estimates, see Zhu Kuoliang, "Yijiu jiuliu nian dianshi ju chuangzuo shitai" (The state of television drama production in 1996), *Dianying yishu* (Film art) 5 (Sept. 1996): 67–74; Xie Xizhang, "1995: Zhongguo dianshi ju huigu" (1995: Chinese television drama in retrospect), *Dangdai dianying* (Contemporary film) 4 (July 1996): 80–89.

2. See Hong Shi, "Zhiboqi Zhongguo dianshi ju de shijian he guannian" (The practice and concepts of Chinese television drama in the period of direct telecast), *Dangdai dianying* (Contemporary film) 1 (Jan. 1994): 87–92; Guo Zhenzhi, *Zhongguo dianshi shi* (History of Chinese television) (Beijing: Zhongguo renmin daxue chubanshe, 1991).

3. Judith Marlene, "The World of Chinese Television," in *China at the Crossroads*, ed. Donald Altschiller (New York: H. W. Wilson, 1994), p. 207.

4. For a discussion of this drama and Chinese television in general, see James Lull, *China Turned on: Television, Reform, and Resistance* (London: Routledge, 1991).

5. Xie Mian and Zhang Yiwu, *Da zhuanxing: hou xinshiqi wenhua yanjiu* (The great transition: studies in the culture of the post-New period) (Harbin: Heilongjiang jiaoyu chubanshe, 1995), pp. 345–92.

6. For clarification of the concept, see Nick Browne, "The Political Economy of the Television (Super) Text," in *Television: The Critical View*, 4th ed., ed. Horace Newcomb (New York: Oxford University Press, 1987), pp. 585–99. Given the latest developments in digital television and computerized image making, the television "supertext" is perhaps evolving into an electronic "hypertext," which may further expand the experience and definition of television viewing.

7. Xie and Zhang, *Da zhuanxing*, pp. 362–63, trans. Sheldon H. Lu. For relevant discussions in English, see Lisa Rofel, "The Melodrama of National Identity in Post-Tiananmen China," in *To Be Continued . . . Soap Operas Around the World*, ed. Robert C. Allen (London: Routledge, 1995), pp. 301–20; Jianying Zha, "Yearnings," in *China Pop: How Soap Operas, Tabloids, and Bestsellers Are Transforming a Culture* (New York: The New Press, 1995), pp. 25–53.

8. For a new study of global television and global soap opera, see Chris Barker, *Global Television: An Introduction* (Oxford: Blackwell, 1997).

9. Robert C. Allen, ed., *To Be Continued*, p. 6.

10. See, for example, Douglas Kellner, "TV, Ideology, and Emancipatory Popular Culture," in *Television: The Critical View*, 4th ed., pp. 471–503; Todd Gitlin, "Prime Time Ideology: The Hegemonic Process in Television Entertainment," in *Television: The Critical View*, pp. 507–32.

11. For assertions of the importance of ethnographic research, see Ien Ang, "Culture and Communication: Toward an Ethnographic Critique of Media Communication in the Transnational Media System," in *What is Cultural Studies? A Reader*, ed. John Storey (London: Arnold, 1996), pp. 237–54; James Lull, *Inside*

Family Viewing: Ethnographic Research on Television Audiences (London: Routledge, 1990).

12. Douglas Kellner cautions us that any overly hasty ethnographic research may result in various fetishisms—the "fetishism of struggle," the "fetishism of audience pleasure"—and warns of the danger to "celebrate resistance *per se* without distinguishing between types and forms of resistance." Kellner, *Media Culture: Cultural Studies, Identity and Politics between the Modern and the Postmodern* (London: Routledge, 1995), pp. 38–39.

13. Jane Feuer, *Seeing through the Eighties: Television and Reaganism* (Durham, N.C.: Duke University Press, 1995), p. 151.

14. Ibid., p. 4. For John Fiske's statements, see his *Television Culture* (London: Routledge, 1987); *Understanding Popular Culture* (London: Unwin Hyman, 1989). Fiske highlights the ability of the viewer to "make do" with popular cultural texts that he/she confronts in everyday life (by way of the theory of Michel de Certeau).

15. Xie Xizhang and Wu Di, "Wenhua toushi: tongsu ju de xingsheng yuanyin ji jiazhi quxiang" (A cultural perspective: the reasons for the flourish of popular dramas and their axiological choices), *Dangdai dianying* (Contemporary film) 6 (Nov. 1994): 79–84.

16. Needless to say, transnational and cross-cultural interactions have always happened in the history of world cinema. Witness Hollywood's appropriation of foreign directors from the silent era (German, Swedish, etc.) all the way to its current flirtation with Hong Kong directors. Hollywood has also featured the "exotic" Western woman in a Chinese setting from early on, for example Marlene Dietrich in *Shanghai Express*, directed by Joseph von Sternberg. As the reader will see, I describe "transnational politics" in a rather specific historical and social context. I emphasize the strategy of China's TV industry to target China's *domestic* audience by using the resources and opportunities afforded by the transnational flow of images, commodities, and capital in the last decade of the twentieth century. For a historical overview of aspects of transnationalism in Chinese filmic discourse, see Sheldon H. Lu, ed., "Introduction," in *Transnational Chinese Cinemas: Identity, Nationhood, Gender* (Honolulu: University of Hawaii Press, 1997), pp. 1–31. For a study of transnationalism in modern China, see Aihwa Ong and Donald M. Nonini, eds., *Ungrounded Empires: The Cultural Politics of Modern Chinese Transnationalism* (New York: Routledge, 1997).

17. See Fredric Jameson, "Introduction: Beyond Landscape," in *The Geopolitical Aesthetic: Cinema and Space in the World System* (Bloomington: Indiana University Press, 1992), pp. 1–6. Here Jameson outlines his concepts of the geopolitical unconscious, allegory, space, and representability, and offers them as solutions to the form-problems of the postmodern era.

18. Heuristic as it may be, Jameson's theory of national allegory has been the subject of reconsideration and debate. See Ahmad Aijaz, "Jameson's Rhetoric of Otherness and the 'National Allegory,'" *Social Text* (fall 1987): 3–25; Madhava

Prasad, "On the Question of a Theory of (Third) World Literature," *Social Text* 31/32 (spring 1992): 57–83. The article is also reprinted in Anne McClintock, Aamir Mufti, and Ella Shohat, eds., *Dangerous Liaisons* (Minneapolis: University of Minnesota Press, 1997), pp. 141–62.

19. See Rey Chow, *Primitive Passions: Visuality, Sexuality, Ethnography, and Contemporary Chinese Cinema* (New York: Columbia University Press, 1995).

20. The drama aroused heated debates about itself in China. For pertinent discussions in English, see Geremie R. Barmé, "To Screw Foreigners Is Patriotic: China's Avant-Garde Nationalists," *China Journal* 34 (July 1995): 209–34; Pamela Yatsko, "Inside Looking Out: Books and TV Dramas about Life Overseas Reflect Existing Chinese Biases," *Far Eastern Economic Review*, Apr. 11, 1996, pp. 58–59; Mayfair Mei-hui Yang, "Mass Media and Transnational Subjectivity in Shanghai: Notes on (Re)Cosmopolitanism in a Chinese Metropolis," in *Ungrounded Empires*, pp. 287–319. Lydia H. Liu, "What's Happened to Ideology: Transnationalism, Postsocialism, and the Study of Global Media Culture," in *Working Papers in Asian/Pacific Studies* (Durham, N.C.: Asian/Pacific Studies Institute, Duke University, 1998).

21. For an insider's account of the drama's financing, see Peng Xin'er, "Fighting Their Way to New York—Exposing a Secret" (*Da dao Niuyue qu—neimu jiemi*), *Dazhong dianying* (Popular cinema) 6 (1993): 10–15. For a story about Robert Denbo, who played David McCarthy in the drama, see Fang Jin, "Yige zai Beijing de Niuyue ren—yanggemen'er 'Dawei' " (A New Yorker in Beijing—foreign brother 'David'), *Dazhong dianying* (Popular cinema) 12 (1993): 14. For a report on Wang Ji, who played the role of Ah Chun, see Zhao Wentao, "Wang Ji yiran liunian Beijing" (Wang Ji still loves Beijing), *Dazhong dianying* 12 (1993): 16.

22. Xie Mian and Zhang Yiwu, *Da zhuanxing*, pp. 380–86.

23. Zha Xiduo (Jianying Zha), "Youce yanjing li de xiyang jing—Beijing ren de Niuyue meng" (Western scenes through tinted glasses—the New York dream of Beijingers), *Jiushi niandai* (The nineties) (Feb. 1994): 16–17.

24. Wu Di, "Beijing tongsu lianxu ju chuangzuo jianxi: cong Kewang dao Beijing ren zai Niuyue" (A brief analysis of the creation of Beijing popular serials: from *Yearnings* to *Beijingers in New York*), *Beijing dianying xueyuan xuebao* (Journal of Beijing Film Academy) 1 (1994): 146–63.

25. *Shanghainese in Tokyo* tells the story of Chinese students in Tokyo. To some critics, this drama is more truthful and realistic than *Beijingers*, but not as shocking and powerful. See Yu Haiyi, "Guanyu dianshi lianxu ju *Shanghairen zai Dongjing* de taolun zungshu" (An overview of the discussions regarding the television serial *Shanghainese in Tokyo*), *Shehui kexue* (Social sciences) (Shanghai) 4 (Apr. 1996): 76–77.

26. See He Ma, "Chuangche mofang he shi xiu" (Is there an end to repetition and imitation), *Zhongguo yinmu* (China screen) (Aug. 1997): 40.

27. For an informative study of the symbolism and politics of the white woman

in contemporary China, see Louisa Schein, "The Consumption of Color and the Politics of White Skin in Post-Mao China," *Social Text* 41 (winter 1994): 141–64.

28. Exoticizing and eroticizing the ethnic other is also a recurrent feature in China's representation of its ethnic minorities, whose women are supposed to dance and sing as well as foreign women. For a parallel study, see Dru C. Gladney, "Representing Nationality in China: Refiguring Majority/Minority Identities," *Journal of Asian Studies* 53.1 (Feb. 1994): 92–123.

29. See the ranking list of the ten best-selling Chinese-made films in 1995 in *Dianying yishu* (Film art) 3 (May 1996): 4. For an inside look at the film's shooting in Russia, see Long Luowan, "Zouchu guomen de dianying ren" (The filmmakers who stepped out of the Chinese border), *Dazhong dianying* (Popular cinema) 12 (1994): 12–13.

30. Bob Young and Rachel DeWoskin, "Foreign Babe in Beijing," *Transpacific* 67 (1996): 14. For a look at the drama's international cast, see Ru Dai, "*Yangniu'er zai Beijing* zhong de waiguo yanyuanmen" (The foreign actresses and actors in *Foreign Babes in Beijing*), *Dazhong dianying* (Popular cinema) 7 (1995): 20–21.

31. Young and DeWoskin, "Foreign Babe," p. 16.

32. A white, female, American graduate student in Asian Studies at the University of Pittsburgh told me about an incident she experienced while doing her own ethnographic research in Harbin during the summer *Russian Girls in Harbin* aired. A Chinese woman apparently mistook her for another "Russian girl" in the area and spat on her. The event is a telling example in contemporary China of the media's effects on cultural stereotypes and misunderstandings.

33. Frantz Fanon, *Black Skin, White Masks*, trans. Charles Lam Markmann (New York: Grove Press, 1967), p. 63.

34. Mary Ann Doane, *Femmes Fatales: Feminism, Film Theory, Psychoanalysis* (London: Routledge, 1991), p. 217.

35. See Gina Marchetti, *Romance and the "Yellow Peril": Race, Sex, and Discursive Strategies in Hollywood Fiction* (Berkeley: University of California Press, 1993).

36. For studies on images of Chinese masculinity, see Steve Fore, "Jackie Chan and the Cultural Dynamics of Global Entertainment," in *Transnational Chinese Cinemas*, pp. 239–62; Anne T. Ciecko, "Transnational Action: John Woo, Hong Kong, Hollywood," in *Transnational Chinese Cinemas*, pp. 221–37; Mark Gallagher, "Masculinity in Translation: Jackie Chan's Transcultural Star Text," *Velvet Light Trap* 39 (spring 1997): 23–41; Tony Williams, "Space, Place, and Spectacle: The Crisis Cinema of John Woo," *Cinema Journal* 36.2 (winter 1997): 67–84.

37. Louisa Schein has analyzed this issue closely. See Schein, "Consumption of Color."

38. See Arif Dirlik, *After the Revolution: Waking to Global Capitalism* (Hanover, N.H.: Wesleyan University Press, 1994); idem, "The Postcolonial Aura: Third-World Criticism in the Age of Global Capitalism," *Critical Inquiry* 20.2 (winter 1994): 328–56.

39. Caren Kaplan and Inderpal Grewal, "Transnational Feminist Cultural Studies: Beyond the Marxism/Poststructuralism/Feminism Divides," *positions: east asia cultures critique* 2.2 (fall 1994): 439. Also see Kaplan and Grewal, *Scattered Hegemonies: Postmodernity and Transnational Feminist Practices* (Minneapolis: University of Minnesota Press, 1994).

40. Some interpret soap operas that feature interracial romance between Chinese men and Western women as expressions of neonationalist sentiments. For example, see Barmé, "To Screw Foreigners"; Keith B. Richburg, "Embracing 'Foreign Babes': China Wary of Cross-Cultural Dating, but Delights in TV Show," *Washington Post*, July 21, 1996, pp. A1, A27; Wendell Yee, "Foreign Babes and *Post* Chauvinism," *Transpacific* 67 (1996): 8. For a different response, which defends this kind of drama, see Rachel DeWoskin, "Foreign Babes," at http:// www.iht.com/iht/edlet/let0821.html (Aug. 21, 1996).

Chapter 11

1. See Xie Mian and Zhang Yiwu, *Da zhuanxing: hou xinshiqi wenhua yanjiu* (The great transition: studies in the culture of the post-New period) (Harbin: Heilongjiang jiaoyu chubanshe, 1995), pp. 29–45.

2. Ibid., pp. 46–73. See also Li Zehou, *Zhongguo xiandai sixiang shi lun* (Studies in modern Chinese thought) (Beijing: Dongfang chubanshe, 1987).

3. For an account of China's experimental fiction, see Jing Wang's introduction in *China's Avant-Garde Fiction: An Anthology*, ed. Jing Wang (Durham, N.C.: Duke University Press, 1998), pp. 1–14.

4. See, for instance, Ma Xiangwu, ed., *Dongfang shenghuo liu: xin xieshi xiaoshuo jing xuan* (Streams of life in the East: selection of the best new realist fiction) (Beijing: renmin daxue chubanshe, 1993).

5. For an informative analysis of Chinese literature in the 1990s, see Xie and Zhang, *Da zhuanxing*, pp. 93–341.

6. Zhang Yiwu, "Postmodernism and Chinese Novels of the Nineties," *boundary 2* 24.3 (fall 1997), pp. 257–58.

7. Earlier, Jia Pingwa had also written a novella with the same title. It won the Award of Outstanding Writing (*youxiu zuopin jiang*) from the literary journal *Renmin wenxue* (People's literature) in 1991. Certain themes in the novella—the appearance of four suns in the sky and fascination with Shao Yong's theory of numbers—are further developed in the novel. See "Feidu" in Jia Pingwa, *Jia Pingwa huojiang zhongpian xiaoshuo ji* (A collection of award-winning novellas by Jia Pingwa), ed. Xuan Zi (Xi'an: Xibei daxue chubanshe, 1992), pp. 589–647.

8. Wang Xiaoming et al., "Jingshen feixu de biaozhi—man tan '*Feidu* xianxiang'" (A sign of spiritual ruins—a discussion of the "*Ruined Capital* phenomenon"), *Zuojia* (The writer) 2 (1994): 68–69.

9. Chen Zhongshi, *Bai lu yuan* (The white deer plains) (Beijing: renmin wenxue chubanshe, 1993).

10. *Dangdai zuojia pinglun* (Review of contemporary writers) 6 (1993) devotes a special section to the novel. See pp. 13–59. For other brief overviews of different responses to the novel, see Zha Xiduo (Jianying Zha), "Tutui tutui de xiao lao nanren jiezuo: ye shuo *Feidu* re" (The masterpiece of a rustic, decadent, little old man—on the *Ruined Capital* heat), *Jiushi niandai* (The nineties) (Oct. 1993): 14–15; Luo Fu, "Cong *Feidu* dao *Muchuang*: Dalu wentan jinkuang you gan" (From *Ruined Capital* to *Tomb Bed*: impressions of the current literary scene on the mainland), *Jiushi niandai* (The nineties) (Feb. 1994): 18–19. For a report on the artistic and literary scene during the early 1990s, which included such popular writers as Jia Pingwa and Wang Shuo, from the perspective of two American journalists, see Nicholas D. Kristof and Sheryl Wudunn, "A Room of One's Own," in *China Wakes: The Struggle for the Soul of a Rising Power* (New York: Random House, 1994), chapter 10, pp. 276–304.

11. Wang Xiaoming et al., "Jingshen feixu de biaozhi," pp. 68–75; Xu Ming, "Yanjiu zhishi fenzi wenhua de yansu wenben" (A serious text for the investigation of intellectual culture), *Xiaoshuo pinglun* (Fiction criticism) 1 (1996): 20–22, 27.

12. Lu Hsun, *A Brief History of Chinese Fiction*, trans. Yang Hsien-yi and Gladys Yang (Peking: Foreign Languages Press, 1964), p. 232.

13. Jia Pingwa, *Feidu* (Ruined capital) (Beijing: Beijing chubanshe, 1993), p. 519. For a study of the interweaving of history and fiction in the Chinese narrative tradition, see Sheldon H. Lu, *From Historicity to Fictionality: The Chinese Poetics of Narrative* (Stanford: Stanford University Press, 1994).

14. Jia Pingwa and Han Luhua, "Guanyu xiaoshuo chuangzuo de dawen" (Questions and answers about the writing of fiction), *Dangdai zuojia pinglun* 1 (1993): 34.

15. Ibid., p. 39.

16. Jia Pingwa, "Da Chen Zeshun xiansheng wen" (A reply to the questions of Mr. Chen Zeshun), *Xiaoshuo pinglun* (Fiction criticism) 1 (1996): 12.

17. Zhong Benkang, "Shijimo: shengcun de jiaolü—*Feidu* de zhuti yishi" (Fin de siècle: the anxiety of existence—the main theme of *Ruined Capital*), *Dangdai zuojia pinglun* (Review of contemporary writers) 6 (1993): 48.

18. Jia, *Feidu*, p. 3.

19. Ibid., pp. 3–4.

20. Jia Pingwa, *Jingxucun sanye* (Scattered leaves of the village of tranquillity and emptiness) (Xi'an: Shaanxi renmin jiaoyu chubanshe, 1990), p. 4.

21. See Jia, *Feidu*, pp. 97–98.

22. Ibid., p. 80.

23. Lei Da, "Xinling de zhengzha: *Feidu* bianxi" (The struggle of the soul: an analysis of *Ruined Capital*), *Dangdai zuojia pinglun* 6 (1993): 28.

24. Jia and Han, "Guanyu xiaoshuo chuangzuo," pp. 38–39.

25. Jia, *Feidu*, p. 6.
26. Quoted in Zhong, "Shijimo," p. 46.
27. Dang Shengyuan, "Shuo bu jin de *Feidu*—Jia Pingwa wenhua xintai tanpian" (No words can exhaust *Ruined Capital*—random remarks on the cultural mentality of Jia Pingwa), *Xiaoshuo pinglun* (Fiction criticism) 1 (1996): 24–25.
28. Jia, *Feidu*, p. 527.
29. Ibid., pp. 230–32.
30. Ibid., p. 516.
31. Ibid., p. 55.
32. Ibid., p. 348.
33. Jia, "Da Chen Zeshun xiansheng wen," p. 12.
34. Jenaro Talens, "Writing against Simulacrum: The Place of Literature and Literary Theory in the Electronic Age," *boundary 2* 22.1 (spring 1995): 20.
35. Li Xianshou, *Saoren: yige dushi de qing'ai gushi* (The Romantic: a love story in a metropolis) (Beijing: wenhua yishu chubanshe, 1995).
36. Shu Tong, *Shisan bukao* (Being independent) (Beijing: Zuojia chubanshe, 1996).
37. Hence, it is perhaps overhasty to call the novel "post-allegorical," as a Chinese critic reminds us, for the text about the ancient capital could be a proper allegory of fin de siècle China as a whole. See Kuang Xinnian, "Cong *Feidu* dao *Baiye*" (From *Ruined Capital* to *White Night*), *Xiaoshuo pinglun* (Fiction criticism), 1 (1996): 15–19, esp. pp. 17, 19.
38. Wang Anyi, *Jishi yu xugou: Shanghai de gushi* (Reality and fiction: a Shanghai story) (Taipei: Maitian, 1996). See Wang Der-wei's introduction, pp. 7–25.
39. Wang Weiming, *Yuwang de chengshi* (A city of desire) (Shanghai: Wenhui chubanshe, 1996).
40. For a comprehensive study of the subject, see Yingjin Zhang, *The City in Modern Chinese Literature and Film: Configurations of Space, Time, and Gender* (Stanford: Stanford University Press, 1996).
41. See ibid., pp. 90–116.
42. Jia Pingwa also talks in his essays about the ancient character of the city and its residents' love of antiquity, but with more piety and praise than gloom and doom. See Jia Pingwa, *Shuohua* (Talks) (Xi'an: Shaanxi renmin chubanshe, 1995), pp. 95–102.
43. It is interesting to note that U.S. president Bill Clinton stopped first in Xi'an during his historic nine-day trip to China in the summer of 1998. His hosts gave him an "emperor's welcome" at the southern gate of the city wall. Thus, the president of the United States must also come to Xi'an to pay tribute to Chinese culture.
44. Georg Simmel, "The Metropolis and Mental Life," in *The Sociology of Georg Simmel*, trans. and ed. Kurt H. Wolff (Glencoe, Ill.: Free Press, 1950), pp. 409–24; Walter Benjamin, "On Some Motifs in Baudelaire," in *Illuminations*, trans. Harry Zohn (New York: Schocken Books, 1969), pp. 155–200.

45. Mian Mian, *Tang* (Sugar) (Taipei: Shengzhi, 2000). Wei Hui, *Weihui zuopin quanbian* (Complete works of Wei Hui) (Guilin: Lijiang chubanshe, 2000).

Postscript

1. Maurice Meisner, *The Deng Xiaoping Era: An Inquiry into the Fate of Chinese Socialism, 1978–1994* (New York: Hill and Wang, 1996), pp. 300, 327.
2. See, for instance, Erik Eckholm, "Big Smuggling Ring with a Wide Reach Scandalizes China," *New York Times*, Jan. 22, 2000, pp. A1, A6; Elizabeth Rosenthal, "Beijing Abuzz Over Smuggling Scandal," *New York Times*, Jan. 27, 2000, p. A12.
3. Perry Anderson, *The Origins of Postmodernity* (London: Verso, 1998), pp. 122–23. Incidentally, a picture from the explosion series by Chinese artist Cai Guo-Qiang graces the front cover of Anderson's book.
4. Andrew G. Walder and Jean C. Oi, "Property Rights in the Chinese Economy: Contours of the Process of Change," in *Property Rights and Economic Reform in China*, eds. Jean C. Oi and Andrew Walder (Stanford: Stanford University Press, 1999), pp. 7–10.

Index

Abbas, Ackbar, 138
academy, the: function, 27, 40, 78, 84–86; public sphere, 43–45; Western critical theory, 34, 61
action films (Hong Kong), 123–33, 137, 235, 265
Adorno, Theodor, 59
advertisements, 215–16, 222, 255
agency, 43, 57, 63, 69
Ai Jing, 107
Alia, 90, 95(fig.), 97(fig.)
alienation, 33–34, 58, 252
allegory: anti-allegory, 241; national allegory, 157–58, 160, 236–38, 241, 298–99nn17,18; post-allegory, 240–41, 303n37; *Ruined Capital* as, 245, 250; soap opera as, 234; urban culture, 250
alterity, 192, 236, 300n28; diaspora, 166–72; soap opera, 225–34
Althusser, Louis, 5, 6
Anderson, Perry, 265–66, 304n3
Appadurai, Arjun, 121
Arac, Jonathan, 9, 42, 45
Argentina, 113–15
art exhibits: *Asian Art Exhibition* (Pittsburgh), 178, 189; Berlin-China (1966), 168–69; Capital Normal University (China), 168; *Carnegie International Triennial Exhibition 1999/2000* (Pittsburgh), 180, 192; China/Avant-Garde Exhibition (Beijing), 143, 145; China's New Art: Post-1989 (Hong Kong), 145; Chinese Avant-garde Art (Barcelona), 145; Chinese Women Artists (Bonn; 1998), 291n25; The Great Exhibition of Chinese Art, 283n2; *Half of a Century of Chinese Woodblock Prints* (University of Pittsburgh), 189; Inside Out-New Chinese Art, 145–46; New Chinese Art Exhibition (Long Island), 185; Shanghai Biennial, 143; University of Oregon, 145; Venice Biennial Art Exhibition, 145–46, 182–83
art films, 91–92, 125, 126, 130–32, 134, 219, 236
art. *See* avant-garde art
artist as ethnographer, 166, 219
artists: Cai Guo-Qiang, 146, 174, 185–89, 304n3; Chen Zhen, 174, 180–83; Fang Lijun, 146, 147, 149; Feng Mengbo, 146, 153–54; Gu Dexin, 159, 175, 189–91; Ju Ming, 174, 176–77; Qin Yufen, 174, 175–76, 178; Qiu Zhijie, 164, 165; Tseng, Joseph (Tseng Kwong Chi), 183–85; Wang Guangyi, 146, 147, 149–51; Wang Jinsong, 146, 148–49; Wang Ziwei, 184–85; Xu Bing, 155–56, 166, 169–72, 174, 180, 290–91n18; Yin Xiuzhen, 160–63; Yu Youhan, 146, 150, 152; Zhang Huan, 160; Zhang Peili, 159, 161, 164; Zhang Xiaogang, 154; Zhu Jinshi, 166–69, 172, 176
Asia Society (New York), 145–46
Asian financial crisis, 4, 55, 56–57, 71–74
Asian masculinity. *See* masculinity
Asian modernity. *See* modernity/modernism
Asian values (*yazhou jiazhi*), 38, 40–43, 49, 72, 277n22
Assayas, Olivier, 129–32, 288n26
avant-garde art, 20, 141–92, 223, 289–90n7; alterity, 166–72; body art, 159, 160; categories, 146–47; "Chineseness," 173–92; conceptual art, 159; cultural identity, 141–72; diaspora, 143, 158, 166–72; experimen-

305

tal art, 20; installation art, 145, 161–65, 175–78, 180–85, 189–92; literati painting, 142; mixed media, 156, 159, 171; "New Measurement" group, 159; official reaction to, 147, 158; parody, 178–79; performance art, 145, 166, 170–72, 180, 186–89; political pop, 144–58, 174, 185; postmodernism, 141–72; process art, 159; satire, 153–54; video art, 159; Western tradition, 146–47; woodblock prints, 189
avant-garde art movement (*qianwei yishu*), 145

baishi (unofficial history), 209
Bakhtin, M. M., 206, 295–96n25
bar culture, 24–25
Barmé, George R., 295n21
Batman/Batman Returns, 128, 131–32
Baudelaire, Charles, 258
Baudrillard, Jean, 18, 22, 101, 135, 217
"beauty women writers" (*meinü zuojia*), 258–59
Beijing, 1, 231–34, 254, 264, 266, 283n2, 292n4; Central Business District (CBD), 25; Chaoyang District, 24–25; China/Avant-Garde Exhibition, 143, 145; *Foreign Babes in Beijing*, 231–34; Haidian District, 25; international community, 24–26; portrayal of in *Yearnings*, 207–8; shopping malls, 142; *Turandot* performance, 23; Western fast food business, 24–26, 67, 184–85
Beijing Film Academy, 34
Beijing Film Studio, 228, 231
Beijing School (*jing pai*), 257, 258
Beijing Television Art Center, 222
Beijing Television Station (Beijing TV), 214, 222
Beijing University, 12, 34–35
Beijingers in New York (*Beijingren zai Niuyue*), 200, 215, 222–24, 227, 299–300n25
Belgrade: embassy bombing, 74, 80, 183, 263–64
Benjamin, Walter, 258
Berlin Film Festival(s), 127, 221
Berlin, Isaiah, 82
Bertolucci, Bernardo, 174
Beverley, John, 272–73n9
Bhabha, Homi, 62, 270n11
billboards. *See* commodity signs
Bloch, Ernst, 67

Blow Up, 114–15
body art, 159, 160
Bolshevik Revolution, 51–52, 225
Bond, James, 21–22, 134–36
bopu dashi (pop masters), 144, 147
Bové, Paul, 276n44, 296n38
Britain, 104–6, 113, 134–36, 283n2
British Cultural Studies, 216
Brosnan, Pierce, 21, 134, 135(fig.), 136
Buddhism, 35, 250
Buenos Aires, 113–14
Burton, Tim, 128
bushi (supplemental history), 209

Cahoone, Lawrence E., 64
Cai Guo-Qiang, 146, 174, 185–89; *Cultural Melting Bath*, 185; *Dragon: Explosion on Issey Miyake Clothing*, 187, 188(fig.), 189; "explosion" series, 186–89, 304n3; *Project for Extraterrestrials* series, 186, 187(fig.)
calligraphy, 142, 161, 164–66, 171–72
Can Xue, 240
Cannes Film Festival(s), 108, 112, 294–95n15
Cao Guilin: *Beijingers in New York* (novel), 200
Cao Zheng, 283n1
capitalism: Asian paradigm, 64, 82, 263; bureaucratic capitalism, 263; capital accumulation, 93, 94–98; entrepreneurs (*geti hu*), 10; gender politics, 94–98; history, 4, 69; in India, 277n16; modernity, 62, 69, 77, 102
Castel, Lou, 129
CBS (Columbia Broadcasting System), 265
CCP. *See* Chinese Communist Party (CCP)
CCTV. *See* China Central Television
Cen Fan, 105
censorship, 91, 143, 201, 236, 248, 259
Central Symphony Orchestra (Beijing), 199
Centro d'Art Santa Monica (Barcelona), 161
Certeau, Michel de, 298n14
Chan, Charlie, 265
Chan, Jackie, 22, 123, 130, 133, 137, 265, 288n29
Chan, Peter (Chan Ho San), 22, 108, 111, 286n15
Chang, Eileen, 256
Chang, Silvia, 116
Chaoyang District (Beijing), 24–25
Chen Chong (Joan Chen), 16, 174

INDEX

Chen Kaige: Asian masculinity, 236; early films, 155; *Farewell My Concubine*, 174, 200, 294–95n15; New Chinese Cinema, 20, 125, 144; self-ethnographic films, 34, 92, 219; *Yellow Earth*, 293n5

Chen Lai, 279n7

Chen Xiaoming, 46, 273n10

Chen Yinke, 40, 78

Chen Zhen, 174, 180–83; *Daily Incantations*, 180, 181(fig.), 182; *Dialogue Between Nations/Roundtable*, 182; *Fifty Strokes*, 182, 183

Chen Zhongshi: *The White Deer Plains*, 243

Cheung, Leslie, 112, 113(fig.)

Cheung, Maggie, 22, 106, 109(fig.), 119(fig.), 287nn17,25, 288nn28; as action film star, 123–33, 138; *Actress*, 131; *Comrades, Almost a Love Story*, 108–12, 286n15; *Heroic Trio/Executioners*, 127–28, 131; *Irma Vep*, 129(fig.); *Song of the Exile*, 116–17; *The Soong Sisters*, 106, 287n17; *Supercop*, 133

Cheung Yuen-ting, 106

Chiang Kai-shek, 106

China Central Television (CCTV): American programs on, 100–101, 214, 226, 236; *Beijingers in New York*, 200, 215, 222–24, 227, 299–300n25; *Foreign Babes in Beijing*, 231–34; *Oshin* (Japanese soap opera), 214; *Russian Girls in Harbin*, 226–28, 229(fig.), 234, 300n32

China, People's Republic of (PRC): coloniality, 60–61, 261, 262; embassy bombing (Belgrade), 74, 80, 183, 263–64; founding, 68, 204, 257; Four Modernizations, 52, 53–55, 272n5; Great Leap Forward, 52, 54, 214; international relations, 79–80, 187, 225–30; late twentieth century, 1–28, 261–67; Ministry of Culture, 32; 100-Days reform movement, 51; participation in global capitalism, 13, 14, 46, 120, 220, 262; popular culture and official discourse, 43–44, 54, 196, 198, 206–8, 210–11, 220, 232; property ownership, 267; Reform and Openness Era (*gaige kaifang*), 54–55, 57; Sino-U.S. relations, 21, 79–80, 187; WTO membership, 3, 72, 74, 264–65, 267

China/Avant-Garde Exhibition (Beijing), 143, 145

China/Chineseness: avant-garde art, 171–92; beyond Chineseness, 189–92; cultural production, 120–21, 174; parody, 178–89; signifiers, 175–78. *See also* Orientalism

Chinese Academy of Social Sciences, 82, 83

Chinese Box, The, 286n15, 288n28

Chinese Communist Party (CCP), 9, 230; cultural apparatus, 294n7; founding, 51–52, 264; funding for *Beijingers in New York*, 222; orthodox ideology, 208–9, 210, 211, 217; party congresses, 3, 71, 122; reaction to popular culture, 206, 207–8

Chinese cultural foundations (*zhongti xiyong*), 51

Chinese Marxism. *See* Maoism

Chinese national studies (*guoxue*), 2, 82; content, 38–40, 78–80; globalization, 78–80, 84; postmodernism, 65–66, 76

Chinese New Wave Cinema. *See* film industry (China)

Ching Siu-tung, 123

Chow, Rey, 201, 282n5

Chow Yun-fat, 22, 124, 286n7

chun wenxue (pure literature), 240, 240–41

Chung, Cherie, 125

Chung, Danny, 115

cinema. *See* film industry

cinema verité, 124, 132

Cinema Village (New York), 125, 288n29

citizenship: Hong Kong, 106, 111, 113; nationality, 104–21; recontextualization, 108, 116–21, 267

Clark, Paul, 294n7

classical novels, 244–45, 248–50, 251

Clinton, Bill, 303–4n43

Cloth Tiger Book Series, 259

cognitive mapping, 43, 47, 85, 218

cold war/post–cold war, 7–8, 21–22, 79–80, 144; allegory and soap opera, 234; geopolitical imaginary, 134–36, 137

colonialism, 5, 60–61, 62, 79

Columbia Broadcasting System (CBS), 265

comedy (*xiju*), 214

commercialization, 11, 12, 36, 157; culture, 14, 15, 35, 80, 199, 211–12; writers as celebrities, 253–54

commercials, 215–16, 222

commodification: art, 142, 147, 149, 179; commodity-fetishism, 144, 157–58; culture, 86, 138, 153, 157–58, 211, 289n37; of Mao Zedong, 202

commodity signs, 1, 10, 11, 218, 240, 254

communisim, 263
Communist Party. *See* Chinese Communist Party
Communist Revolution, 68, 105, 257, 264; official culture, 204; popular culture usage, 196–97, 201; in Western theory, 5
communitarianism, 72
computer(s): as artistic medium, 172
Comrades, Almost a Love Story (*Tian mimi*), 108–12, 116, 120, 121, 286n15
conceptual art, 159
Confucian capitalism, 4, 49, 279n8; mini-dragons, 14, 56, 57, 77; modernity, 55–57, 76–78; weaknesses, 72–73
Confucianism, 35, 56, 65, 96; future, 48–49; legacy, 76–78; Neo-Confucianism, 76–77; New Confucianism (*xin ruxue*), 38; Post-Confucianism, 278n6; revival of, 40–43, 69, 77; scholar officials, 32, 206, 209–10, 220
conservatism/neo-conservatism, 75–78, 281n26
consumerism, 70, 86, 141–42, 146, 153; consumer society, 35, 81, 142; cultural production, 198, 275n30; growth, 46, 80, 147, 211–12; self-identity, 95, 100
contra-modernity (*fankang xiandaixing*), 58
contradictions: Mao's theory on, 6, 16–17
corruption, 252, 263
Cortazar, Julio, 114–15
critical negation, 45, 276n44
cross-cultural relations, 180, 265; popular culture, 225–30, 298n16; soap opera, 225–30, 233–38, 300n28; transnational communication, 169–72, 182
Cui Jian, 201
Cui Zhiyuan, 83
cultural consumption (*wenhua xiaofei*), 141, 142
cultural fastfood (*wenhua kuaican*), 141
cultural fever (*wenhua re*), 241
cultural hegemony, 79, 123, 179, 195, 206, 210, 296n38
cultural identity, 41, 42, 120, 143, 183, 192; American postmodernism, 157–58; avant-garde art, 141–72; diaspora, 166–72; globalization, 56, 143, 225; national allegory, 157–58; national self-imaging, 218–19, 224; postmodernism, 49–50, 141–72; soap opera, 225

cultural phenomenon (*wenhua xianxiang*), 201
cultural production, 80, 198; Chineseness, 120–21, 174; globalization, 61, 74, 102, 157–58, 184, 200, 211–12, 237, 267; Xibei, 242–43
cultural reflection (*wenhua fansi*), 33, 75–76, 197, 241, 243
Cultural Revolution: continued revolution (*jixu geming*), 52; cultural production under, 102, 214; disillusionment, 59, 204; icons, 142, 149, 153–54, 202; impact on intellectuals, 31, 33–34, 102; life under, 181, 207; reflection in literature, 258; rhetoric, 5–6, 52, 75–76, 186–87; satire, 149, 153–54, 186–87; subjectivity under, 33–34, 102; Western critical theory, 5–7, 16
cultural studies (China). *See* Chinese national studies
cultural studies (U.S.), 5–7, 9, 16, 216–17
culture: consumerism, 141–42; counter-culture (*fan wenhua*), 204; elitism/elite culture (*jingying wenhua*), 35, 80–81, 206, 212, 217, 256; emergent, 210–11, 217, 256; folk culture, 196–97, 201, 293n5; guardians of culture (*wen*), 32; intercultural relationships, 169–72; official, 204–5, 210; residual, 210–11; rural/urban, 196–97, 250, 294n7; "sign system," 197, 198; subculture (*ya wenhua*), 204; visual/televisuality, 17–23, 99, 100–102, 217; women warriors, 125, 137. *See also* commercialization; commodification; cross-cultural relations; globalism; popular culture; postmodernism
culture industry, 198, 219, 296n25, 298n16
cyberspace. *See* internet
cynical realism: *wanshi xianshi zhuyi*, 146

Dalai Lama, 106
daoting tushuo (rumor and gossip), 209–10
David and Alfred Smart Museum of Art (Chicago), 146
dazhong wenhua. *See* popular culture
Debord, Guy, 18
deconstructionism, 64
Democracy Movement, 43, 264; aftermath, 2, 37, 78, 143, 149; background, 32, 76, 198, 296n31; discrediting, 208; *Farewell China*, 116–21; Goddess of Democracy statue,

118–19; in Hong Kong, 111–12; impact on intellectuals, 11, 34; popular music usage, 203; transnational media coverage, 2, 18
Denbo, Robert, 299n21
Dench, Judi, 134
Deng Lijun, 109, 110, 111, 120–21, 197–98
Deng Xiaoping, 3, 12, 52, 101, 114, 283n2. *See also* economics
Derridean philosophy, 68
Desperation, 282n3
detective and crime drama (*jingfei ju*), 214
deterriorialization, 108, 109, 120–21, 238
DeWoskin, Rachel, 231, 234
dianshi ju (television drama), 214
diaspora, 104–21; alterity, 166–72; avant-garde art, 143, 158, 166–72; cultural identity, 166–72, 183, 267; displacement, 108–10, 113–20, 183–85, 200; "Greater China," 44; intercultural relationships, 169–72; masculinity discourse, 221–25; modernity discourse, 17, 39–40, 56, 76–77; national affiliation, 108, 116–21, 183, 267; popular culture, 197–98, 200; post-ism debate, 39–40; postmodernist discourse, 17, 40–41; public sphere, 44, 259. *See also* cultural production
diaspora (films): *Comrades, Almost a Love Story,* 108–12; *Farewell, China,* 116–21; *Full Moon in New York,* 116–21; *Happy Together,* 112–15
Dietrich, Marlene, 298n16
difference/différance, 64, 68
Dirlik, Arif, 12, 15, 47, 56, 77
disan shijie piping (third world criticism), 78–79
displacement, 108–10, 113–20, 183–85, 200
Doane, Mary Ann, 234–35
Dongdaqiao xiejie (Beijing), 24
Doyle, Christopher, 112, 115
Duara, Prasenjit, 50–51
During, Simon, 19
Dynasty, 101, 214, 226, 236

Eagleton, Terry, 15–16
"East Is Red, The" (*Dongfang hong*), 197
economics/Deng reform era, 2–4, 8–10, 14, 64, 207, 217, 254; Asian financial crisis, 4, 55, 56–57, 71–74; capital accumulation, 89, 90, 93, 94–98; central planning, 54; development policies, 61–63; disillusionment, 202, 263; Fordism/post-Fordism, 2, 10, 14, 26, 67, 102; globalization, 71–86; libidinal economy, 93–98, 219–25, 235–38; "one country two systems" (*Yiguo liangzhi*), 107, 114; Reform and Openness era (*gaige kaifang*), 54–55, 57; television, 100–102; township enterprises *xiangzhen qiye,* 54–55
economism, 9–10, 102
elitism/elite culture (*jingying wenhua*), 35, 80–81, 206, 212, 217, 256
Engels, Friedrich, 62
Enlightenment, The, 15, 16, 41–42, 58, 59, 68; post-Enlightenment, 50, 64, 69. *See also* humanism (Marxist); Western culture
entrepreneurs (*geti hu*), 10
environment, 160–61, 166
Ermo, 89–102, 236; capital accumulation, 93–98; comparison to *The Story of Qiu Ju,* 92–93; financial backing, 292n7; gender politics, 94–98; libidinal economy, 93–98, 219–25; spectatorship, 98–100; synopsis, 90–91; televisuality, 93–94, 99, 100–102
eroticism, 248, 252–55
Escobar, Arturo, 61–62
Eternity (*Wanshi liufang*), 284n3
ethnicity, 17, 83, 116, 183
ethnography/self-ethnography, 34, 92, 166, 216, 219, 298n12
Eurocentrism, 15, 41, 42, 49, 50, 64, 67, 69. *See also* Western culture
Executioners, 123, 127–28
exoticism, 200, 225–28, 231–36, 258–59, 300n28
experimental art, 20
experimental fiction (*shiyan xiaoshuo*), 240
"explosion" series: (Cai Guo-Qiang), 186–89, 304n3

Fa Mulan, 138
Falungong, 262–63
fan wenhua (counter-culture), 204
Fang Lijun, 146, 147, 149; *Series II, No. 6* (*Di erzu, di liufu*), 149(fig.)
Fang Lizhi, 198, 273n14
fankang xiandaixing (contra-modernity), 58
Fanon, Frantz, 234–35
Farewell China (*Ai zai biexiang de jijie*), 116–21
fashion industry, 35, 187–89

fast food business, 24–26, 67, 184–85
Featherstone, Mike, 10
feizao ju. *See* soap opera
feminism. *See* women
Feng Gong, 229, 230
Feng Mengbo, 146; *The Video Endgame Series*, 153(fig.), 154
Feng Menglong, 175
Feng Xiaogang, 222
Feng Xiaoning, 105, 114
Festival Hong Kong (Cinema Village), 288n29
fetishism, 126, 144, 157–58, 298n12
Feuer, Jane, 216–17
Feuillade, Louis, 131
fictionality, 244–52
Fiedler, Leslie, 206
Fifth Generation film directors, 89, 91, 92, 125, 126, 242, 281n1
film industry (China), 19, 21, 105–6, 213; art films, 91–92, 125, 126, 130–32, 134, 219, 236; globalization, 92, 200, 298n16; New Wave Cinema, 20, 34, 61, 89, 92, 144–45, 242, 293n5, 294–95n15; films: *Ermo*, 89–102, 236; *In the Heat of the Sun*, 16, 258; *The Red River Valley*, 21, 105–6, 114; *A Wild Kiss to Russia*, 228, 230
film industry (France), 129–32
film industry (Hollywood), 20, 21, 106, 112, 130, 264–98n16; anti-China content, 80; Asian action films, 124, 125, 137–38; for Asian markets, 124, 125, 138, 174; Asian stereotypes, 235; global hegemony, 123, 130; films: *Kundun*, 21, 80, 106, 136, 174; *Mulan*, 23, 137–38, 289n37; *Red Corner, The*, 21, 80, 106, 136, 174, 265; *Seven Years in Tibet*, 21, 80, 106, 136, 174
film industry (Hong Kong), 22, 108–21; action films, 123–33, 134; art films, 126, 134; Asian masculinity, 235; globalization, 123–24, 130–31; Hong Kong New Wave, 123, 134; return of Hong Kong to China, 106–7; films: *Comrades, Almost a Love Story*, 108–12, 116, 120, 121, 286n15; *Farewell China*, 116–21; *Full Moon in New York*, 116–21; *Happy Together*, 112–15, 116; *The Soong Sisters*, 106, 116, 287n17
film industry (Soviet Union): *Lenin in 1918*, 230
Fiske, John, 18, 217, 298n14
fleurs du mal, les (flowers of evil), 191

folk culture, 196–97, 201, 293n5
foot massage, 92
Fordism/post-Fordism. *See* economics
Foreign Babes in Beijing (*Yangniu zai Beijing*), 231–34
foreigners: exoticization, 225–28, 231–36, 258–59, 300n28
Foucault, Michel, 37, 84
Four Modernizations, 52–55, 272n5
Frankfurt School, 83, 84, 206, 216, 296n25
Frank's Place (Beijing), 24
Freud, Sigmund, 34
Fu Manchu, 130, 265
fuhao xue (semiotics/semiology), 245–46, 250, 251
Fukuyama, Francis, 2
Full Moon in New York (*Ren zai Niuyue*), 116–21

gaige kaifang (Reform and Openness), 54–55, 57
Gan Yang, 83
Gao Xingjian, 259
Gaobie geming (*Farewell Revolution*), 58
Gates, Bill, 266
GATT (General Agreement on Tariffs and Trade), 72
Ge Fei, 240
Ge Zhijun (actor), 93
gender/gender politics, 83, 90, 93; capital accumulation, 94–98; international relations, 230; popular culture, 221; reconfiguration of, 136–37. *See also* masculinity; women
General Agreement on Tariffs and Trade (GATT), 72
Geng Jianyi, 146
Georg Kolbe Museum (Berlin), 169
Gere, Richard, 21, 106
geti hu (individual entrepreneurs), 10
Ghenghis Khan, 185
global capitalism: Asian financial crisis, 4, 55–57, 71–74; and China, 13, 14, 46, 120, 220–21, 237, 262; cultural production, 211, 237; expansion, 2, 12, 53, 70, 123, 200, 237; hegemony, 46–47, 66–67; impact, 44, 69, 73–74, 80–81, 84, 237; intellectuals, 69, 80–81, 223; Marxist theory, 83; mini-dragons, 14, 56, 57, 77; modernity/postmodernism, 56, 57, 62–63, 66, 77

global village, 89–102, 266
globalism: "China" signatures, 91–94; cultural imaginary, 4–11, 46, 100–102, 159, 182, 211–12; global popular, 123
globalization: Asian modernity discourse, 55–57; Chinese national agenda, 219, 298n16; cultural nationalism, 71–86; geopolitical remapping, 18, 133–37, 143, 186, 218; Hong Kong action films, 122–38; "humanistic spirit," 80–81; impact on daily lives, 182; intercultural relations, 172; localization, 18, 23–28; national identity, 216–19; national studies, 78–80, 84; paradox of, 89, 102; postmodernism, 12–13, 80–81; self-reflexivity, 122–38; soap opera, 216; televisuality, 100–102; visual culture, 19–20, 216. *See also* transnationalism
Goddess of Democracy statue, 118–19
Golden Bear Award, 221
Golden Harvest films, 22, 123, 130
Golden Horse Award (Taiwan), 108
Golden Palm Award, 294–95n15
Gong Li, 125–26, 286n15, 288n28
gonggong kongjian (public space), 44, 274n29
gongju lixing (instrumental rationality), 58–60, 69–70
gongye dongya (industrial East Asia), 279n7
gossip/gossip columns, 209–10
Gramsci, Antonio, 44, 67
grand récit (grand narrative), 35
Great Leap Forward, 52, 54, 214
Great Wall of China, 186
Greater China. *See* diaspora
Grynstejn, Madeleine, 191–92
Gu Dexin, 159, 175; *10–30–1999*, 189, 190, 191(fig.)
Gu Mu, 274n21
Gu Wenda, 283n2
Guggenheim Art Museum (Soho), 185
Guide to Shopping High Quality Goods (Beijing), 141–42
guoxue. *See* Chinese national studies

Habermas, Jürgen, 59, 121, 209, 275n30
hai pai (Shanghai School), 256–59
Haidian District (Beijing), 25
Hall, Arsenio, 265
Hall, David, 64–65
Hall, Stuart, 203
Han Xin, 283n2

Hanart T Z Gallery (Hong Kong), 144, 145, 283n2
"Happy Together," 115
Happy Together (*Chunguang zhaxie*), 112–16
Harbin, 225–30
Hard Rock Cafe, 24
Harvey, David, 289n4
Hashimoto, Ryotaro, 72
Heidegger, Martin, 34
Heroic Trio/Executioner, 123, 124, 127–28, 131
Hiroshima, 186
historical reflection (*lishi fansi*), 33, 75–76, 243
historiography (*zhengshi*), 209–10
Hitchcock, Alfred, 132
Hitler, Adolf, 190
Holden, William, 112
Hollywood. *See* film industry (Hollywood)
homosexuality, 112–15, 200. *See also* sexuality
Hong Kong, 17, 44, 104–21, 287n17; action films, 122–38, 265, 288n29; citizenship, 106, 111, 113; colonial status, 60, 135–36; Confucianism, 77; cross-cultural relations, 265; Democracy Movement, 111–12; displacement, 108–9, 115; economic growth, 56, 72–73, 119–20; "one country two systems" (*Yiguo liangzhi*), 107, 114; postmodernism debate, 47; return to mainland, 10, 21–22, 104–8, 138, 283nn1,2
Hong Kong Film Awards, 108
Hong lou meng, 244–46, 248–50, 251, 254
"hooligans," 204, 258
Horkheimer, Max, 59
Hou Hsaio-hsien, 288n26
hou xin shiqi. *See* post–New Era
hou yuyan (post-allegorical writing), 240–41, 303n37
Houston, Whitney, 150
houxue dashi (post-masters), 39
houxue (post-ism), 2, 38–42
hsiao-shuo (*xiaoshuo*; small stories), 65, 209
Hu, Kelly, 265
Hu Xu, 214
Hua Guofeng, 9–10
Hua Mulan, 138
Hui, Ann, 116, 123, 134
human rights, 74, 232
humanism (Marxist), 45, 47; Chinese humanities (*wen shi zhe*), 38; enlightenment discourse, 31–36, 38, 68, 75, 81, 83–

humanism (Marxist) (*continued*)
 84; "humanistic spirit" (*renwen jingshen*), 38–39, 42, 80–83, 243, 253; post-ism, 2, 38–42; subjectivity, 39, 42, 217
humanism (Western). *See* Western culture
Hung, Sammo, 22, 134, 265
Huntington, Samuel, 182
Hutcheon, Linda, 60

ICA. *See* International Confucian Association
iconography: Cultural Revolution, 149; global capitalism, 184; Mao Zedong, 142, 144, 146, 149–53, 157, 183–89, 202, 289n2; Mickey Mouse, 184, 185; Orientalism, 126; pandas, 180; Western commercial products, 149, 150, 153
identity: alterity, 166–72, 178, 192; consumerism, 95, 100; "enactment" of, 128; intellectual identity, 71–86; politics, 20–21, 42, 82, 179. *See also* cultural identity; displacement; national identity
IMF (International Monetary Fund), 57, 73
In the Heat of the Sun, 16, 258
India, 277n16
Indonesia, 57, 72, 73
Industrial Revolution, 101
industrialization, 9–10, 54, 69, 161
installation art, 145, 158–72, 175–78, 180–85, 189–92
instrumental rationality (*gongju lixing*), 58–60, 69–70
intellectuals (*zhishi fenzi*), 31–47, 77, 205; the academy, 43–45; artistic quality vs. financial gain, 208, 223, 253, 296n30; attacks on, 207, 208; Cultural Revolution, 31, 33, 102; as elitists, 80–81, 206, 210, 212, 296n38; function, 11–15, 26–28, 32–37, 44–47, 242; future, 41–43, 84–86; global capitalism, 69, 80–81, 223; identity discourse, 36–38, 41–42, 48–50, 56, 71–86; postmodernism/"humanistic spirit," 31–37, 80–81; praxis, 43–45; as resistors, 47, 56, 85, 86, 210, 254; in *Ruined Capital*, 239–59; social activism, 37, 78; social status, 35, 37–39, 80–81, 240, 243, 247–48, 253; third world role, 37, 78, 241
International Confucian Association (ICA), 41, 274n21; *ICA Bulletin*, 41, 274n22
International Monetary Fund (IMF), 57, 73
internet, Web page for Beijing events, 266

intertextuality, 244–52
Irma Vep, 124, 128–32, 288n28
Irons, Jeremy, 286n15, 288n28

James Bond/Bond films, 21–22, 134–36
Jameson, Fredric, 6–9, 12, 13, 157, 218, 282n3; on cognitive mapping, 47, 85; on mediatizing art, 159; on national allegory, 236, 241, 298–99nn17,18; postmodernism lectures, 34–35, 45–46; on third world intellectuals, 37
Japan, 57, 61, 72, 77, 275n27, 284n3
Jet Li, 22, 124
Jia Pingwa, 161, 242–43, 257, 301–2n7; on artifice, 244–45; as celebrity, 253; on character creation, 249–50; *Ruined Capital* (*Feidu*), 242–58; self-censorship, 248; on semiotics, 245–46; on writers as resistors, 254; on Xi'an, 250, 303n42
Jiang Wen, 16, 223, 258
Jiang Wu, 227
Jiang Zemin, 3, 20, 21, 71, 106, 122, 271n37
Jin ping mei, 244, 250, 253, 254
Jin Yong, 197
jing (Confucian Classics), 209
jing pai (Beijing School), 257, 258
jingfei ju (detective and crime drama), 214
jingying wenhua (elite culture), 35, 80–81, 206, 212, 217, 256
jixu geming (continual revolution), 52
Jones, Andrew, 203, 295n18
Ju Dou, 126
Ju Ming, 174; *Tai Chi* series, 176, 177(fig.)
Jusdanis, Gregory, 50

Kang Youwei, 51
Kant, Immanuel, 33, 34
karaoke, 35
Keep Cool (*Youhua haohao shuo*), 292n4
Kellner, Douglas, 298n12
Kentucky Fried Chicken, 67
Kersey, Paul, 106
Kim Young Sam, 72
Kingston, Maxine Hong, 138
Komar, Vitaly, 150
Korea. *See* South Korea
Korean War, 118
Kosolapov, Alexander, 150
Kosovo, 74, 80, 183
Krauss, Rosalind, 19

INDEX 313

Kundun, 21, 80, 106, 136, 174
Kwan, Stanley, 116, 123, 126, 131

Lai Ming, Leon, 108
Lam, Ringo, 22, 130
Lao She, 257
Last Emperor, The, 174
late twentieth century, 1–28, 261–67
Latin America, 62, 67, 270n12, 272–73n9
Law, Clara, 116
Leaud, Jean-Pierre, 129, 131
Lee, Ang: *Wedding Banquet,* 221
Lee Kuan Yew, 56, 274n21, 277n9
Lee Teng-hui, 79, 187
Lee, Wen-ho, 80, 183, 185, 264
Legend of Empress Lü, The (Lühou chuanqi), 282n8
Leung Chiu-wai, Tony, 112, 113(fig.)
Leung Ka-fai, Tony, 117
Levenson, Joseph R., 48–49
Li Hongzhang, 283n2
Li Jianxin, 231
Li Jun, 106
Li Ka Shing, 274n21
Li Ruihuan, 207
Li Shan, 146; *Mao* series, 152–53
Li Shenzhi, 82, 277n22
Li Xianshou: *The Romantic: A Love Story in a Metropolis,* 255
Li Xianting, 146–47
Li Zehou, 33, 58–60, 63, 274n21
Li Zhongxiao, 222
Liang Xiaosheng, 271n16
lianxu ju. See television serials
liberalism, 81–84
libidinal economy, 93–98, 219–25, 235–38
Lin Bao, 52
Lin, Brigette, 125
Lin Yü-sheng, 278n5
Lin Zexu, 284n3
Link, Perry, 294n8
lishi fansi (historical reflection), 33, 75–76, 243
lishi ju (historical drama), 214, 242
literature, 35, 200–206, 239–59, 252–58; classic Chinese novels, 244–45, 248–51; eroticas, 253–54; experimental fiction (*shiyan xiaoshuo*), 240; fictionality, 244–52; genres, 244–52; grand narrative (*grand récit*), 35; intertextuality, 244–52; literati novel (*wenren xiaoshuo*), 255; Mao era/New Era, 239–40; Nobel prize, 259; parody, 203–5, 241; photo-realism, 154, 241; political role, 239–40, 254; popular literature, 34, 240–59, 303n37; 303n37; post-allegorical writing (*hou yuyan*), 240–41, postmodernist, 240; pure literature (*chun wenxue*), 240; realism/new realism, 19, 146, 205, 240, 245, 248–49; satire, 203–5, 241; small stories (*hsiao-shuo*), 65; urban novels, 243, 249, 252–59; vernacular novel, 249; novels: *Hong lou meng,* 244–46, 248–51, 254; *Jin ping mei,* 244, 250, 253, 254; *Ruined Capital,* 239–59
Liu Binyan (Liu Pin-yen), 198, 273n14, 272n6
Liu Chunhua, 142
Liu Junning, 82
Liu Peiqi, 93, 95(fig.)
Liu Wei, 146, 154–55
Liu Xiaobo, 198, 206, 208, 296n31
Liu Zaifu, 34, 63, 198
Locke, John, 82
Logan, Bey, 127
Love Is a Many Splendored Thing, 112
Lover (Pinter), 199
Lu, Sheldon H., 65–66, 243, 250, 278n25, 302n13
Lu Xun, 32, 37, 244; *The True Story of Ah Q,* 224
Luderowski, Barbara, 190
Lulu's (Pittsburgh), 23–24, 26
Luo Zhongli: *Father,* 155
Lyotard, Jean François, 35, 65–66

Ma Yuan, 240
Macao/Macau, 60, 261, 262
McClintock, Anne, 69
McDonald's restaurants, 25, 67, 184–85, 289n37
MacFarquhar, Roderick, 278n6
McLuhan, Marshall, 101
Madonna, 115
Mahathir, Mohamad, 57, 72
Malaysia, 57
Manual of a Complete Marriage, The (Wanquan jiehun shouce), 116
Mao Dun, 257
Mao Zedong, 6, 11, 14, 66, 102, 118, 257; contradictions theory, 6, 16–17; Cultural Revolution, 52, 75; folk culture, 197; icons of, 142, 144, 146, 149–53, 157, 183–89, 202, 289n2

Mao Zedong re (Mao Zedong fever), 202
Maoism (Mao Zedong Thought), 5–6, 8, 16–17, 35, 51–52, 59, 204; and intellectuals, 32–33; parody, 205; slogans, 10, 186; socialist realism, 58
market economy. *See* socialist market economy
marketing/marketization, 73, 142, 263; art, 142; culture, 14, 15, 100, 141–42, 255–56; eroticism as marketing device, 252–56
martial arts drama (*wuxia ju*), 214
martial arts/action films, 22, 124–35, 137, 265
Martial Law, 265
Marx, Karl, 52, 62
Marxism (Chinese). *See* Maoism
Marxism/Leninism, 5–6, 8, 33, 51, 59, 82–84
Marxist humanism. *See* humanism (Marxist)
masculinity: Asian tradition, 125, 137, 219–30, 234–38; centrality, 226–30; intercultural contexts, 221–30; national identity, 220–21; reconstruction, 219–30; soap opera, 213–38; transnationalism, 234–38
masochism, 253
mass culture: Communist Party usage, 208; globalization, 216–19; marketing, 255–56; national character, 197; political use, 203, 208, 217; postmodernism, 10–11, 45, 81
mass media, 189–90; cold war rhetoric, 21–22, 79–80, 136, 144; commercialization, 197, 275n30; Democracy Movement coverage, 2, 18; expansion of, 39, 80, 183; geopolitical remapping, 132, 133–37; image industry, 221–25, 234–38, 266; intercultural relations, 234–38, 265, 300n32; masculine images, 219–30, 234–38; national self-imaging, 218–19, 224; public sphere, 43, 45, 203, 209–10; transnationalism, 19–20, 234–38; visuality, 17–23, 89–102; Western hegemony, 123, 136. *See also* soap opera
materialism, 154, 254
May Fourth Movement, 31–32, 51, 75–77, 78, 264; enlightenment discourse, 35, 39, 68, 81; legacy, 204–5, 210, 262
media. *See* mass media
Mehta, Zubin, 23
meinü zuojia (beauty women writers), 258–59
Meisner, Maurice, 263
Melamid, Alexander, 150
metaphysics, 245
Mian Mian, 258; *Sugar* (*Tang*), 259

Mickey Mouse, 184, 185
Microsoft Corporation, 266
millennium, 26
mini-dragons, 14, 56, 57, 77
minimalism/postminimalism, 159, 166
Ministry of Culture, 32
mixed media, 159
Miyake, Issei, 187
Miyoshi, Masao, 85
modernity/modernism, 48–70, 240; agency, 43, 57, 63, 69; alternative forms, 42–43, 50–53, 55–57, 61–64, 147; Asian, 31–37, 49, 58, 77, 143, 147, 276n4; capitalism, 57, 66, 69, 77; Confucian capitalism, 55–57, 76–78; contra-modernity (*fankang xiandaixing*), 58; diasporic discourse, 17, 39–40, 56, 76–77; Eurocentrism, 41, 50, 64, 69, 226; globalization, 62, 89; instrumental rationality, 58–60, 69–70; Li/Liu dialogues, 58–60; modernity/modernization, 70, 75, 90, 272n5; negative consequences, 69–70, 252; postcolonialism, 58–64; socialist modernity, 53–55; temporalities, 58–60; transnational discourse, 55–57; urban novels, 243, 249, 252–59
modernization: cultural disruption, 93, 102; impact, 160–61; national agenda, 52–55, 219, 272n5; shopping malls, 142; slogans, 52, 155, 217; television, 93–94; urban novels, 243, 249, 252–59
Monroe, Marilyn, 153
Mou Zongsan, 279n9
movies. *See* film industry
Mr. Nice Guy, 137
MTV (Music Television), 35
Mui, Anita: as action heroine, 123–26, 138, 286n12; *Executioners,* 127–28; *Heroic Trio,* 127–28
Mukerji, Chandra, 196
Mulan, 23, 137–38, 289n37
multiculturalism, 185
Munch, Edvard: *Scream,* 149
Museum of Chinese History, 105, 283n2
music. *See* popular music
Musidora, 131, 132
"My 1997" ("*Wo de 1997*"), 107
"My Motherland" ("*Wo de zuguo*"), 118, 121

Naisbitt, John, 41
Najita, Tetsuo, 62–63

"Nan ni wan", 201
narcissism, 253
nation-state, 83, 120–21; citizenship, 104–8, 111, 120–21; erosion of, 18, 68, 116–20, 143; globalization, 18, 186; sovereignty, 105, 106, 108; visual identity, 21, 27–28
national allegory, 157–58, 160, 236–38, 241, 298–99nn17,18
National Art Gallery (Beijing), 143, 145
national identity, 111, 115, 120–21, 183, 224–25; deterritorialization, 238; fragmentation, 218; globalization, 216–19; homeland, 115; Hong Kong, 106, 113, 115; masculinity, 220–21; media representations, 224; self-imaging, 235; soap opera, 216–19. *See also* cultural identity, identity
national studies. *See* Chinese national studies
nationalism, 23–28, 107, 237, 264; cultural, 71–86; as emotional state, 111, 121; flexibility, 108, 116–20; globalization, 186; masculinity, 235; mass culture industry, 197; soap opera content, 230
nationality, 104–21
NATO. *See* North Atlantic Treaty Organization
nature, 70
neo-colonialism, 73, 79
neo-Confucianism, 76–77. *See also* Confucianism
neo-conservatism (*xin baoshou zhuyi*), 281n26
neo-nationalism, 237–38, 301n40
New China, 7–8
New Chinese Cinema. *See* film industry (China)
New Era (*xin shiqi*), 8–11, 31, 33, 35–36, 81; literature, 239–40; Marxist humanism, 33–34; subjectivity, 155
New Left, 81–86
New Measurement Group (*Xin jiexi xiaozu*), 159
New Perceptionists (*xin ganjue pai*), 257
New Period. *See* New Era
New Wave Cinema. *See* film industry (China)
new world order, 2, 121, 135
New York City, 110, 116–19, 265; *Beijingers in New York*, 200, 215, 222–24, 227, 299–300n25; Chinese community, 200, 223
Nietzsche, Friedrich Wilhelm, 34
Ning Jing, 105–6

North Atlantic Treaty Organization (NATO), 74, 80, 183, 262, 263–64
Northwest region (Xibei), 242–43
nostalgia, 202, 242
novels. *See* literature
numerology, 250, 251

Occidentalism, 52–53. *See also* Orientalism
Odermatt, Herve, 177–78
Oh Homecoming (*Guilai xi*), 283n2
Olijnyk, Michael, 190
100-Days reform movement, 51
Ong, Aihwa, 63, 77
Opium War, 51, 105
Opium War, The (*Yapian zhanzheng*), 21, 105, 114, 116, 284n3
Orientalism, 49, 52, 173–92, 200, 265; Asian stereotypes, 235; Chinese use of, 40, 61, 178, 219, 236; female film stars, 126; in Hollywood films, 112, 130; parody, 183–85; post-Orientalism, 179, 192, 292n9; third world criticism, 78–79. *See also* cultural production
Oshin (Japanese soap opera), 214
other, the, 37, 225–30, 300n28
overseas Chinese. *See* diaspora
Oviedo, José, 272–73n9

Paik Nam June, 101
panda bears, 180
parody: avant-garde art, 178–89; Chineseness, 178–89; intellectuals, 205; national allegory, 241; official culture, 204–5; in popular culture, 200–206, 241; soap opera, 230
party congresses, 3, 71, 122
patriarchal discourse, 235, 237
Peking Opera, 175–76
Peking Opera Blues, 125
People magazine, 133
Perelman, Bob, 7–8
performance art, 145, 158–65, 170–72, 180, 186–89
periodization, 11–15
petits récits, les (small stories), 65
Pfeiffer, Michelle, 131
photo-realism, 154, 241
photography, 183, 189–90, 241
Piazzolla, Astor Pantaleon, 115
Pinter, Harold: *Lover*, 199

Pitt, Brad, 21, 106
Pittsburgh Mattress Factory, 189
Pittsburgh, Penn., 23, 26, 180
Pittsburgh Post-Gazette, 24, 271–72n39
Pizza Hut, 67
Place Vendome (Paris), 176
political pop (*zhengzhi bopu*), 144–58, 174, 185
politics: apoliticism in popular culture, 195; cold war rhetoric, 21–22, 79–80, 136, 144; Deng reform era, 2–4, 8–10; erotic literature, 253; geopolitical remapping, 133–37; identity politics, 20–21, 42, 82, 179; literature, 239–40, 254; popular music, 203; postmodernism, 15–17, 42, 68; role of intellectual, 37, 78; sexuality and transnational politics, 234–38; soap opera, 234–38; transnationalism in Chinese media, 234–38. *See also* cultural production
pop masters (*bopu dashi*), 144, 147
Popper, Karl, 82
popular culture (*dazhong wenhua*), 10–11, 15, 19, 35, 39, 80, 193–261; Asian action heroine, 137–38; avant-garde art, 20, 145–57; cold war rhetoric, 21–22, 79–80, 136, 144; commercialization, 35–36, 197, 255; commodification, 138, 289n37; dialectics of, 195–212; globalization, 39, 122–23, 200–201, 206–7, 237; historical overview, 196–200, 209–10, 262; literature, 200–206, 239–59; music, 200–206; official discourse, 43–44, 54, 196, 198, 206–8, 210–11, 220, 232; parody, 200–206; public sphere, 43, 45; soap opera, 213–38; televisuality, 89–102, 200; transnationalism, 137–38, 199–200, 225–30, 298n16. *See also* masculinity; Western culture
popular literature. *See* literature
popular music (*tongsu yinyue*), 35, 115, 199, 200–206, 220, 295n18
post–cold War. *See* cold war
post-Confucianism. *See* Confucianism
post-Enlightenment. *See* Enlightenment, The
post-ism (*houxue*), 2, 38–42
post-masters (*houxue dashi*), 39
post–New Era (*hou xin shiqi*), 11, 34–35, 39, 76, 80–81, 270n16; literature, 239–40; political pop, 145–57; subjectivity under, 155–56
post-socialism. *See* socialism
postcolonialism, 40, 48–70, 78–79, 281n2; in China, 59–62; contra-modernity, 58, 62; cultural identity, 166–72; exoticization of western women, 225–28, 231–36, 300n28; modernity, 58–64, 277n22
postminimalism/minimalism, 159, 166
postmodernism, 4–11, 16, 49–50, 281n2; American, 64, 157–58; avant-garde art, 141–72; in China, 13–14, 31–37, 45–47, 64–70, 240; cultural identity, 49–50, 67–68, 141–72; culture, 10–11, 46, 149; globalization, 46, 80–81, 101–2, 192, 211–12, 237, 267; Jameson lectures on, 45–46; national allegory, 157–58, 160; paradox, 265–67; parody, 205, 206; periodization, 11–15; politics, 9–10, 15–17, 42, 43–45, 65–66, 68; subjectivity, 81, 144; televisuality, 100–102; third world, 67, 267, 270n12, 272–73n9
postsocialism. *See* socialism
Prakash, Gyan, 179, 277n16
Pratt, Ray, 203
praxis, 43–45, 63
PRC. *See* China, People's Republic of
process art, 159
propaganda: attacks on intellectuals, 207, 208; popular culture, 206–8, 224; soap opera, 225–30, 232
Pryce, Jonathan, 134
P.S. 1 Contemporary Art Center (New York), 146, 185
public shareholding, 3, 54
public sphere: the academy, 43–45; in diaspora, 44; mass media, 209–10; popular music, 203, 295n18; public space (*gonggong kongjian*), 44, 274n29; tabloid journalism, 209–10
Puccini, Giacomo, 23

Qiang Wen, 227
qianwei yishu (avant-garde art movement), 145
qigong (traditional exercise), 250, 263
Qin Yufen, 174–76, 178; "Lotus in Wind," 175, 176(fig.); *Spring in the Jade Hall*, 175–76
qing (way of the world), 244
qingjie ju (melodrama), 214
qingjing xiju (sitcom), 214, 215
Qiong Yao, 197
Qiu Zhijie: *Copying the "Orchid Pavilion Preface" a Thousand Times*, 164, 165(fig.)

Queens Museum of Art (New York), 185

racism, 234–35
radicalism, 75–78
Rauschenberg, Robert, 147
re (intellectual "fever"), 34
realism/new realism, 19, 58, 146, 205, 240, 244–52
Red Corner, The, 21, 80, 106, 136, 174, 265
Red Detachment of Women, The, 138
Red Guards, 16, 186
Red River Valley, The (*Honghe gu*), 21, 105–6, 114
Reform and Openness Era (*gaige kaifang*), 54–55, 57
Renaissance, 101
renwen jingshen ("humanistic spirit"), 38–39, 42, 80–83, 243, 253
reportage, 34
Republican Revolution (1911), 51
Reynaud, Berenice, 126, 130
Robbins, Bruce, 41
rock music (*yaogun yinyue*), 201–3, 206, 295n18
romance, 125
Romance of the Three Kingdoms, 287n17
Romm, Mikhail, 230
Rothrock, Cynthia, 133
Rouge, 126
Ruan Lingyu, 126–27
Ruined Capital (*Feidu*; Jia Pingwa), 239–59; allegory, 245, 250; assessments of, 243, 250, 302n10; character creation, 249–50; conclusion, 250–51; fictionality, 244–45; intertextual references, 244, 248; language structure, 254–55; marketing, 253–56; post-allegorical literature, 303n37; "Postscript" (*Houji*), 244–45; root-searching novel, 256; urban novel, 252–58. *See also* literature
Rulin waishi, 254
Rumble in the Bronx, 130
rumor and gossip (*daoting tushuo*), 209–10
Rush Hour, 265
Russia, 61, 74, 225–30, 234
Russian Girls in Harbin, 225–30, 229(fig.), 234, 300n32

Said, Edward, 52, 85–86
Salle, David, 289n4
Sandler, Irving, 159
Sanlitun jiuba jie (Beijing), 24–25
SAR (Special Administrative Region), 121
Sartre, Jean Paul, 34
satire, 149, 153–54, 186–87, 203–5, 241
Scharres, Barbara, 125
Schoeni Art Gallery (Hong Kong), 283n2
Schudson, Michael, 196
Scorese, Martin, 21, 106
Scott, Ridley, 132
secret societies, 262
self-censorship, 248
self-reflexivity, 122–38
semiotics/semiology (*fuhao xue*), 245–46, 250, 251
Serfs (*Nongnu*), 106
Seven Years in Tibet, 21, 80, 106, 136, 174
sexuality, 190–91, 199–200, 292–93n13; bisexuality, 125; and foreigners, 258–59; homosexuality, 112–15, 200; literature, 252–53; soap opera, 213–38; stereotypes, 234–35; transnational politics, 234–38
SEZs (Special Economic Zones), 10, 12
Shaanxi province, 201, 220, 242, 247
Shanggan Ridge (*Shanggan ling*), 118
Shanghai, 180–81, 196–97, 225, 284n3, 294n7; colonial status, 60; humanist spirit, 81, 82; urban novels, 254, 256–59
Shanghai Express, 298n16
Shanghai School (*hai pai*), 256–59
Shanghainese in Tokyo, 222, 299–300n25
shehuizhuyi. See socialism
shehuizhuyi shichang jingji. See socialist market economy
Shenzhen, 10, 263
shimin wenhua (plebian culture), 217
shinei ju (indoor dramas/soap operas), 206, 214, 215. *See also* soap opera
shiyan xiaoshuo (experimental fiction), 240
Shohat, Ella, 67
Shu Tong: *Being Independent* (*Shisan bukao*), 255
sign (*xiang*), 245
Simmel, Georg, 258
simulacra, 218, 240, 254
Singapore, 56, 72, 77
Sino-British Joint Declaration (on return of Hong Kong), 107, 112
Sino-U.S. relations, 21, 79–80, 187
Siqin Gaowa, 116

slogans/sloganeering, 52, 53, 107, 155, 186, 217
soap opera (American), 216–17
soap opera (*feizao ju*), 21, 35, 206, 213–38; alterity, 225–34, 236, 300n28; cross-cultural relations, 225–30, 233–38, 300n28; foreign women, 225–26, 228, 231–34; libidinal economy, 219–25; masculinity, 213–38; national identity, 216–19, 225–30; politics, 234–38; sexuality, 234–38; transnationalism, 216, 234–38
soap opera (Japan), 214, 299–300n25
social praxis, 63
socialism (*shehuizhuyi*), 53–54, 155, 217; central planning, 54; Chinese socialist economic paradigm, 64; postsocialism, 154, 259, 281n2; realism, 58, 205
socialist market economy (*shehuizhuyi shichang jingji*), 12, 14, 93, 155, 158, 198, 217; disillusionment with, 82, 202; diversification, 55; impact, 37–38, 46–47; public sphere, 43; transition to, 53–54. *See also* economics
socialist modernity, 53–55
SOEs (State Owned Enterprises), 54
Solomon, Andrew, 149
Song of the Exile (*Ketu qiuhen*), 116–17
Soong: Ailing, Meiling, and Qingling, 106, 287n17
Soong Sisters, The (*Songjia huangchao*), 106, 116, 287n17
Soros, George, 72, 77–78
South Korea, 56, 61, 77; Asian financial crisis, 57, 72–73
sovereignty, 74, 105, 106, 108
Soviet Sots Art, 150
Soviet Union, 54, 227
Special Administrative Region (SAR), 121
Special Economic Zones (SEZs), 10, 12
spectacles, 18, 186, 242, 266
spectatorship, 98–100
spirituality, 56
Spring in the Jade Hall (*Yutang chun*), 175–76
Stam, Robert, 67
stardom: female, 124–37
State Owned Enterprises (SOEs), 54
Statue of Liberty, 110, 118–19
stereotypes, 226, 234–38, 300n32
Sternberg, Joseph von, 298n16

Story of Qiu Ju, The, 92–93
Stuntwoman, 133–34
Su Tong, 240
subjectivity: impact of Cultural Revolution on, 33–34; loss of, 241; new masculinity, 220; post-ism, 39–40; post-socialism, 154; postmodernism, 81; reconstitution of, 42, 58–60, 75, 76
Suharto, Mohamed, 57, 72
Sun Sha, 226
Sun Yat-sen, 106, 283n2
Supercop/Police Story III, 133
supplemental history (*bushi*), 209
"Sweet Love" (*Tian mimi*), 110
symbols/symbolism. *See* semiotics

tabloid journalism, 209–10, 225
Tai Chi, 178
Taipei, 114
Taiwan, 17, 44, 72, 114, 187; colonial status, 61; future of, 74, 262, 264; mini-dragons, 56, 77; postmodernism debate, 47; three sisters allegory, 106, 127, 287n17
Taiwan Museum of Art, 186–87
Taiwan Strait, 264
Taiyuan TV, 214
Talens, Jenaro, 254
Tang Song, 145
Tang Yijie, 274n21
Taoism, 35, 65, 250, 251
technology/technocrats, 36, 172, 297n6
television: as global culture medium, 100–101, 183; impact on Chinese culture, 99, 266; overview, 213–16, 242; spectatorship, 98–100; symbolism of, 93–94; technical advances, 297n6
television (China): American TV series, 100–101, 214; content, 200, 214–15, 225, 235, 242; direct telecast period (*zhibo qi*), 214; *New Star* (*Xin xing*), 214; return of Hong Kong, 104; televisuality, 89–102; *A Veggie Cake*, 214. *See also* China Central Television; soap opera
television serials (*lianxu ju*), 35, 141–42, 203, 206; *Beijingers in New York*, 200, 215, 222–24, 227, 299–300n25; *Chinese Ladies in Foreign Companies*, 222; *Foreign Babes in Beijing*, 231–34; *Russian Girls in Harbin*, 226–28, 229(fig.), 234, 300n32; Shanghai-

nese in Tokyo, 222; *Stories of the Editorial Office*, 215, 222; *The Great Qin Empire*, 215; *The Legend of Empress Lü*, 282n8; *Yearnings*, 207–8, 215, 222, 223
television (Western): Democracy Movement coverage, 2, 18; *Dynasty*, 101, 214, 226, 236; *Martial Law*, 265; MTV, 35
televisuality, 89–102
territoriality, 106, 120
Thailand, 72
Thatcher, Margaret, 283n2
"The Second Coming" (Yeats), 27–28
theme parks, 184
third world: agents of change, 43, 57, 69; cultural categories, 146–47; development policies, 61–62, 63; indigenous criticism, 78–80; intellectuals' role, 26–28, 37, 43, 46, 57, 69, 241; modernity dialectic, 57, 61–62; national allegory, 157–58, 160, 236–38; post-Orientalism, 179, 192, 292n9; postmodernism, 5, 9, 157–58, 267; racial/sexual stereotypes, 234–35; Western modernity, 57; Western women as exotics, 234–36
Three Kingdoms, 185
Three Worlds Theory, 5–6, 9, 16, 60
Tian Zhuangzhuang, 92, 294–95n15
Tiananmen Square: aftermath of Democracy Movement protests, 84, 143, 202; Goddess of Democracy statue, 118–19; Helmsman's Portrait, 149; McDonald's Restaurant, 25; Monument of People's Heroes, 105; Museum of Chinese History and Revolution, 105; popular music, 203; significance of, 148–49, 264
Tianjin, 60
Tibet, 21, 74, 105–6
Titanic, 20, 122–23
TNCs. *See* transnational corporations
To Catch a Thief, 132
To, Johnny, 123
To Live, 174
Tocqueville, Alexis de, 82
Tomorrow Never Dies, 21–22, 124, 133–37, 135(fig.)
Tong, Stanley, 22, 265
tongsu ju (popular drama), 214
tongsu yinyue (popular music), 35, 115, 199, 201–3, 220, 295n18
totalistic antitraditionalism, 278n5

township enterprises *xiangzhen qiye*, 54–55
transnational corporations (TNCs), 25, 55, 62, 84, 266; impact on third world intellectuals, 84, 85
transnational feminist practices, 237
transnationalism, 23–28, 143, 267; art films, 91–92, 125, 126, 130–32, 134, 219, 236; Chinese media, 234–38; Confucian capitalism, 55–57; culture, 56, 179, 211–12, 225; impact on daily lives, 211–12; libidinal economy, 93–98, 219–25, 235–38; localization, 18, 23–28; masculinity, 234–38; nation-state, 16, 68, 116–20, 143; national identity, 216–19; popular culture, 137–38, 199–200; self-reflexivity, 128–32; sexuality, 234–38; soap opera and transnational politics, 213–38
Tsang, Eric, 108, 109
Tsang, Sir Donald, 278n3
Tseng, Joseph (Tseng Kwong Chi), 183–85
Tsui Hark, 22, 125, 130
Tu Wei-ming, 274n21
Tucker, Chris, 265
Turandot (Puccini), 23
T.V. Garden (Paik), 101

underground art, 158
United States: American postmodernism, 157–58; Chinese art exhibits, 145–46, 185; Chinese community, 121; Chinese embassy bombing, 74, 80, 183, 263–64; cultural studies, 7, 9, 216–17; *Foreign Babes in Beijing*, 231–34; global hegemony, 73, 74; green card, 110, 117; martial arts films, 130; Sino-U.S. relations, 21, 79–80, 187; WTO membership for China, 3, 72, 74, 264–65, 267. *See also* Western culture
universalism, 41–42, 58, 68, 69, 241
universalists/specialists debate, 37–38, 41–42, 48–49, 84
University of Pittsburgh, 23, 189
urban culture/urbanization, 69, 196–97, 250, 252, 294n7
urban novels/writers, 243, 249, 252–59

Vampires, Les, 129–31, 287n19
Venice Film Festival, 292n4
vernacular novel, 249
video art, 159
Virilio, Paul, 19

visuality, 17–23, 213–38
von Hayek, Friedrich A., 82

Walt Disney studios, 23, 137–38
Wang Anyi: *Reality and Fiction: A Shanghai Story,* 256
Wang Binglin, 231
Wang Guangyi, 146, 147; *Great Criticism* series, 149–50, 151(fig.)
Wang Guowei, 40, 78
Wang Hui, 83
Wang Jianwei, 159
Wang Jin, 283n1
Wang Jinsong, 146; *Taking a Picture in Front of Tiananmen Square,* 148(fig.), 149
Wang Luyan, 159; *Bicycles,* 160
Wang Meng, 203–4
Wang Ning, 46, 273n10
Wang Shuo, 201, 203–5, 242, 295n21; anti-allegory, 241; as celebrity, 253; "hooligan" literature, 149, 203–4; *No Man's Land,* 205; *Playing with Heartbeat,* 205; postmodernism, 81, 205; as urban novelist, 258; *Yearnings,* 207–8
Wang, Wayne, 286n15, 288n28
Wang Xizhi: "The Orchid Pavilion Preface," 161, 164, 165
Wang Youshen, 175; *Darkroom,* 189–90
Wang Zhen, 201, 208
Wang Ziwei: *Mao and Mickey,* 184(fig.), 185
wanshi xianshi zhuyi (cynical realism), 146
Warhol, Andy, 144, 147, 153, 157
Weber, Max, 49, 56, 77
Wei Hui, 258; *Shanghai Darling (Shanghai baobei),* 259
wen (culture), 32
Wen, Ming-na, 289n36
wen shi zhe (Chinese humanities), 38
wenhua fansi (cultural reflection), 33, 75–76, 197, 241, 243
wenhua kuaican (cultural fastfood), 141
wenhua re (cultural fever), 241
wenhua xianxiang (cultural phenomenon), 201
wenhua xiaofei (cultural consumption), 142
wenren xiaoshuo (literati novel), 255
Western culture: attitudes toward China, 5, 20, 80, 265; avant-garde art, 146–47; fast food business, 24–26, 67, 184–85; hegemony, 51, 79, 94, 123, 136, 142, 146–47;
modernity/modernism, 50, 57, 64; philosophy and critical theory, 5–7, 16, 34–35, 61, 79; popular culture, 17, 138, 289n37; postmodernism, 64, 157–58; values/symbols, 42, 67, 149, 150; "Westernization," 51, 142. See also Orientalism
White Lotus Movement, 262
Wild Kiss to Russia, A (Kuangwen Eluosi), 228, 230
Williams, Raymond, 210
Wing Chun, 133
women: Asian action heroines, 122–38, 289n36; exoticization of, 200, 225–28, 231–36, 300n28; female character creation, 249–50; marginalization, 233, 234; portrayals of, 92–93, 124–33, 225–26, 233–34, 258–59; post-feminism, 161; stereotypes, 226, 234–38; transnational feminist practices, 237; urban novelists, 258–59
Woman Warrior: Memoir of a Girlhood Among Ghosts, The (Kingston), 138
Wonder Woman, 128
Wong Jing, 125
Wong Kar-wai, 108, 112, 114–15, 123, 284n10
Wong, Suzie, 112, 133, 134, 235
Woo, John, 22, 124, 130, 132, 286n7
Wood Street Galleries (Pittsburgh), 180
woodblock prints, 189
World of Suzie Wong, The, 112
World Trade Organization (WTO), 3, 72, 74, 264–65, 267
World Wide Web. See internet
Wu Li, 222
Wu Mali, 175, 189; *Victorian Sweeties,* 189, 190
Wu, Vivian (Wu Junmei), 106, 287n17
wuxia ju (martial arts drama), 214

Xi'an, 242, 254; Jia Pingwa on, 250, 303–4n42,43; *Ruined Capital* setting, 246–47, 256, 258
xiang (sign), 245
xiangzhen qiye (township enterprises), 10, 54–55
Xiao Lu, 145
xiaoshuo (hsiao-shuo; small story), 65, 209
Xibei, 242–43
Xie Fei, 219, *Women from the Lake of Scented Souls (Xiang hun nü),* 221
Xie Jin, 105, 114, 138
Xie Mian, 215, 241

xiju (comedy), 214
xin baoshou zhuyi (neo-conservatism), 281n26
xin ganjue pai (New Perceptionists), 257
xin lishi xiaoshuo (new historical novel), 241–42
xin ruxue (New Confucianism), 38
xin shiqi. See New Era
xin xieshi (new realism), 240
Xiu Xiu: The Sent-Down Girl, 174
Xixiang ji, 245, 254
Xu Baoqi, 92
Xu Ben, 40
Xu Bing, 166, 168–72, 174, 290–91n18; *A Book from the Sky*, 155, 156(fig.), 169; *A Case Study of Transference*, 170(fig.), 171, 179; *Cultured Animal: Panda Pigs*, 180; *Square Words*, 171(fig.), 172
Xu Jilin, 82
Xu Qingdong, 228
Xu Youyu, 82
xungen wenxue (root-searching literature), 241, 256

ya wenhua (subculture), 204
Yan Jiaqi, 198
Yanan, 196–97, 294n7
Yangguang canlan de rizi (*Heat of the Sun*), 16, 258
yanqing ju (melodrama), 214
yaogun yinyue (rock music), 201–3, 206, 295n18
yazhou jiazhi (Asian values), 38, 40–43, 49, 72, 277n22
Yearnings (*Kewang*), 207–8, 215, 222, 233
Yeats, W. B.: "The Second Coming," 27–28
Yeh, Sally, 125
Yeoh, Michelle, 21, 22, 106, 288n29; as action film star, 123–28, 138; *Executioners*, 127–28; *Heroic Trio*, 127–28; *Stuntwoman*, 133–34; *The Soong Sisters*, 287n17; *Tomorrow Never Dies*, 133–37, 135(fig.)
Yes, Madam, 133
Yin Xiuzhen: *Ruined Capital*, 161, 163(fig.); *Sowing and Planting*, 161, 162(fig.); *Washing the River*, 160–61
Yu Hua, 240

Yu Youhan, 146, 150; *The Waving Mao*, 152(fig.)
Yuen Woo-ping, 22, 133
Yutang chun (*Spring in the Jade Hall*), 175–76

Zakaria, Fareed, 277n9
Zappa, Frank, 115
Zen (Chan) aesthetic, 168
Zha Jianying, 207
Zhang Huan: *65 Kilograms*, 160
Zhang Peili, 159; *Divided Space*, 161, 164(fig.)
Zhang Taiyan, 78
Zhang Xianliang, 199, 220, 273n14
Zhang Xiaogang: *Bloodline: The Big Family, No. 2*, 154(fig.)
Zhang Xiaowu, 222
Zhang Yimou, 23, 125, 200, 221, 292n4; *Ju Dou*, 126; New Chinese Cinema, 20, 92, 144, 219; films: *Raise the Red Lantern*, 126, 174, 200, 236; *Red Sorghum*, 220, 236; *To Live*, 174; *Turandot*, 23
Zhang Yiwu, 46, 215, 241, 273n10
Zhang Zhen, 113
Zhang Zhupo, 250
Zhao Yiheng (Henry Zhao), 40
Zhao Ziyang, 10, 57
Zheng Junli, 105
Zheng Xiaolong, 222
zhengshi (official historiography), 209–10
zhengzhi bopu (political pop), 144, 145–58, 174, 185
zhibo qi (direct telecast period), 214
zhishi fenzi. See intellectuals
Zhongnanhai Compound, 262
zhongti xiyong (Chinese cultural foundations), 51
Zhou Enlai, 52
Zhou Li, 200, 222; *A Chinese Woman in Manhattan*, 224–25
Zhou Xiaowen, 89, 91–93, 219, 281n1, 282nn3,7–8; *Ermo*, 89–102, 226, 292n7; filmography, 91, 103
Zhu Jinshi, 166–69, 172, 176; *Square Formation/Impermanence*, 169(fig.); *Water of Lake Houhai*, 166, 167(fig.), 168
Zhu Rongji, 3
Zhu Xueqin, 82
Zhuangzi, 13, 65, 251